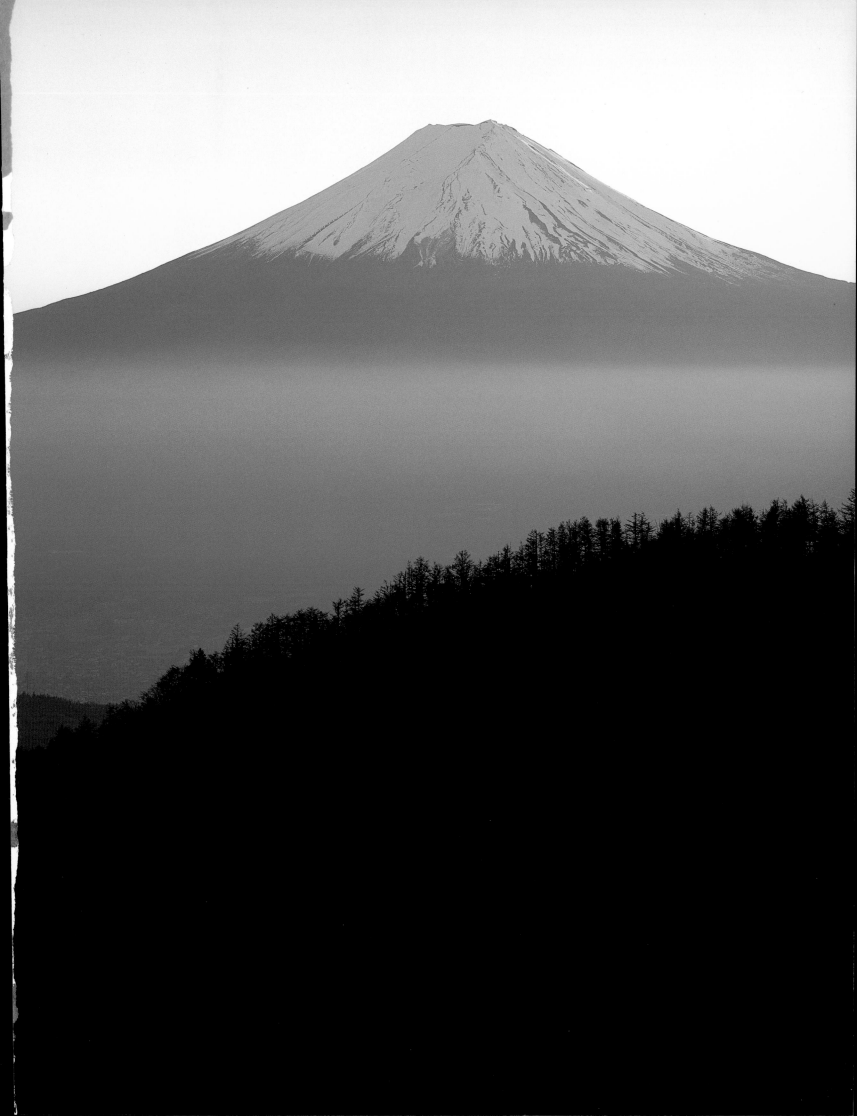

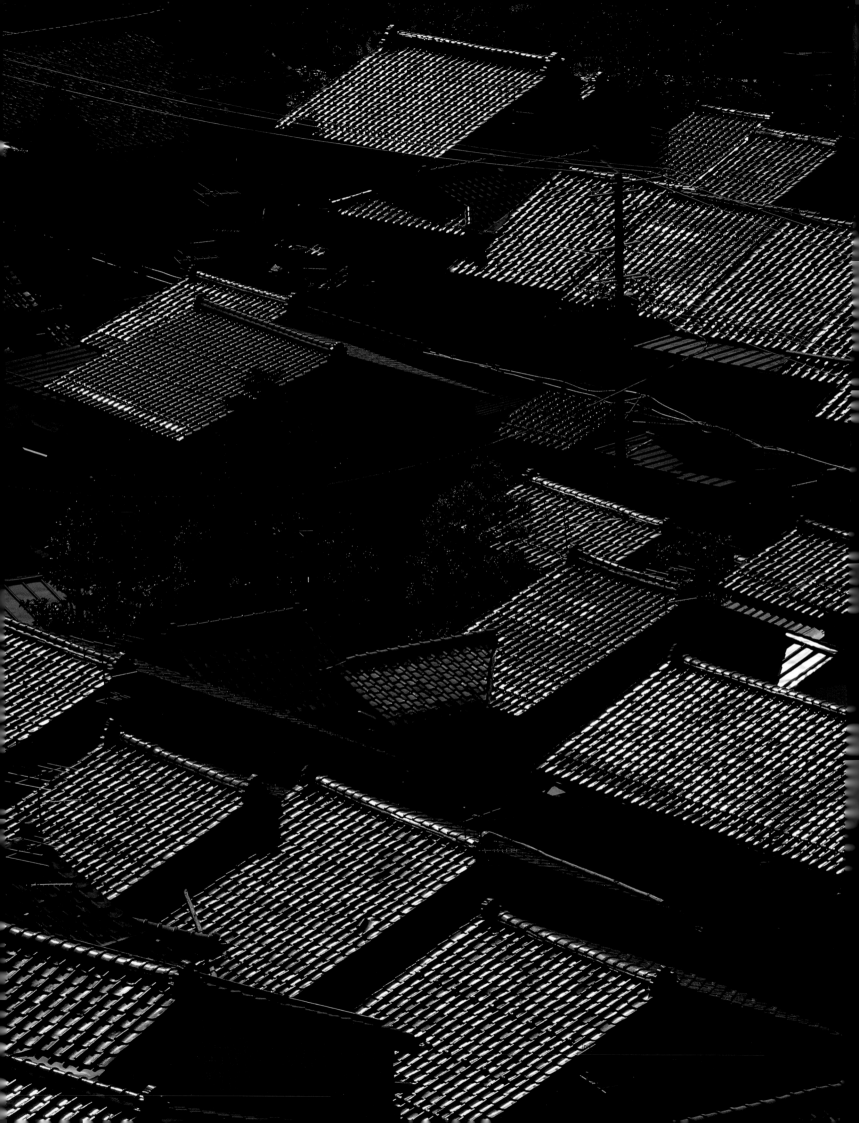

The Cycle of Life

H.I.H. Prince Takamado

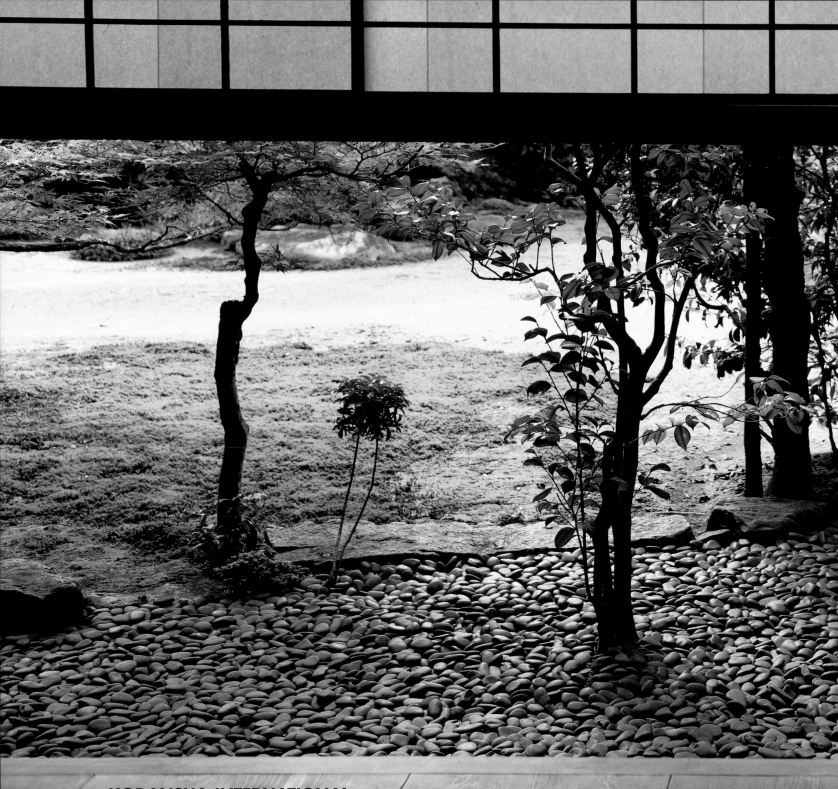

KODANSHA INTERNATIONAL
Tokyo • New York • London

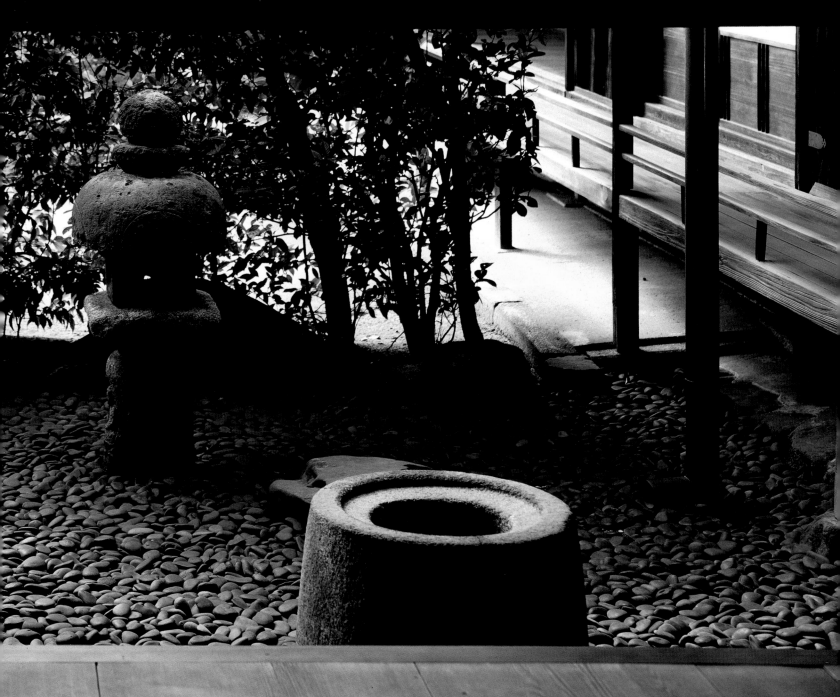

CONTENTS

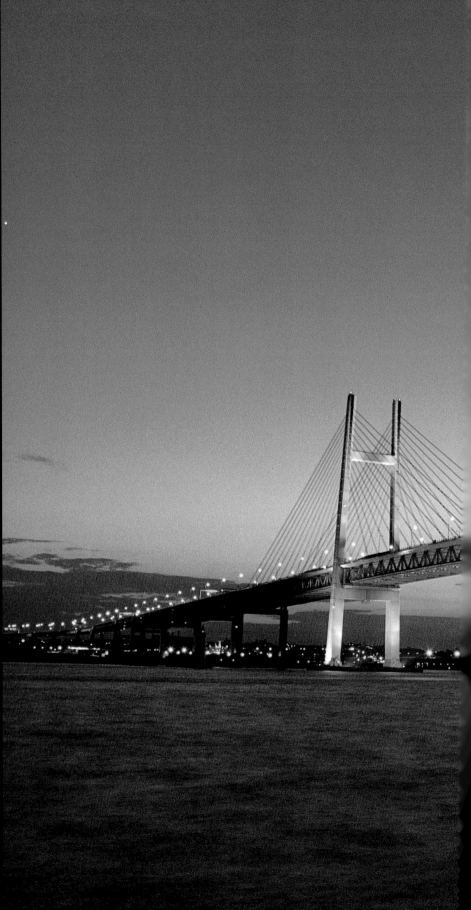

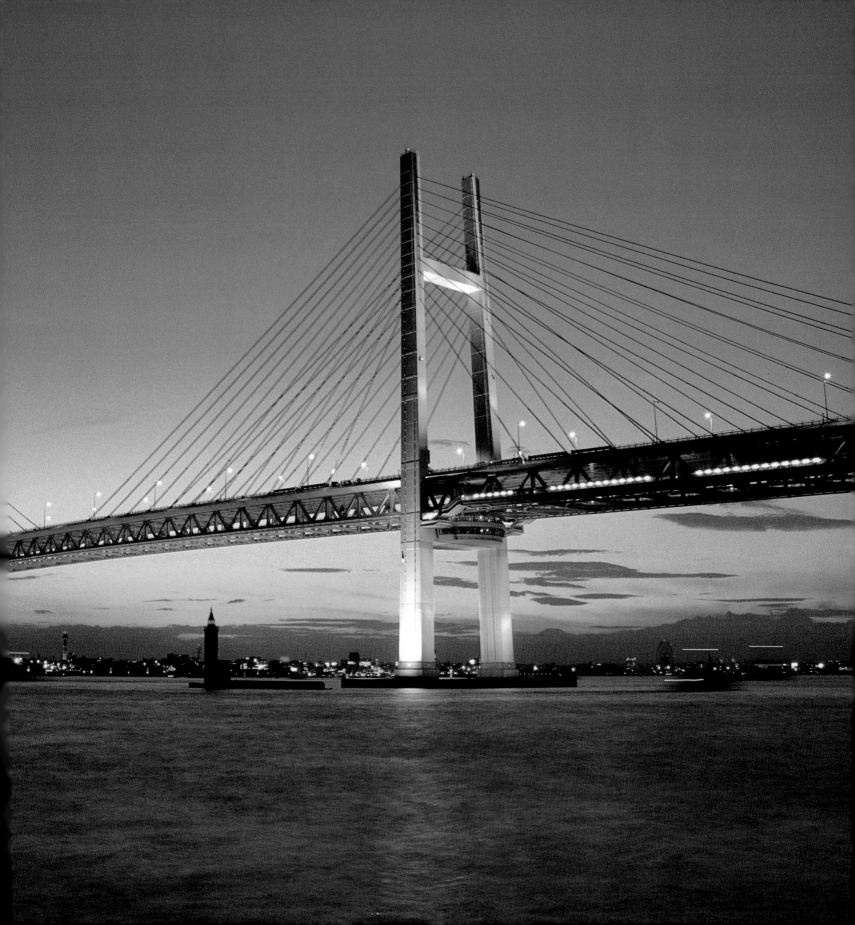

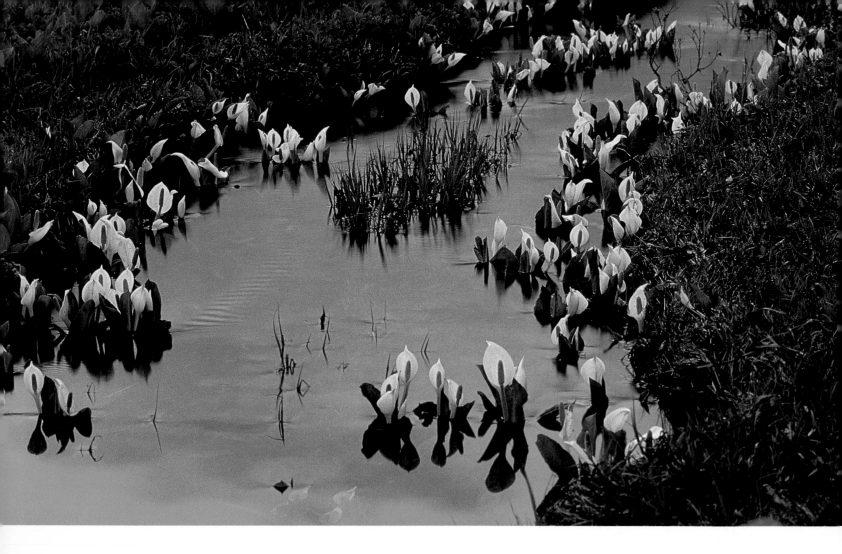

NOTE: The names of contemporary and historical Japanese are given in the traditional manner, surname preceding given name.

Published by Kodansha International Ltd., 17–14 Otowa 1-chome, Bunkyo-ku, Tokyo 112, and Kodansha America, Inc.

Distributed in the United States by Kodansha America, Inc., 114 Fifth Avenue, New York, New York 10011, and in the United Kingdom and continental Europe by Kodansha Europe Ltd., 95 Aldwych, London WC2B 4JF.

Frontispiece: Mt. Fuji in December **Pages 2–3:** Nara's Horyuji temple at sunset **Pages 4–5:** Tiled roofs, Kanazawa **Pages 6–7:** The garden of Kohoan subtemple seen from the reception area, Daitokuji temple, Kyoto **Pages 8–9:** Rainbow Bridge, Yokohama Bay **Page 10:** "Kamchatka Skunk Cabbage" in Oze, Fukushima/Gunma prefectures

Copyright © 1997 by Kodansha International
Printed in Japan. All rights reserved.
First edition, 1997
1 2 3 4 5 6 7 8 9 01 00 99 98 97

LIBRARY OF CONGRESS CATALOGUING-IN-PUBLICATION DATA PENDING

ISBN 4-7700-2088-0

FOREWORD

H.I.H. Prince Norihito Takamado

Japan is a beautiful country, and I never tire of its beauty throughout the cycle of the seasons.

To date, I have visited some thirty countries all over the globe, and each of them possesses its own natural beauty, its own rich culture, and a people to whom it owes this culture. There are many beautiful countries and cities and some in which I would have liked to reside. In fact, I was fortunate enough to have lived in Canada for three years. Even so, I am still happy that I was born and raised in Japan.

Admittedly, Japan can boast no natural wonders that could be described as "stretching as far as the eye can see," "surpassing the imagination," or "the largest in the world." Nature here is more compact. As a glance at any map will show, Japan is a small country—indeed, Canada is about twenty-six times larger. However, unfolding in a gentle arc from northeast to southwest, Japan is blessed with a climate and terrain of astonishing variety—from northern areas where snowfall measures over ten meters in winter, to tropical regions noted for pineapples, mangoes, and other lush vegetation. Japan is divided by a backbone of mountain ranges, covered by a variety of vegetation, and has many lakes, swift-flowing streams, and fertile plains well suited for cultivation.

Being an island nation, Japan has always been blessed with an abundant supply of resources from the sea. Freedom from invasion in the past enabled it to preserve its own distinctive culture and, thanks to a natural setting that is mild, rich in seasonal changes, and blessed with the fruits of the mountains, fields, and seas, its inhabitants were able to create a culture that coexisted in harmony with nature, in a spirit of gratitude for its blessings.

The subtle shifting of the seasons has endowed the Japanese with a fine sensibility to almost imperceptible changes. The seasonal variation in Japan's plant life inspired not only the art of flower arrangement (*ikebana*), but also the sense of impermanence that was infused into the spirit of the tea ceremony (*cha no yu*). A similar awareness of nature created the beauty of the Japanese garden. The daily lives of the Japanese were based on agriculture and fishing, both of which are intricately connected with the seasons. Thus, numerous festivals and customs are based upon and reflect the season. The wide seasonal variety and range of agricultural produce (including vegetables that grow in the wild) and the profusion of fresh fish available have fostered the gourmet

concept that all foods should be consumed at precisely the peak of their season (*shun*).

Japan's has been called a culture of wood and paper. Wood (including also bamboo and straw) is perhaps the one material that contributed the most to the advancement of Japan's culture. The five-storied pagoda of the Horyuji complex is the world's oldest wooden structure, while the Shosoin repository bears silent witness to the excellence of wooden buildings for storage and preservation purposes. Trees have given us an invaluable material that is used in the making of furniture, eating utensils, musical instruments, and sculptures, as well as the raw material that led to the development of lacquerware. In use as early as the Jomon period (?–200 BC), and as can be seen by the English word "japan," lacquerware came to represent Japanese art.

Japanese handmade paper, one of the most durable papers in the world, encouraged the development of calligraphy, painting, and print-making. In the form of *shoji* (paper-covered sliding doors), it visually separates inside from outside, without cutting them off from each other completely, by allowing an appropriate amount of light to enter from outside. Admittedly, its insulating properties are rather poor, which probably precludes the use of *shoji* in countries whose climates are colder than Japan's.

The Japanese aesthetic sense seeks by visual or auditory means to elicit a response in the viewer/listener's imagination, and thus to show things that are not actually there. Therefore, in ink painting, variations in "blackness" of the ink can suggest both the green of rugged pines and the azure of the sun-washed sea. The *kare-sansui* ("dry landscape") seen in some Japanese gardens is achieved by placing rocks and plants to evoke waterfalls and flowing streams. In the same way, the famous rock garden of Ryoanji, and the sand garden of the Silver Pavilion—both at temples in Kyoto—use a few precisely laid stones or deliberately raked patterns to evoke vast natural vistas. In short, the beauty of the Japanese garden re-creates nature in a condensed form so that, as one gazes upon it, the grandeur of nature is seen within the mind's eye. Thus, although the process may be artificial, the result is always to create something that appears natural. So it is with bonsai, the art of creating miniature potted trees, now widely practiced all over the world. Similarly, the wind chimes that are hung beneath the eaves in summer to create an impression of coolness

with their tinkling, and the sprinkling of water at the entrance to the home that creates such a refreshing effect, are both ingenious manifestations of a highly refined sensibility. The tiny netsuke carvings that I happen to collect are another manifestation of this same aesthetic.

In former times, culture and technology entered Japan from China and the Korean Peninsula, as well as from Southeast Asia, India, and even the Middle East. During the 250 years or so of Tokugawa shogunate's "Closed Door" policy, exchange with the outside world was severely limited, but the resulting introspection brought about an inner maturing and refinement in cultural and artistic spheres, resulting in the emergence of a highly developed culture. With the Meiji Restoration of the mid-nineteenth century, Japan was able to enrich its culture further by energetically importing the culture and technology of the West.

Harmony and identification with nature lie at the heart of Japanese culture. However, economic and social progress in the modern world have encouraged a materially oriented civilization that has tended toward the destruction of the natural environment, and, unfortunately, Japan's own economic development has also followed a similar path. Today, when the conservation and protection of flora and fauna have become major worldwide concerns, the time has come for the Japanese to develop a new awareness of the culture that they themselves have created, and to reflect seriously upon what kind of response, what kind of action, are necessary today.

It is my earnest hope that this book will help readers to broaden their appreciation of Japan's special beauty and the characteristic sensibility of its people, both of which have been fostered by the natural setting, history, and traditions of our land, and also, that in a spirit of gratitude for the rich blessings of the earth, they will all join us in attempting to build a better world that will preserve those blessings for all time.

JAPAN—A PERSONAL VIEW

C. W. Nicol

I decided to go to Japan in 1954, when I was fourteen. The practice of judo and the acquaintance of a wonderful Japanese gentleman sparked my interest, first in the Japanese martial arts, then in the culture in which these arts had developed.

It took eight years for me to get to Japan. For the first six months after I arrived I lived in the Kodokan, the great hall of judo in Tokyo. Training was tough, but satisfying. I studied judo and karate, and found that the martial arts were integrated into the culture in completely different ways from, say, boxing or fencing in the West.

From the beginning, my friends and martial arts teachers took me on trips to the mountains and the coast, and I fell in love with the nature which gave birth to this culture. As I studied Japanese I was increasingly able to travel alone, and it was not the famous shrines and temples but the remote mountain hamlets and fishing villages that I was drawn to.

Just a short trip from Tokyo brought me to wilderness where deer, bears, and wild boar roamed. There were animals I knew well from Britain—foxes, badgers, hares, and such—but there were also creatures I had only read about: the goatlike serow, flying squirrels, raccoon dogs. The wildlife astonished me in its diversity, but then, what other countries can claim to have ice floes in the north and coral seas in the south?

I have settled in northern Nagano Prefecture, on forty-five acres of mixed secondary growth woods and abandoned meadows. Together with a local forester, I am nursing the woods back to health, and the results, after just ten years of work, delight and astound me. We have identified ninety-three species of birds in our woods, as well as bears, foxes, martens, weasels, raccoon dogs, hares, dormice, and flying squirrels. Reptiles are abundant too, and I don't think we'll ever finish cataloguing all the insects. In spring, the woods are carpeted with violets.

Our woods are beautiful, but they are just one corner of Japan. Most Japanese will say theirs is a homogenous culture, but as a naturalized Japanese I can tell you that wherever you go, especially in the countryside, you realize that in fact Japan is multi-cultured, with many different local foods, customs, rituals, festivals, and crafts.

I have an endless list of places I want to hike, climb, sail, swim, or just

visit. As I travel in Japan I especially enjoy the fact that wild and natural foods are eaten as part of the normal diet. In the cities, supermarket blandness may be taking over, but most Japanese, if given the chance, are eager to add mountain vegetables and wild mushrooms to their diet, or to try the infinite variety of fresh- and saltwater fish and seafood. Food is served fresh in Japan, and you can usually recognize what you are eating—it still has its own shape and color. Traditionally, enormous care is taken in how food looks and how it is served. There is a story behind each dish. A visit to a traditional inn demonstrates this, although there is usually so much food, and in such variety, that I am forced to give up halfway though the meal.

The indigenous arts and crafts are still a normal part of life for many Japanese and are so integral to my daily life that I don't know how to write about them. From the carved hardwood practice swords in my dojo to the lacquer bowls I drink my miso and wild mushroom soup from, they are just there, and always have been. I have modern heating in my house, but we still have a hundred-year-old charcoal kiln in the woods, and a dozen ways to use the charcoal we make. In our work in the woods we sometimes use modern chainsaws, but most of the time we are wielding traditional hand tools, made locally as they have been for centuries. If you take that extra step off the beaten track, you find this blending of old and new everywhere.

I have spent much of my life in Japan. I work and travel all over the country, my wife and most of my friends are Japanese, and I speak the language, but I don't pretend to understand the Japanese people. Their inward-turning stubbornness can be infuriating. You learn to live and laugh with it, and in fact, as I grow older I am starting to recognize the same trait in myself. On the other hand, the Japanese will go as far as possible out of their way not to offend. Westerners have a great deal of difficulty in grasping the endless unspoken nuances in the Japanese manner, but the intentions behind the formal speech are often completely straightforward. As a writer publishing in Japan I find it most refreshing that the word of an editor is enough. There is rarely a need for a written contract—very different from the situation in Europe or North America.

I am a naturalist and Japan is one of the countries I watch closely. I have made it my home. There is much to complain about and I do so vociferously.

Wonderful virgin forests have been destroyed, rivers and coastlines concreted and polluted, and wildlife habitat reduced alarmingly, especially in the last twenty years. But I still believe that the people have a deep love not only for their nation but for nature, and that we will see a gradual and increasing movement to preserve and rebuild.

When I first climbed a mountain on Yakushima, an island south of Kyushu, and stood before a massive cedar tree authorities believed to be around seven thousand years old, I felt a mixture of gratitude and awe—gratitude that it still stood there, and awe that a living thing could be so old. As the taboos and prejudices about the history of pre-imperial Japan fall away, and more and more spectacular archaeological finds come to light, we see the tapestry of a rich and ancient culture unfolding. On my table I have a replica of a pot which was made before the pyramids were built. It is so old, yet so exuberantly modern at the same time. That, I think, is Japan.

NATURE AND JAPAN

PART I

◀ Wind surfing near Mt. Fuji

A SPECIAL RELATIONSHIP

John Bester

At one time, in Japan as elsewhere, the shifting seasons were the background that shaped the daily lives of the people: the crops they grew, the homes they built and lived in, the gods they created and worshiped, their rituals and their festivals. The seasons shaped inner sensibilities, too, producing the subtly varied patterns that gave them form and stability.

But as to what caused this annual and only partly predictable cycle, people were almost entirely ignorant. They blessed the regular rains, cursed them when they overreached themselves, prepared themselves against the snowfall, and mended their homes when Nature momentarily lost her benevolence and smashed them. They lived, in short, more or less ignorant of all but their immediate surroundings: as the Japanese are fond of saying, "at one with nature."

Perhaps even more than people in the West, the Japanese were innocent of the world. No Age of Discovery, no Great Voyages, had widened their knowledge or spurred their curiosity concerning the relationship between their country on the one hand and the continents, the globe itself, on the other. Of even the shape of their home islands, they had if anything only the roughest idea. A map was a local account of domain lands, or a piecing together of a few of them. Only in the eighteenth and nineteenth centuries did the Japanese get down to the real business of map-making.

Then came the period of discovery of the world at large and the encounters with modern thought in the latter half of the nineteenth century. And after that, in the mid-twentieth century, everything changed, not just for Japan but for everyone: our basic point of view shifted, withdrew into space as it were, and we now gaze on our environment with an almost frightening objectivity. From satellite photographs, we finally see our earth for what we have long been told it was—a blue and white ball suspended, lovely and vulnerable, in an infinite darkness. Half incredulously, we see the actual outlines of countries that were once so patiently traced by sailing ships, creeping in and out along distant coasts.

Not so many centuries ago, the Japanese archipelago suffered the indignity of being shown on Western maps as a simple, undifferentiated bulge on the eastern periphery of the Asian continent, or at best as a group of amorphous lumps in the sea. Now we see it, unmistakably, as it is. More than that, the actual creation of the seasons, the scene against which the drama of human

society has unfolded, can be seen from space in pretty patterns of blue and white: the great swathes of cloud that bring the summer monsoon; the winter band of white along the center of the main island, where the central mountain ranges hold clouds from the continent to ransom for their snow; the white whirls that are typhoons approaching from the south in the autumn, threatening and capricious.

This new awareness is shared, of course, by other countries. With Japan, though, it came within such a short period that a post-industrial society still preserves customs and outlooks that in other advanced countries have gradually disappeared or been refashioned over a period of many centuries. How sadly irrelevant many of those local festivals seem today! Does this mean, though, that there is nothing essentially special about the Japanese relationship with nature and the seasons? I don't think so. The Japanese sometimes talk, with a naiveté that almost provokes impatience, as though they had invented the seasons, as though no other country had ever so much as seen a red leaf in autumn or a cherry tree in spring. But their sense of a unique rapport with the environment is not entirely unjustified, for in Japan's case a whole combination of factors tends to make that relationship especially complex and subtle.

So far apart are the northern and southern extremities of the archipelago that the climate shades off into the sub-Arctic in the north and the sub-tropical in the south; yet the special position of the islands in relation to the mainland and the seas to the south gives even the main islands a climate that, without being extreme, encompasses an extraordinary range of vegetation, with all its varied effects of color, light, and texture. The topography, too, with complex chains of mountains and hills filling the greater part of the islands, has contrived to hem their inhabitants in within small spaces—sometimes between land and sea— where they have carried on their farming and fishing in constant awareness of, and in close reaction with, the nature all around. The same topography has tended to compartmentalize them socially and politically too, giving particularity to communities and diversity to observances. And all the while—though whether it is the cart or the horse isn't clear—the tendency of the Japanese individual to set himself firmly in the center of things, enjoying and categorizing subtle differences, detecting and recreating recurring patterns, is forever at work.

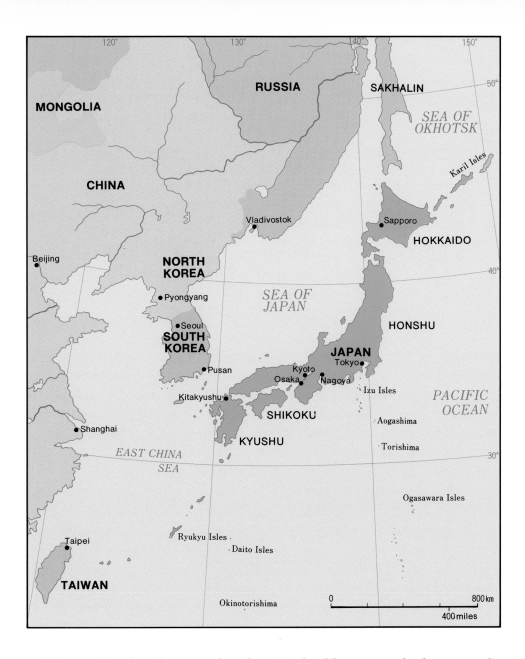

What might thus have produced an intolerably cozy outlook was modified, on the other hand, by the intrinsic uncertainties of a land of earthquakes and volcanoes; by the sheer, savage unpredictability of a normally gentle nature; and by the presence on the islands of Mt. Fuji—a mountain of extraordinary majesty that became, paradoxically, the symbol of a miniaturist nation. And this very complex interaction with the seasons was given further subtle overtones by the legacies of animist Shinto and the gently resigned view of existence peculiar to Japanese Buddhism.

Today, nature and the seasons have undoubtedly lost some of their more positive associations with everyday life. They have lost some of their substance, too. This is particularly so when they are seen by the short-term visitor, who is condemned to witness some of the worst of contemporary Japanese culture (including the television fare in hotel rooms). Even Kyoto and Nara—the vaunted "spiritual homes" of the Japanese people—are almost buried in the midst of a surpassingly ugly conurbation. If the traveler ventures into the countryside, much of the time will be spent on main roads lined with strings of blue, red, and yellow billboards, junkyards filled with used cars, and monstrous "leisure facilities."

If only one gets away from that urban sprawl, though, or takes a side road into the more remote countryside, one will find the small, lyrical sights that identify the seasons and create their poetry still alive, even though the Japanese, on the surface at least, live increasingly apart from them. It will gradually become clear, too, that people are in fact being over-modest when they tell you that Japan has "four clearly marked seasons"; this European observer, at least, can distinguish six or seven, each with its own beauties and its own pleasures.

For such an observer living, say, in Tokyo or elsewhere on the Pacific side of Honshu, the familiar seasonal stereotypes of his childhood—spring, summer, autumn, winter—no longer apply. On this side of Honshu, the New Year is not a season when nature seems to have stopped, but is part of a continuous pageant of clearly defined, colorful scenes. It is an arbitrary curtain-raiser, as it were, to a drama on which the curtain never falls.

Beyond the island's central ridges there lies the snow country, where winter winds from the continent draw a thick veil of white across the back of the land. But on the Tokyo side of the island, all is pellucid, bright: far too cheerful and full of signs of the continuity of life for one to speak of the "dead of winter." The fields are bare and brown, but around them green grass mingles with pines on the hills and in the valleys, and the yellow-green of bamboo. Already, the narcissi are blooming in sunny, sheltered spots.

As February gives way to March, the sharp edges are blurred by vague shapes of rain and cloud: a period too late for winter, too early for spring. Even the plum blossom fails to establish a true sub-season. As April arrives,

though, a drowsy haze settles over the land, and clouds of cherry blossom settle on town and countryside alike. This, the first great event since the new year, could perhaps be called spring; but for that European observer the associations are somehow wrong. The cherry blossom, especially as seen against the occasional

blue sky, is pure and lovely. But the year has already lost its innocence; and how is one to associate this symbol of evanescence with the image of renewed hope?

Then, unexpectedly, the ambiguous curtain of cloud and rain lifts to reveal the next scene. Known prosaically in Japanese as *shoka* (early summer) it should, more poetically, be entitled "the year's true awakening." Trees and hills dissolve into a pointillistic shimmer of yellow and pale green dots that spread and proliferate until the whole atmosphere seems filled with clouds of soft and varied greenery. From banks that were bare and brown until yesterday, undergrowth rises in incredible profusion. This is not "spring," either, but the season has a freshness and life that seems more worthy of the name.

Soon, the green is varied with splashes of purple iris and mauve wisteria, and, a little later, with the pinks and reds of azalea. In the countryside, frogs are heard croaking at night, and occasionally a black butterfly of astonishing size will start out of the bushes on country paths, all but convincing the timid that it is a bat.

But early summer does not lead straight into summer proper. Rain follows: heavy, sporadic rain that at this stage seems merely to heighten the world's green freshness. Then the intervals between showers shorten, till one day in June the Meteorological Agency cautiously announces that the rainy season seems to have begun. The trees, their freshness gone, are part of a dull backdrop of uniform green. A bare month and a half of the rainy season seems interminable, but just as one is about to accept misery as the norm, it all ends, often quite literally with a bang—a violent thunderstorm that the next morning leaves the sky hot and blue.

Summer is the time of crowded beaches and the magical green of the sea; of white surf breaking on a Sunday afternoon after most of the swimmers have gone; of children in the country clutching nets and gazing wide-eyed up into trees in search of cicadas; of fireworks and the intensity of childish faces

caught in the light of a Roman candle; of ghost stories—though these are going out of fashion in an age of horror movies; of rooftop beer gardens and other hot-weather delights.

Around the end of July, firework displays celebrate the height of the season and the beginning of its decline. The beaches are still crowded, but the jellyfish are out, and the greenish light of late afternoon over the waves takes on an almost heartbreaking quality. Inland, in the hot silent woods, the cry of the cicadas

seems to grow shriller and more plaintive. Step by step, summer retreats. There are typhoons, but some days are pleasantly cool and the rice is growing golden in the fields. Soon comes the autumn equinox, and punctually the "equinox flowers" (spider lilies) appear, tall crimson blooms that spring up suddenly along hedgerows, in graveyards, and on the paths between paddy fields. The more spectacular insects of summer disappear, leaving only a small yellow butterfly flitting through the deepening shadows of the garden.

At this point, the drama, by my childhood standards, should end. Sniffling before a backdrop of damp beeches, drawing a few wisps of mist about it, the year should shuffle off stage. But in Japan there is still a final act to come. There, beyond the central mountain ranges, the winds are blowing from the continent, again bringing with them blue skies and the first frosts. Dry and cold, they provoke a kind of spontaneous combustion of nature in the hills. First, the summits catch fire, then a red glow spreads down the hillsides, swallowing everything before it, till the whole world is ablaze. The lower hills and plains do not catch fire—though a stray spark from those great inland conflagrations will cause a tree to blaze up here and there, or ignite the golden flares of the ginkgo trees. Here, autumn achieves its effects mostly with light: the cool, slanting light that gives everything an almost unnatural three-dimensional quality. Shadows are blacker and more velvety than before. A quiet exultation fills the air; there are days when autumn seems to stride the hills, touching the treetops with gold and softening the outlines of the ugliest buildings.

Yet all the while, nature is withdrawing quietly, without fuss and without weeping: here, autumn is dry, bright, almost inorganic. And though autumn gives way to winter, it is never sad and sodden. Spring is always a possibility; by December, the narcissi are beginning to bloom in the same spot as before. There is, indeed, no "dead of winter." The cycle of the seasons will go on, with no final curtain.

And will it continue to go on, and to play an important part in Japanese life as before? Will the destruction of nature advance until there are virtually no seasons, as we know them, left at all? Surely not. Admittedly, too much has happened in Japan within too short a time, and many of the outward observances of the seasons will doubtless disappear, just as they have long since disappeared in the West. Yet, at even 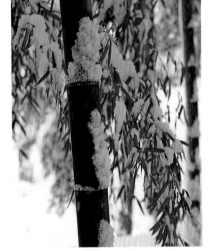 the most superficial level, it would be difficult to ruin the seasons completely in Japan, if only because, in a country so crammed with hills and mountains, there is often little people *can* do but drive roads through them so that they can go and enjoy—the seasons. Moreover, since much of Japanese culture is based on a shared recognition of recurrent patterns in the world round about, and on their reflection in human life, it seems unlikely that the seasons will ever be far from the consciousness of the people.

Deep down, too, things are changing, not necessarily for the worse. In the past, the famous "harmony with nature" undoubtedly gave birth to some of the most moving combinations of architecture and nature to be found anywhere (to see some of them, along with many modern horrors, one has only to go to Kyoto). But it had its deplorable side too. Just as with the vaunted "harmony" in human relations, a lack of any real sense of difference—of any clear dividing line between the self and the "other"—can mean a lack of real respect: since you are "at one" with the whole, it is all right to make free with it, insensitively and for your own purposes.

And that is surely going to change. If things go well, the attitudes to nature

that were quite apparent already in the literature of a thousand years ago are going to be modified by a new, more modern awareness of the outside world. Combining with an increasingly thoughtful and relaxed attitude to affluence (now that some of the initial excesses are over), it may well engender a new type of respect for nature.

And finally, one should never forget the generation factor. As years pass and new waves of young people first encounter the cycle of nature, whatever surrounds them throughout the year will take on the subtler associations of its season. It is not just a time of year, but a time of life, too, that roots sights and smells so firmly in the recesses of memory. The smell of the first breeze of spring blowing off long-lying snow, or the first unexpected hint of autumn in the morning sunlight have the power to bring tears to the eyes at any age. More often than not, though, the emotion derives from some long-forgotten moment in the most impressionable years of childhood or early adulthood. Elderly Japanese may miss the winter smell of charcoal burning in the brazier of a tatami room, or the scent of mosquito incense drifting across a sultry summer night. Such things are, sadly, lost indeed. But there are others waiting to take their place. In the rising generation, the freshness of discovery and the subtle machinations of the hormones are at work as ever—on the aroma of coffee in a carpeted hotel corridor on a winter's morning, the smell of an automobile parked in the hot summer sun, and a thousand other things, trivial in themselves—imprinting their minds with indelible associations, and fueling the nostalgias of the future.

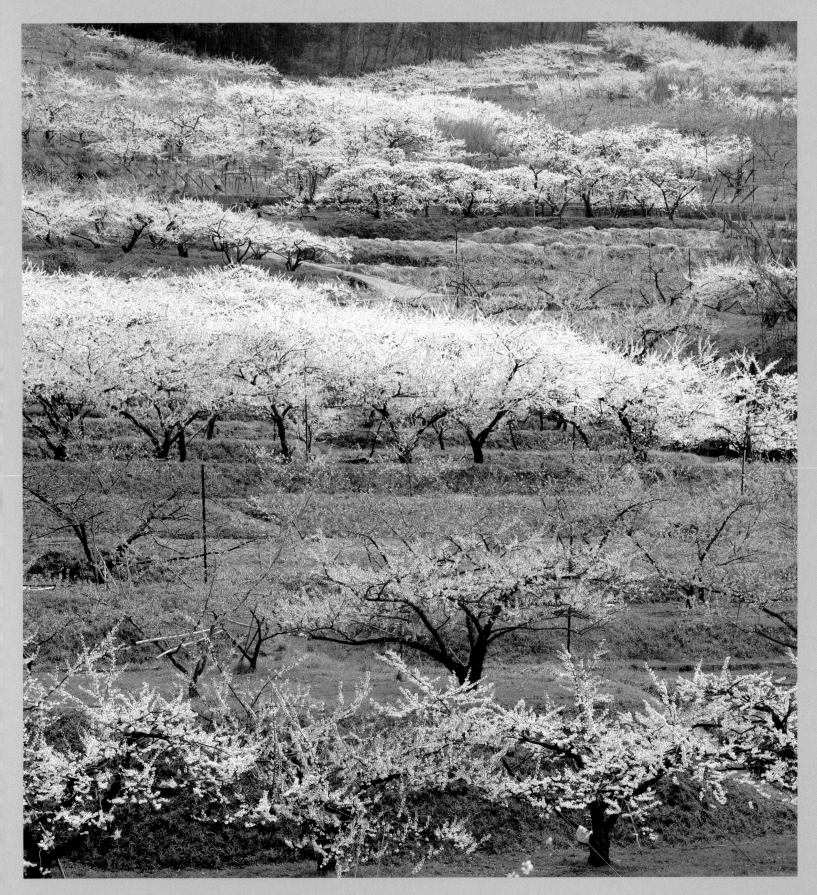

SPRING

Plum and peach blossoms

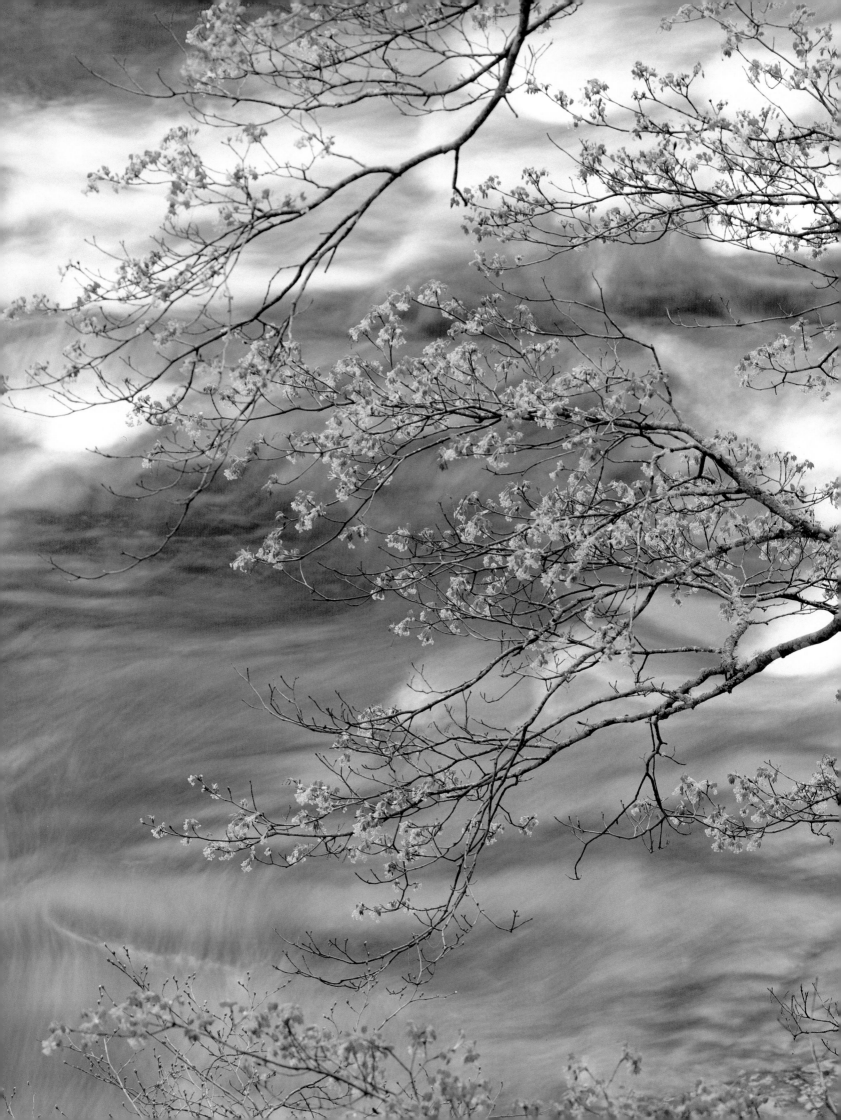

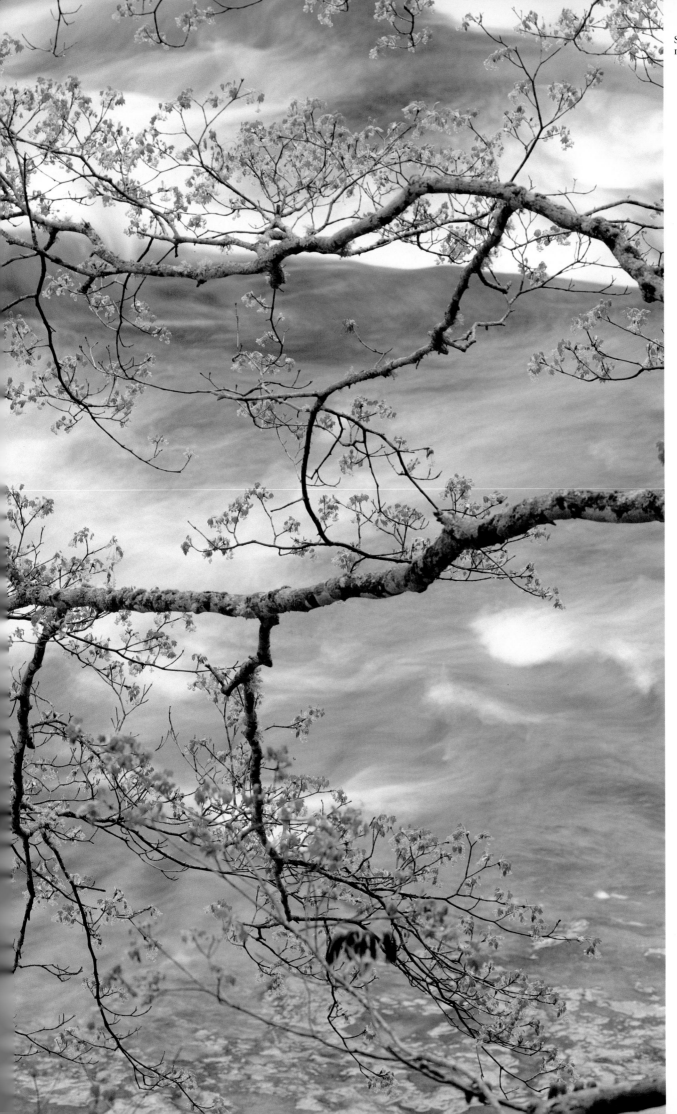

Spring foliage by a
mountain stream

Mt. Daisen and
rape blossoms ▶

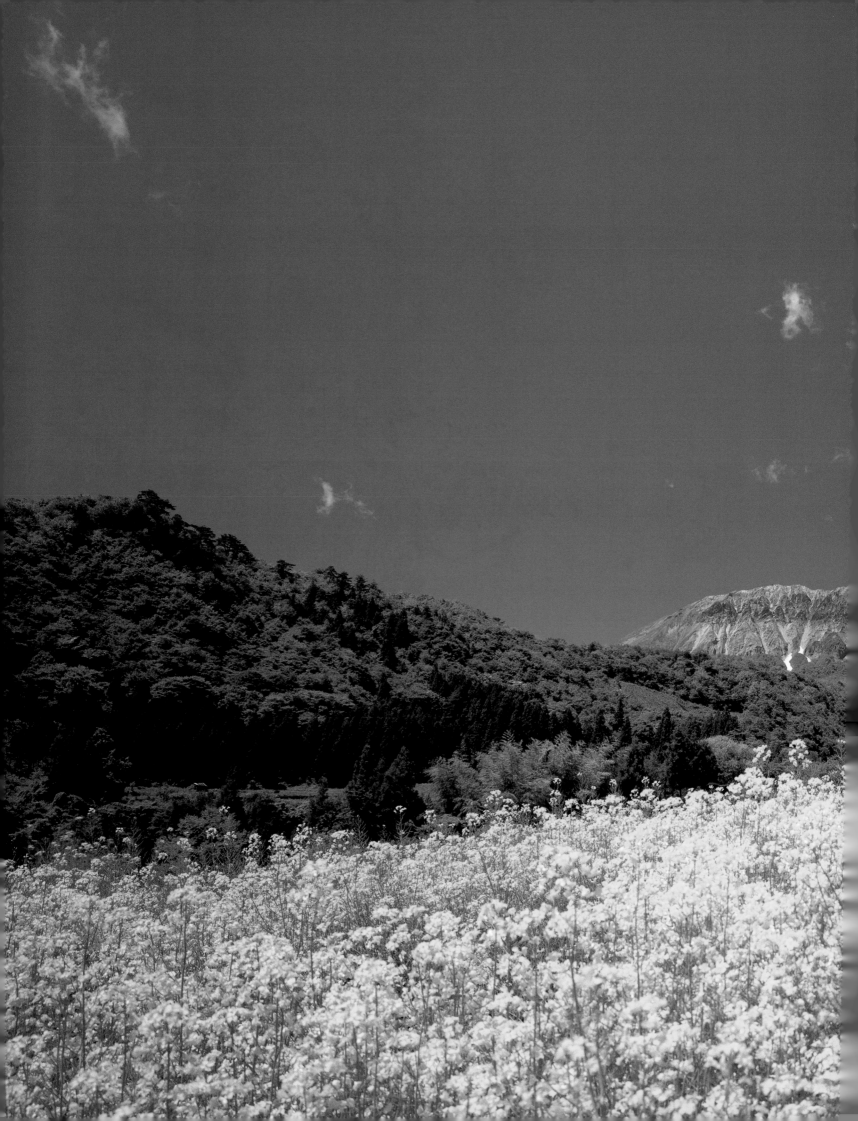

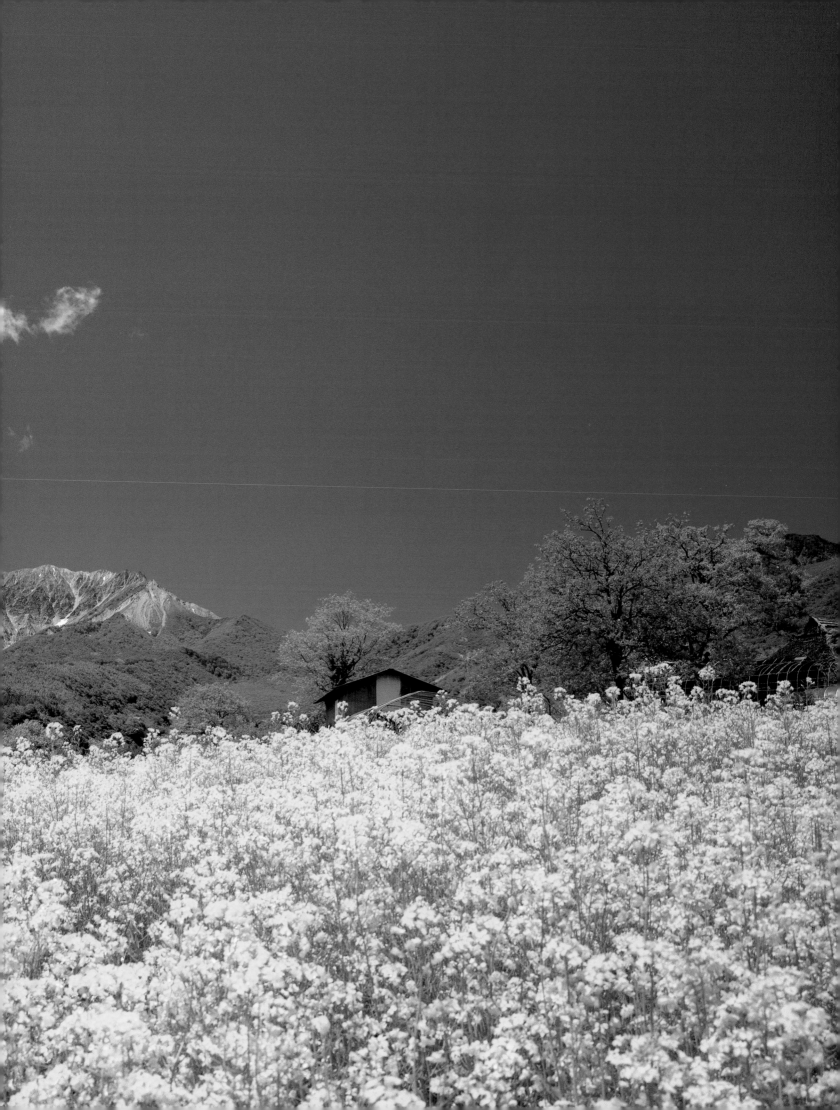

Manchurian violets (*sumire*)

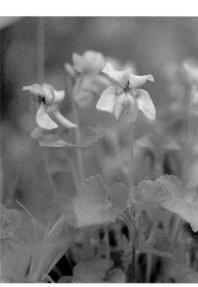

Purple-leaf violets (*tachitsubo-sumire*)

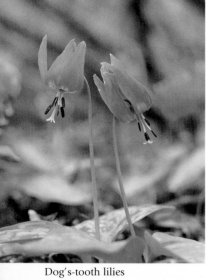

Dog's-tooth lilies

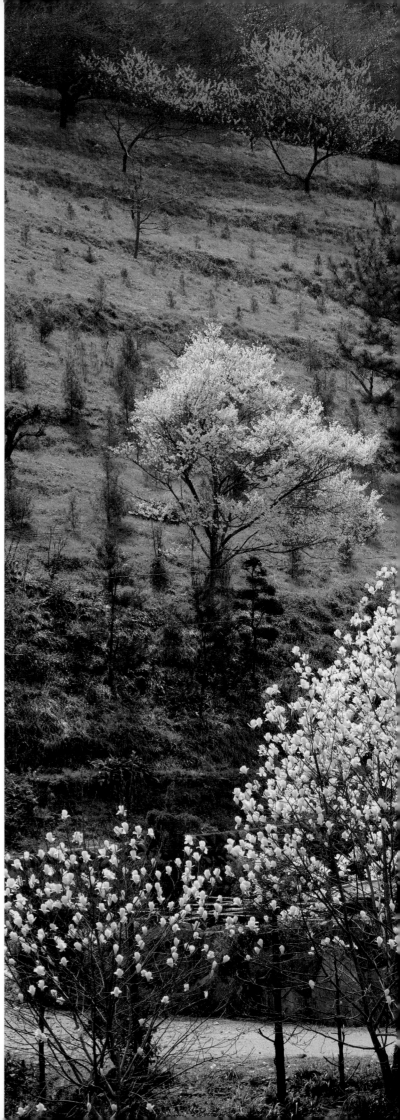

Dandelions

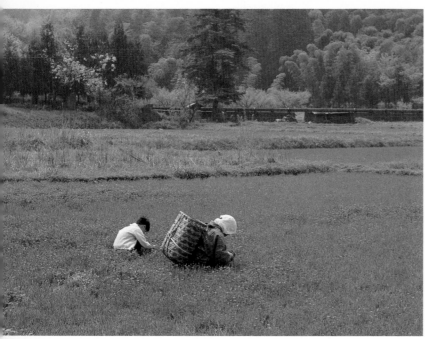

Gathering the Chinese milk vetch (*renge*)

A traditional house (*minka*)
and spring blossoms

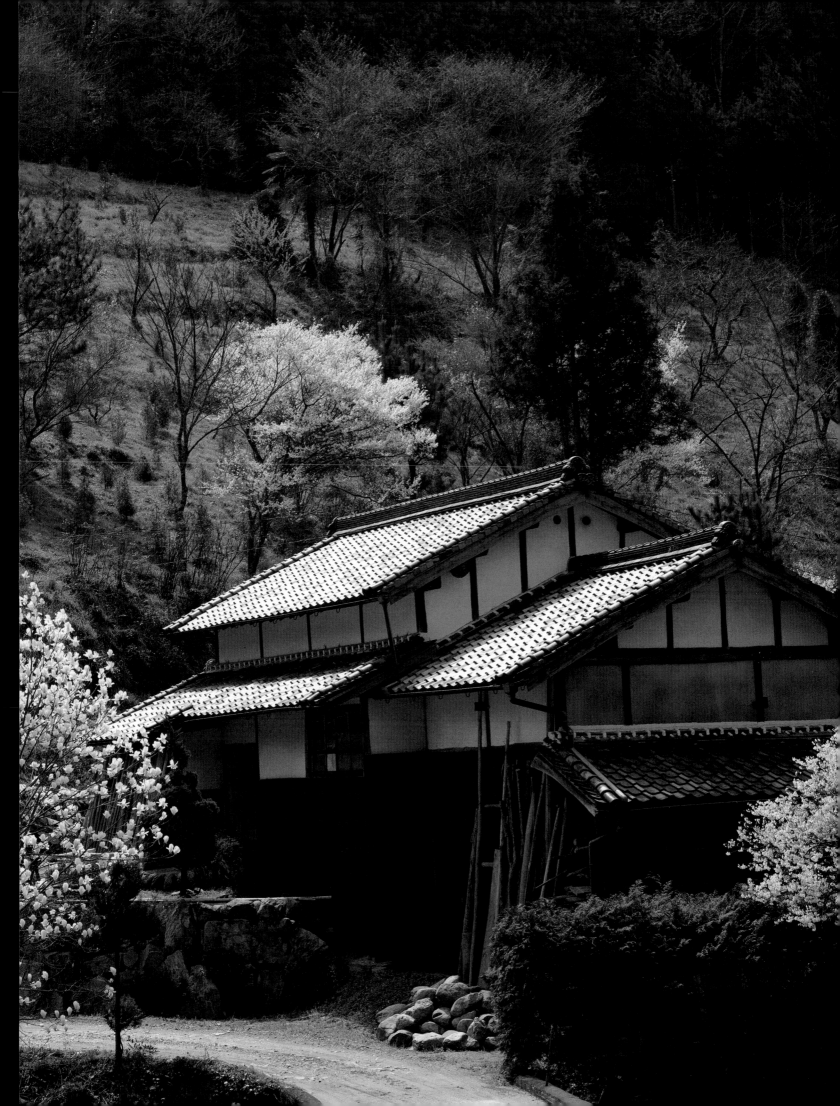

Skylark

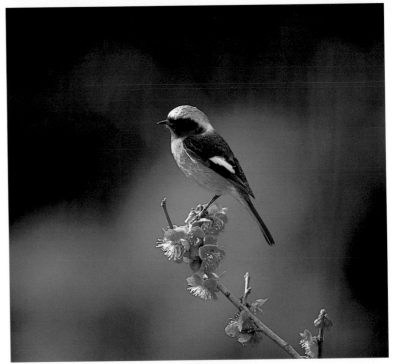

Daurian redstart (*jobitaki*) and red plum blossoms

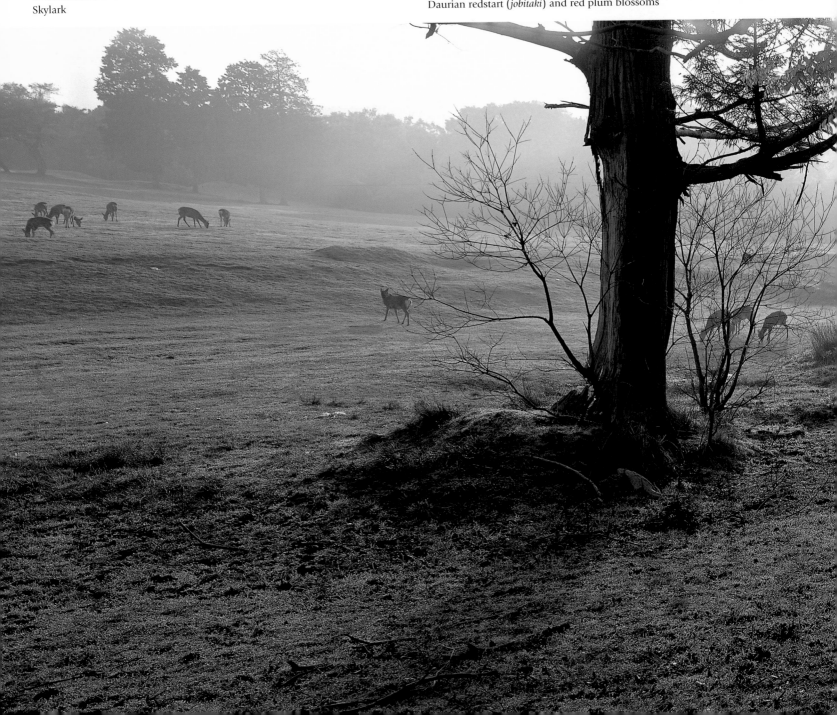

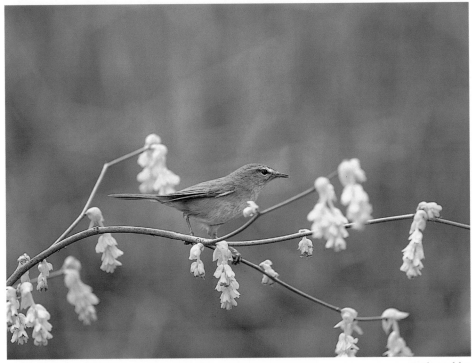

Bush warbler

Cherry blossoms
at Mt. Yoshino
in Nara Prefecture ▶

Deer at Tobihino, Nara

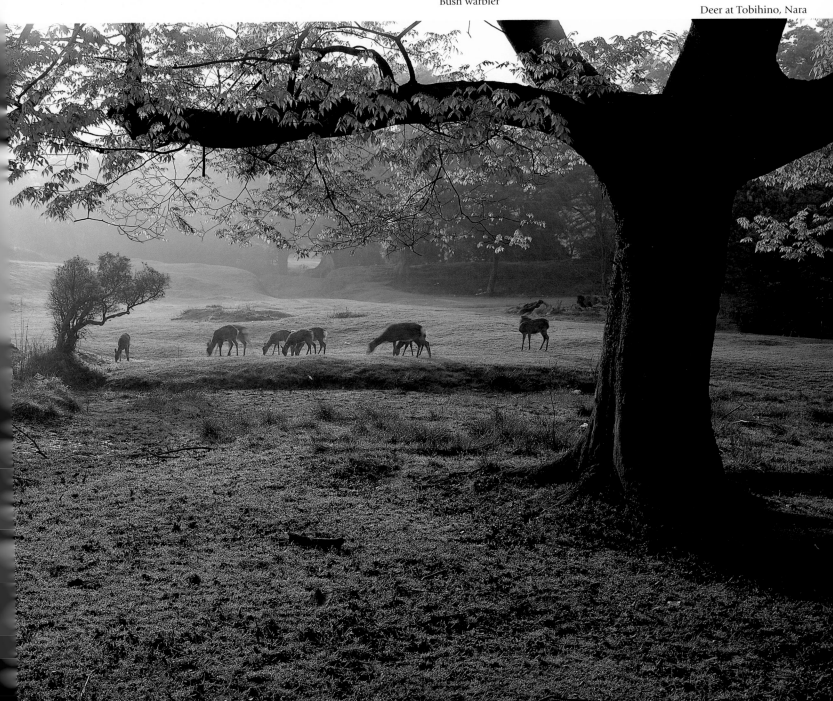

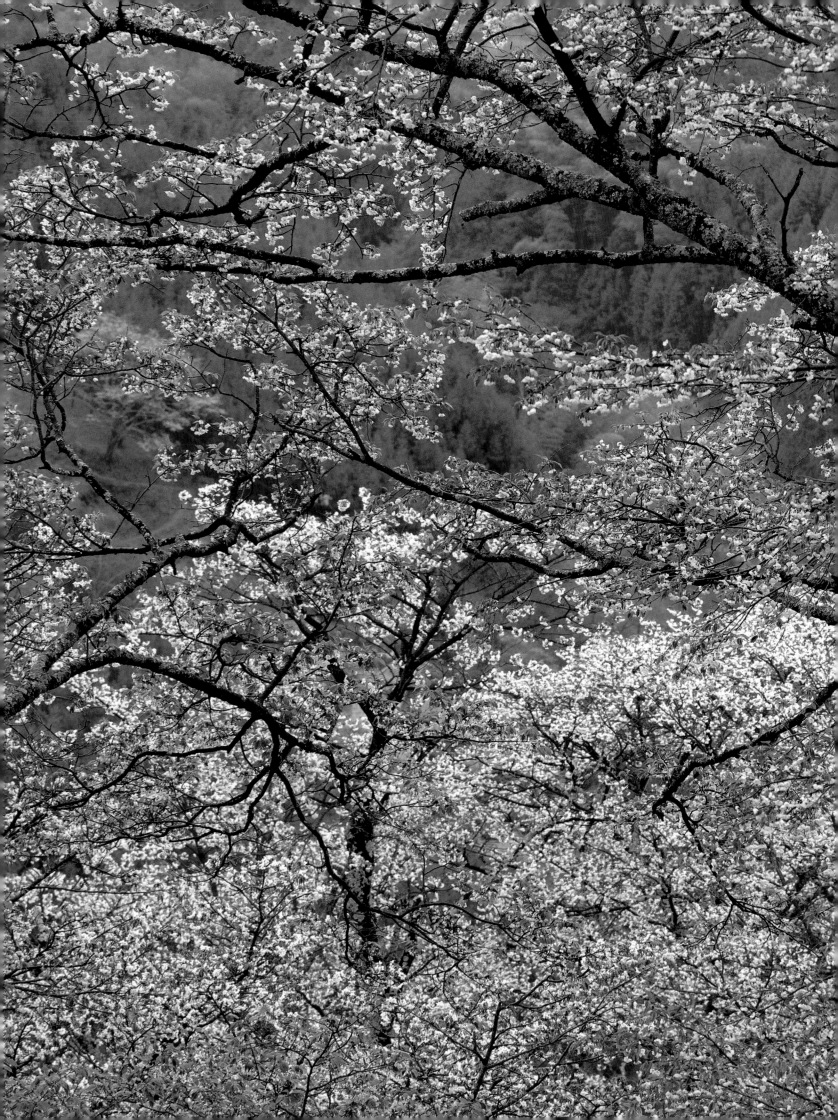

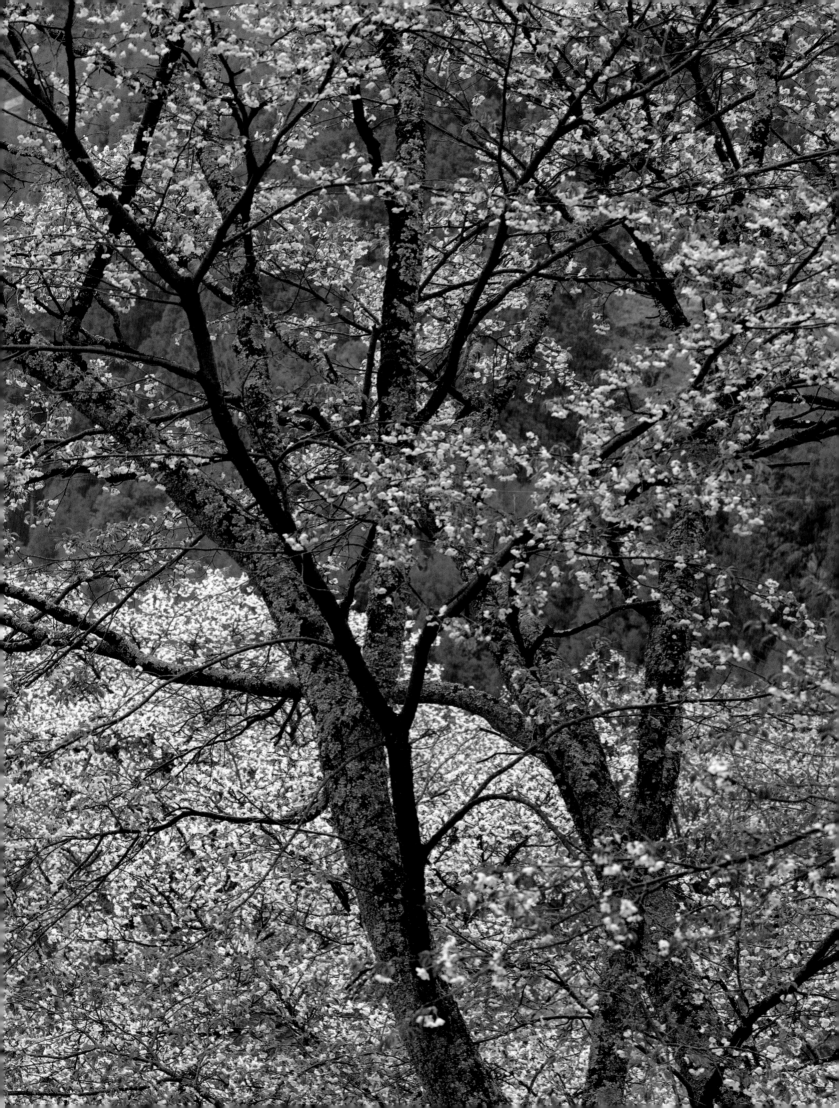

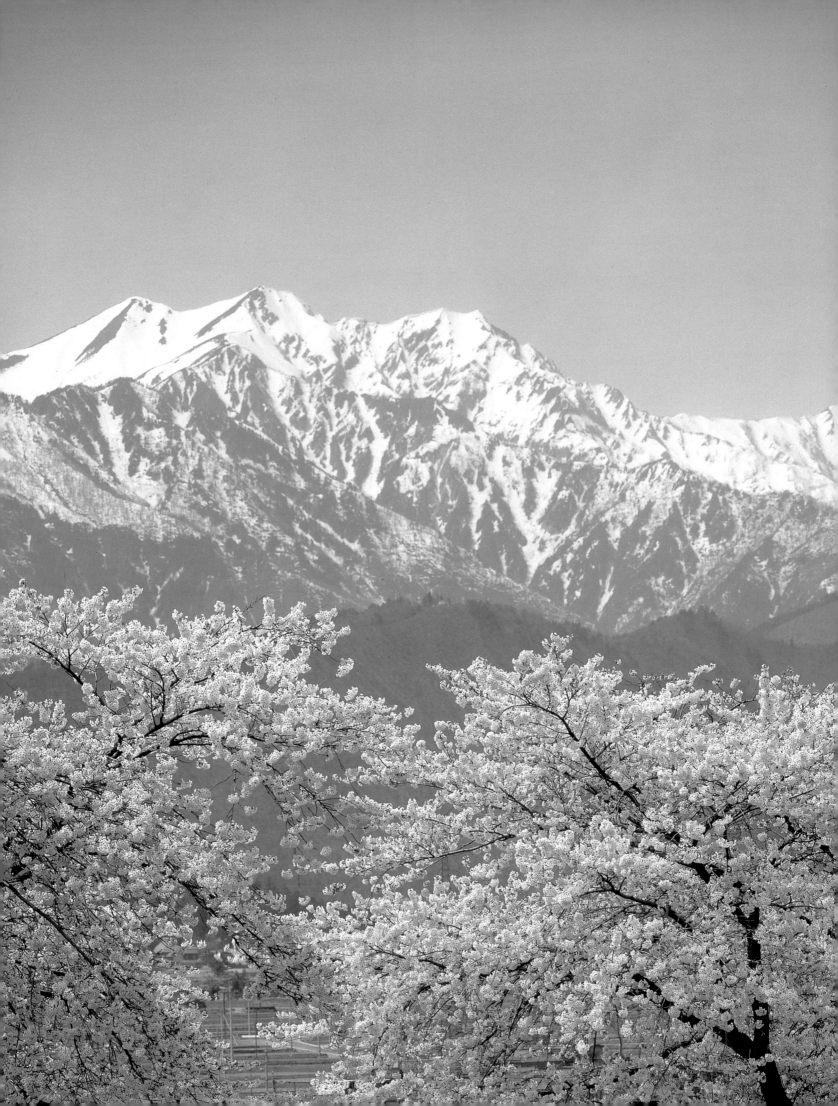

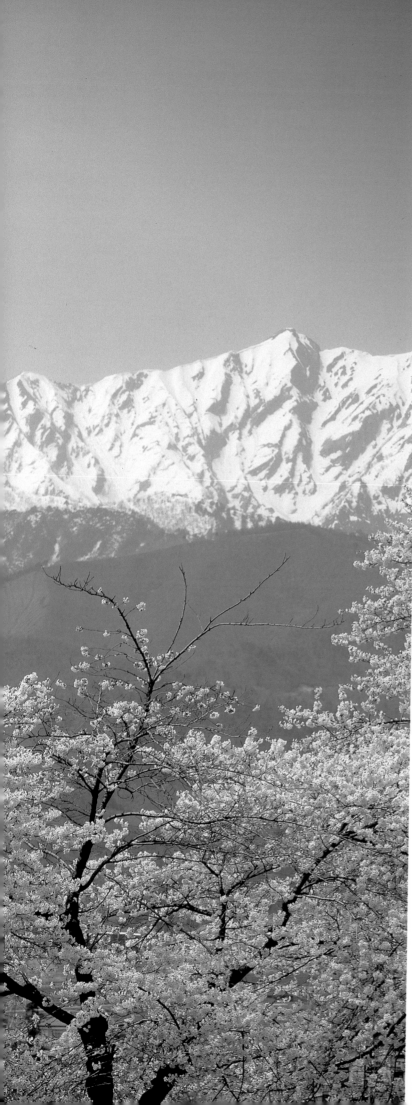

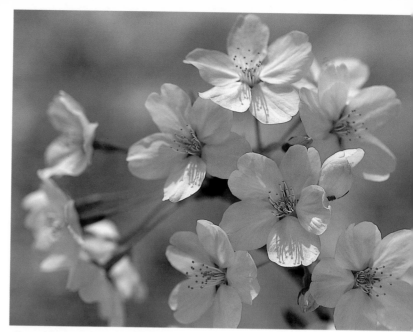

Cherry blossom: *somei-yoshino*

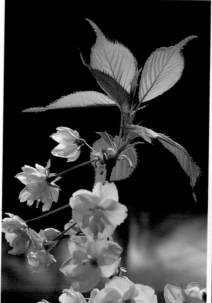

Cherry blossom: *ukon-zakura*

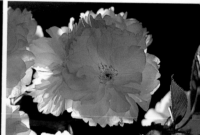

Cherry blossom: *kiku-zakura*

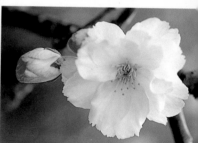

Cherry blossom: *ichiyo-zakura*

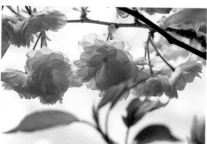

Cherry blossom: *kanzan-zakura*

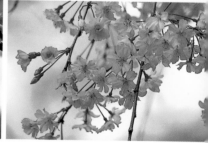

Cherry blossom: *beni-shidare-zakura*

Mt. Hakuba in cherry blossom time

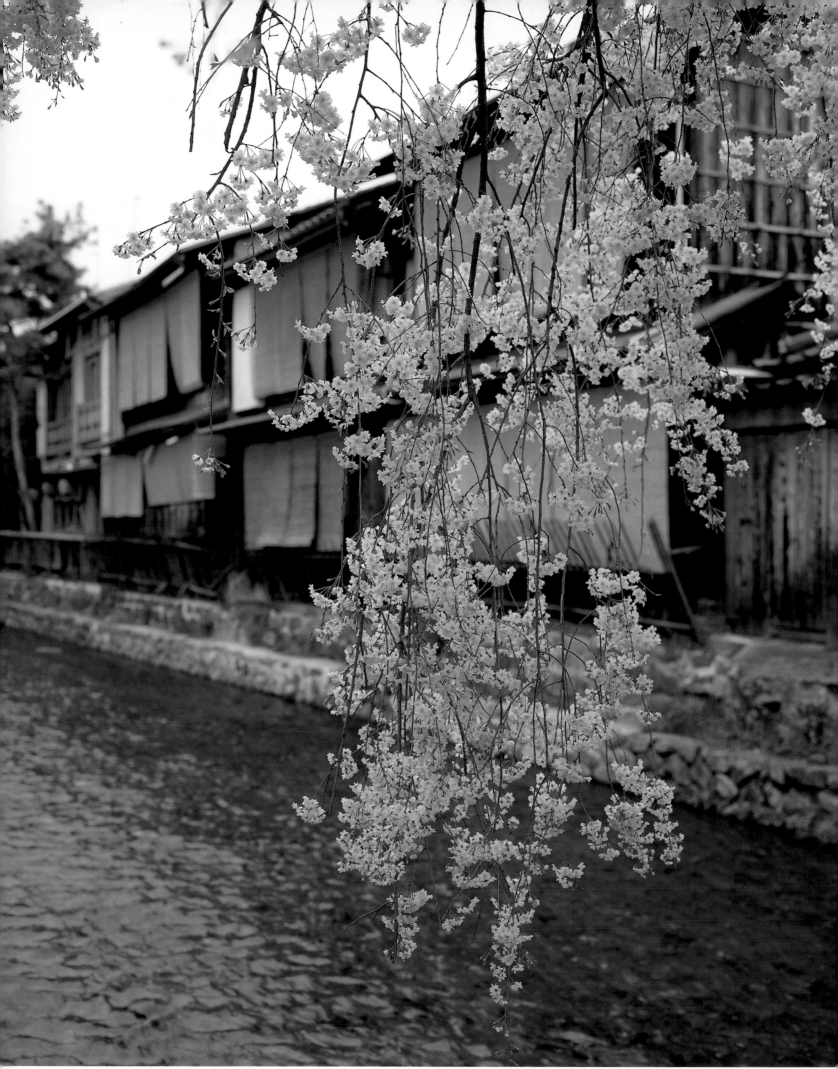

Weeping cherry at Gion Shinbashi in Kyoto

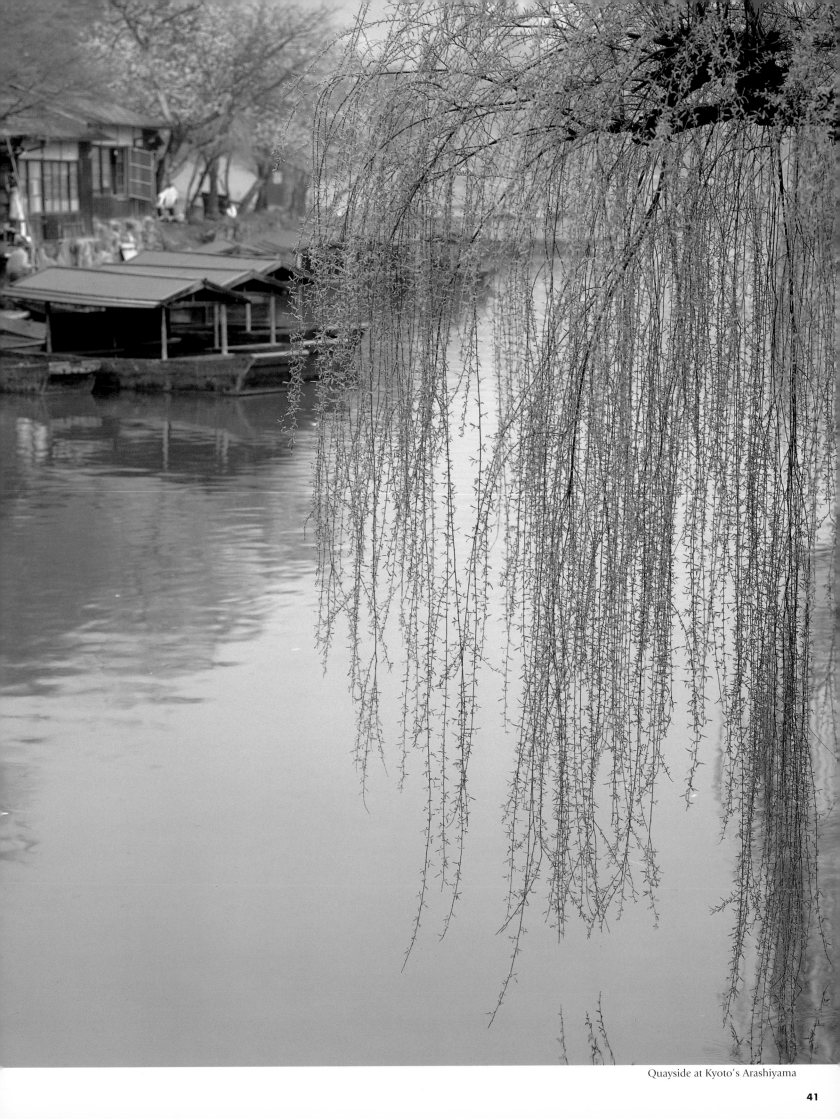

Quayside at Kyoto's Arashiyama

Kerria (*yamabuki*) blooming by the river

Tea fields in Shizuoka

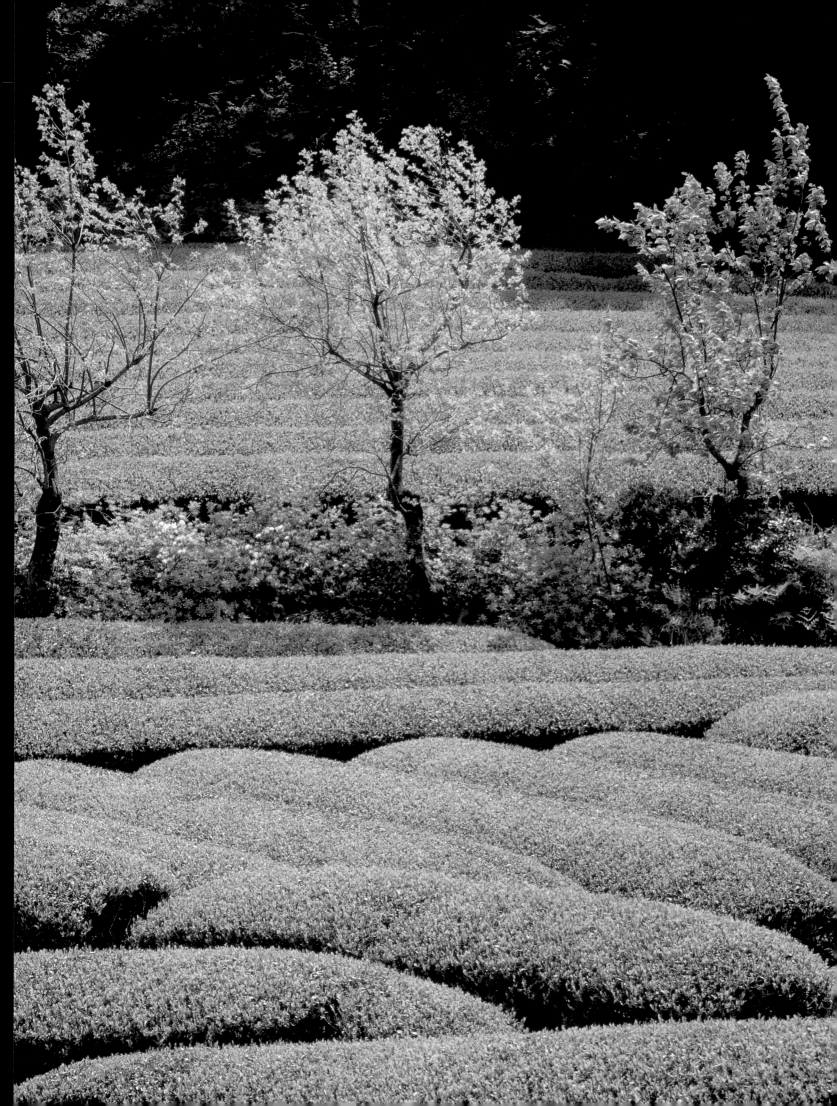

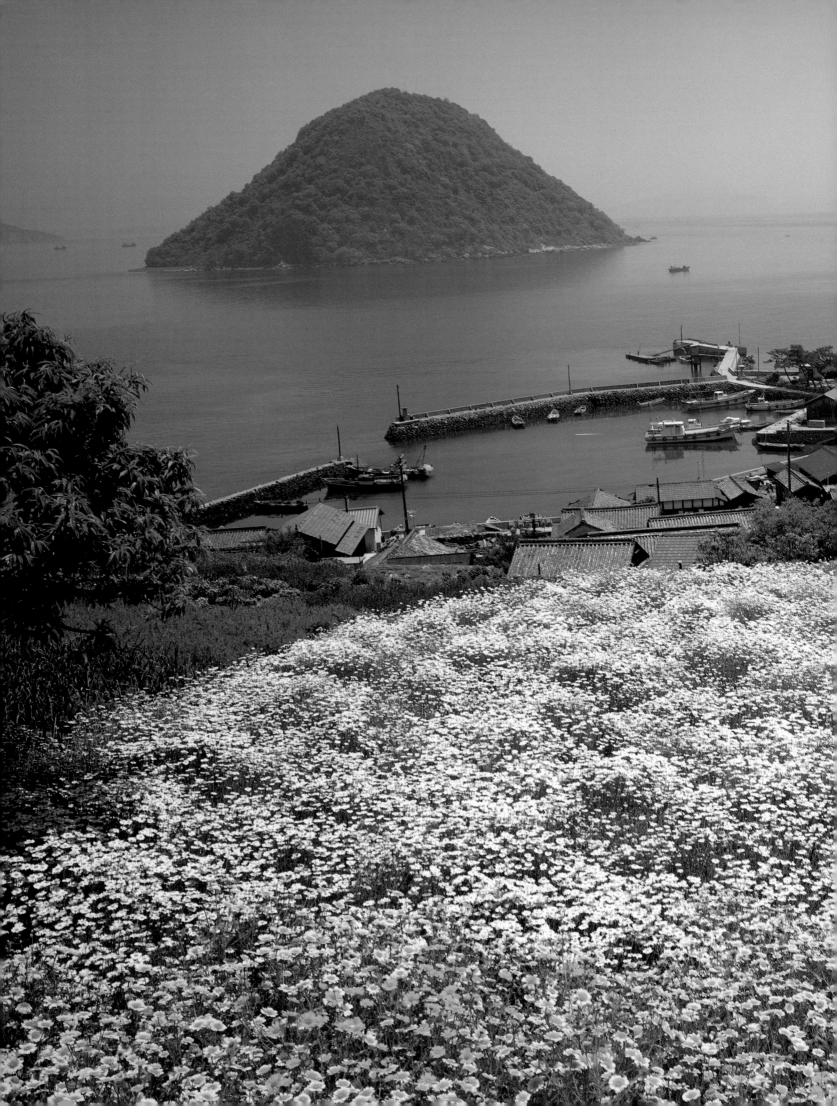

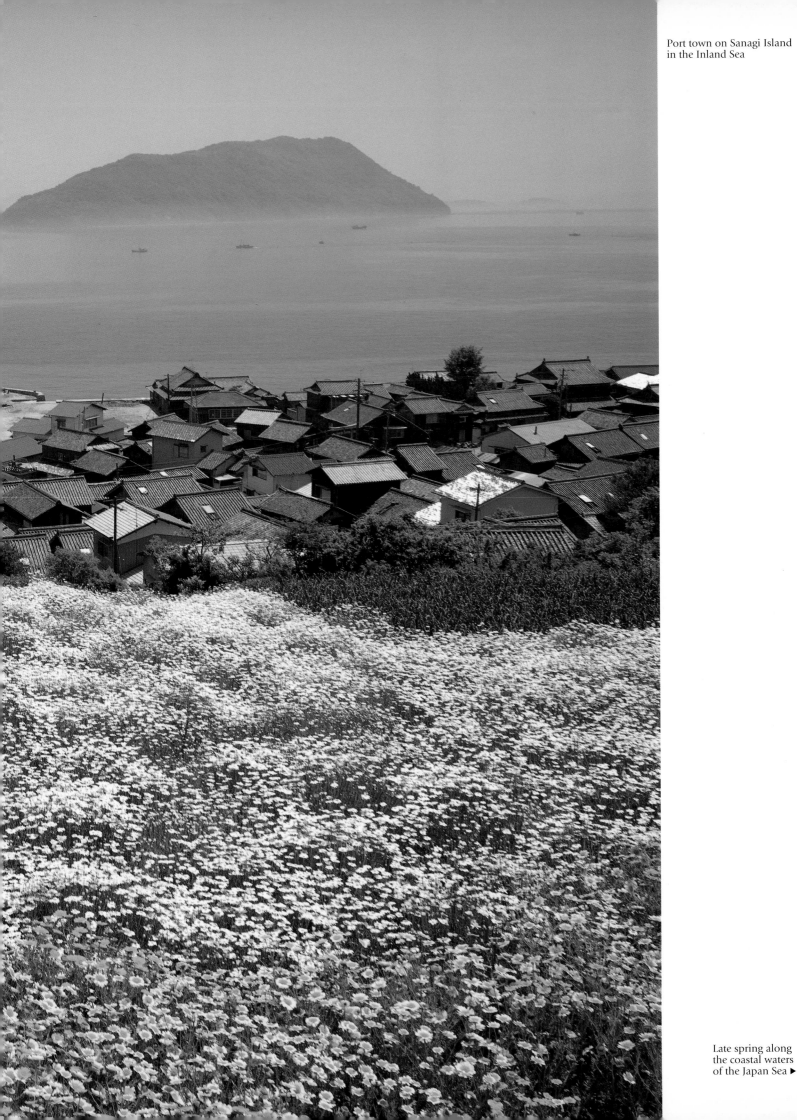

Port town on Sanagi Island
in the Inland Sea

Late spring along
the coastal waters
of the Japan Sea ▶

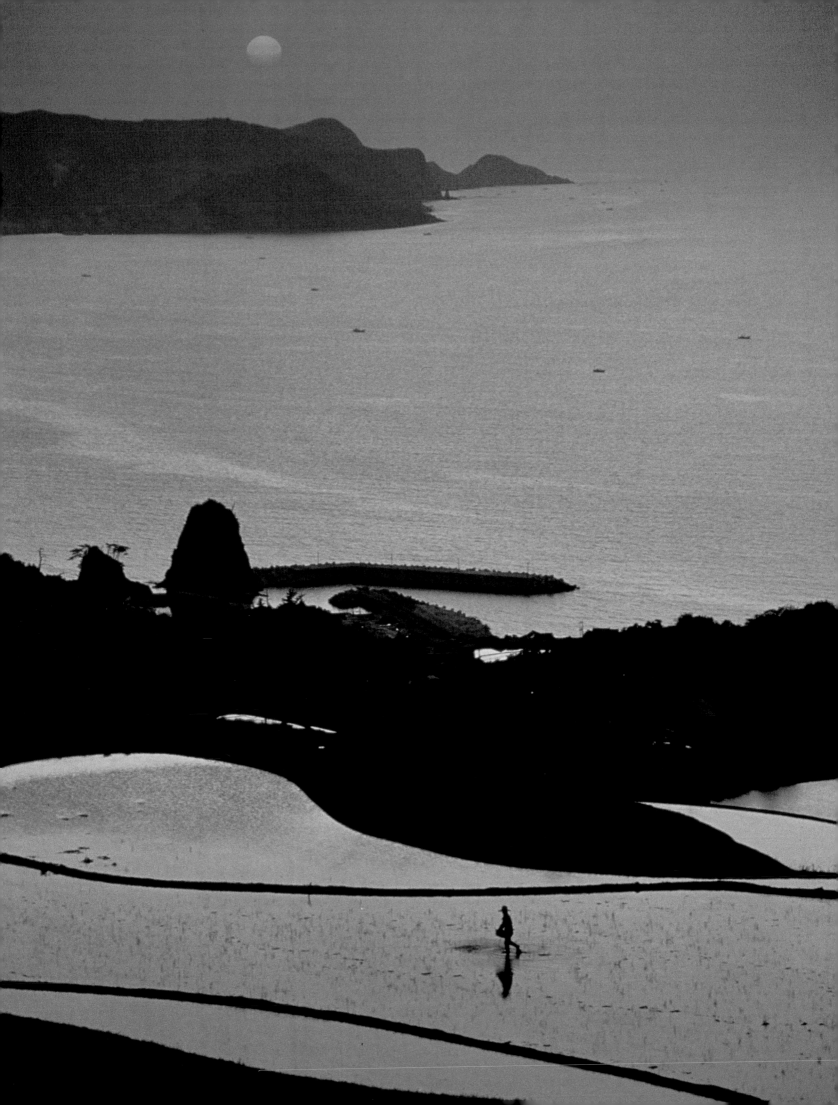

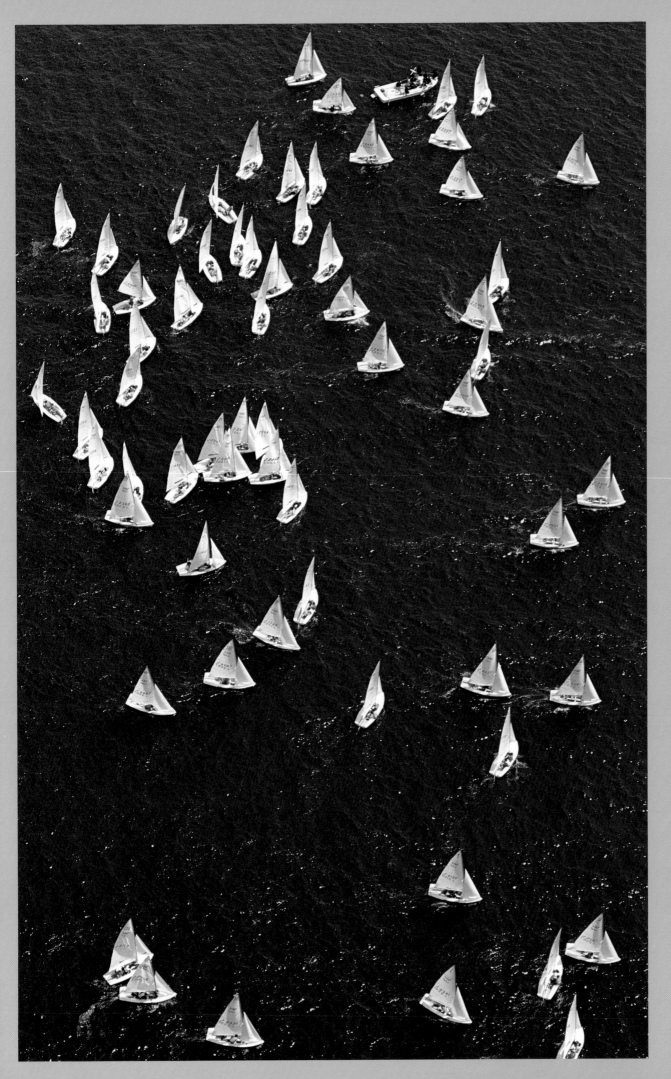

Yacht race in Sagami
Bay, near Tokyo

Cedar forest in Yoshino, Nara Prefecture

Murooji temple in Nara, with flowering dogwood and rhododendron

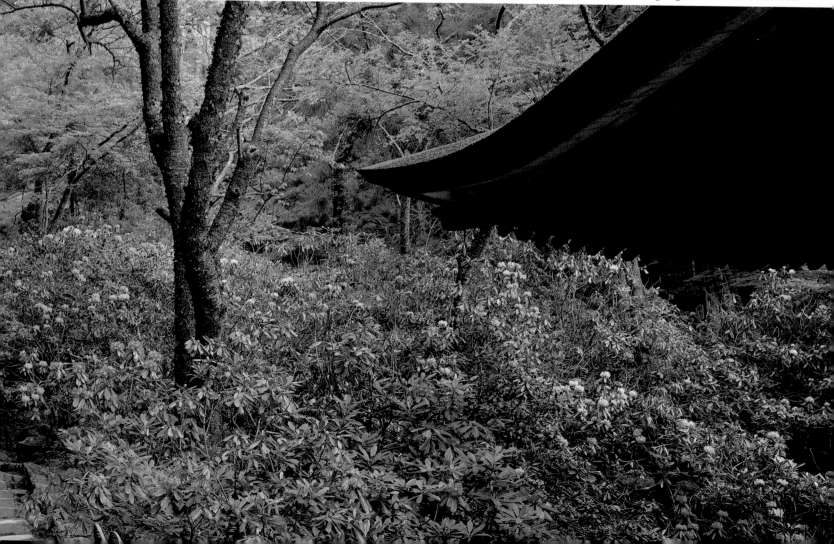

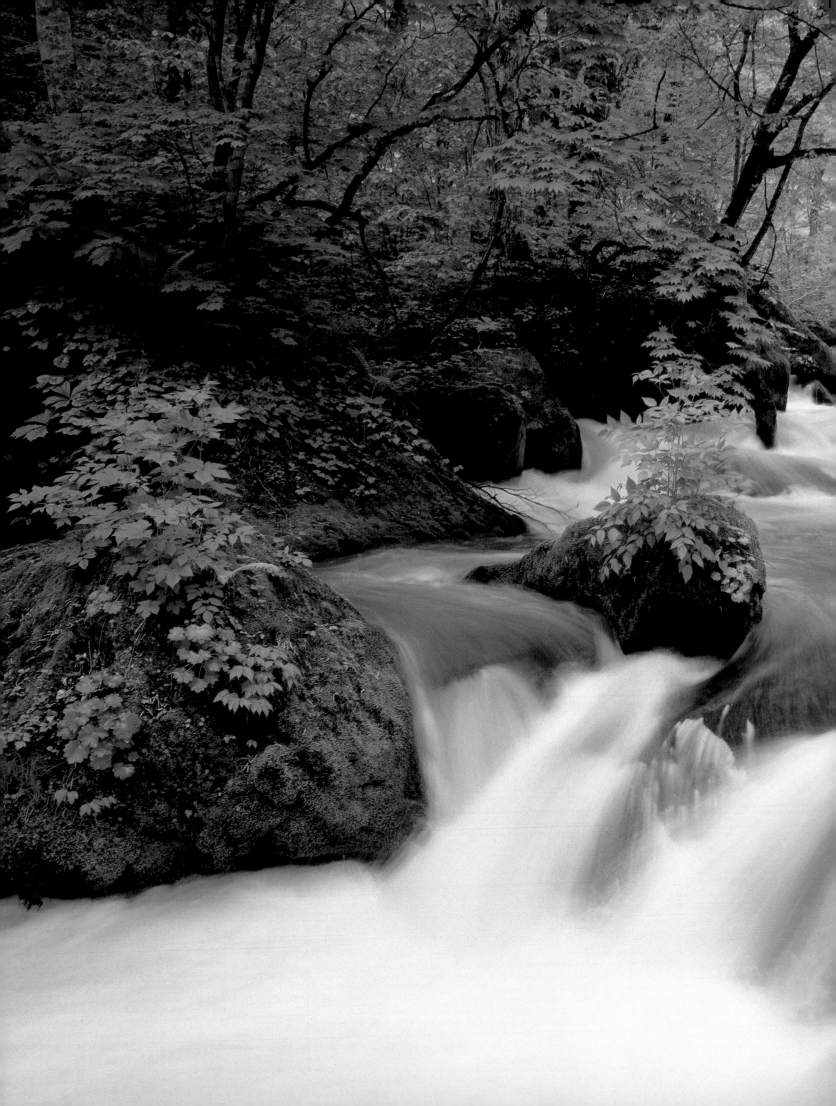

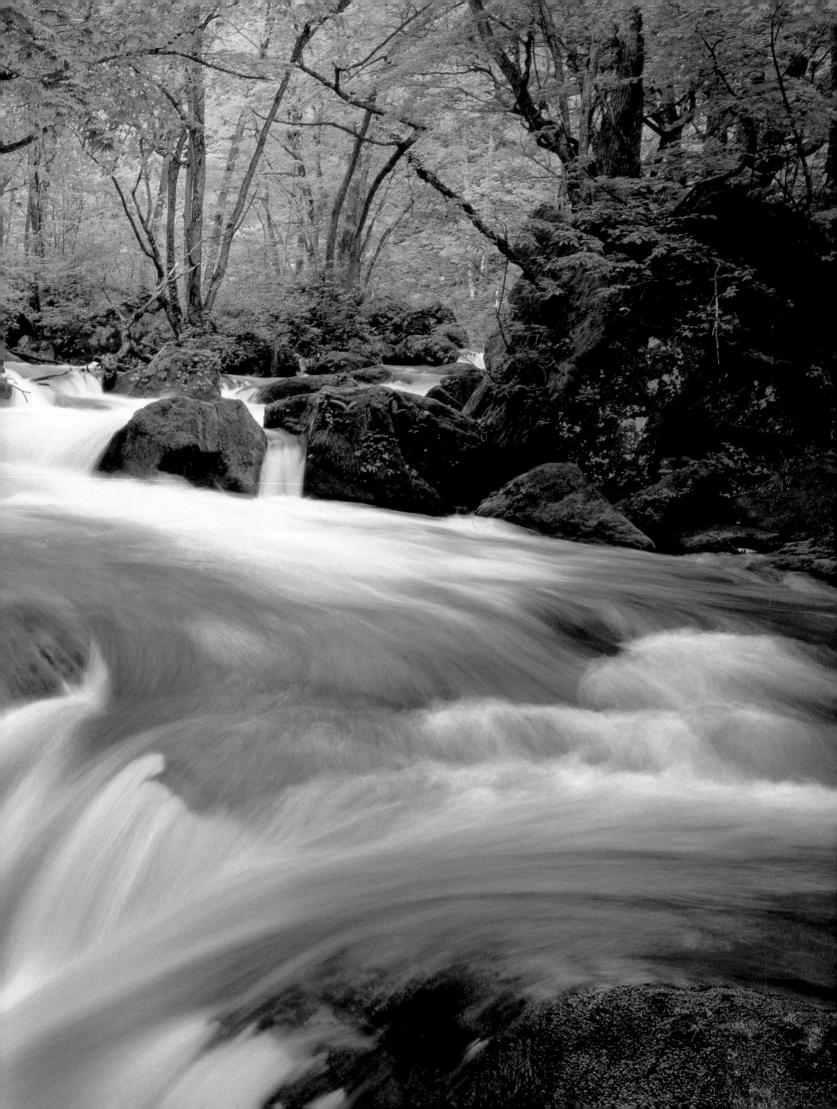

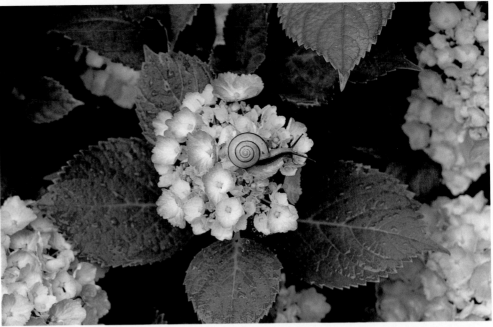

◀ Oirase Gorge swollen
with spring runoff

Hydrangea and snail

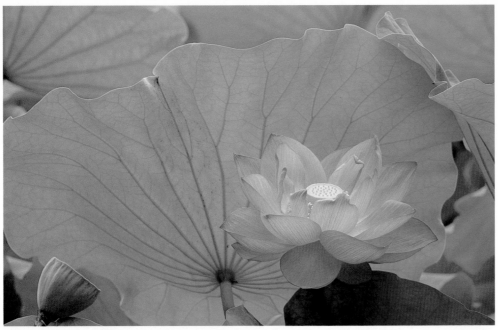

Water lily

The moss garden of Saihoji temple

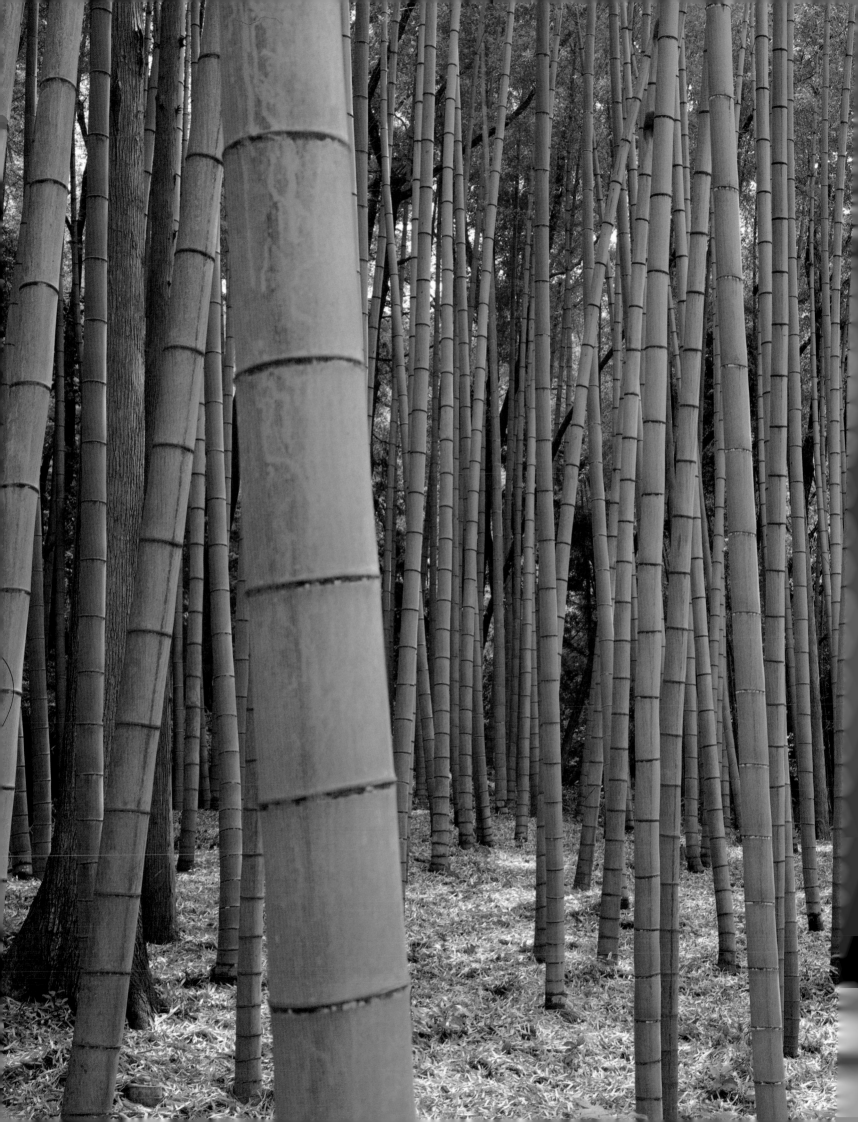

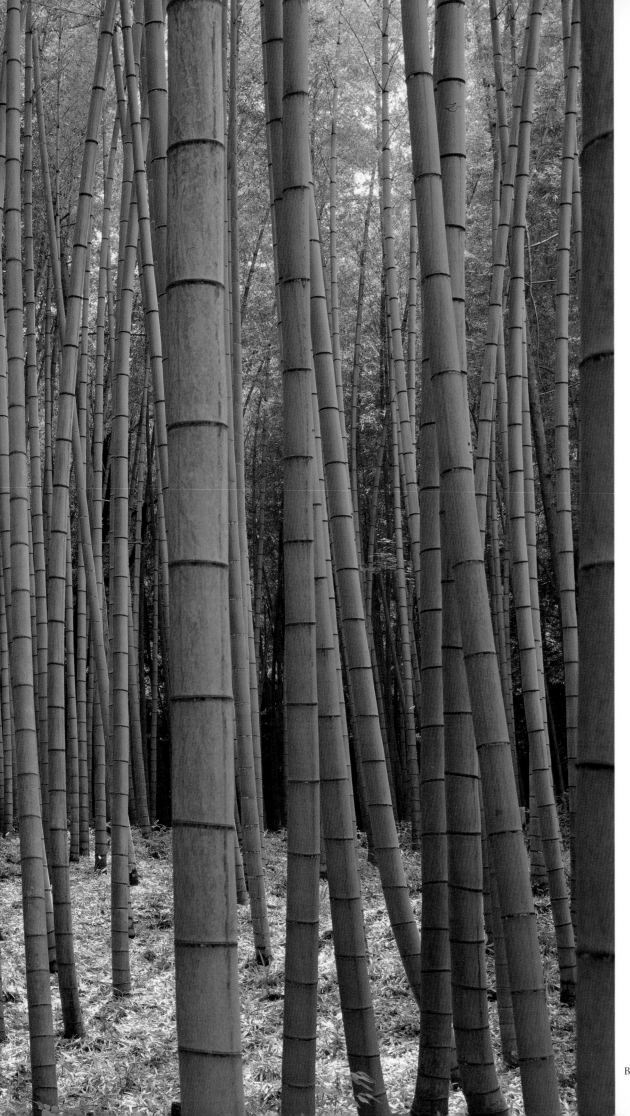

Bamboo grove, Sagano

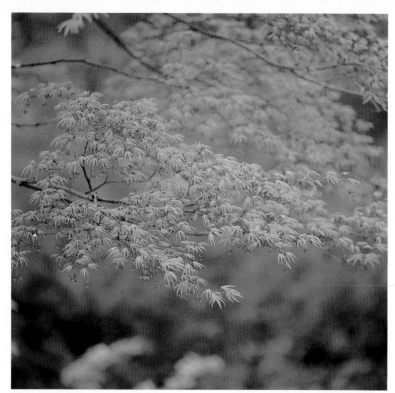
New maple foliage

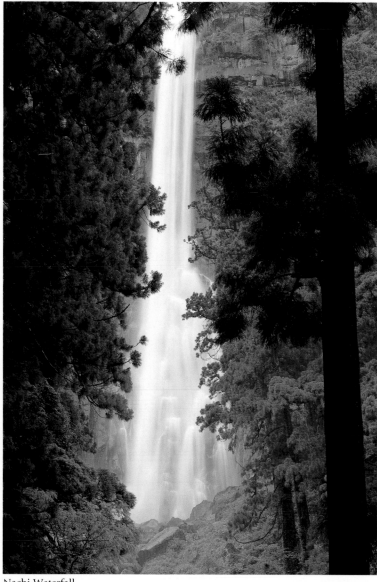
Nachi Waterfall

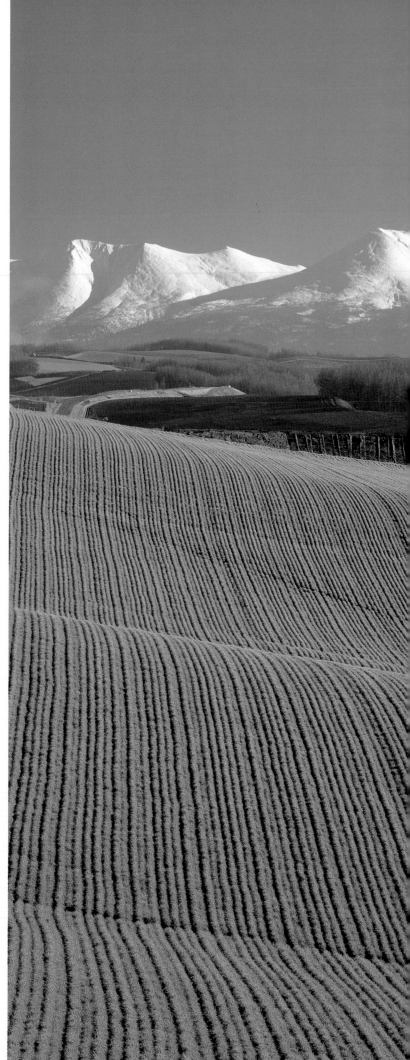
Hokkaido farmlands and
the Tokachi Mountains

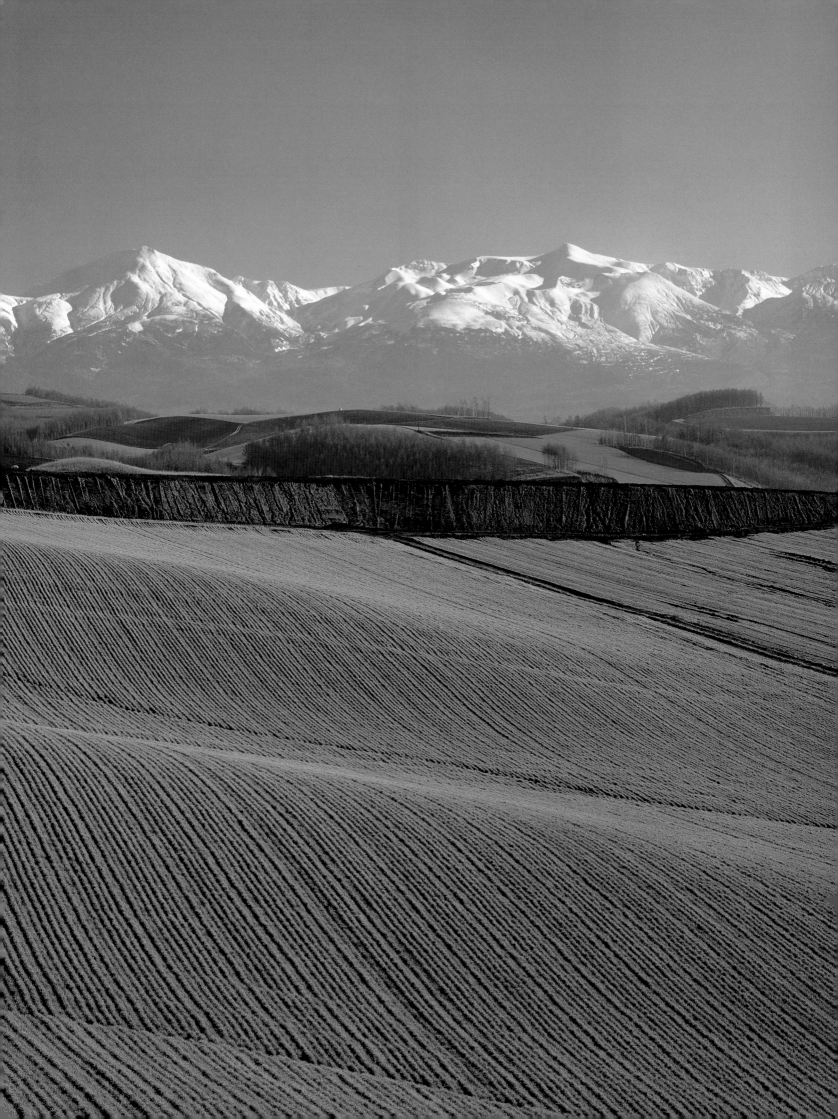

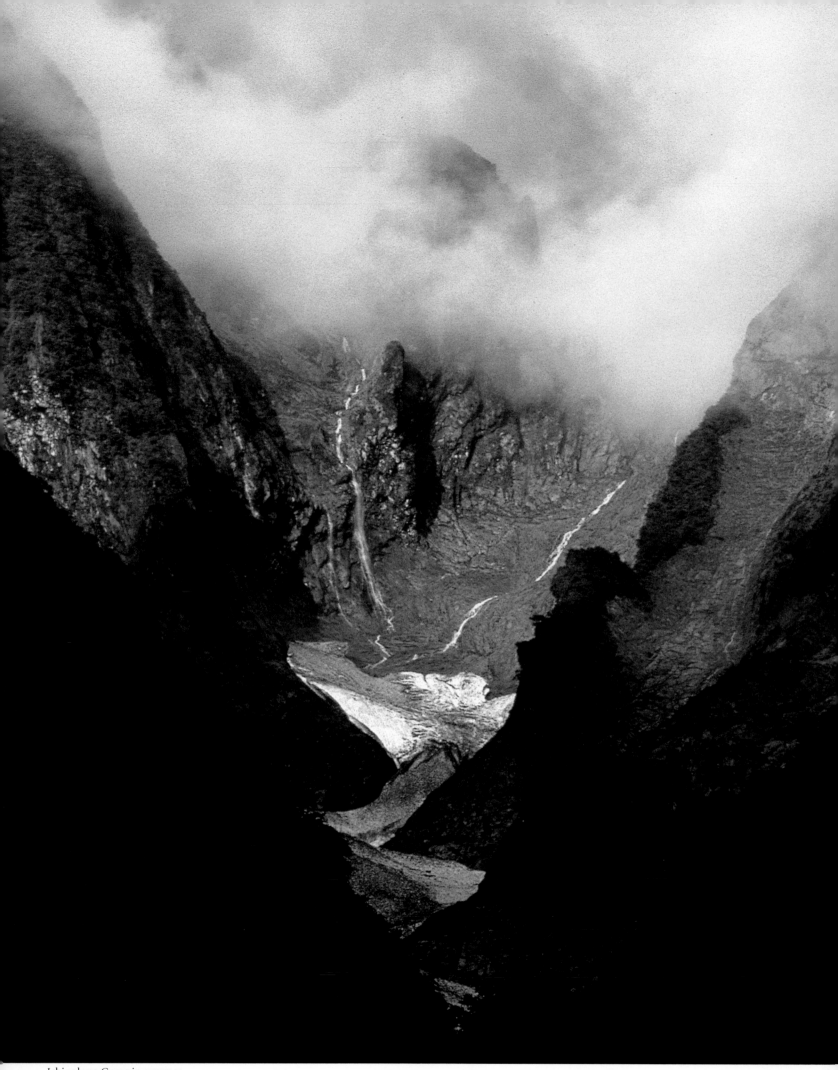

Ichinokura Gorge in summer

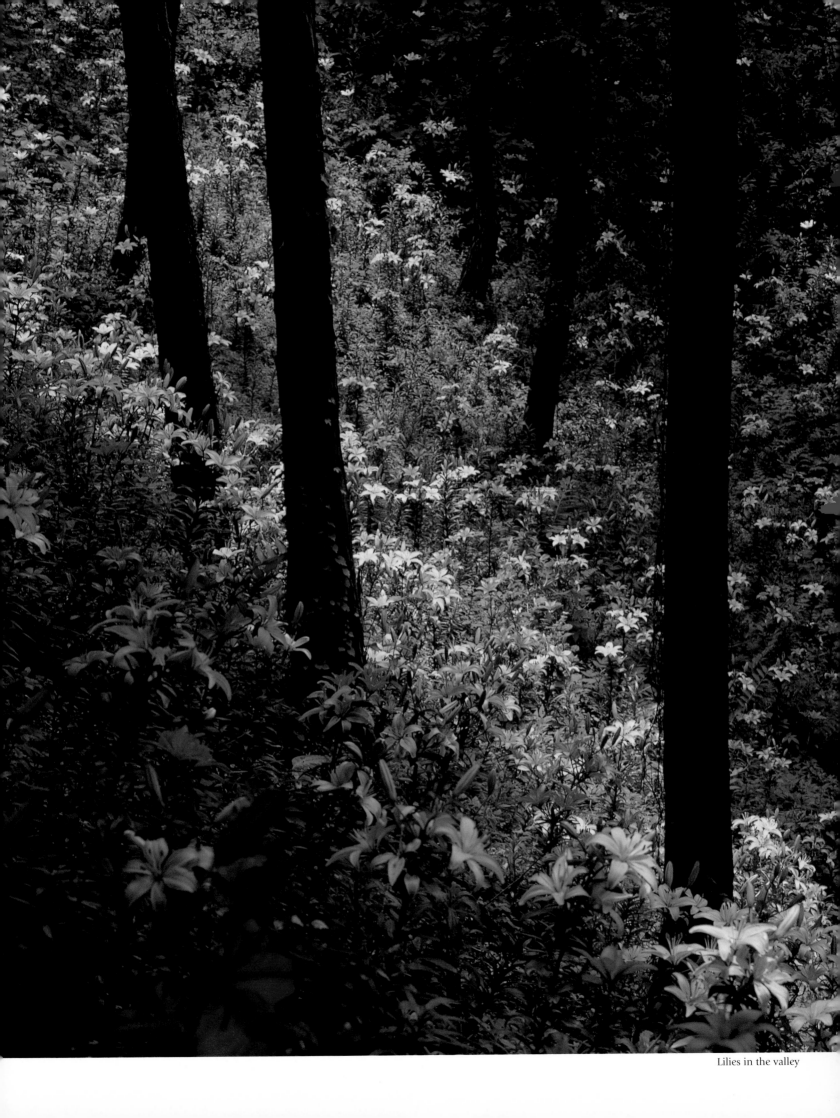

Lilies in the valley

Bumblebee

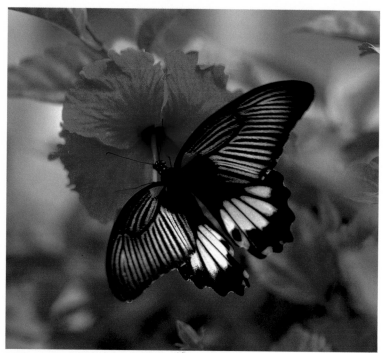

Hibiscus and swallowtail butterfly

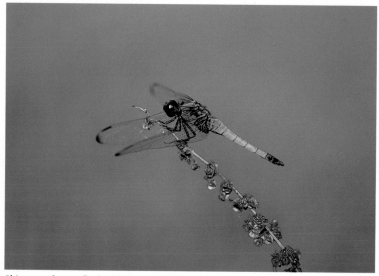

Skimmer dragonfly (*o-shiokara-tonbo*)

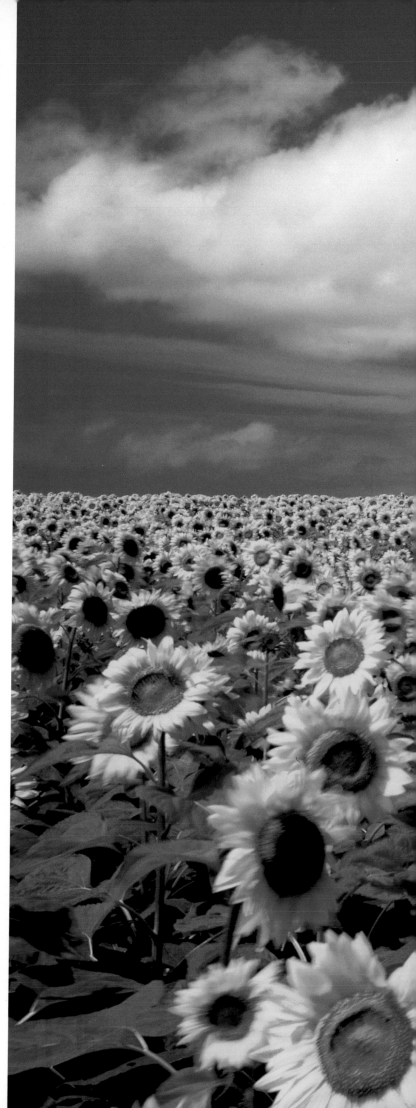

Sunflower field
in Hokkaido

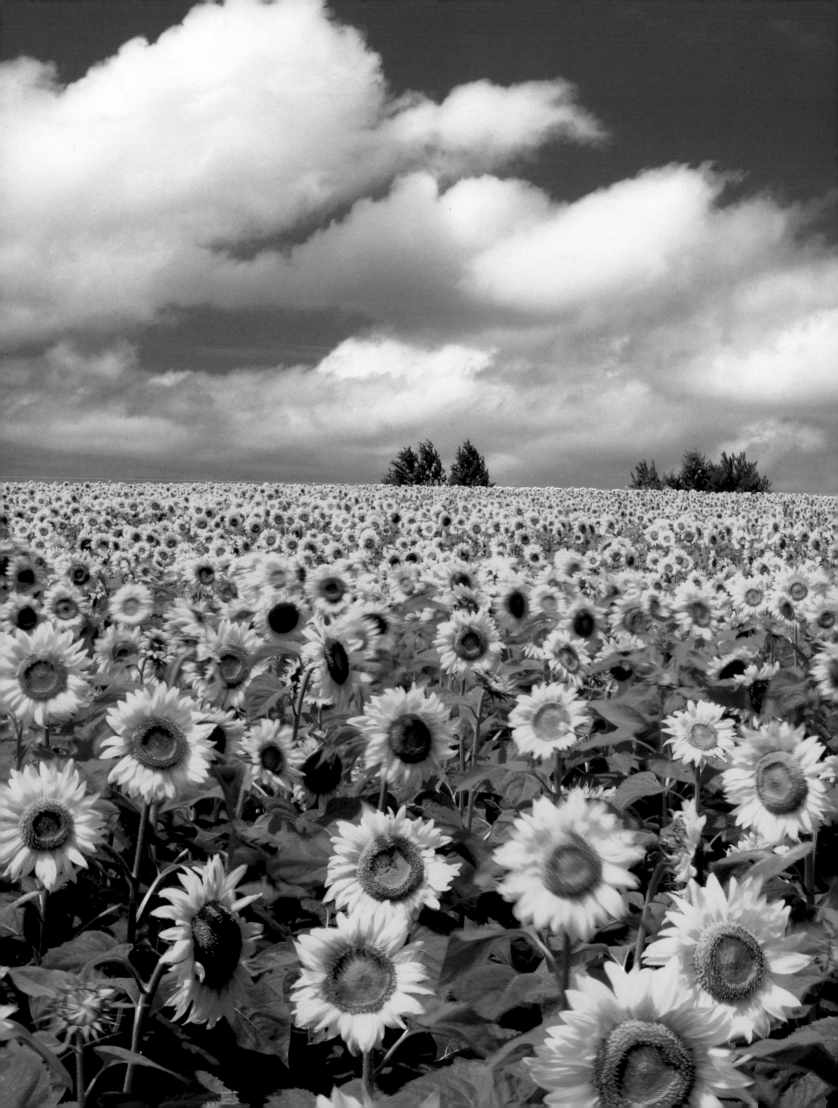

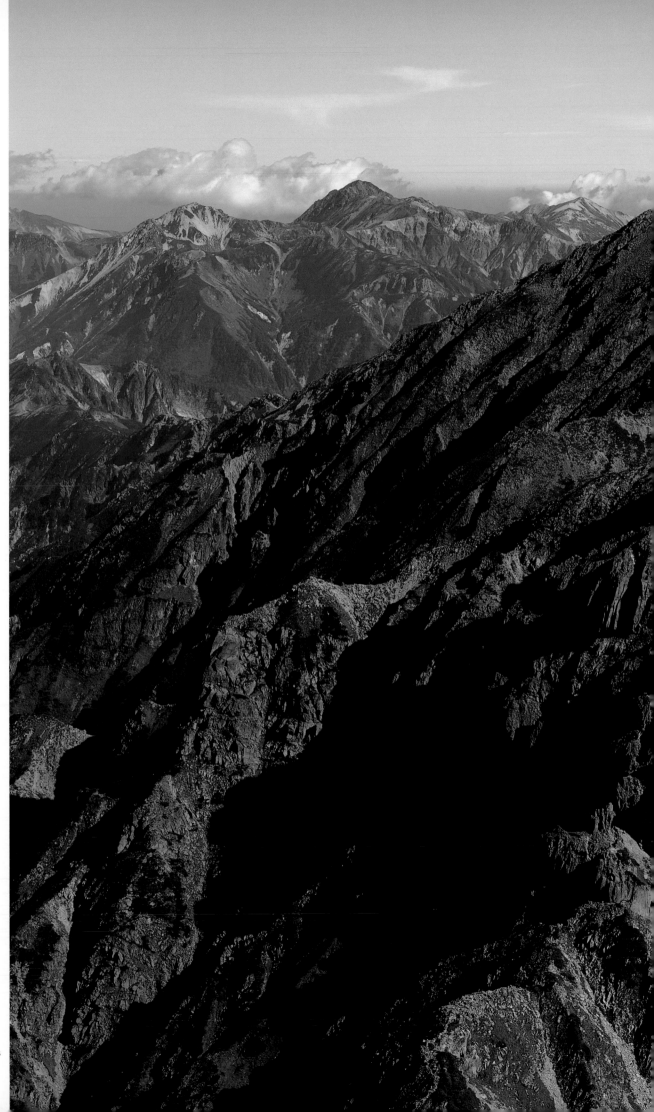

The Northern Alps
in summer

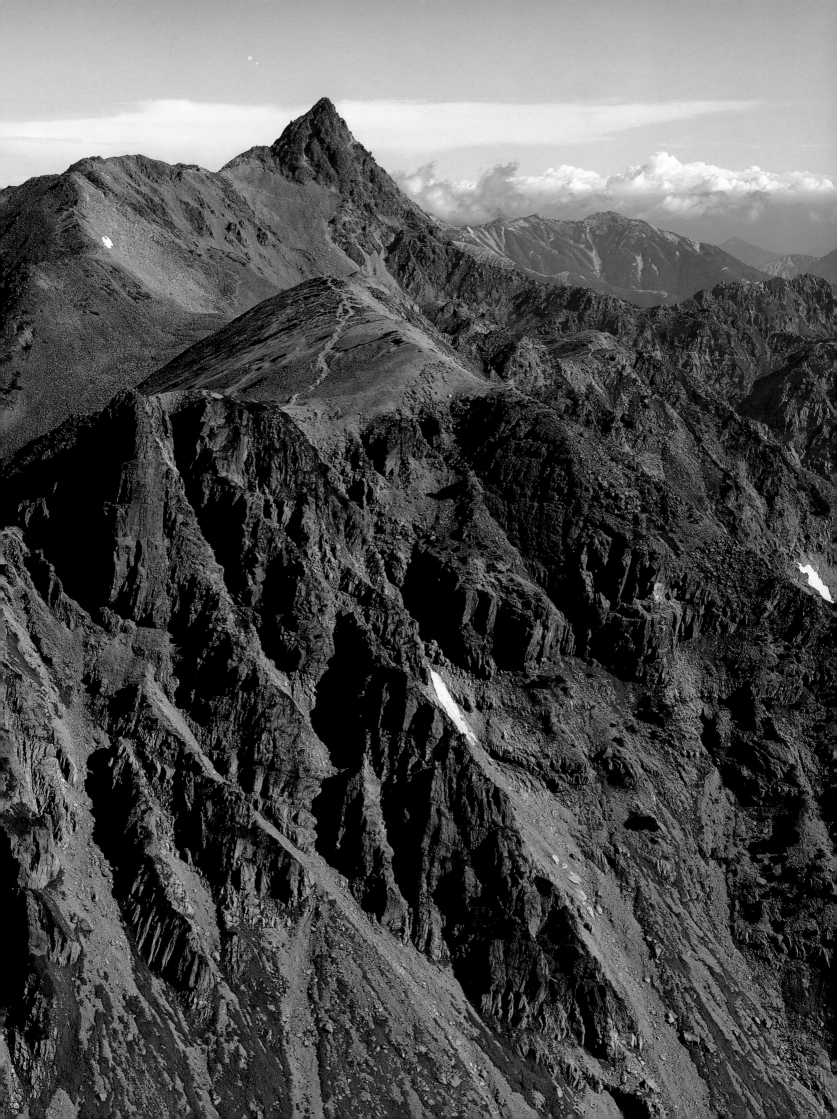

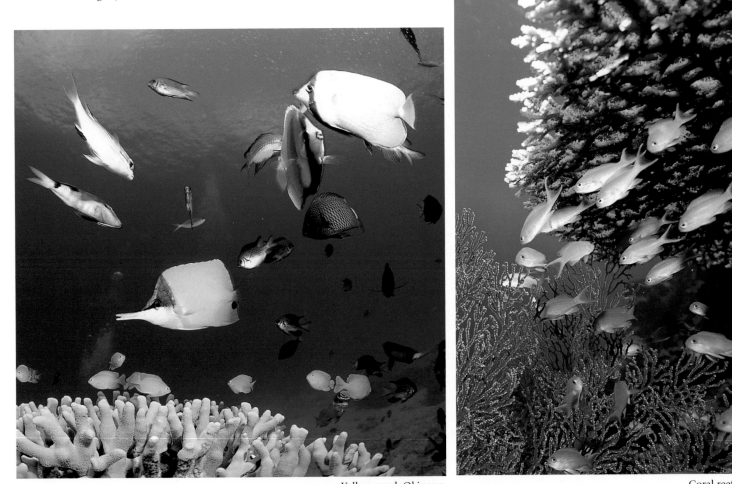

Yellow coral, Okinawa

Coral reef, Okinawa

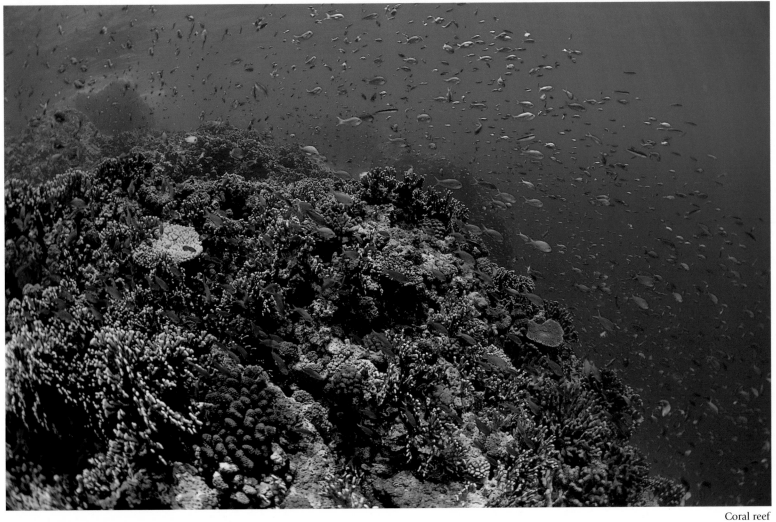

Coral reef

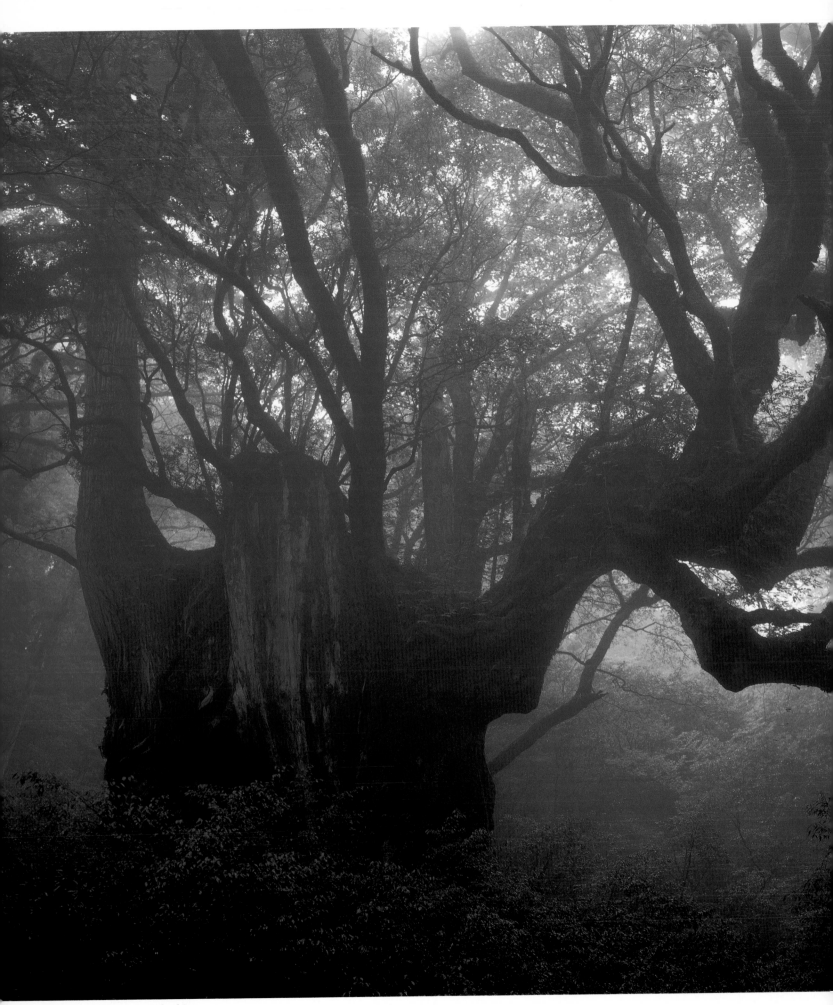

The primeval forest on Yakushima

AUTUMN

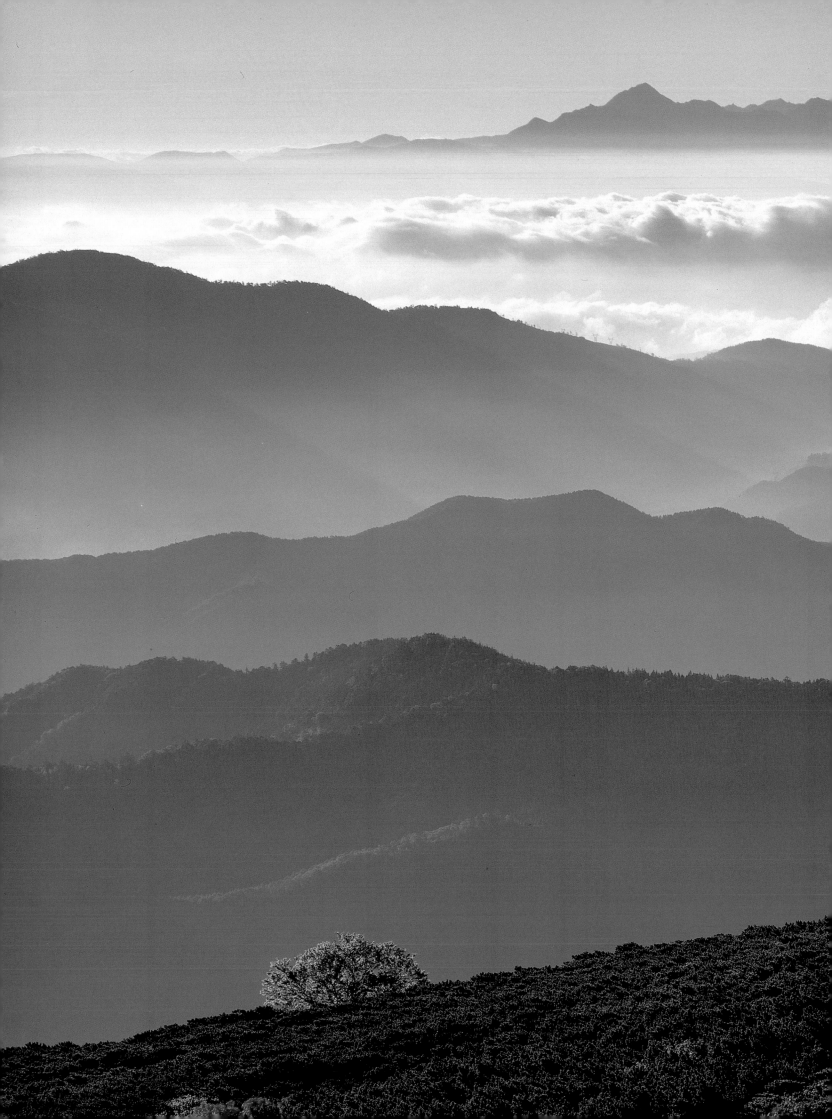

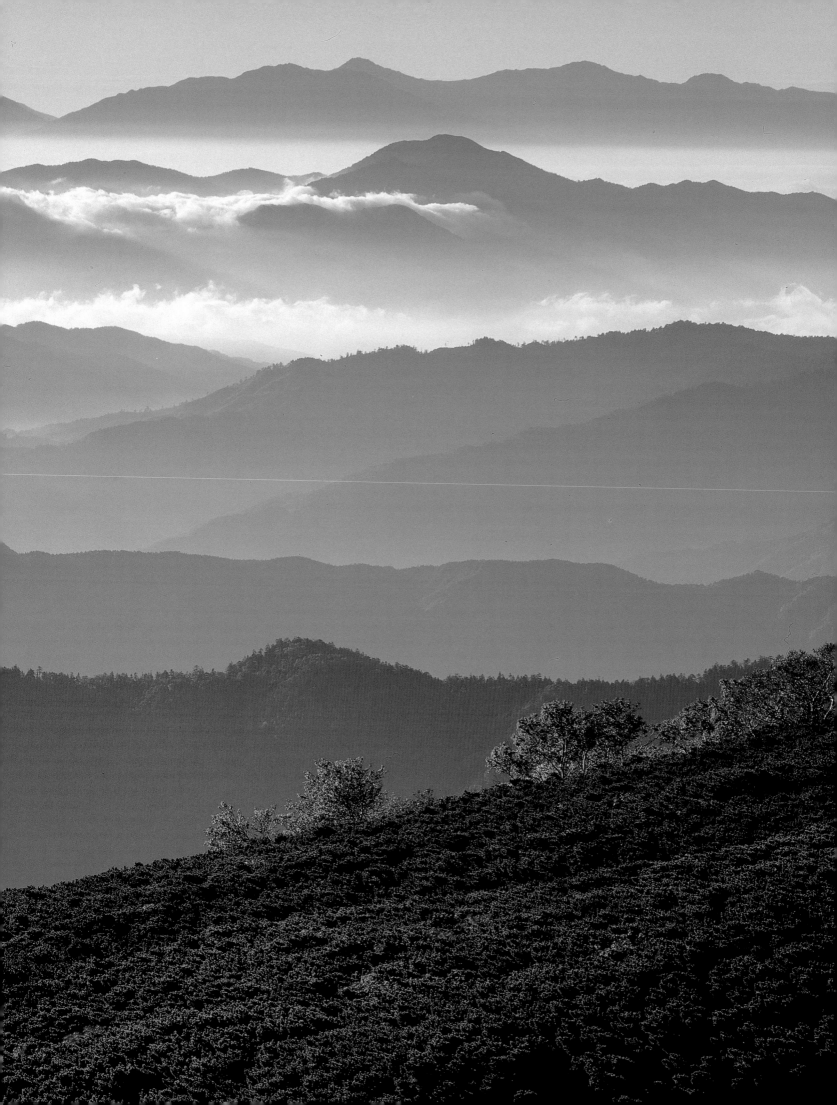

Autumn in Akino, Nara Prefecture

Paddies ready for the harvest
and red spider lilies

◀ Mountains and the
Norikura Highlands

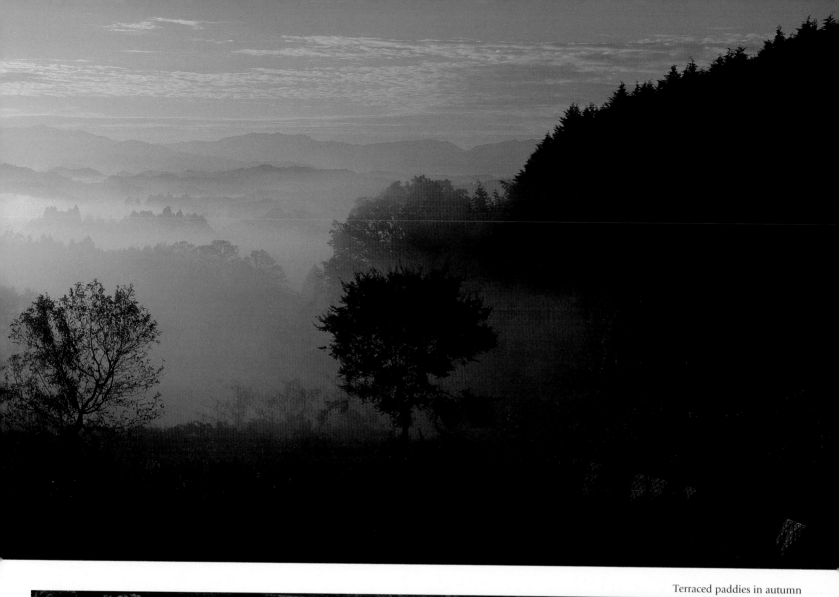

Terraced paddies in autumn

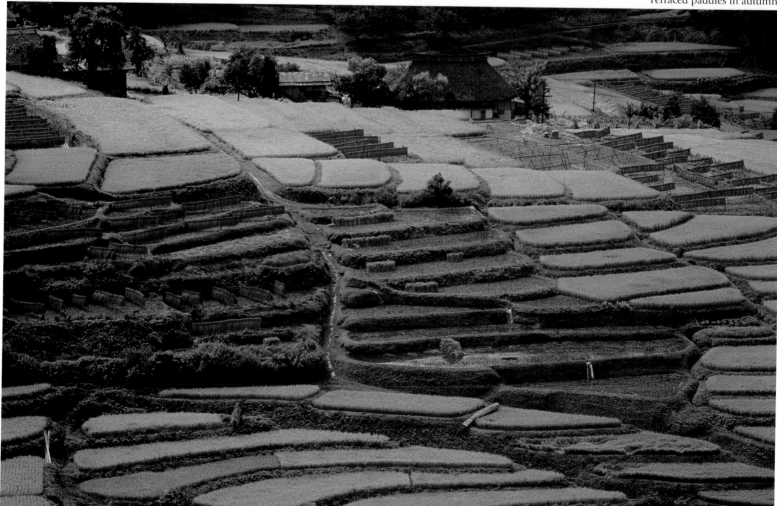

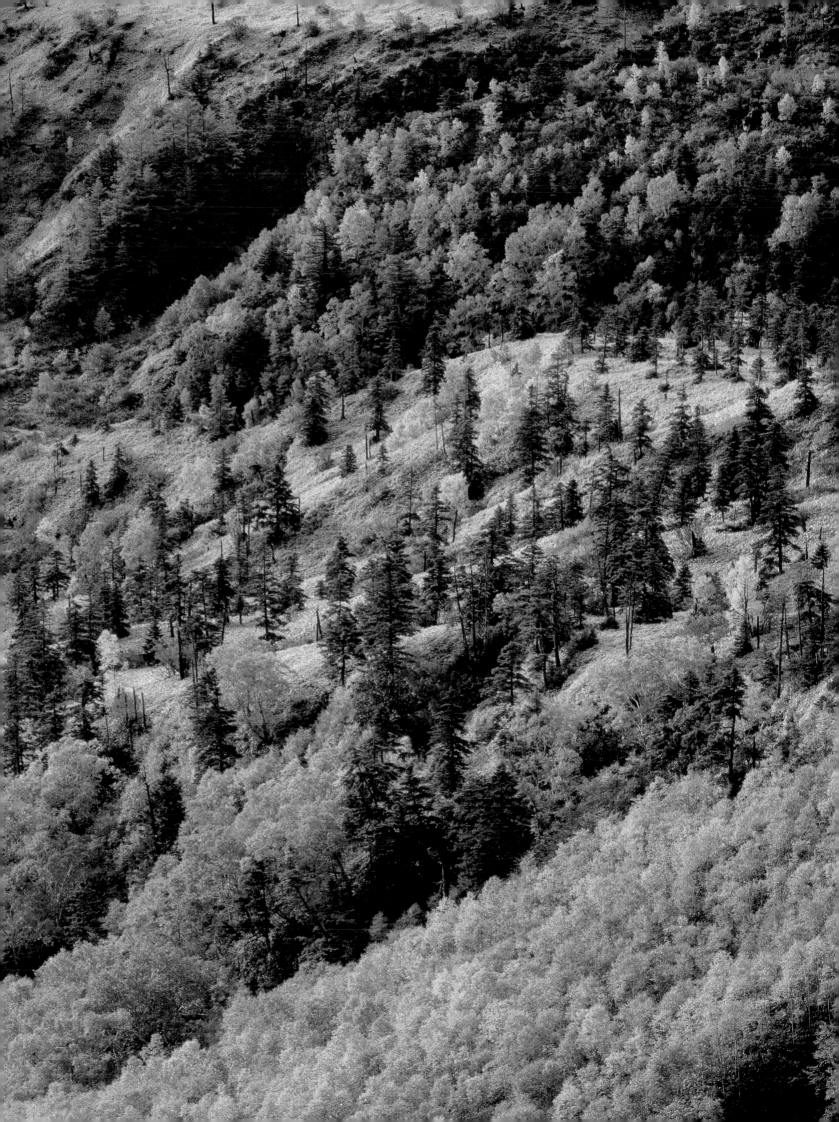

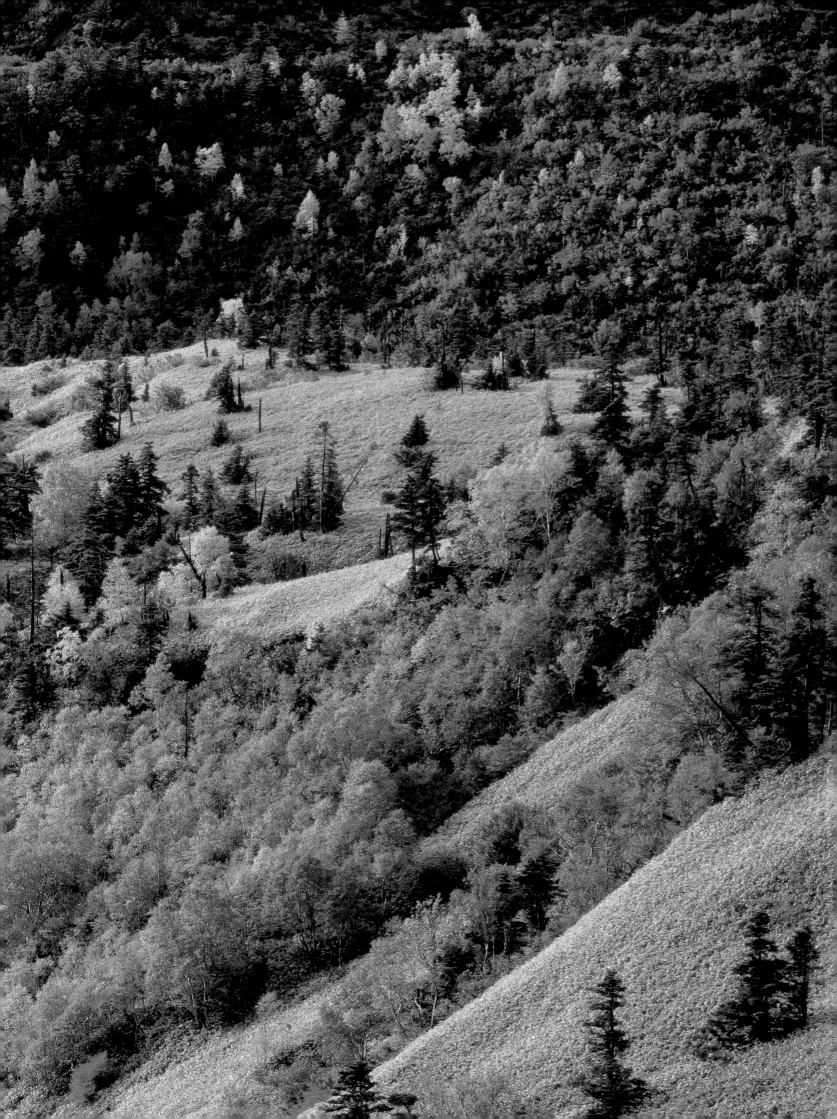

◄ Autumn foliage on
Mt. Shirane

Dahurian patrinia (*ominaeshi*)

Silver grass (*susuki*) on the hillside of Wakakusayama

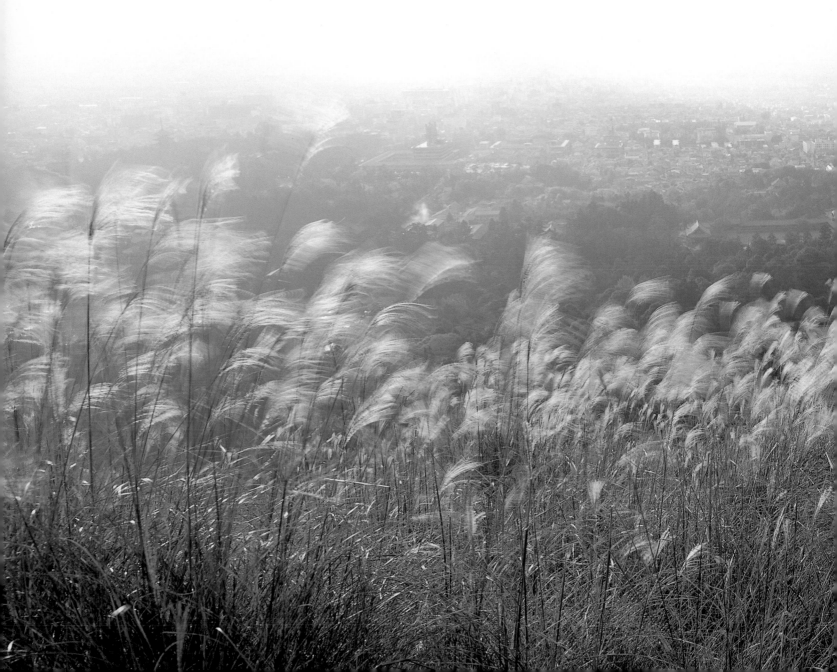

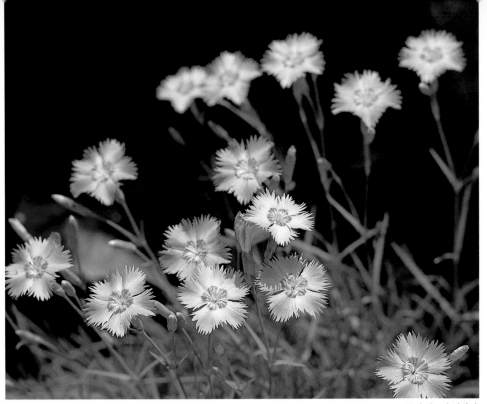

Pink (*nadeshiko*)

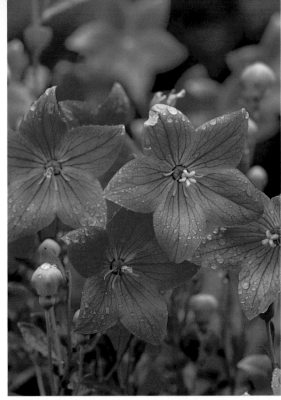

Balloon flower (*kikyo*)

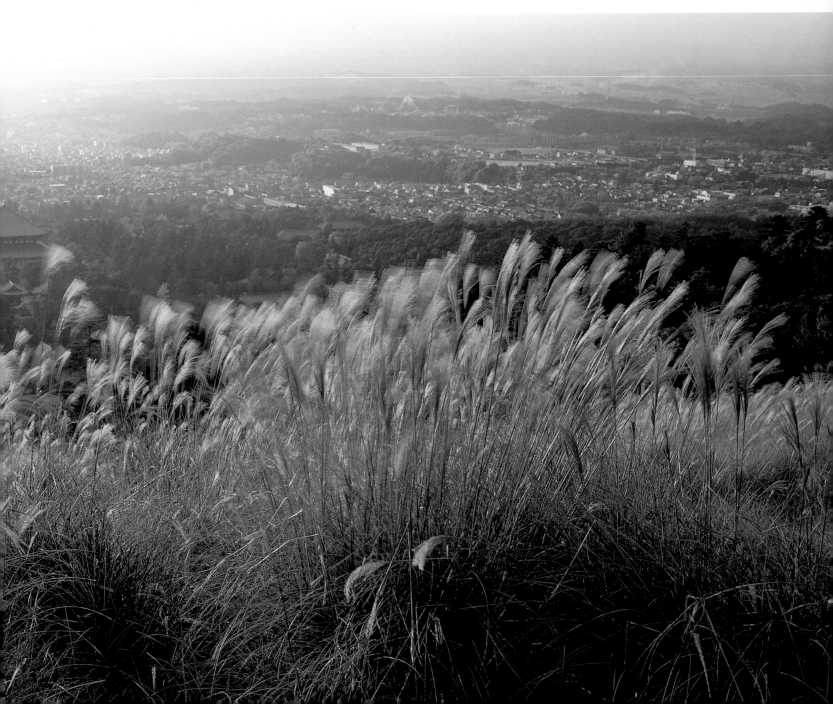

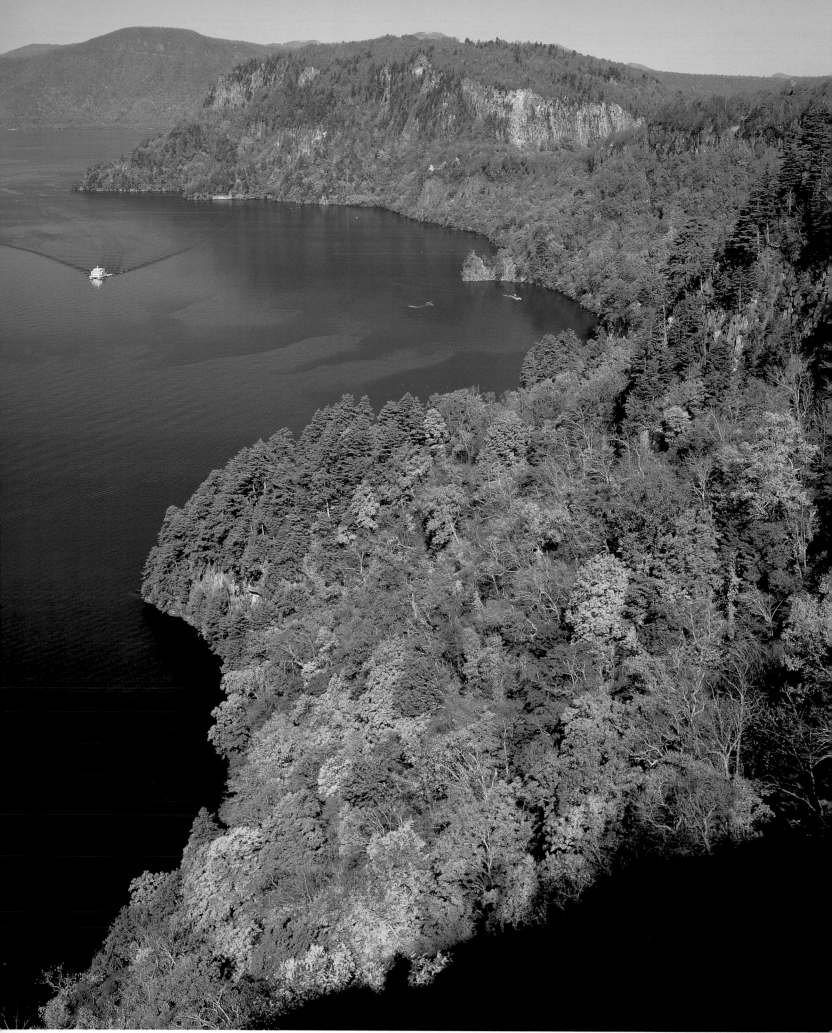

Autumn foliage at Lake Towada

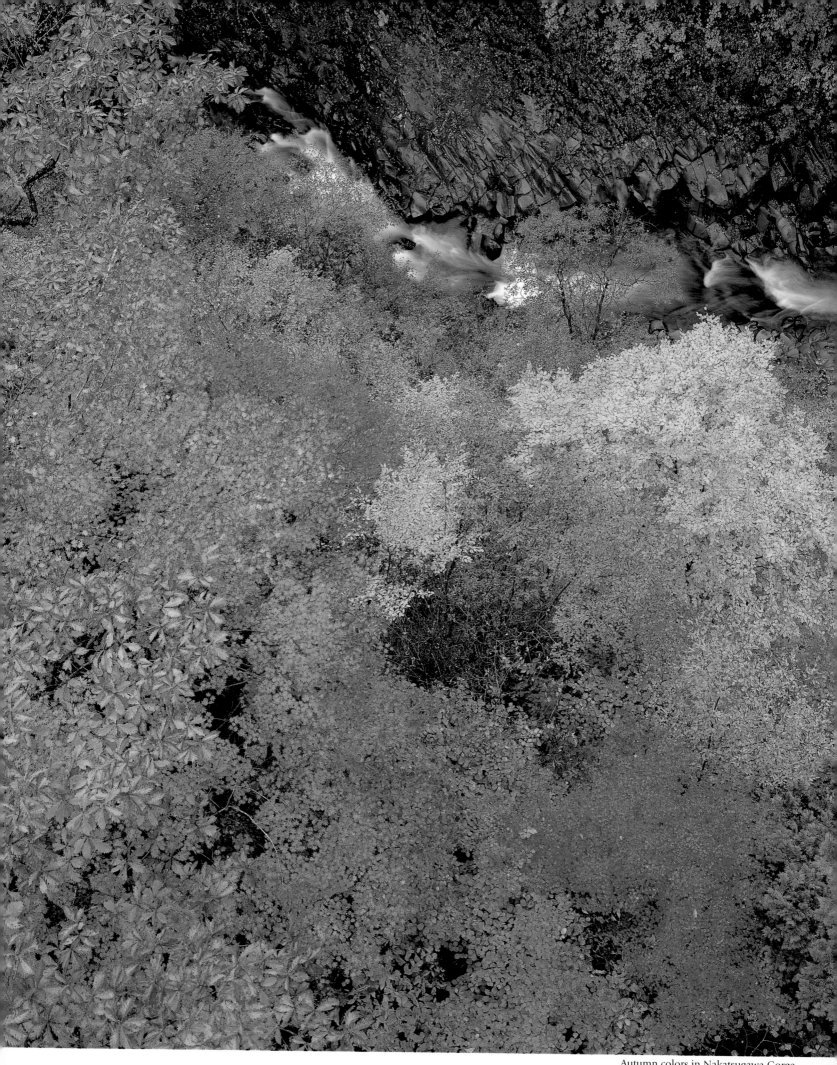

Autumn colors in Nakatsugawa Gorge

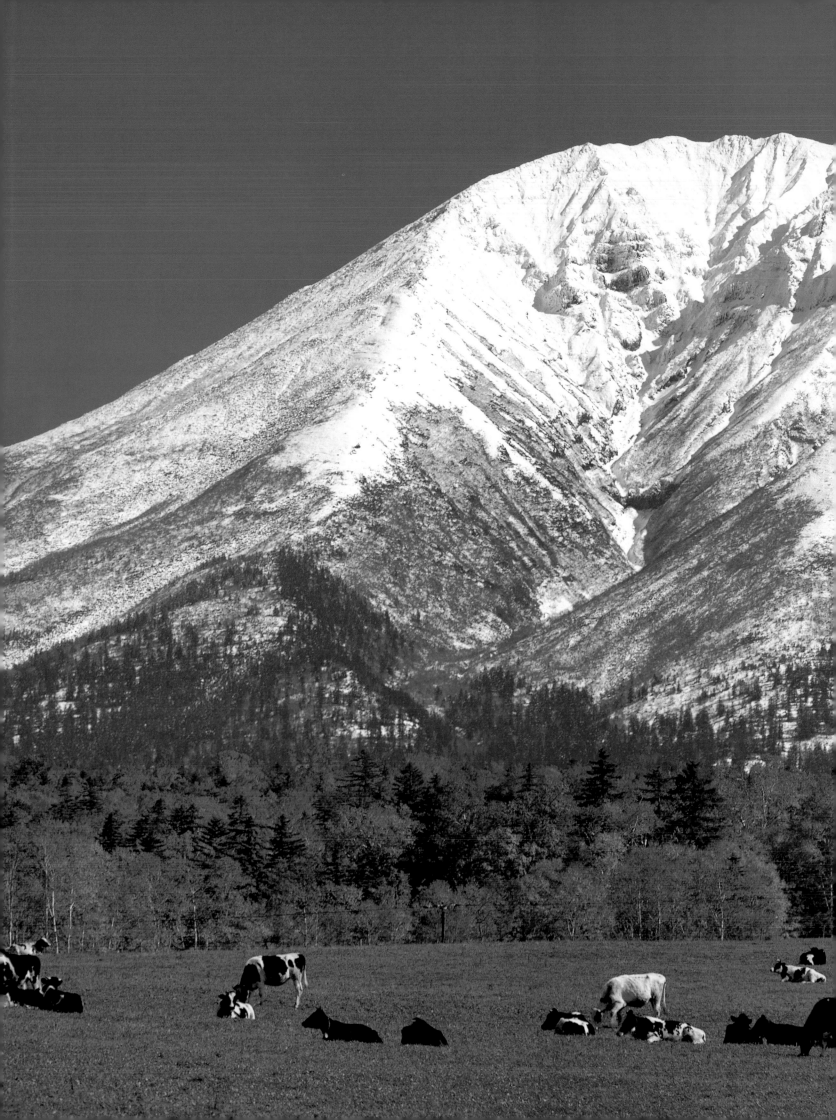

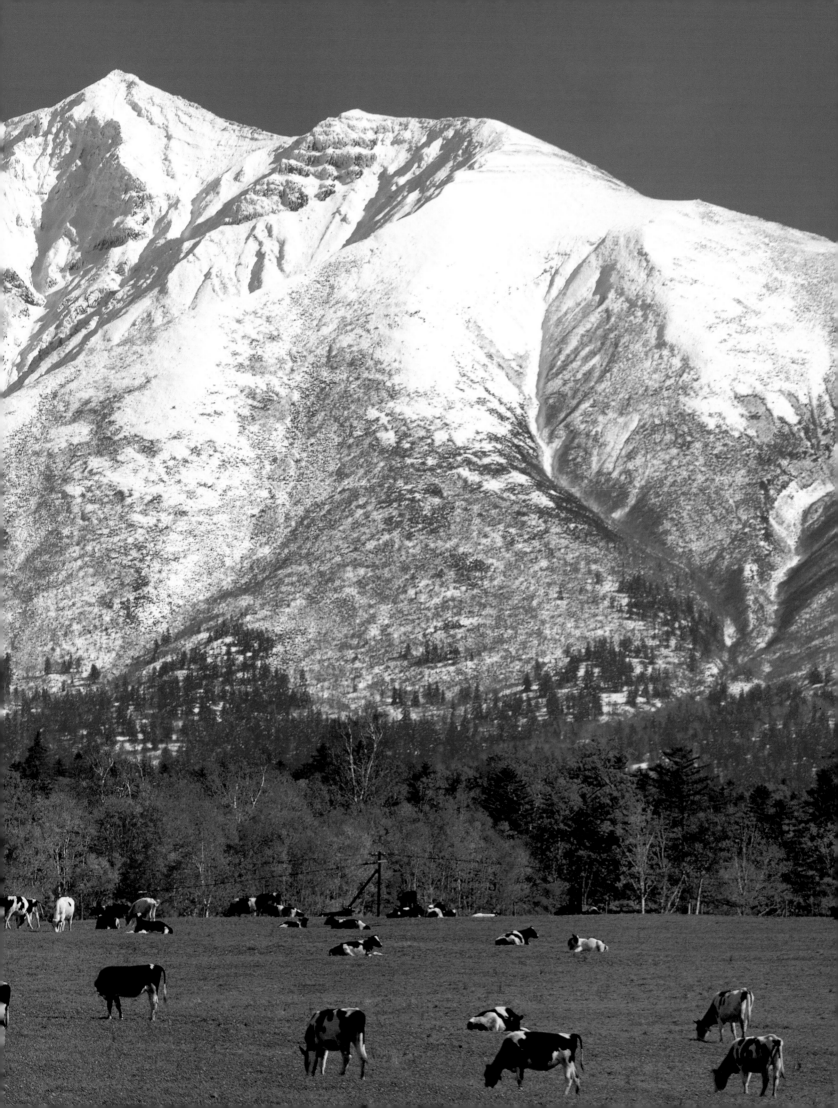

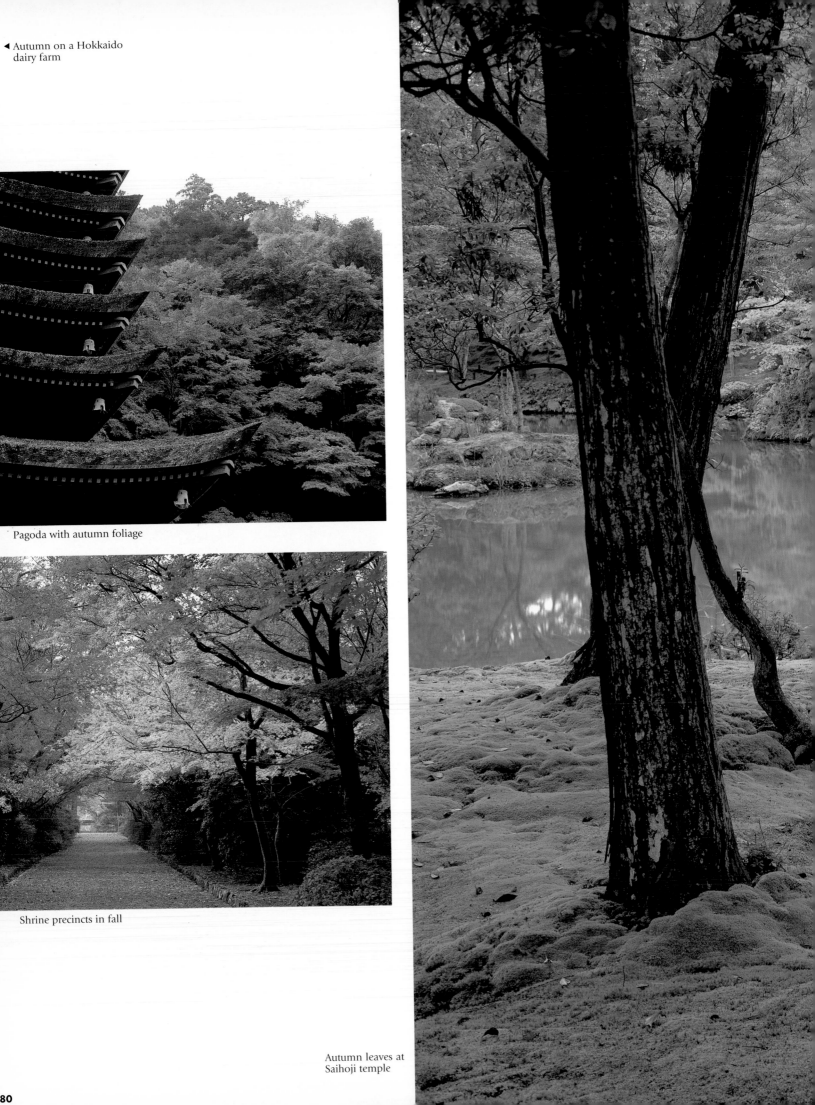

◄ Autumn on a Hokkaido
dairy farm

Pagoda with autumn foliage

Shrine precincts in fall

Autumn leaves at
Saihoji temple

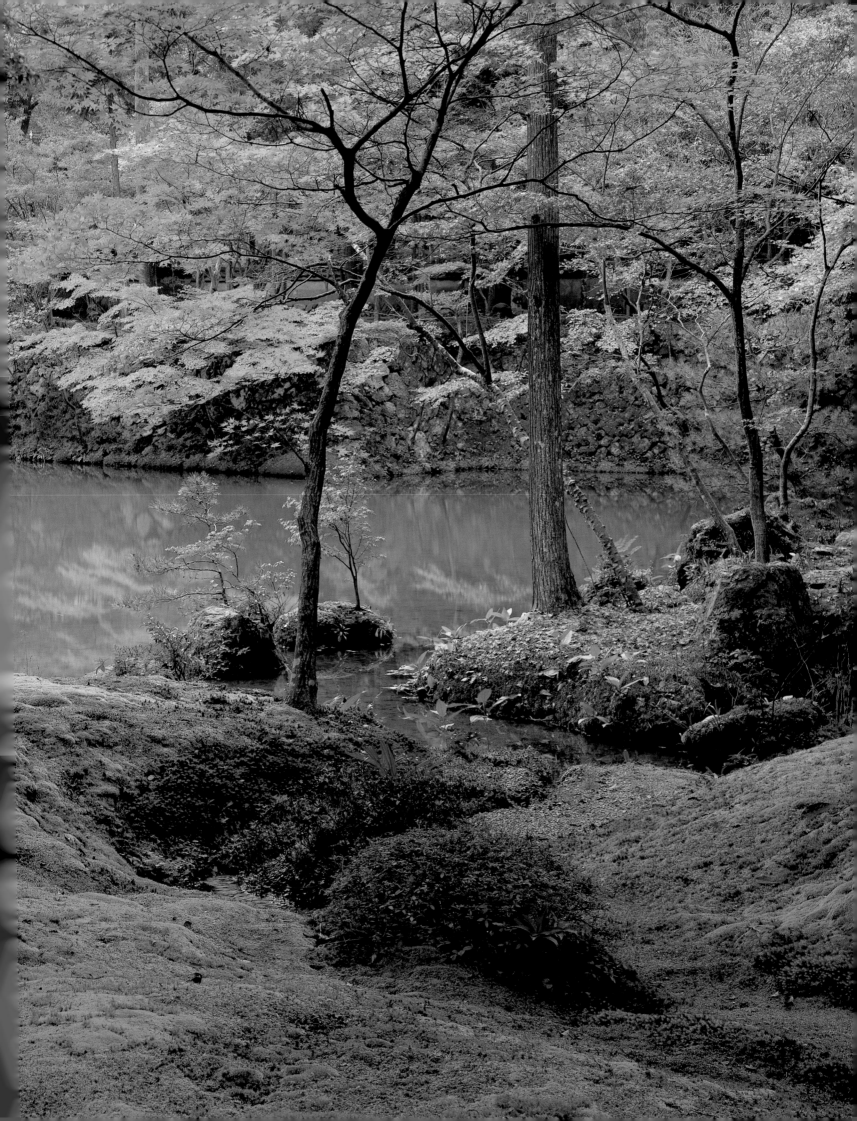

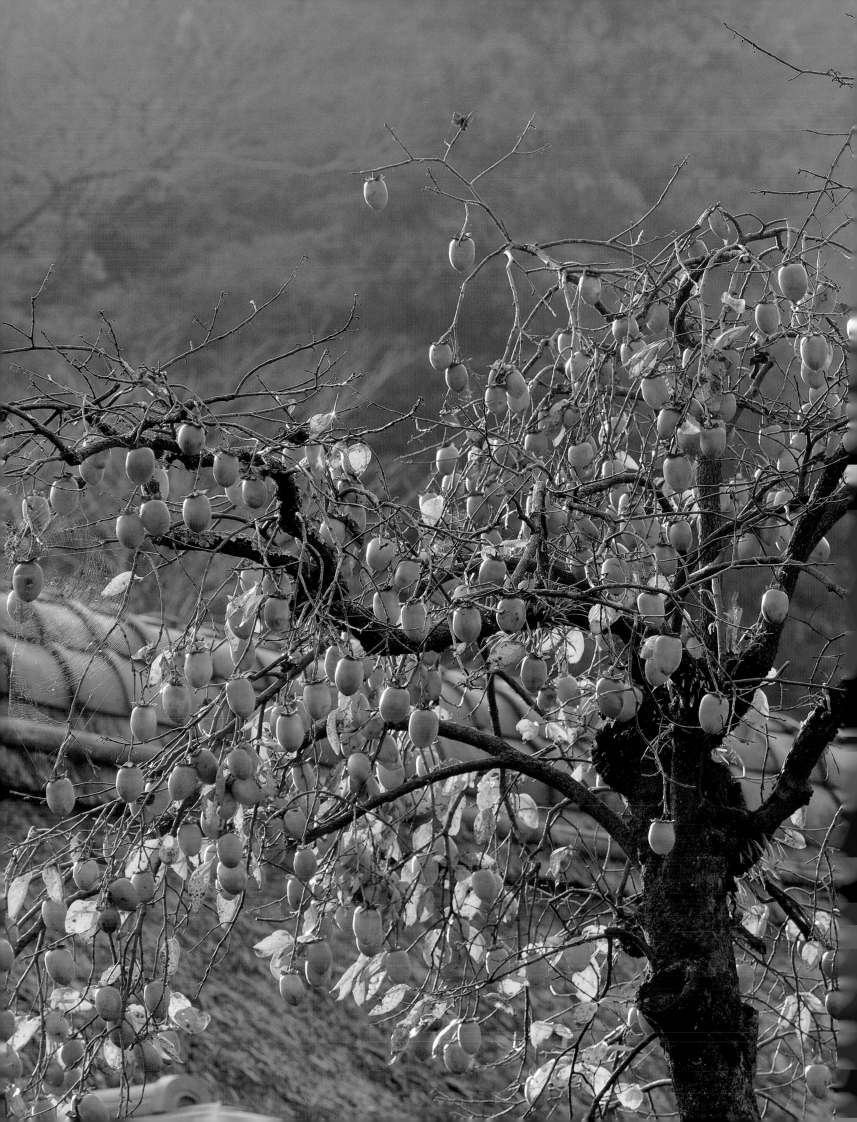

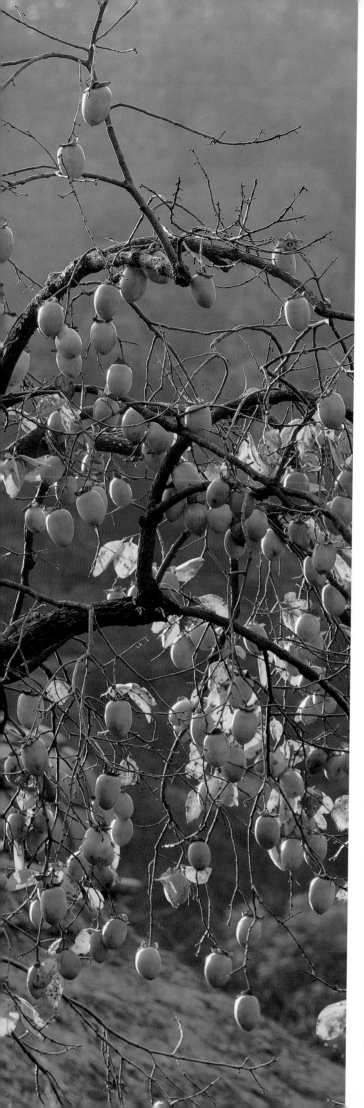

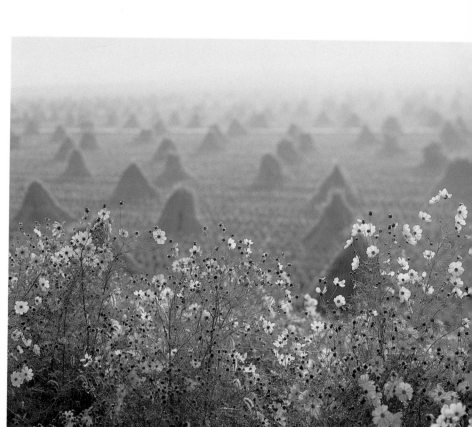

Persimmons in fall

Cosmos and mounded rice straw

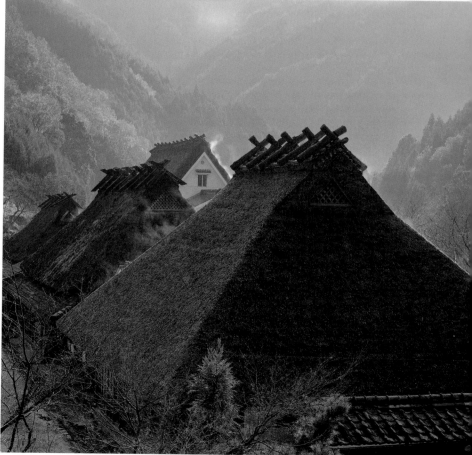

Traditional houses in autumn

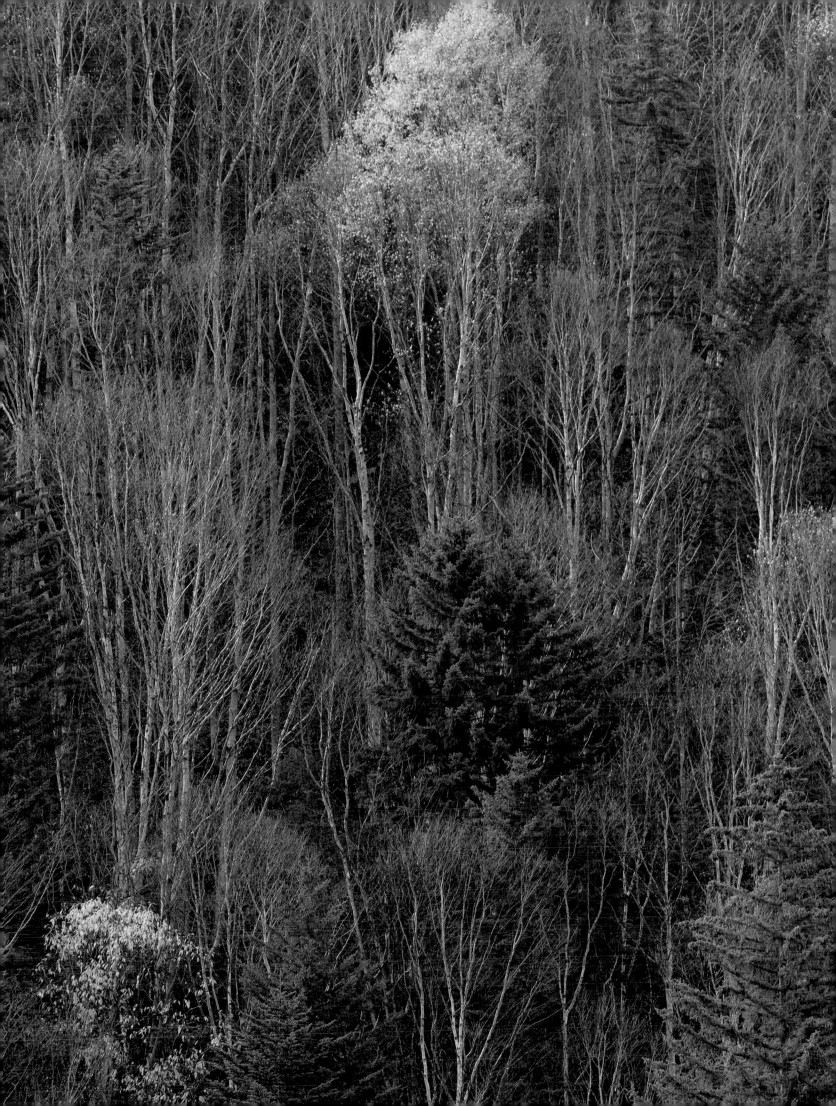

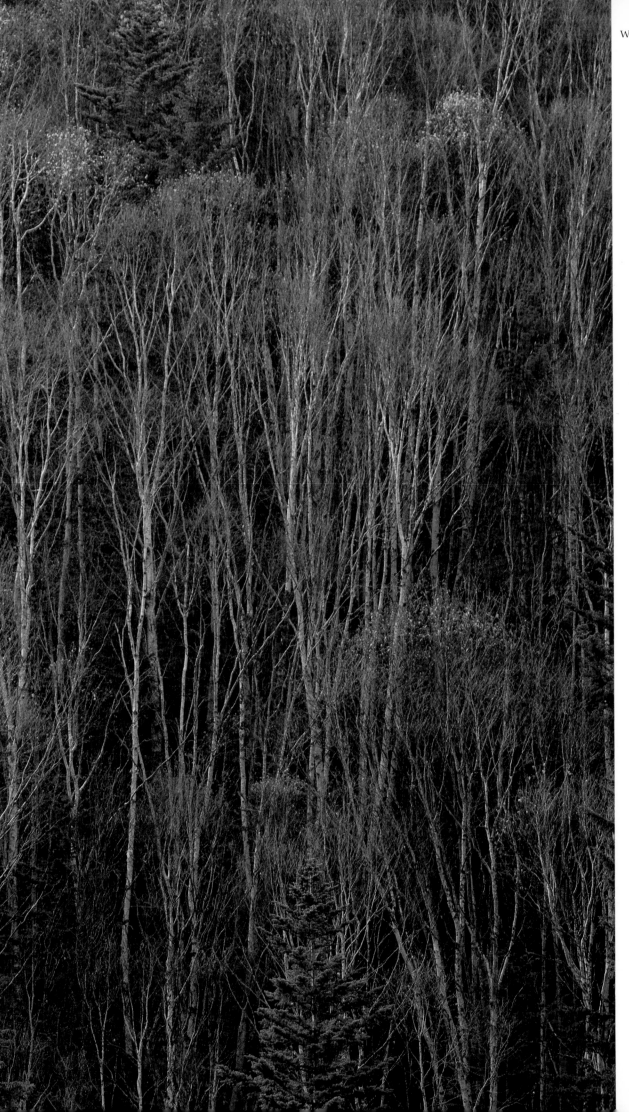

White birch in late autumn

Islands of the
Kujukushima
group, Kyushu ▶

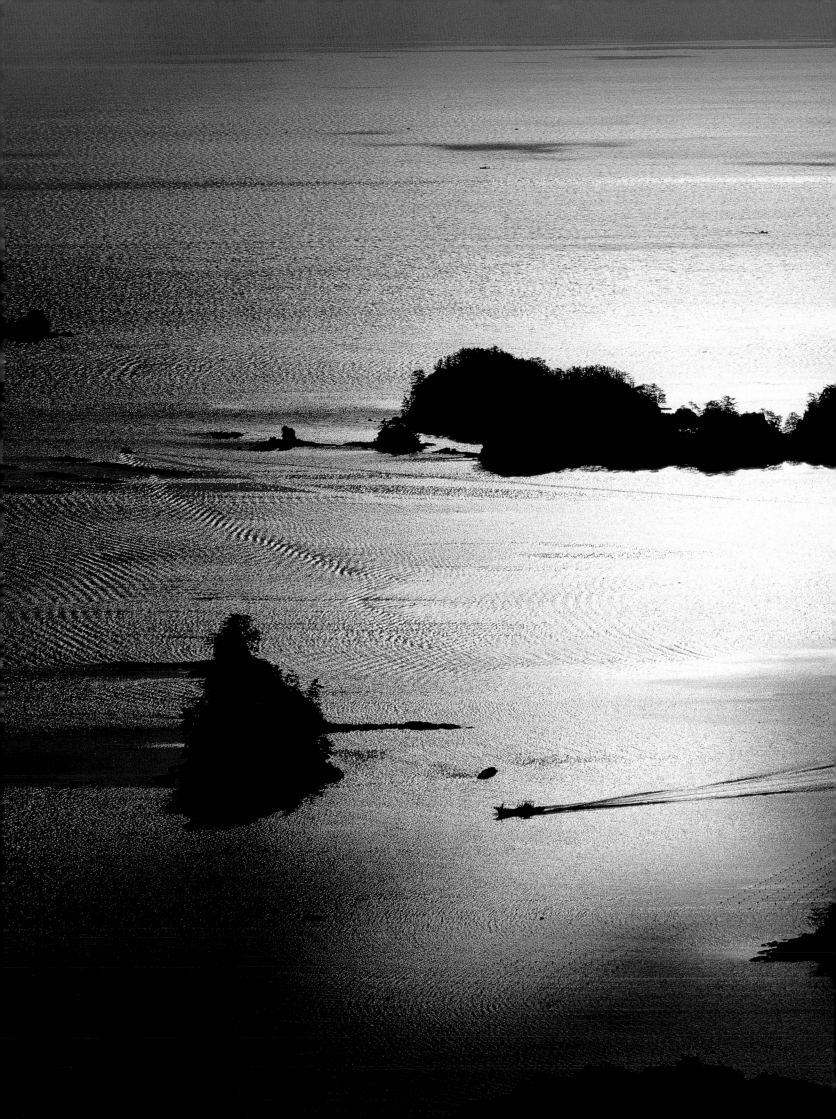

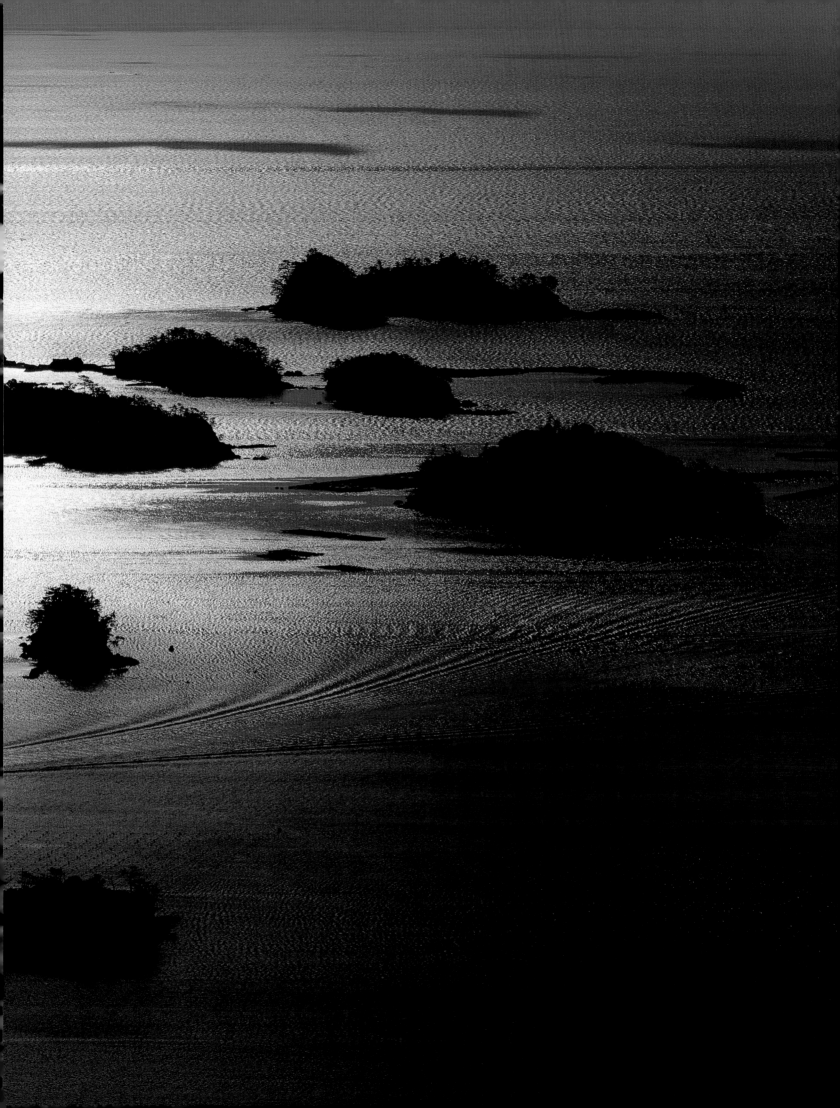

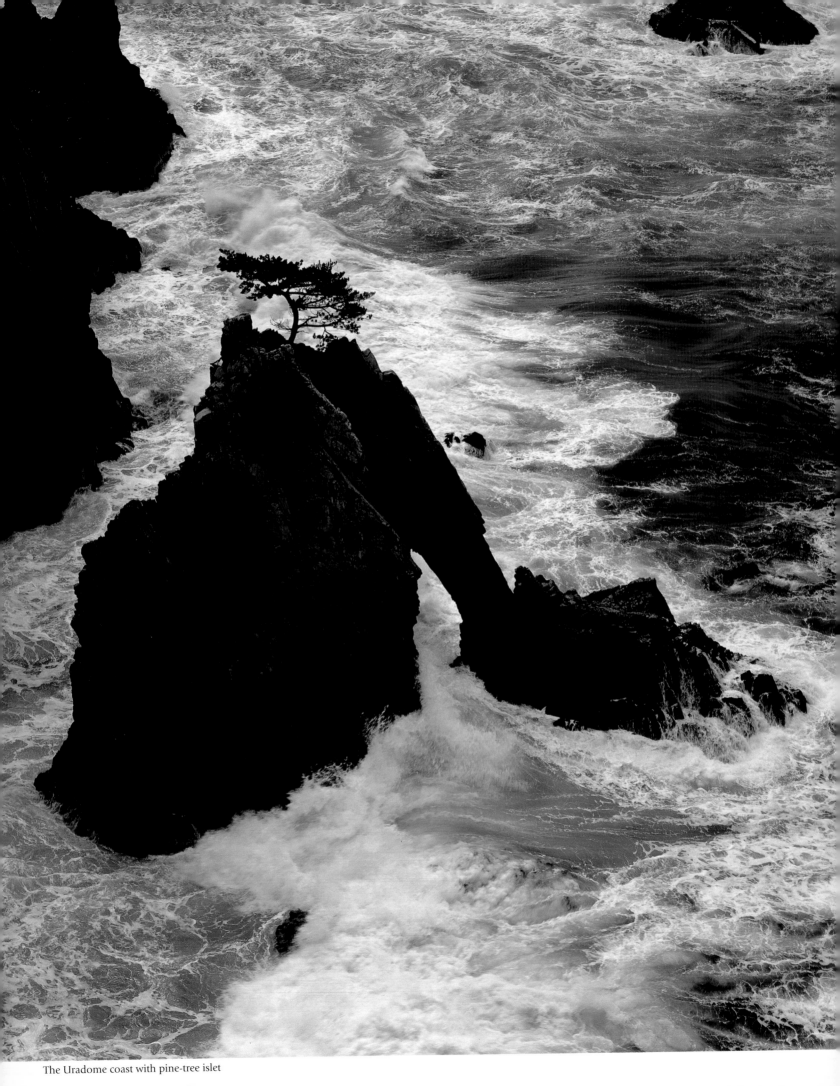

The Uradome coast with pine-tree islet

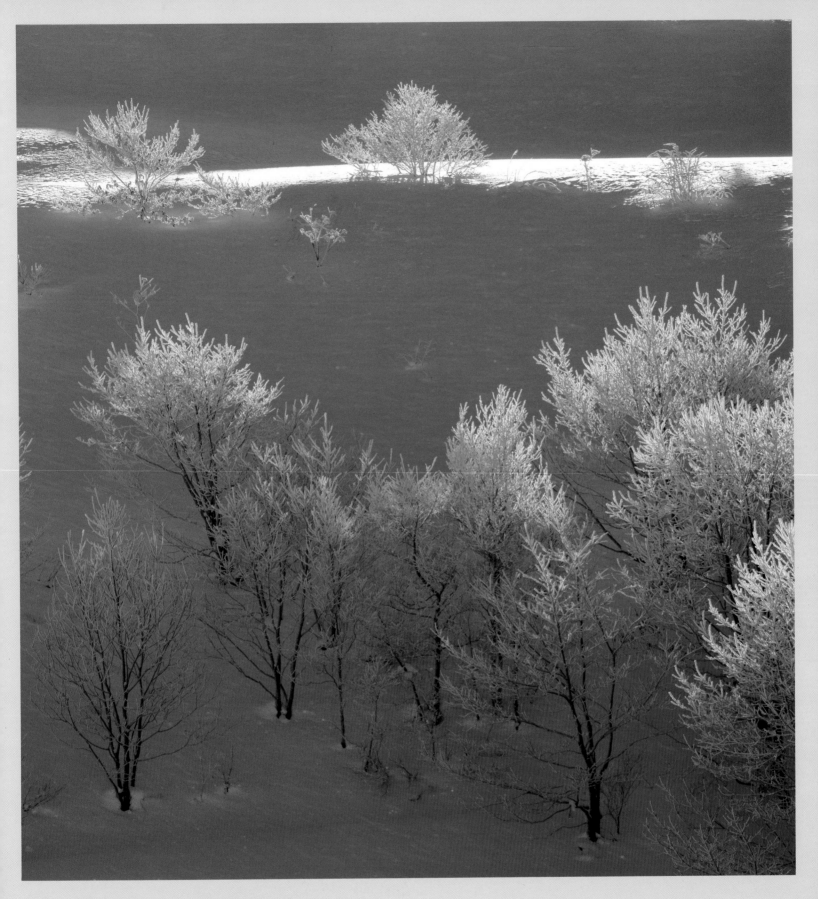

WINTER

White frost (*muhyo*)

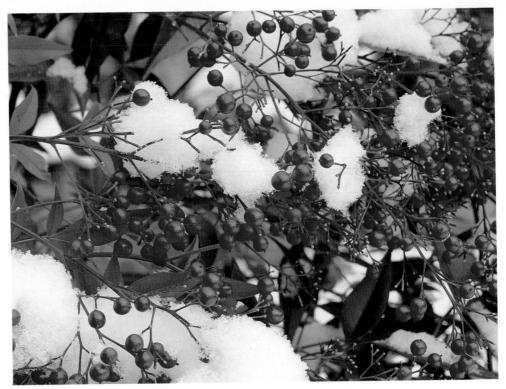

Nandina (*nanten*)

Hasedera temple in the snow

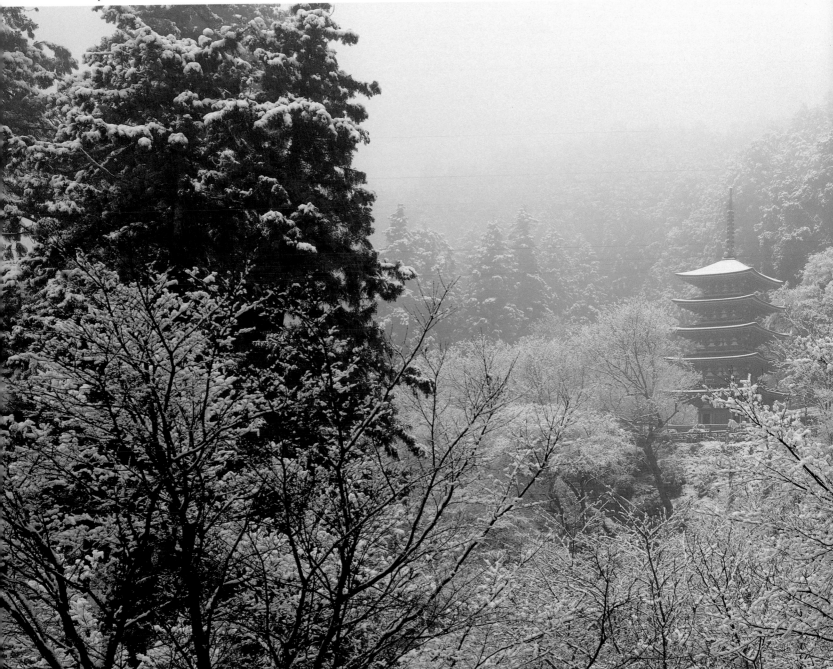

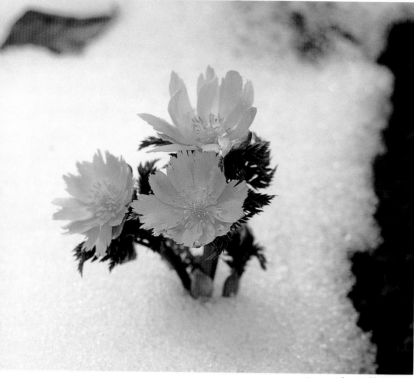

Amur adonis (*fukujuso*)

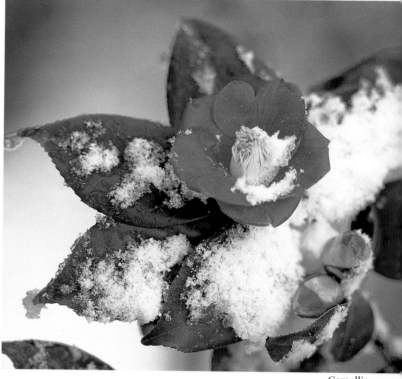

Camellia

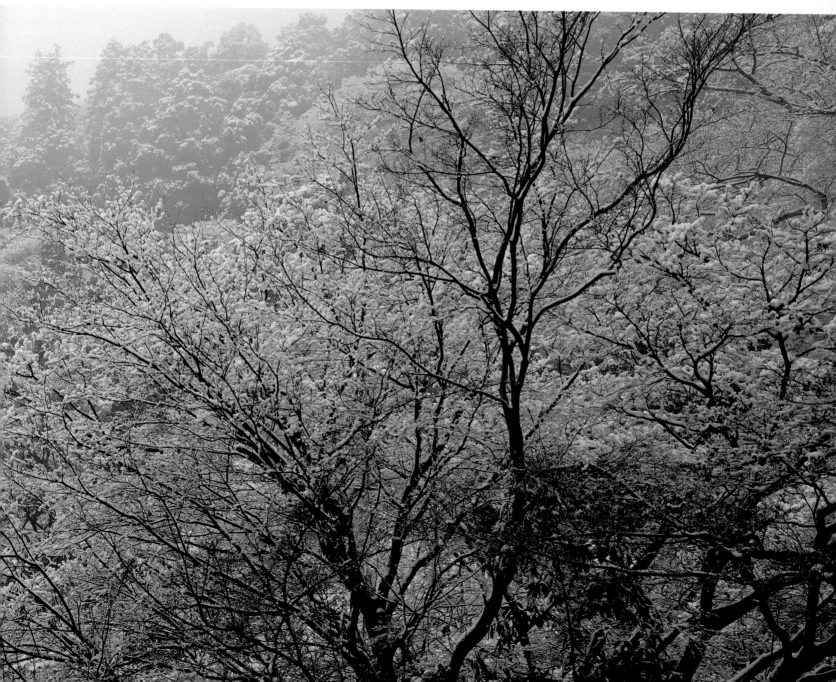

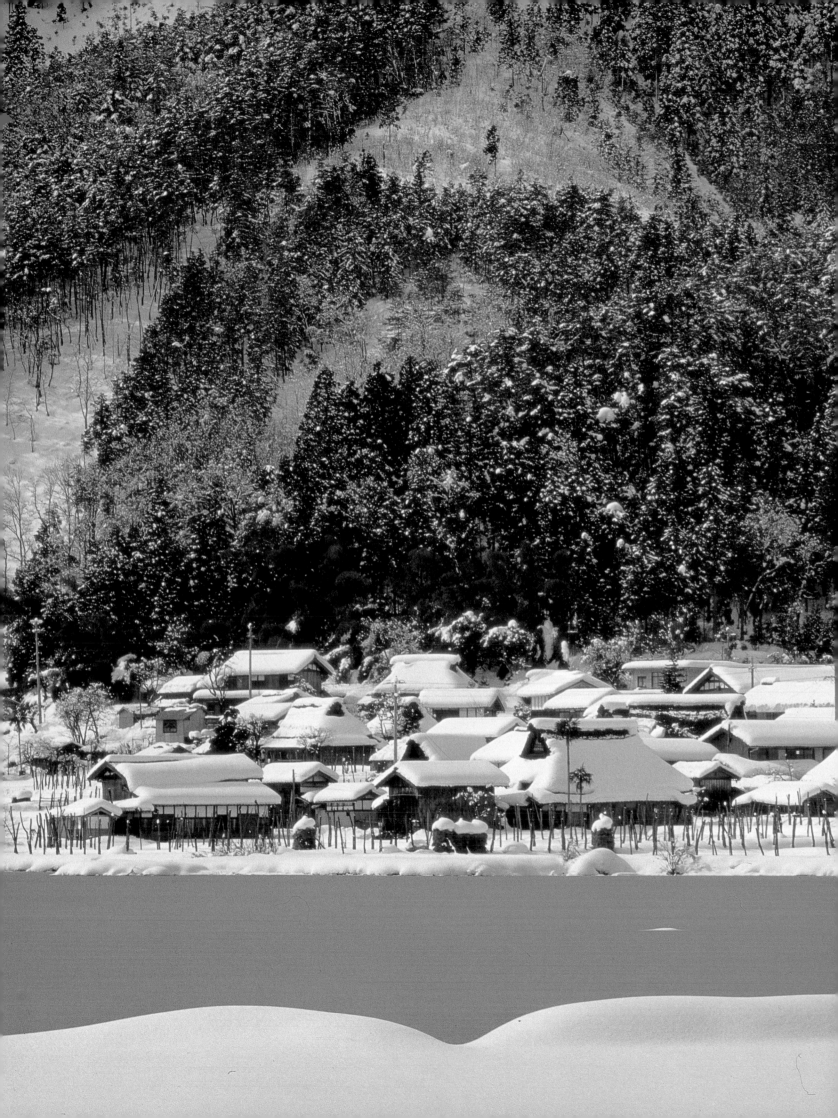

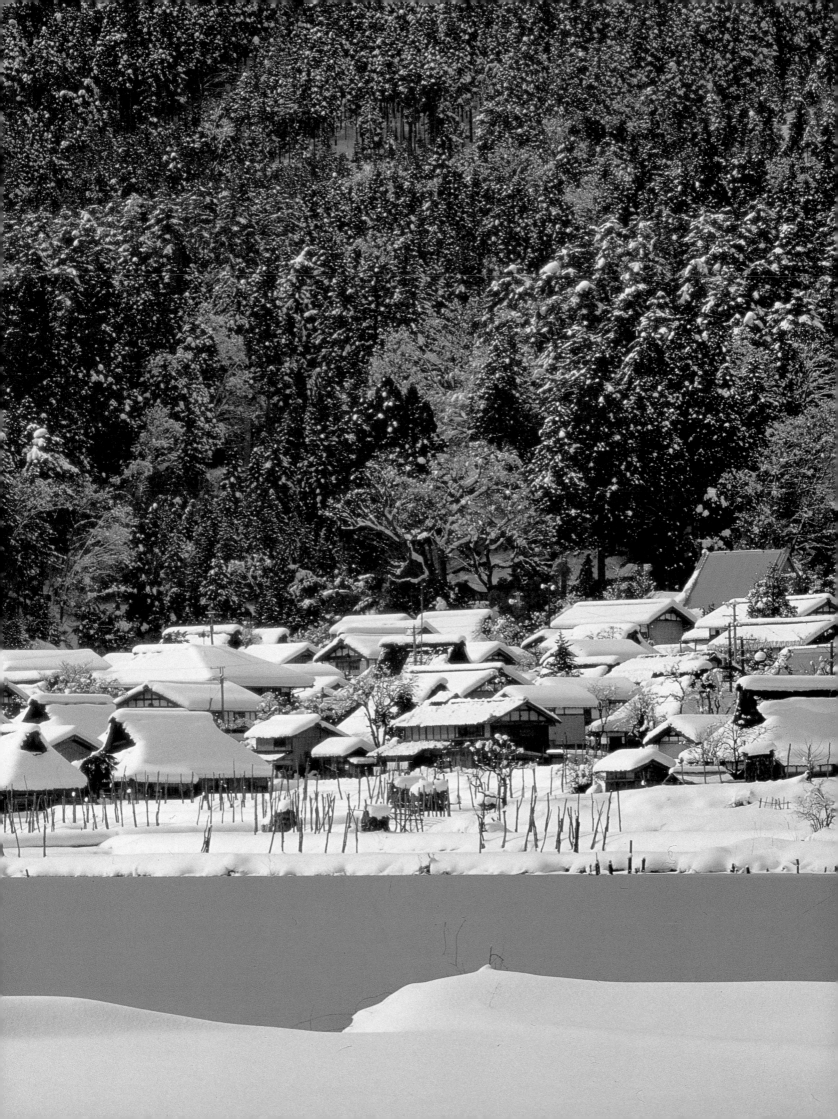

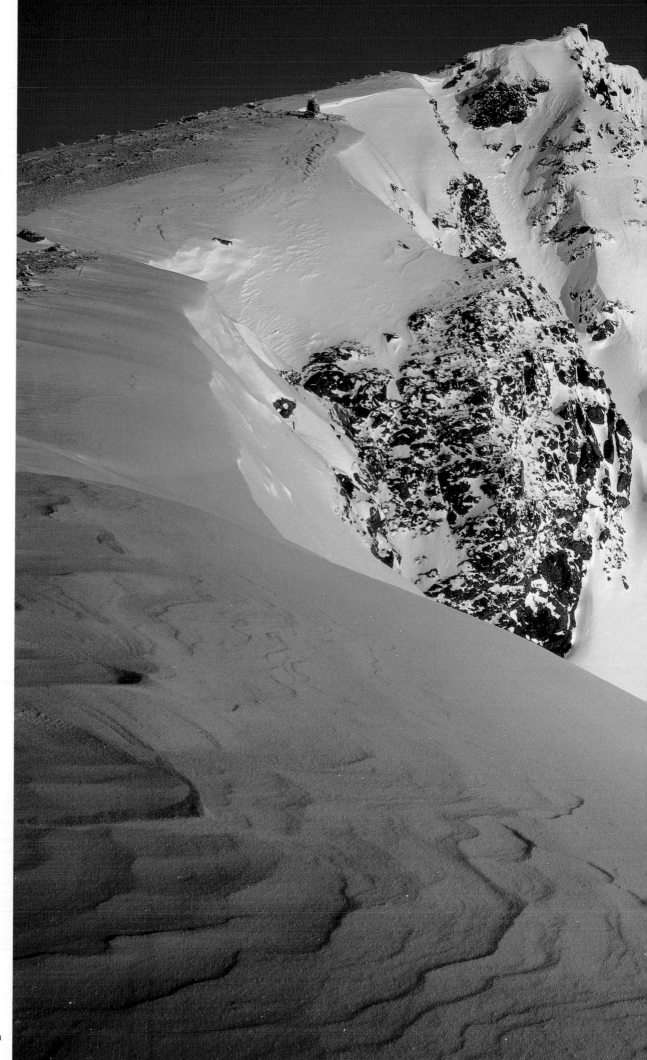

◄ Traditional homes
in the snow

Midwinter on Mt. Hakuba

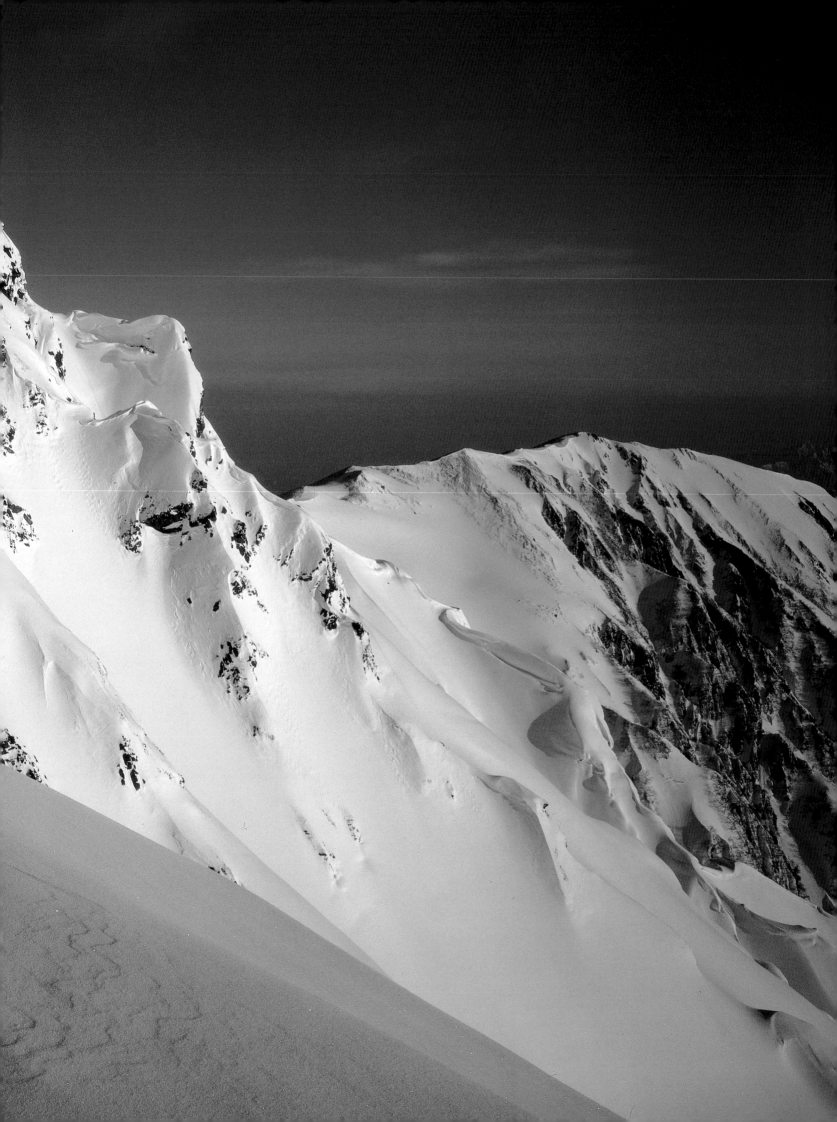

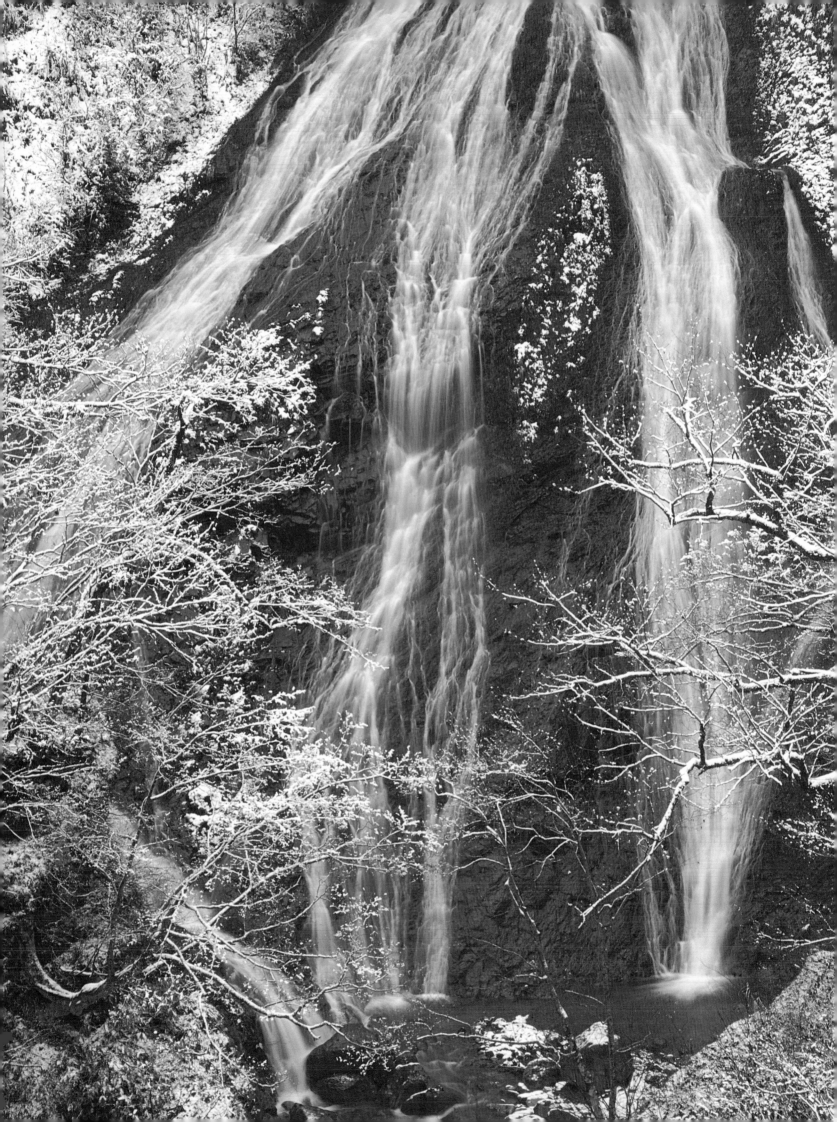

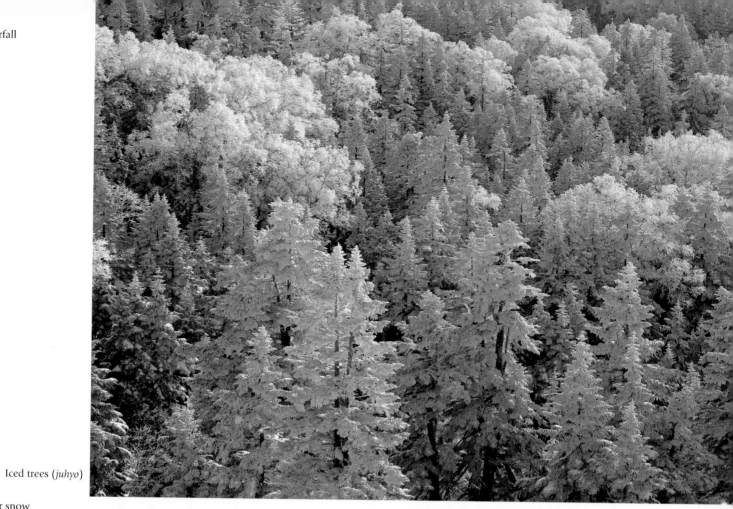

◄ Winter waterfall

Iced trees (*juhyo*)

Iced trees under snow

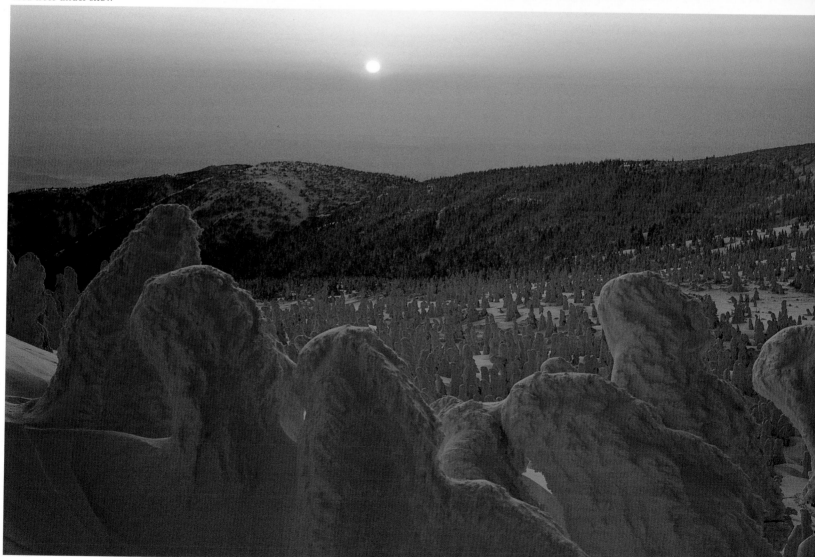

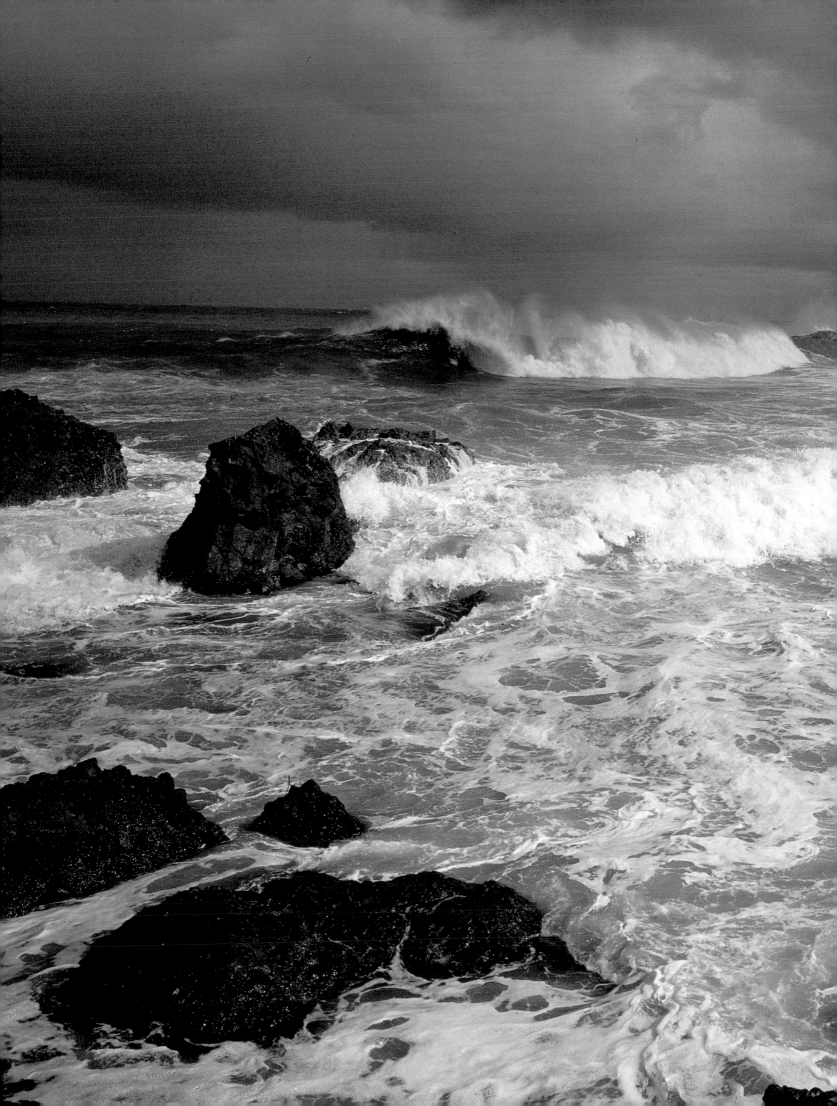

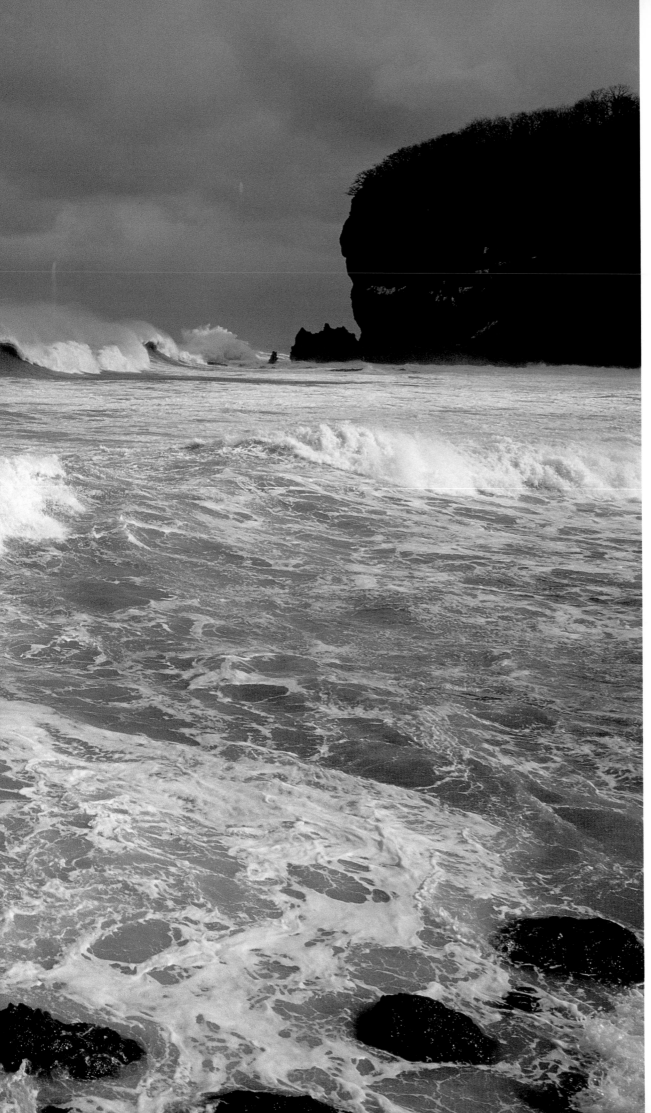

Stormy seas, Otaru,
Hokkaido

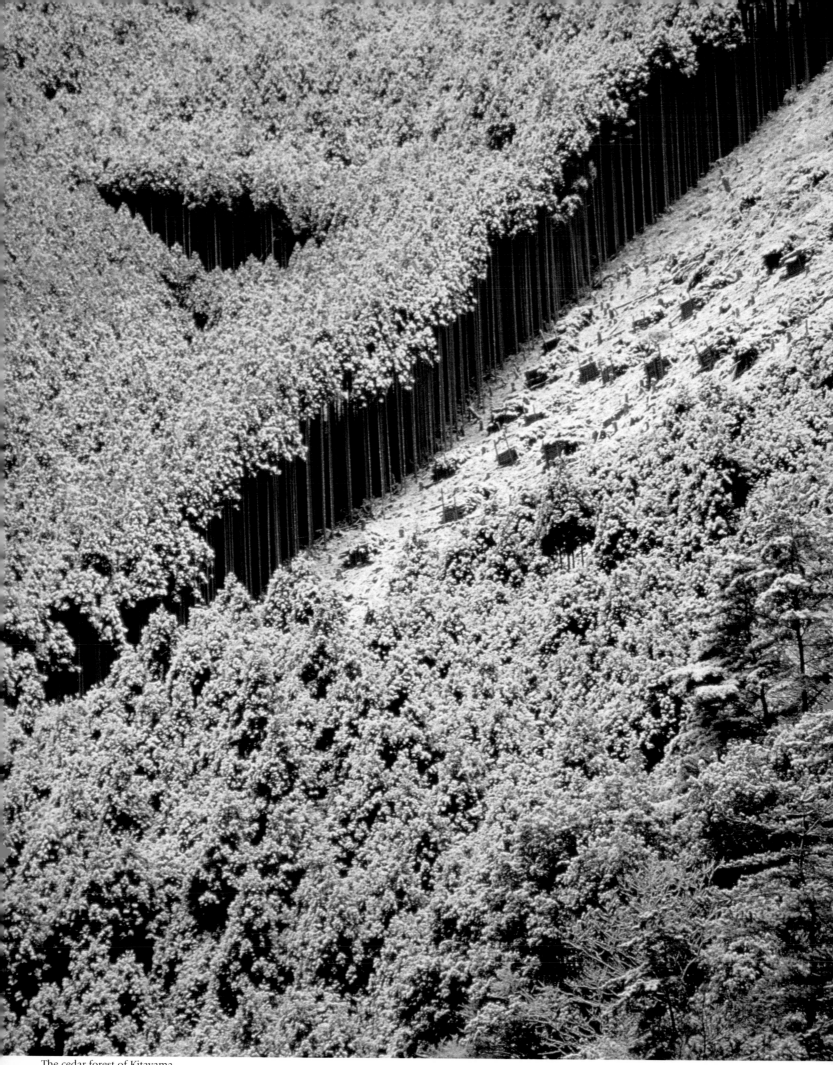

The cedar forest of Kitayama

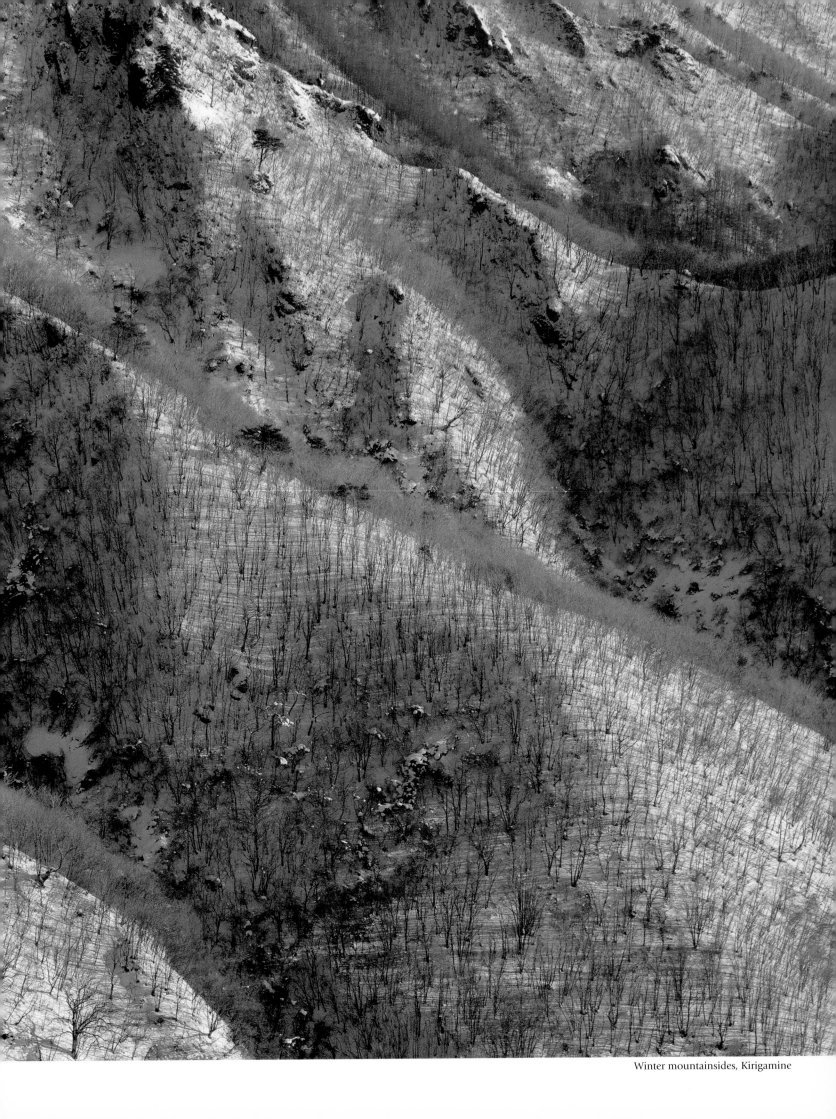

Winter mountainsides, Kirigamine

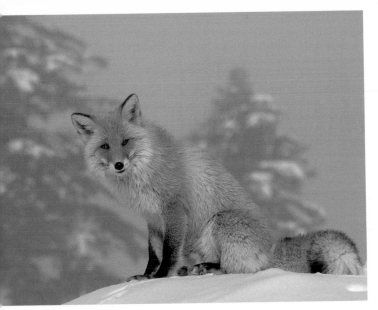

Red fox

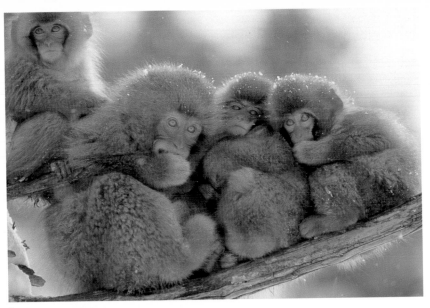

Japanese macaque

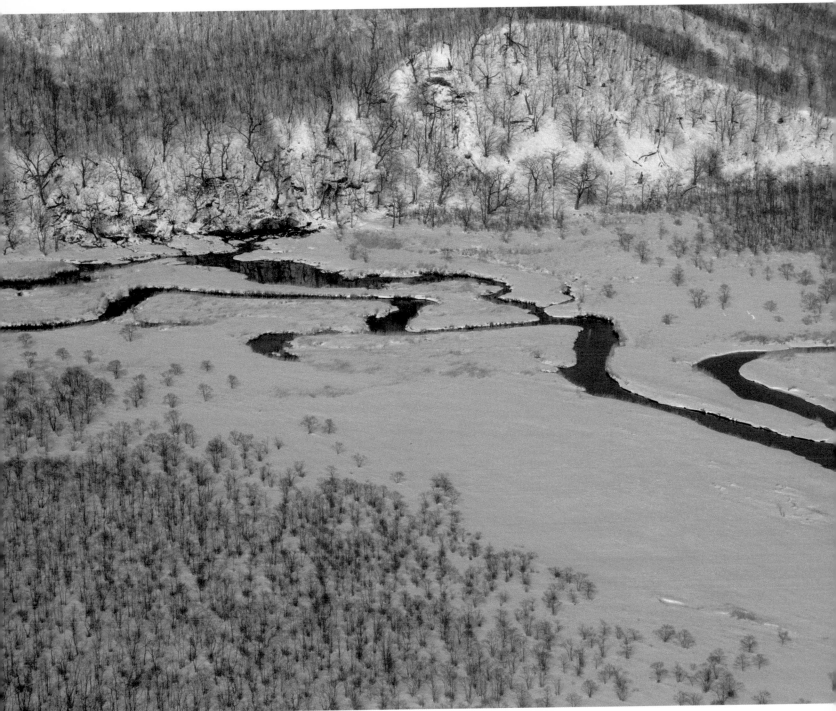

Winter in the Kushiro Wetlands

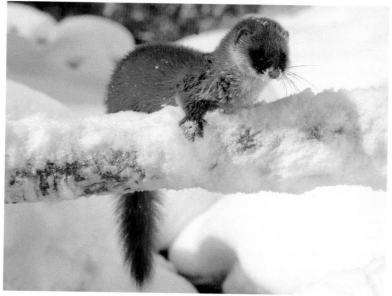
Japanese weasel

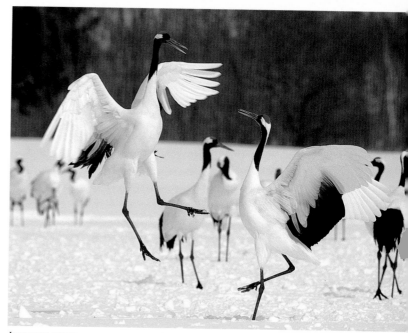
Japanese crane

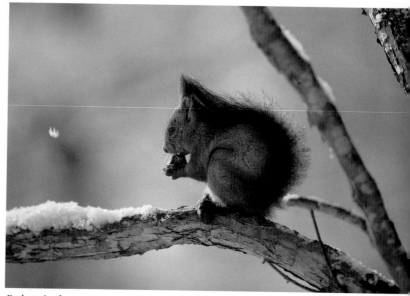
Red squirrel

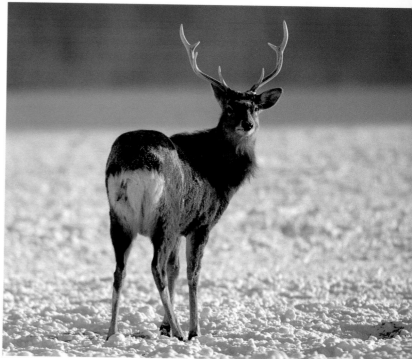
Sika deer

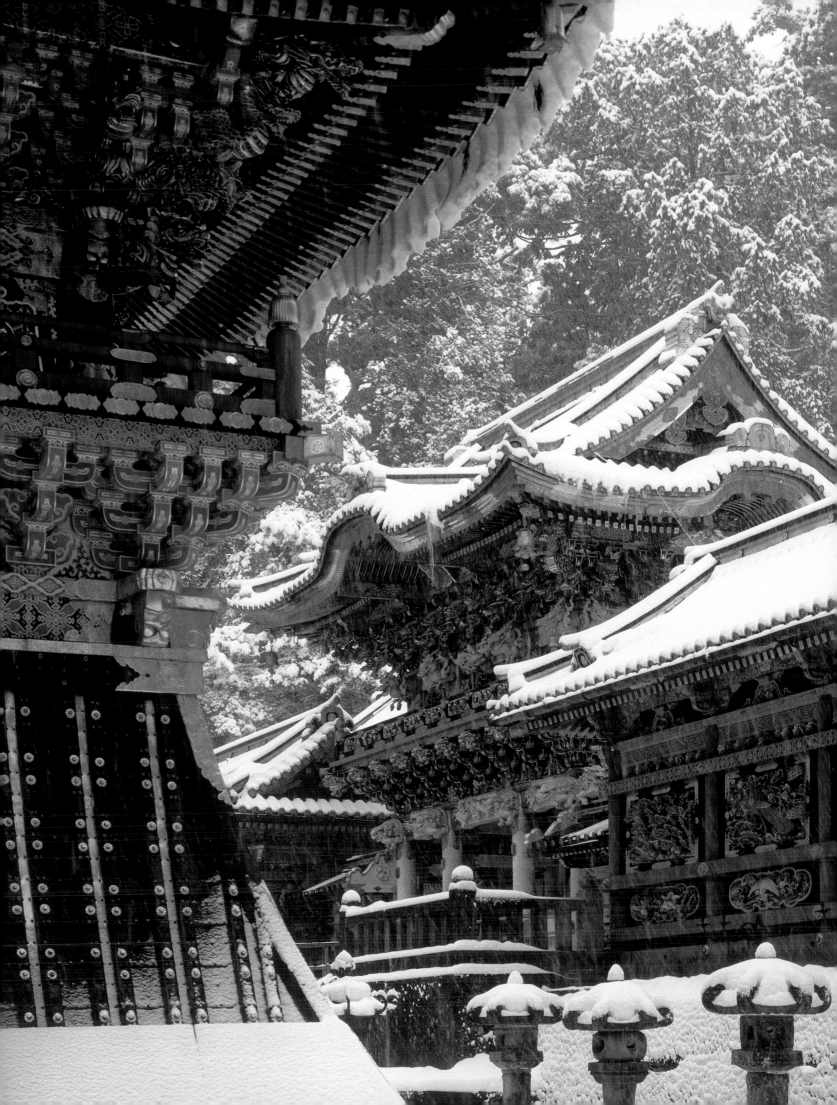

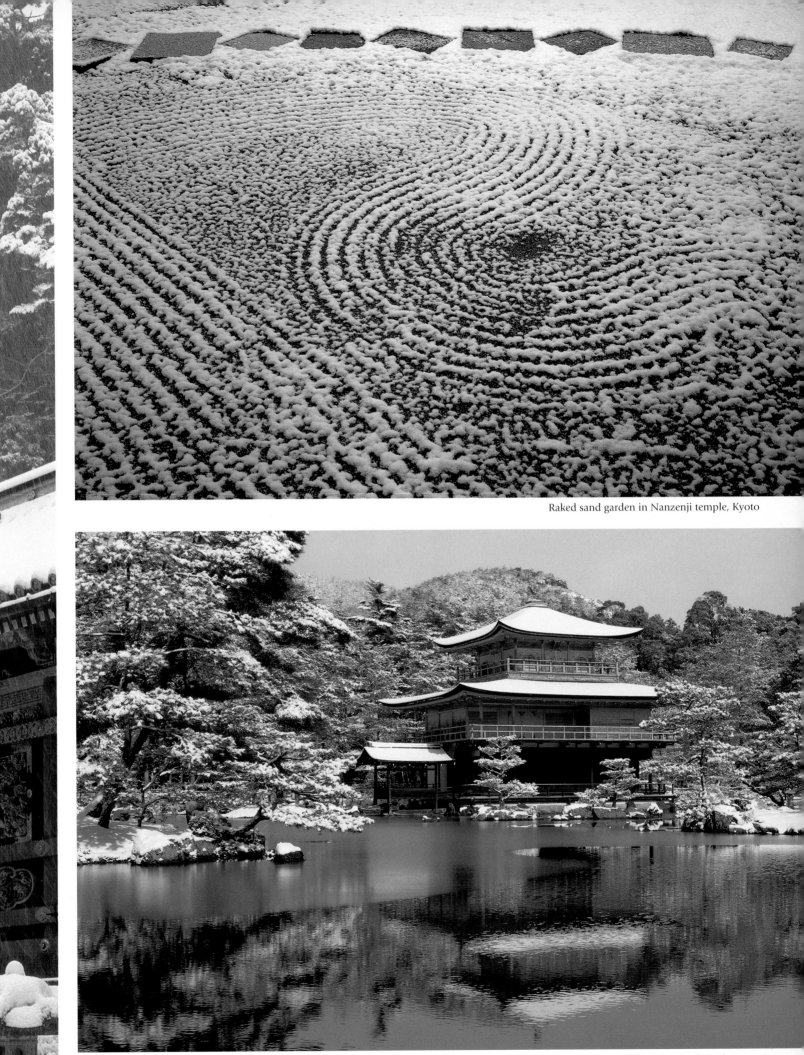

Raked sand garden in Nanzenji temple, Kyoto

Kinkakuji temple in the snow

◀ Nikko shrine in the snow

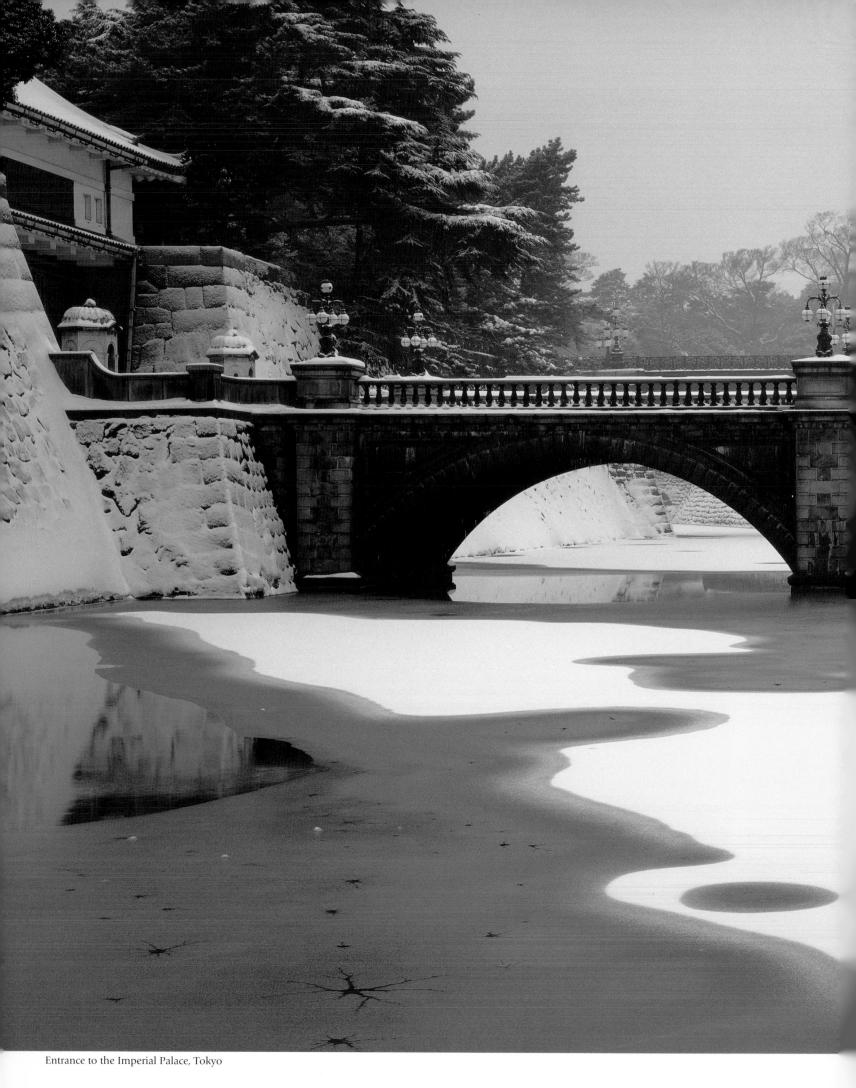

Entrance to the Imperial Palace, Tokyo

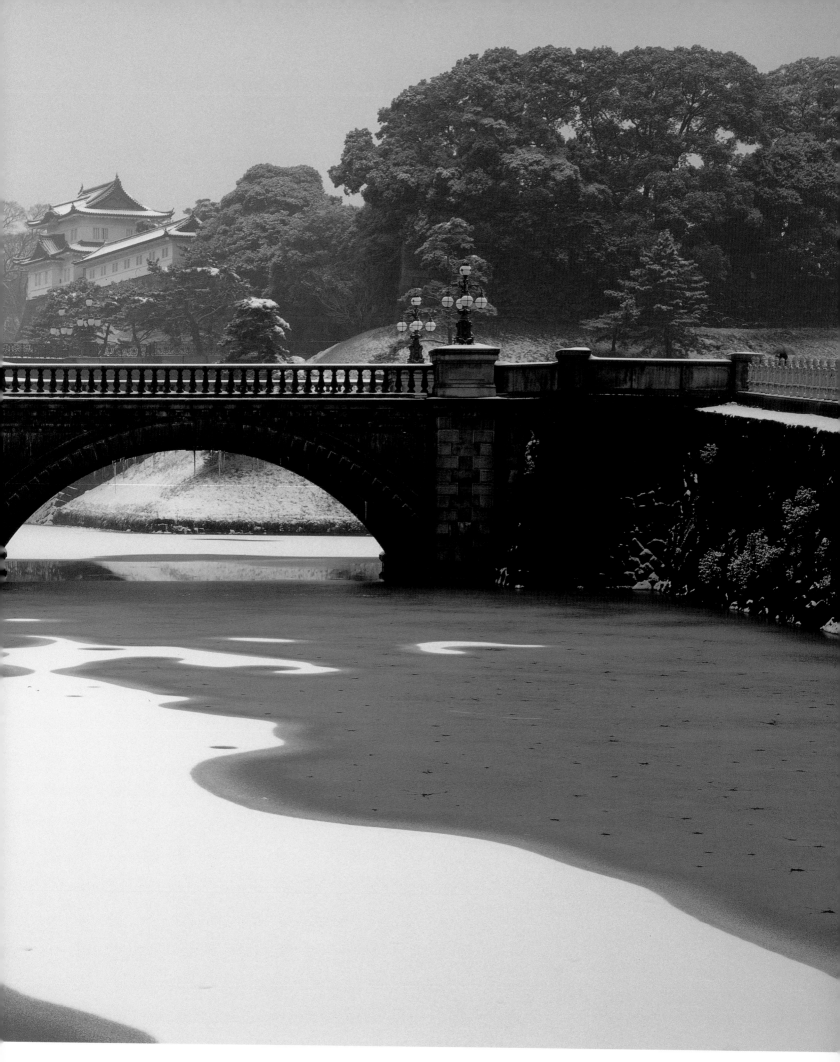

Drifting ice floes off the coast of Hokkaido in the Okhotsk Sea ▶

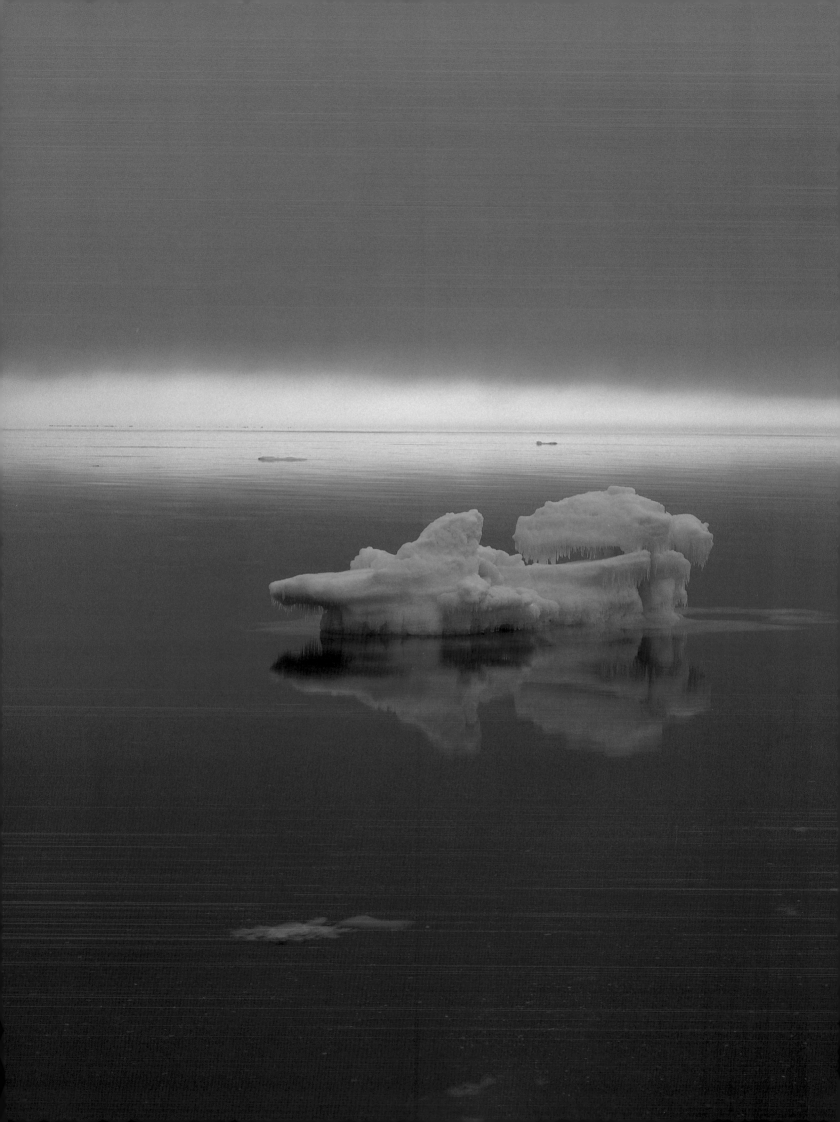

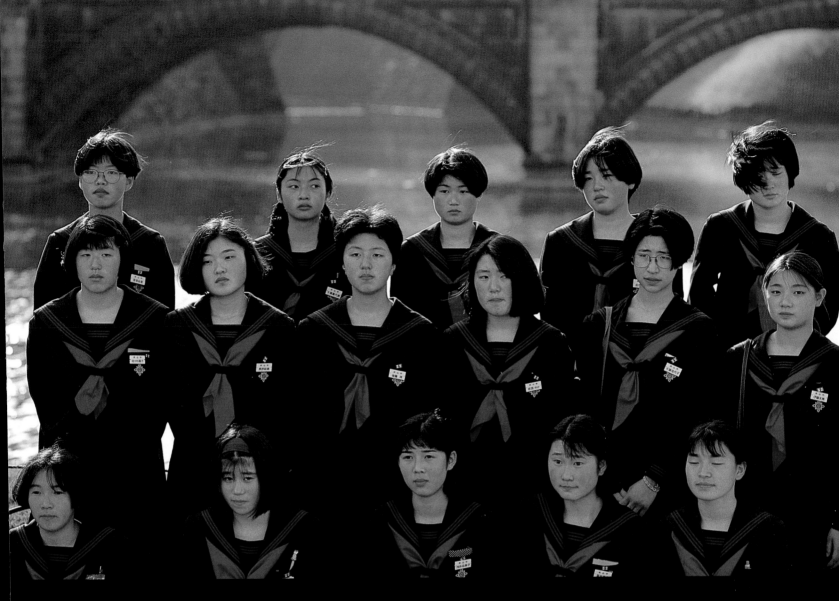

DAILY LIFE AND RITUAL

PART II

NATURE AND THE LIFE CYCLE IN JAPAN

Juliet Carpenter

The Japanese love of nature is legendary. From earliest times, Japanese poetry has sung the beauties of nature: the *Man'yoshu*, a revered treasury of poems from the seventh and eighth centuries, contains not only praise for *ume*, the plum blossoms that were a standard feature of Chinese tradition, but for the particularity of Japanese mountains, trees, rivers, and wildlife as well. A couple of centuries later, by the time of the first imperial poetry anthology (*Kokinshu*), cherry blossoms had become the object of such general admiration that the word *hana*, or flower, was used as a synonym for *sakura*, the cherry blossom.

Today *hanami*, literally "flower-viewing," still refers exclusively to cherry blossom–viewing, and remains a cherished tradition of the springtime. It has its counterpart in the autumn outings known as *momijigari*, or "maple-leaf hunting." Both originated as pastimes of the court aristocracy during the Heian period, spreading to the common people in the Edo period. The delicate cherry blossoms, vulnerable to capricious April winds and rain, generally last no more than a week. They are appreciated both for their beauty and their brevity, serving as a breathtaking reminder of the shortness of life. Samurai of old saw a metaphor for their own values of purity, bravery, and selflessness in the blossoms' quickness to fall while still in their prime.

The emotions the cherry blossoms instill in the Japanese people are unaffected and complex, and they set the pattern for a response to nature that has always been fundamentally lyrical and aesthetic, not utilitarian or aggressive. The beauty of nature requires an emotional and intuitive response. Moon-viewing and snow-viewing are other popular pastimes that were considered propitious occasions for the declaration of love and the composition of tasteful poetry. *Mono no aware* ("the sadness or pity of things"), an important aesthetic ideal from the days of the Heian court, embodies a profound sensitivity to and appreciation of the ephemeral beauty of nature and human life. As formulated by eighteenth-century scholar-critic Motoori Norinaga, it requires the observer to respond empathetically to nature; it emphasizes the beauty of evanescence and suggests the necessity for cultivated individuals to perceive in the constant flux of nature the underlying reality of life.

Nature in Japan is not all as benign as frail cherry blossoms, bright autumn foliage, harvest moons, and silvery snow, of course. The Japanese archipelago

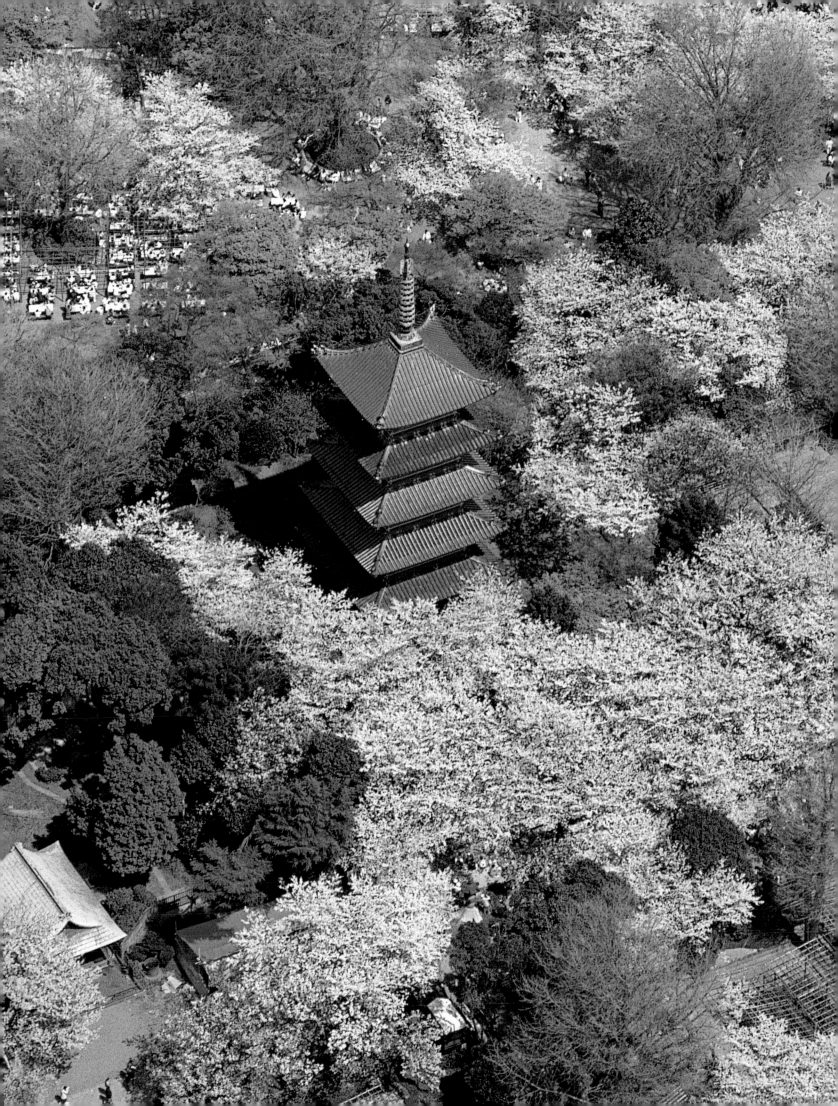

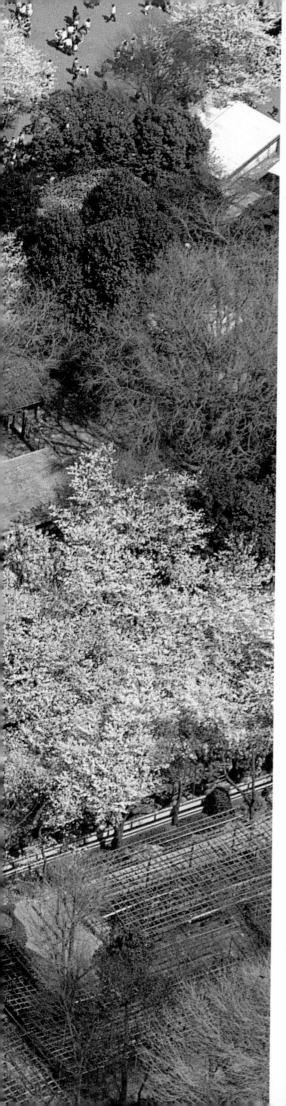

Cherry blossoms at Ueno Park

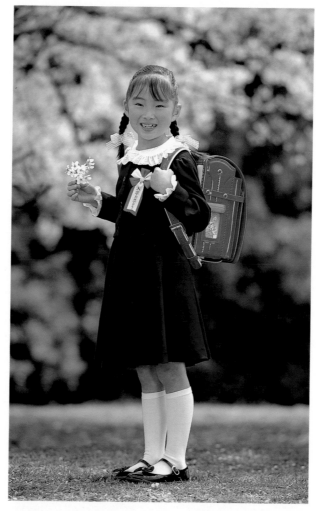

A new student on the day of the school entrance ceremony

Crowds of revelers at cherry-blossom time in Ueno Park

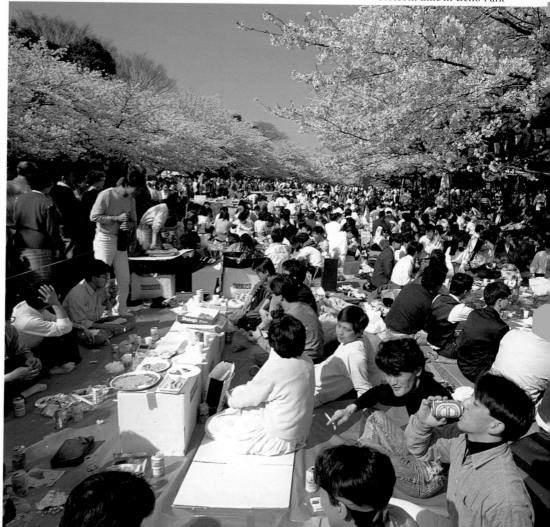

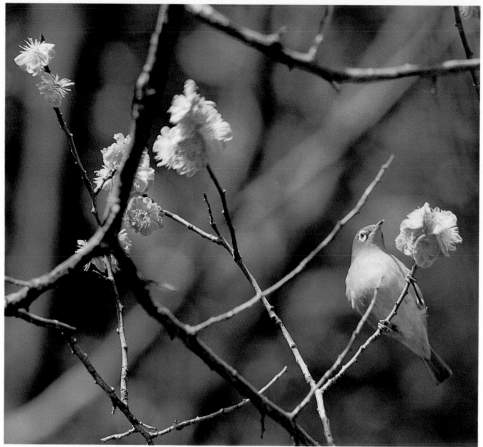

A Japanese white-eye among plum blossoms

is located in the infamous "Pacific Ring of Fire," one of the world's greatest zones of geological activity. Mt. Fuji is only the largest of hundreds of volcanoes, and catastrophic earthquakes on the scale of the January 1995 Kobe disaster have struck with alarming frequency throughout recorded history. Typhoons cost many lives and do hundreds of billions of yen in damages nearly every year, while tidal waves accompanying earthquakes and typhoons also inflict considerable damage on heavily populated coastal areas. Despite these constant threats, however, the Japanese tend to see the forces of nature as intrinsically good, something to be accepted and adapted to rather than fought and conquered. Earthquake and storm have their compensations in a mild climate, abundant scenic charm, and lush vegetation. The paramount blessings of rain, marine products (*umi no sachi*), and animals and plants yielded by the land (*yama no sachi*) are not there "for the taking" but precious gifts of bountiful nature.

It is a curious fact that the Japanese word *shizen*, referring to nature in the abstract, came into general use only in the late nineteenth century to express the Western concept of nature. In the West, Christian doctrine has helped to shape conceptions of nature as either a paradise that man alone corrupts, a wilderness where man is condemned to wage a life-or-death struggle, or a frontier on which man can impose his will. Chinese legend speaks of a mythical "peach-blossom spring" where nature is beneficent and protecting, and man free of the shadow of death. None of these paradigms seems to have a place in the Japanese view of nature, where each and every natural phenomenon is seen as the manifestation of different native *kami*, or Shinto gods. Man is neither the victim, the enemy, nor the lord of nature, but adapter to and collaborator with it. Nature and man are one, inseparable in essence. Nature can

Torii gate in Ueno Park straddles flower-viewing crowds ▶

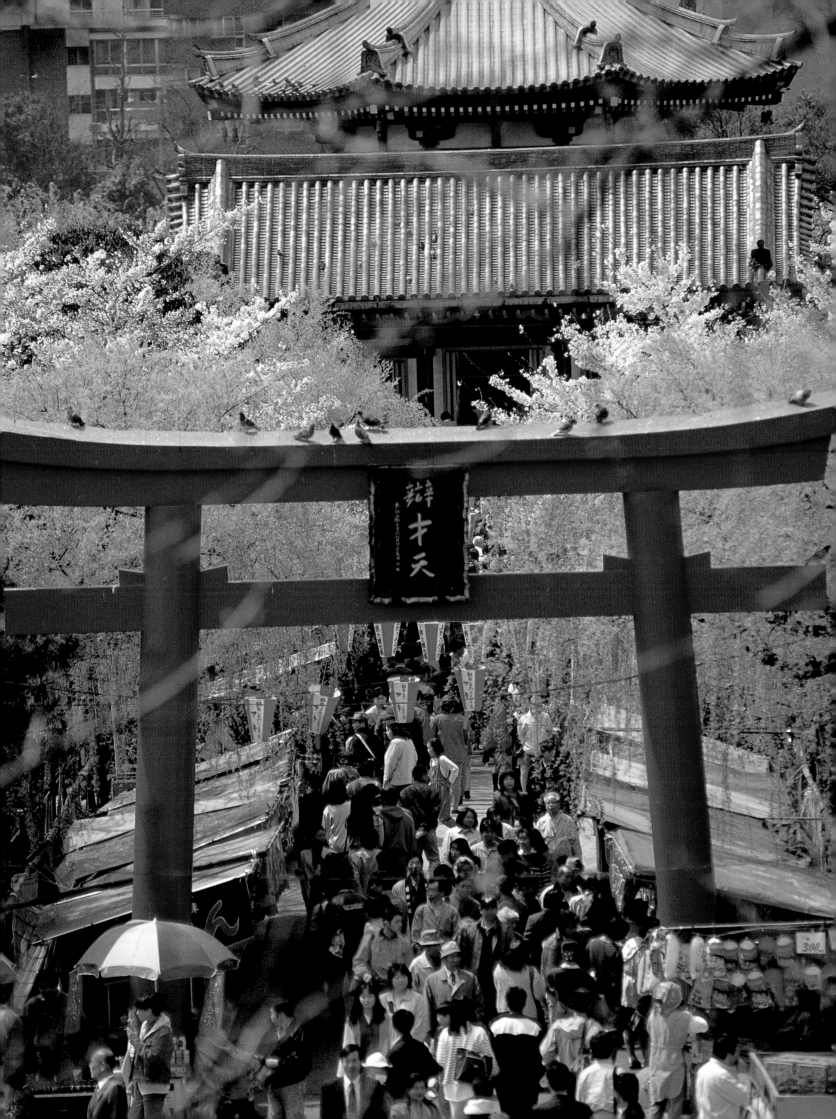

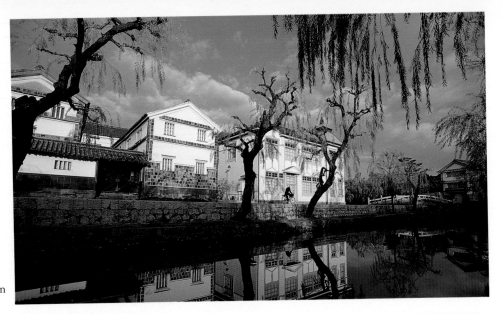

Old warehouses reflected in
a canal in Kurashiki

therefore be neither "owned" nor "subdued," but only entered into and embraced. Death, meanwhile, however terrible, is the natural counterpoint to life, the very thing that imbues it with meaning and beauty.

The Japanese view of nature has always been tied to the rhythm of the seasons. This is true not only because of Japan's long history as an agrarian society but also because of the unparalleled distinctiveness of each of its four seasons. This helps explain why nature is inconceivable in the abstract, and can only be imagined as spring, summer, autumn, or winter. It also explains Japan's profound awareness and appreciation of even minute changes in the seasons and climate.

Sei Shonagon, a late tenth-century court lady and one of Japan's great writers, wrote the following reflections on the seasons in the opening lines of her essays titled *Makura no Soshi* (Pillow Book), almost a thousand years ago. They continue to resonate in the hearts of Japanese people today.

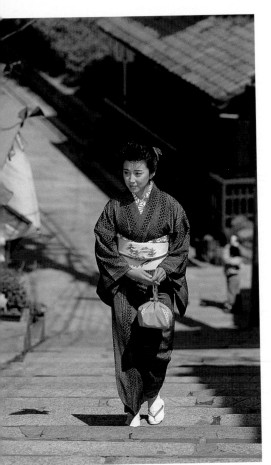

A woman in kimono gracefully mounts
stone steps

In spring, it's the dawn. That moment when the edge of the mountain is gradually whitening, brightening against horizontal strips of purplish cloud.

Night's the thing in summer. When there's a moon, of course. It's good even in the dark, though, when there are fireflies flitting about. It's also good when the rains come.

In autumn, it's the evening. That exquisite instant when, the mountains brought ever so close by the brilliant rays of the setting sun, a flock of crows—in twos, in threes, in fours—intent on the roost, poises for flight . . . and then when the sun has sunk, the sound of the insects, the sound of the wind.

In winter, it's early morning. When it's snowing, of course. The frost white as can be (at any rate, it must be very cold!). Nothing captures the season more perfectly than the hurried lighting up of the fire, and the glowing charcoal borne down some hallway or other.

The specificity of Sei Shonagon's references to the seasons is echoed in the seventeen-syllable haiku, a three-hundred-year-old poetic form that is more popular today than ever. Traditionally, every haiku had to contain a *kigo*, or word evoking a particular season, and most haiku poets today continue to feel that the seasonal element is indispensable. References to weather and the

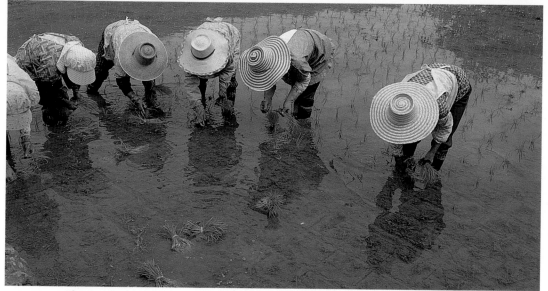

Planting rice

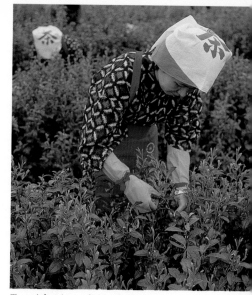

Tea-picker in traditional costume

parade of the seasons are also standard openings in letters—no less in business correspondence than in personal notes. Annual events and festivals, as we shall see, are also intimately connected to the cycle of the seasons, arising in many cases out of ancient agricultural rites.

Even the motifs and designs used in traditional Japanese clothing reflect a love and respect for the seasons, as well as careful observation of the natural world. The flowers of the four seasons are reflected in the colors of ancient robes: willow, iris, pink, sunflower, bush clover, aster, heliotrope, bellflower, gentian, chrysanthemum, saxifrage. Common kimono patterns incorporate not only seasonal flowers and grasses, but water, birds, the moon, breezes, insects, fish. Robes used in performances of the medieval comic drama called Kyogen, still staged today, depict praying mantises, snails, spiders, wasps, and grasshoppers. The range of natural motifs used in Western dress seems extremely limited by comparison.

*

Physically, the Japanese archipelago has a complex configuration. Like the continental United States, Japan extends from just north of the Tropic of Cancer to south of the fiftieth degree of northern latitude. Both countries thus border on the subtropical in the south and the subarctic in the north, with temperate zones in between—but one is a continent, the other a long, narrow archipelago extending from the northeast to the southwest. By contrast, England lies between fifty and sixty degrees of northern latitude; its southern border is further north than the northern borders of both Japan and the United States. Japan's geographical setting near the Eurasian continent to the east and in the monsoon belt, affected by warm and cool oceanic currents, also softens its climate and gives a subtle texture to the passage of the strongly differentiated seasons.

The climate of Japan is characterized above all by diversity. Niigata, in northern Honshu, is famous both for the excellence of its rice and the heaviness of its winter snows—a combination unimaginable anywhere else in the world. The variety of climatic zones in Japan is such that by moving from south to north, one can find rice cultivation in completely different stages simultaneously. Growing seasons are of differing lengths as well. Bees can

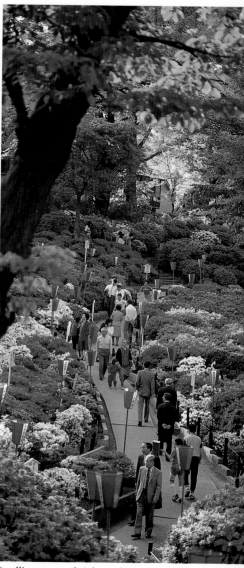

Strolling among bright azaleas

Teatime by hydrangeas in Shibuya, Tokyo ▶

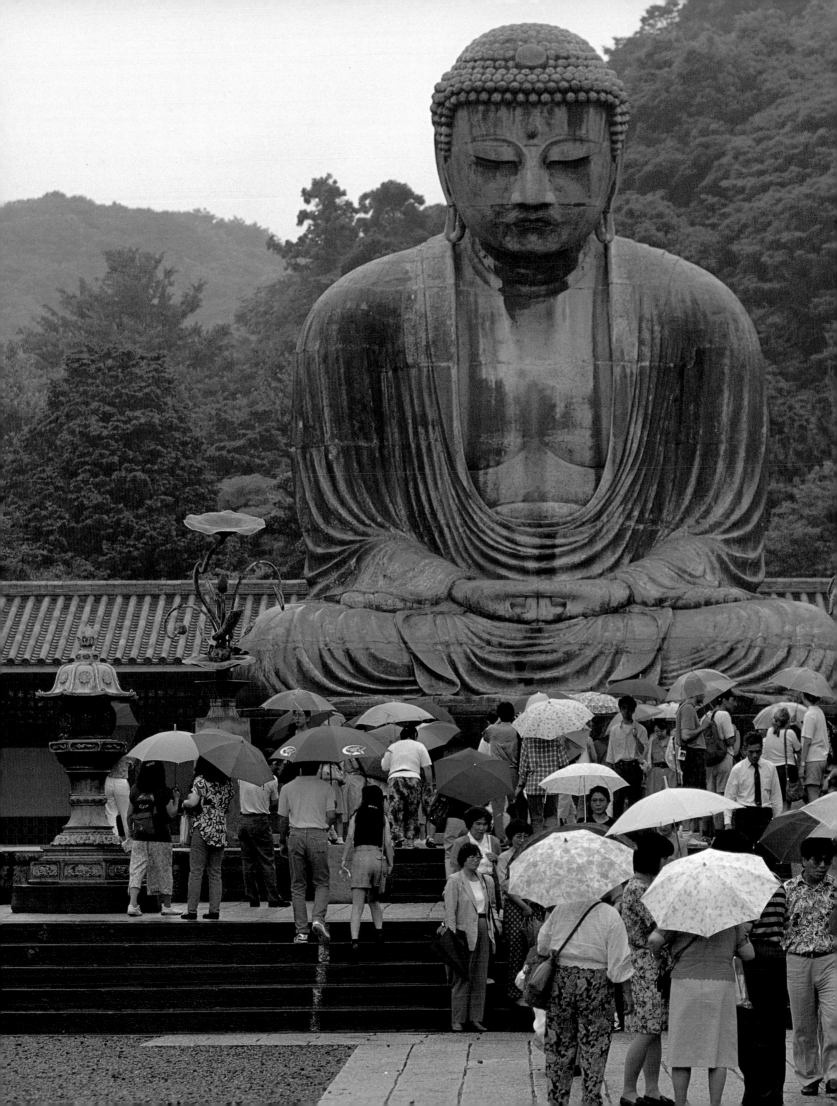

Kamakura's Great Buddha in early summer rain

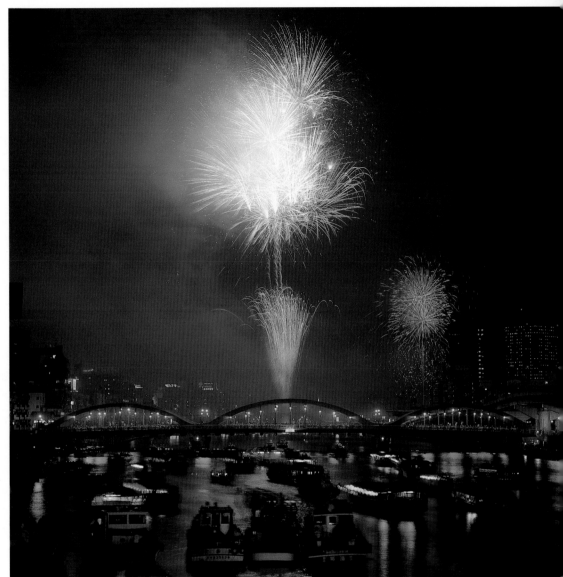

Summer fireworks along
the Sumida River

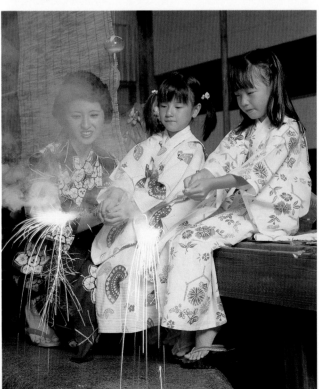

Children in summer kimono
play with sparklers

The *Hozuki Ichi* fair at Tokyo's Asakusa Kannon temple in July, where Chinese lantern plants are featured

find flowers blooming in different parts of the archipelago a full six months of the year. Every spring, weather reports include constant updates on the *sakura-zensen*, or "cherry blossom front," as the area where the cherry blossoms are in full bloom creeps steadily northward.

In early summer, the entire archipelago except for the northernmost island of Hokkaido enters the rainy season, known in Japanese as *baiu*, or "plumblossom rains," the time when flowering plums begin producing fruit. For a month to six weeks, rain falls steadily and oppressively in what amounts essentially to a fifth season of the year. As well as its concentration at this time, rainfall is abundant in Japan throughout the year; King Faisal of Saudi Arabia may unwittingly have summed up its importance to the country when he remarked on a state visit, "In Japan there is rain, and in my country there is oil."

Once the rainy season is over, summer in Japan is steaming hot. The average humidity in Tokyo in the summer is consistently over eighty percent. The intense heat is reminiscent of summer in the tropics, but it does not last as long. As a Japanese proverb has it, "Heat and cold alike last only till the equinox."

Despite the shortness of the summer, traditional Japanese clothing, housing, and lifestyles are geared primarily for that season, suggesting perhaps a Southeast Asian influence. Japanese-style houses are essentially wall-less and open in design, with sliding doors that open directly on veranda and garden.

Midsummer mosaic of pools and bathers ▶

A panoply of umbrellas at Shirahama Beach ▶

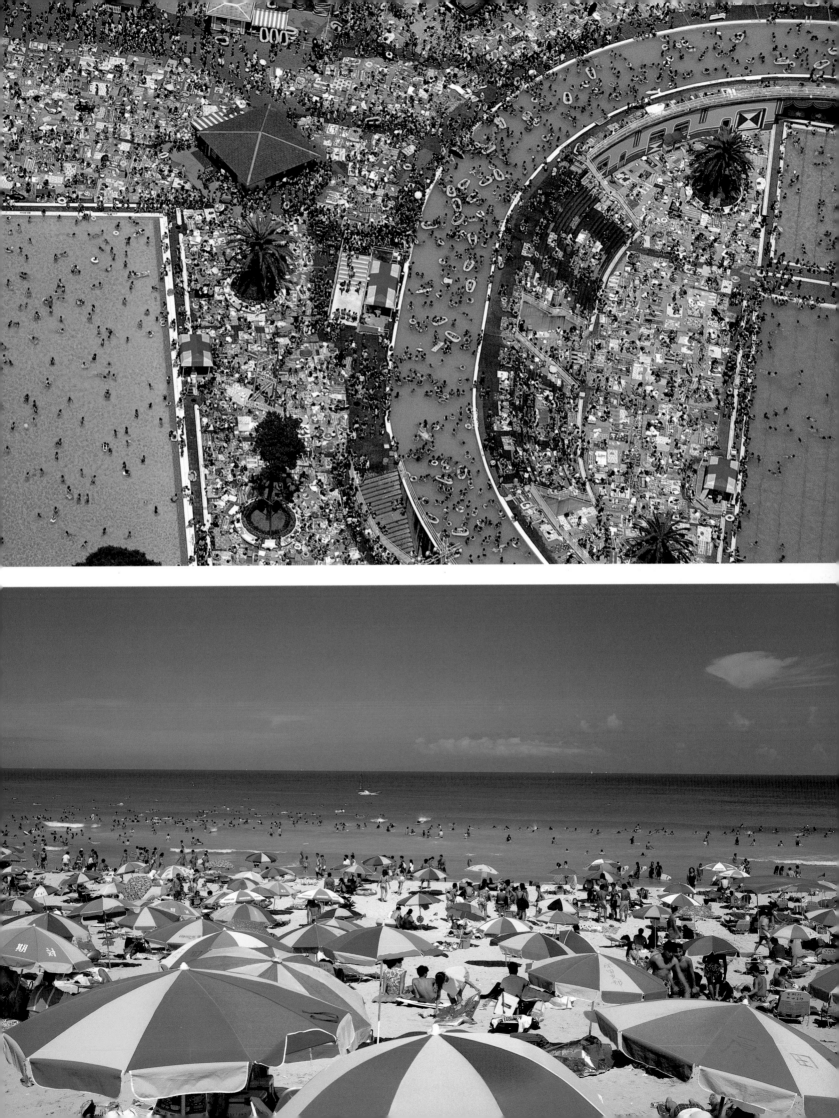

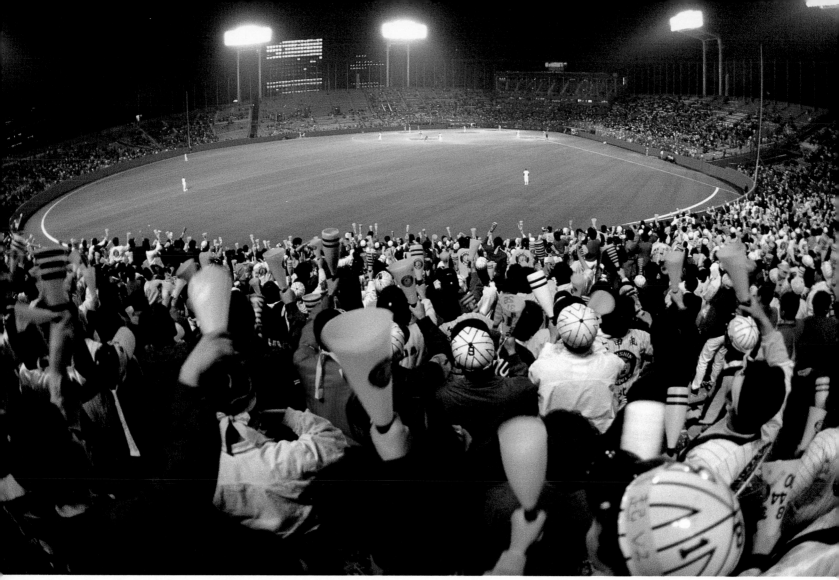

Cheering fans fill a baseball stadium for a night game

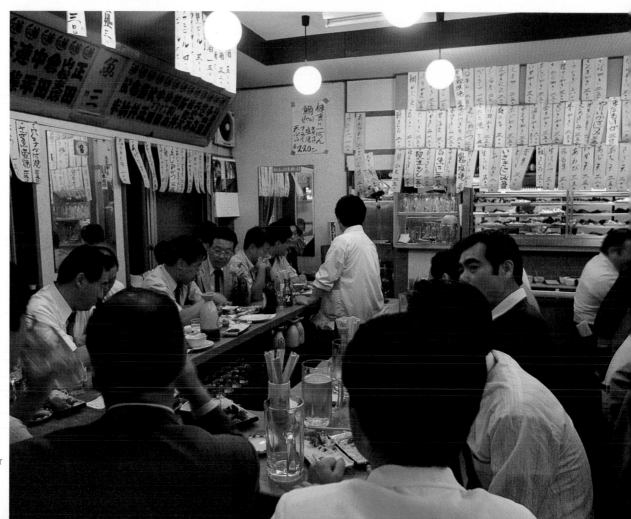

Unwinding after work over grilled chicken and beer

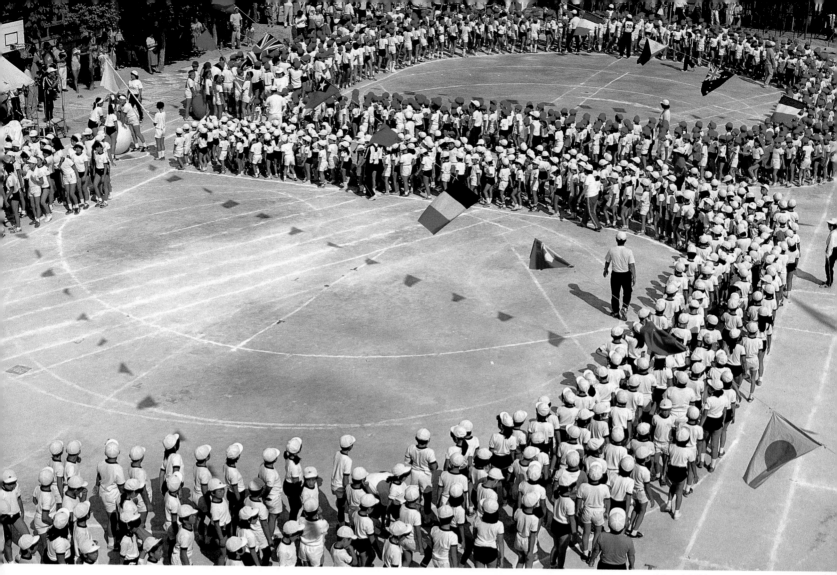

Schoolchildren at a fall field day

Such a house does not insulate or isolate people from nature but rather allows them to remain in touch with it. In a traditional Japanese house, the ideal is not for occupants to be shut in, sealed off from the elements—artificially cool in summer and warm in winter—but for them to continue to interact with nature. The sultriness of summer, in particular, is not always seen as something to flee; a little ingenuity can make it tolerable, or even pleasurable. Summer meals are served in glass dishes and natural containers; wind chimes tinkle in the breeze; hand-held fans bring additional relief, and the garden offers a refreshing view; summer *yukata*, or light cotton kimono, are comfortably open and loose.

Autumn weather in Japan is the most agreeable of the year, with refreshingly low humidity, comfortable temperatures, and pleasant winds. In a reversal of the northward-moving "cherry blossom front" of spring, fall foliage and first frosts make their appearance early in the season in northern Japan, and slowly work their way south. Autumn is associated in the popular mind with reading and culture, with sports, and with the pleasures of good food. Freed from the oppressive heat of summer, people take renewed pleasure in physical exertion, travel, and cultural activities, while restored appetites make the most of fall's harvest bounty. It is a time of peace and fullness. Sporadic typhoons of often devastating destructive power are the season's only drawback.

Winter in Japan has several faces. A range of mountains running down the

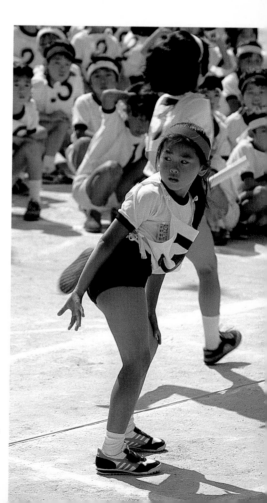

"On your mark, get set . . ."

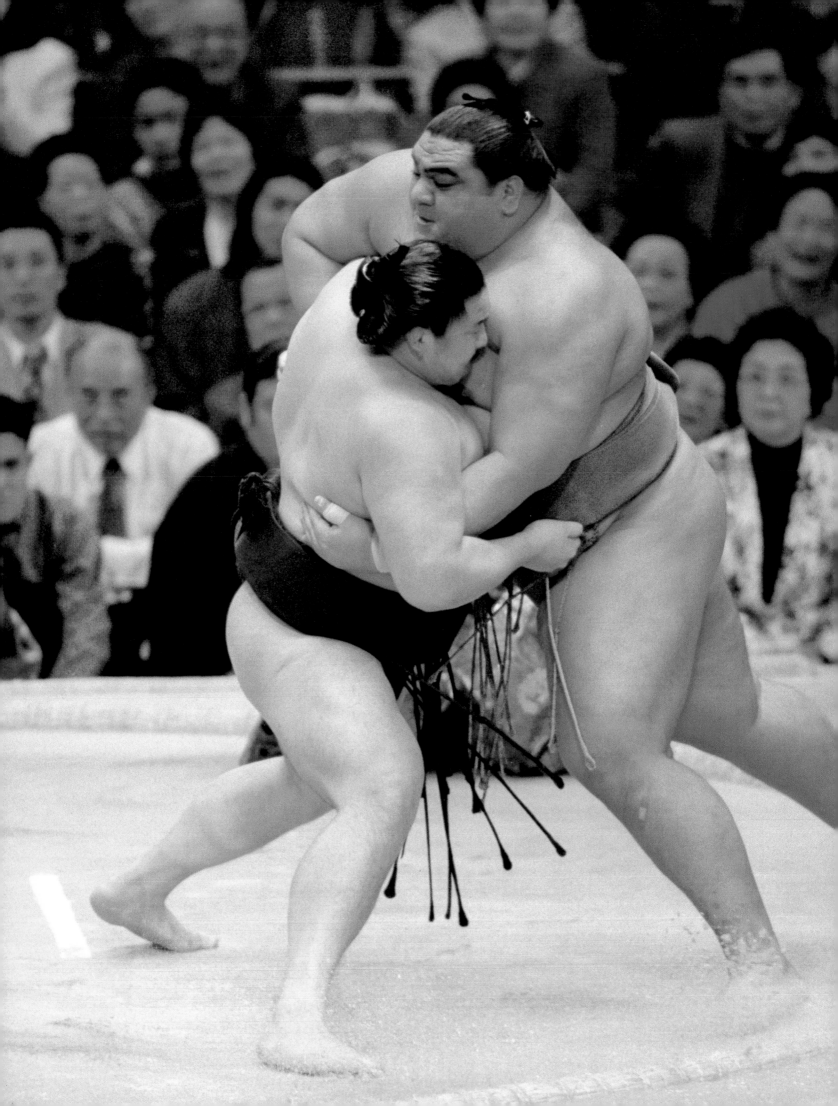

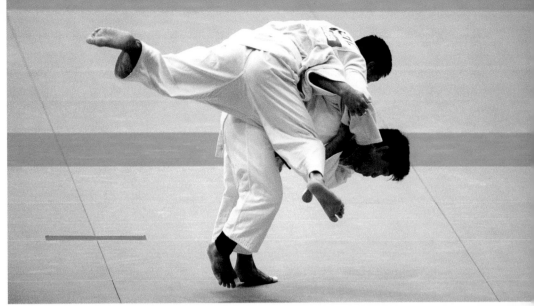
A judo match

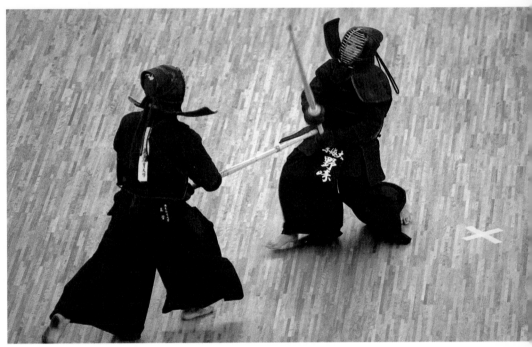
Kendo: the way of the sword

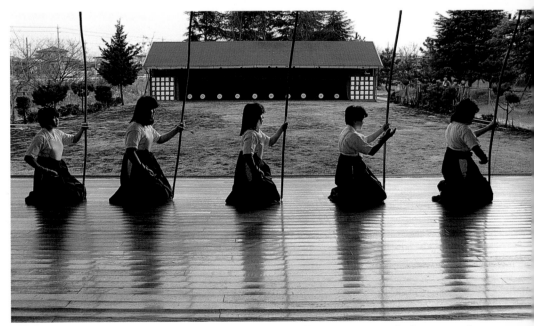
Young women practice Japanese archery

Sumo wrestlers

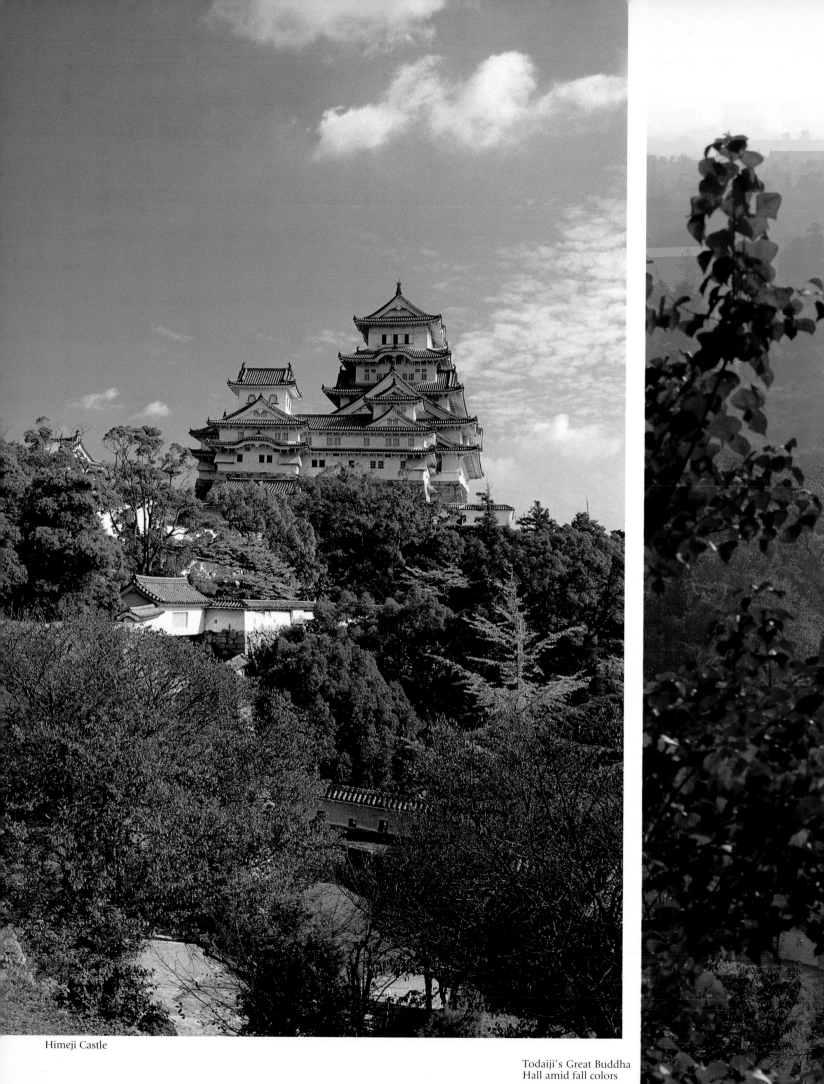

Himeji Castle

Todaiji's Great Buddha
Hall amid fall colors

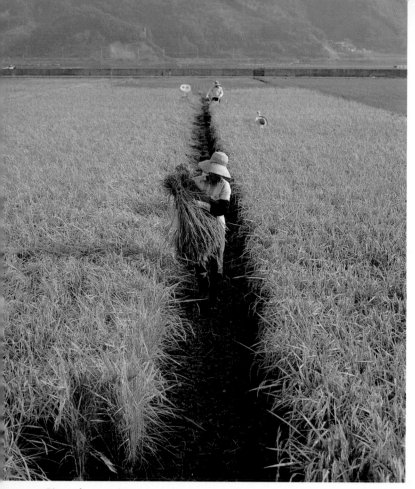

Rice at harvest time

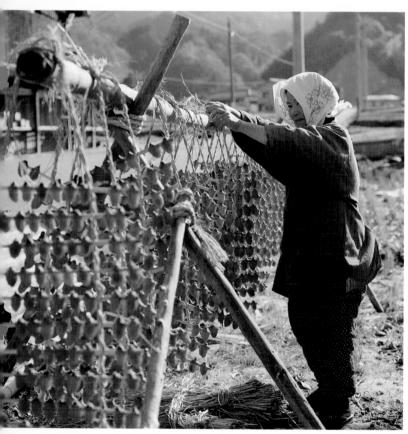

Jewel-like persimmons hanging out to dry

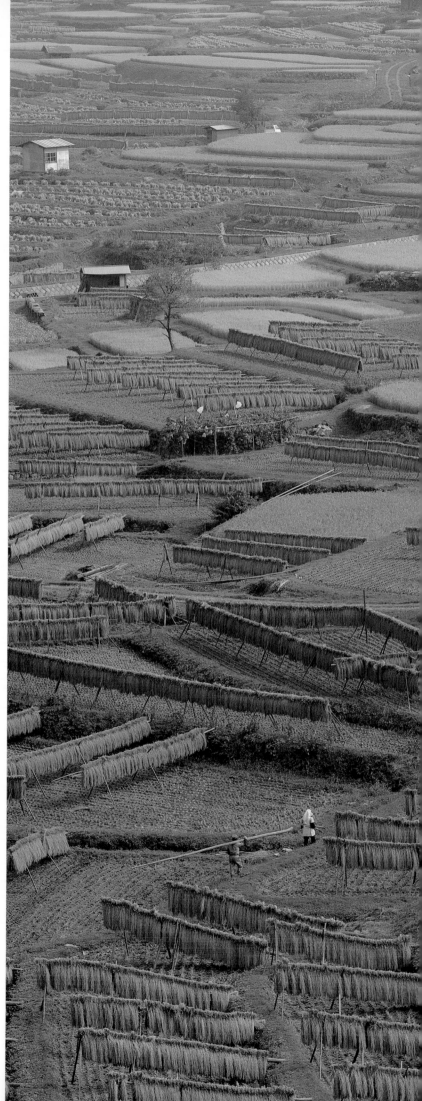

Rice harvest underway
in terraced paddies

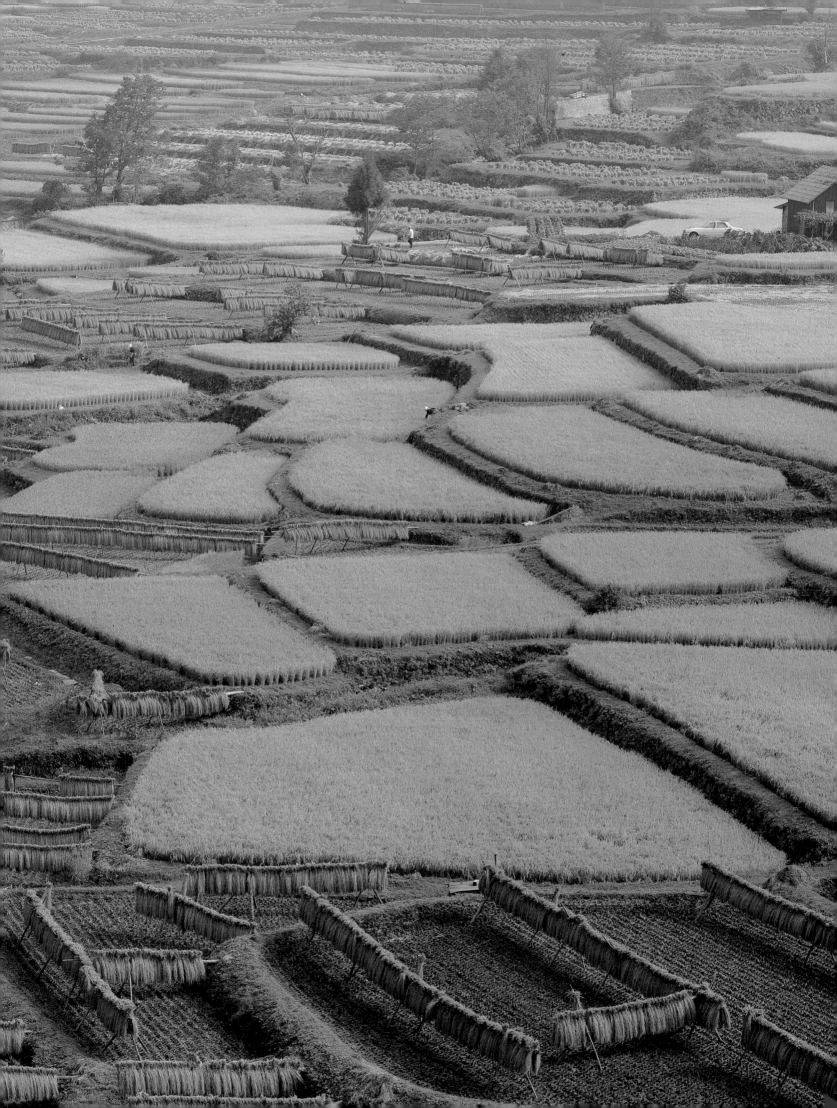

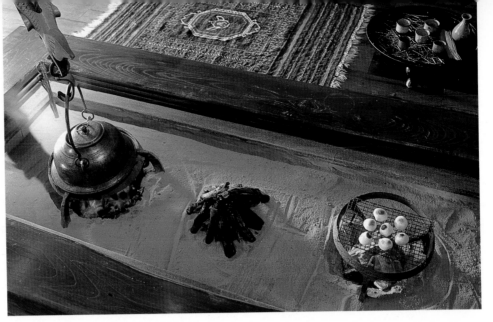

Saké and snacks at
an open hearth

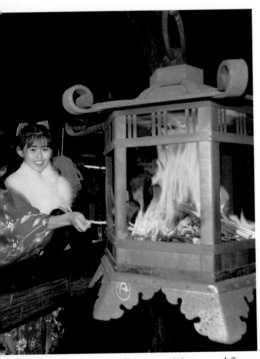

New Year's Eve tradition: receiving sacred fire

Snow country: a cluster of
traditional farmhouses ▶

center of the archipelago like a human backbone divides the country effectively into two. The prevailing winter winds blow from the northwest out of Siberia, gathering warmth and moisture as they cross the ocean, until they hit the northern slopes of the central mountain barrier and dump heavy snowfall along the Japan Sea coastal region. This is the "snow country," or *yukiguni*, immortalized in Kawabata Yasunari's novel of the same name. Accumulations of snow may reach as high as four meters, forcing people to enter and leave their houses by second-story windows. Despite the apparent hardships imposed, in general snow is welcomed as the harbinger of a bumper crop in the year to come.

Meanwhile, on the Pacific Ocean side of central Japan, winter is dramatically different, characterized by colder temperatures, brighter skies, dry, cutting winds, and only occasional snowfall. During winter, snow falls everywhere in Japan except southernmost Okinawa, but in Kyushu it is relatively rare.

Despite the bitter cold of winter in Japan, central heating remains the exception in Japanese homes. Traditional forms of heating include the *hibachi*, a coal brazier; the *kotatsu*, a low, quilt-covered table with a charcoal-burning (nowadays, electric) heating unit underneath, sometimes set over a space in the floor so that the legs may hang down comfortably; and the *irori*, a large square open hearth found mainly in old farmhouses. Kerosene or oil stoves are commonly used nowadays to heat individual rooms. Thick layers of clothing also help ward off the cold, and during a cold spell people often compare notes on how many layers of clothing they have on.

The cycle of the seasons is reflected in the various cycles of life—the daily cycle, with the various household tasks of morning, afternoon, and evening; the individual life cycle, with its milestones from birth to death; and the annual cycle, with patterns of activities established by local, community, and national custom—festive occasions that lend color, rhythm, and meaning to life. The festivals of Japan are a brightly colored patchwork of contrasting fabrics: ancient agricultural rituals and court observances; Shinto rites of purification or thanksgiving; Buddhist festivals of remembrance; historical and mythological events; borrowed Chinese traditions; and, increasingly, imported Western holidays such as Christmas and Valentine's Day. Other practices are political or purely commercial in nature. Despite the increasing secularization

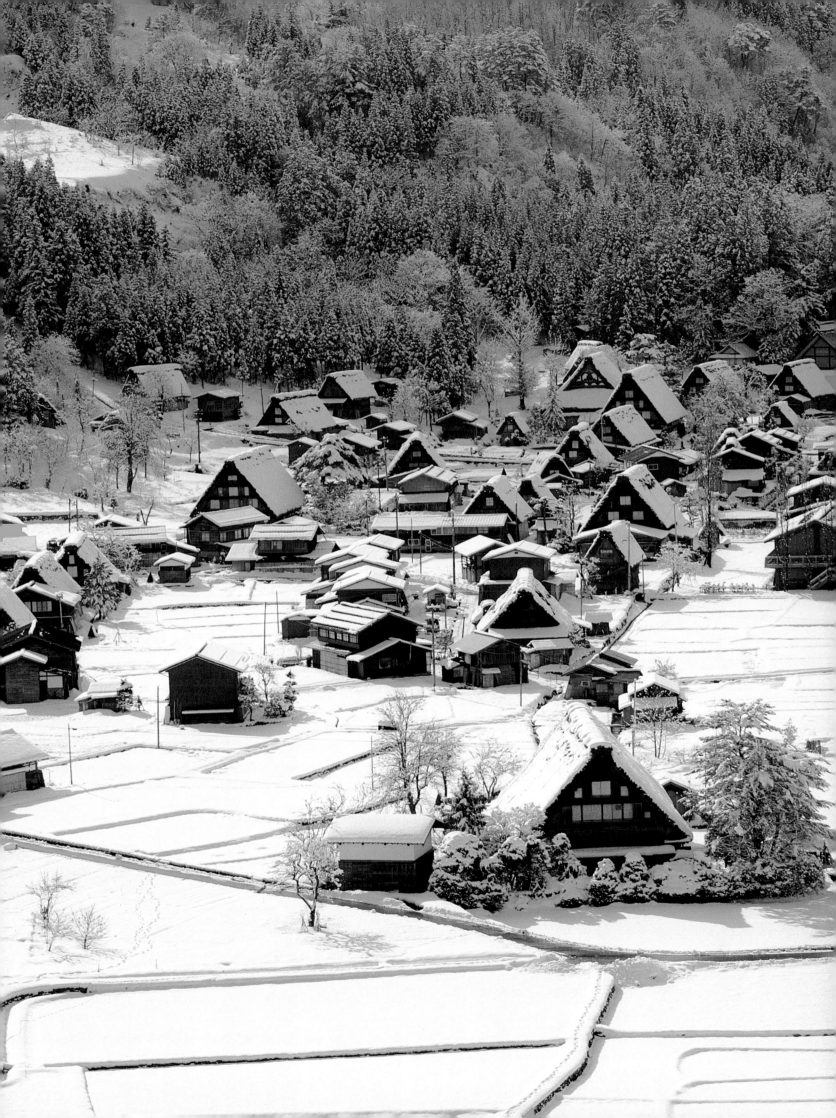

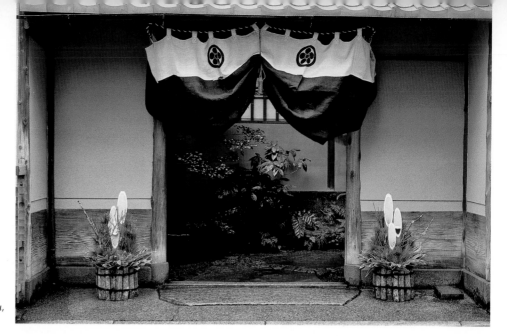

A doorway framed by *kadomatsu*, New Year's decorations

and commercialization of festivals, however, they continue to provide people with a chance to rest from the routine of ordinary life, to reflect on and celebrate their lives and to reconfirm their sense of who they are.

Of all the yearly festivals that mark the cycle of life in Japan, without a doubt the busiest and most important is the New Year. The Japanese word for New Year's, *Shogatsu*, referred originally to the entire month of January but now is limited generally to the first three days of the month, the official time set aside for New Year's festivities. Businesses and government offices close down for at least those three days, and cities become unnaturally quiet as crowds of people desert them to return to their ancestral homes around the country.

In folk tradition, the New Year was a time to welcome the *toshi no kami*, the god of rice-growing and also the deity of the incoming year. The arrival of this *kami* at village houses guaranteed a bountiful rice crop in the year to come, reassuring villagers that life could go on another year without fear of famine. In modern times, *Shogatsu* has inevitably lost some of its spiritual meaning, becoming for many just a chance for an extended overseas vacation—or an extended snooze. Still, for most Japanese it remains a time of quiet reflection and renewal as they return to their birthplaces to reinforce family and community ties and to visit the Shinto shrines of the ancient tutelary deities.

The old year finishes in a whirlwind of activity, with preparations building steadily in intensity. All debts and obligations must be settled before the start of the new year. The house must be ceremonially cleaned inside and out, a practice known as *susuharai*, or "soot-sweeping." The dictum that cleanliness is next to godliness is nowhere taken more literally or acted upon more faithfully than in Japan, where cleanliness is a keystone of cultural and religious identity. The Shinto ethos of purity, simplicity, and cleanliness has influenced all aspects of Japanese life, and so it is only appropriate that the year should begin with a sparkling clean house.

The house must also be decorated for the season. Generally, the doorway or entrance is hung with a sacred rope made of rice straw, the *shimenawa*, which is decorated with straw pendants and symbolic paper offerings to the household *kami*. The front of the house may also be decorated with a pair of *kadomatsu*, small pine trees arranged with straw and lengths of bamboo, while

Visitors at a shrine in sumptuous New Year attire ▶

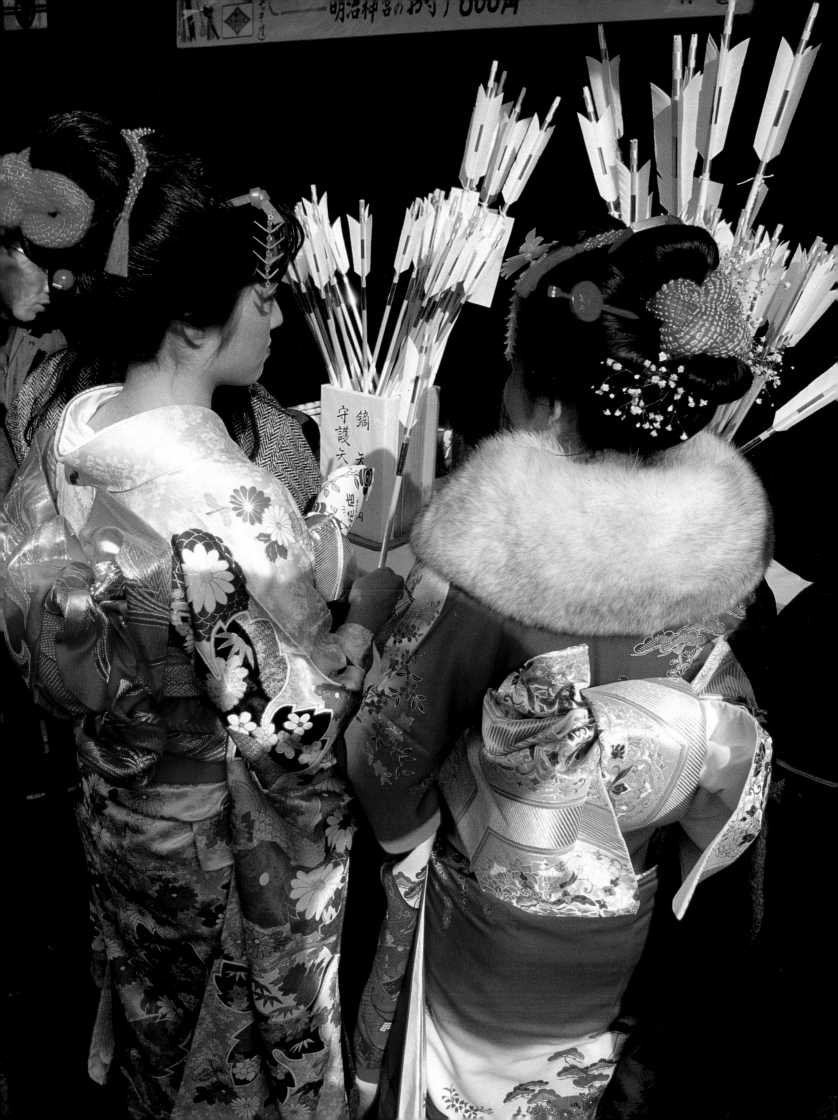

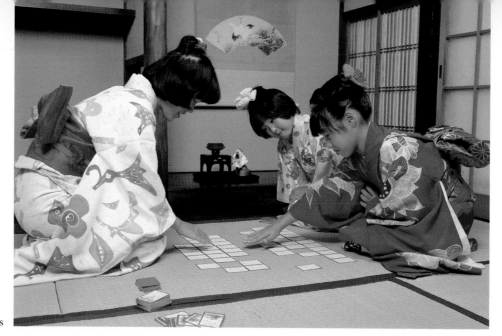

Playing New Year's card games

Kites soar in a blue sky

Pagoda of Yasaka Shrine on
a snowy night in Kyoto ▶

inside sacred offerings of saké and *kagamimochi*, cakes of pounded rice, are indispensable. Decorations of ferns, bitter oranges, and lobster are displayed to signify long life, prosperity, and good fortune.

On New Year's morning, family members greet one another with cries of *"Akemashite omedeto gozaimasu"* ("Congratulations on the New Year"), and sit down for a feast of traditional dishes in the presence of the god of the new year. Special New Year's foods include *zoni*, a soup containing rice cakes boiled with vegetables and fish or meat; *toso*, or spiced saké; and an array of colorful boxed delicacies known as *sechi-ryori*, traditionally prepared with great labor by the women of the household, to be served cold during the holidays. Ready-made versions are available in the department stores for those unwilling or unable to make their own, but many housewives still take pride in cooking the many dishes themselves. *Mikan*, or mandarin oranges, are another popular New Year's food.

On New Year's morning or later in the day (or perhaps a day or two after, if the weather is unfavorable), the family will dress up in their best kimonos or other clothes to visit the community shrine for *hatsu-mode*—literally, the "first visit" of the New Year. Others may visit a temple or a major shrine located somewhat farther from home. Wherever they choose to go, they will toss coins into an offertory box, and pray for health, prosperity, and good fortune in the coming year. For a nominal sum, they may also draw a slip of paper telling their fortune for the new year, and tie it to a tree or shrub in hopes that favorable predictions will come true and unfavorable ones be nullified. Each year, over eighty million Japanese—fully two-thirds of the population of the entire country—are said to visit a temple or shrine during the first three days of the new year.

In the predawn hours of *Ganjitsu* ("original day"), the first day of the new year, many people climb a mountain or nearby hill to pay their respects to the sun as it rises (*hatsu-hinode*, "first sunrise"). Other traditional New Year's activities are a badmintonlike game called *hanetsuki*, kite-flying, top-spinning, and *karuta*, a type of card game. People continue to enjoy these old-fashioned pursuits to some extent, although the lavishly decorative battledores used in the game of *hanetsuki*, featuring colorful depictions in silk collage of the faces of beautiful women or kabuki actors, are nowadays far more likely to serve as

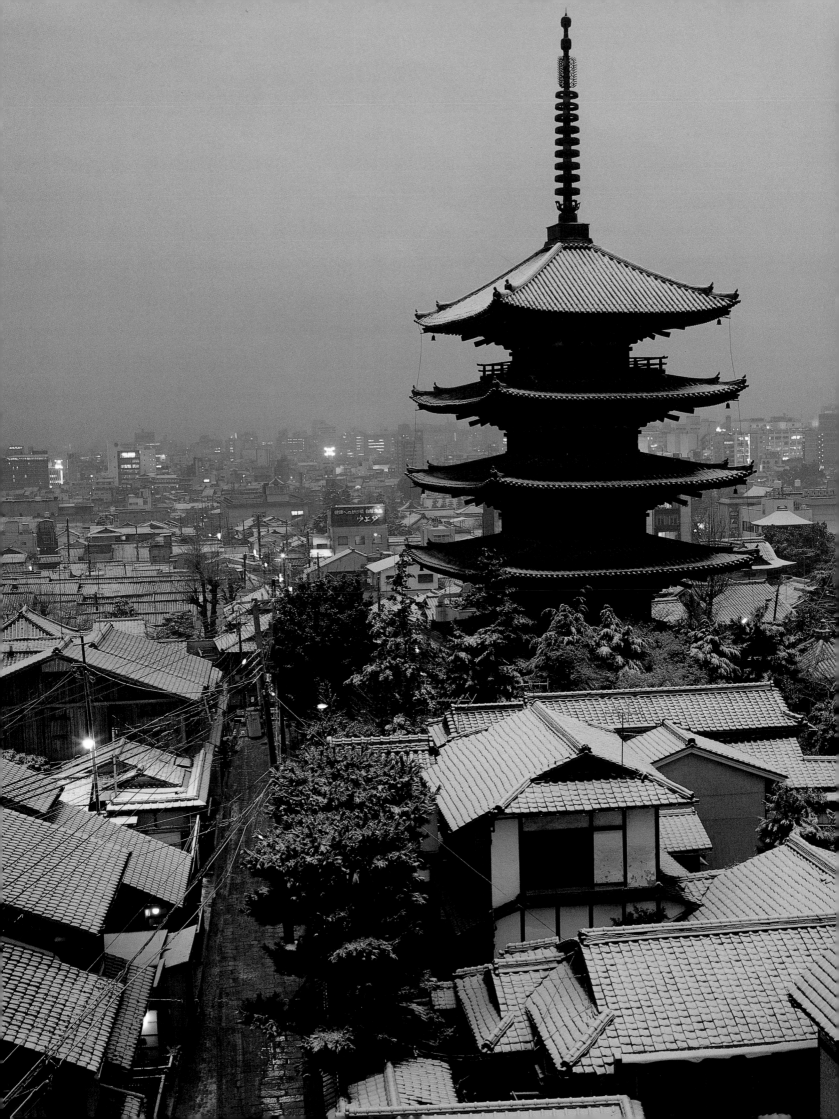

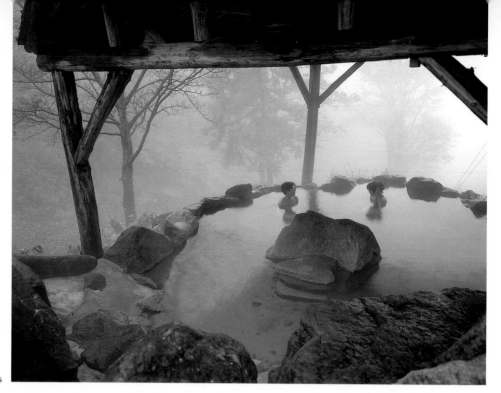

A hot spring in the backwoods

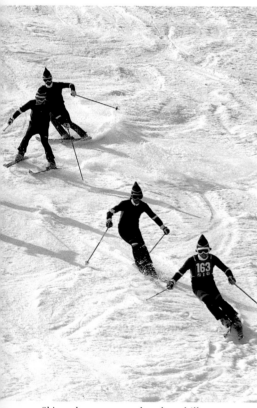

Skiers chase one another downhill

room ornaments than they are to be brandished in street competition.

A round of visits to and from friends and relatives is another traditional part of the first few days of the new year. Children have a special reason to look forward to such visits, for they receive gifts of *otoshidama*—originally bits of leftover rice cake, now money tucked inside a small, brightly decorated envelope. It is a lucrative deal for the children: a well-connected ten-year-old is likely to receive the equivalent of anywhere from a couple of hundred to a thousand dollars.

Nengajo, or New Year's postcards, are another well-established part of the holidays that provide an expression of goodwill and a once-yearly point of contact for more far-flung relationships. The average household receives just under a hundred cards; before mid-January, over five billion are exchanged nationwide, seventy percent of them actually arriving on New Year's Day in a spectacular burst of postal efficiency. Many are beautifully handcrafted, usually portraying the Chinese zodiac animal of the year or some other auspicious design along with a greeting that may be formal and perfunctory or informal and newsy.

Special events continue to unfold during the first two weeks of the new year. January 2 is the day for getting traditional arts such as calligraphy or tea ceremony off to a fresh start. The Budokan, the mammoth hall for the martial arts in Tokyo, is the site each year for a calligraphy competition in which some seven thousand children and adults participate in shifts. On January 7, a rice gruel containing seven purifying herbs is traditionally served. New Year's decorations are taken down on the fourteenth and burned the next day in a community bonfire known as *don-don-yaki*, bringing the season to its close.

Young people of the appropriate age who may not have chosen to wear kimono at New Year's will have another chance on January 15, Coming of Age Day (*Seijin no Hi*), a national holiday to honor all those who have turned or will turn twenty during the calendar year. For many young women, the day is a much-anticipated chance to wear and be photographed in *furisode*, an elaborate formal long-sleeved kimono worn only by unmarried women—nowadays

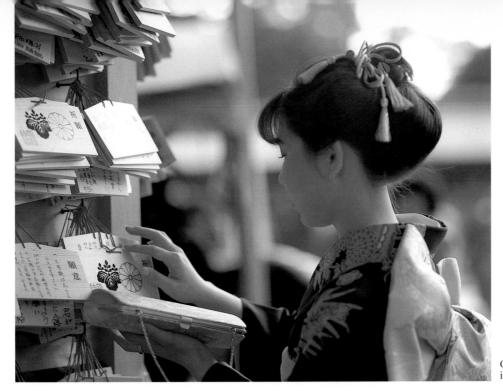

Coming of Age Day: a young woman
in formal kimono visits a temple

usually rented for the occasion because of its prohibitive cost. Centuries ago, families held private coming-of-age ceremonies for their adolescent boys and girls, who thereafter adopted hairstyles, clothing, and sometimes names symbolic of their new status as adults. Until about the twelfth century, girls coming of age would also apply black stain to their teeth—an adult cosmetic practice that spread later to men as well, and eventually was confined to married women, before fading away at the end of the nineteenth century under Western influence. The onset of menstruation in young girls is honored in the family circle by a special congratulatory dish of rice and red beans at dinner.

Nowadays, on Coming of Age Day local governments across Japan hold receptions for twenty-year-olds, featuring speeches by the mayor and other heads of local government, to congratulate the fledgling adults and remind them of their civic responsibilities. College students whose classes have just resumed after winter holidays often make a hasty trip back home to participate in the event. After the ceremony, it is customary for participants to exercise an adult prerogative by going out drinking together. In Kyoto, young women mark the event by participating in *toshiya*, or ceremonial archery, at the Sanjusangendo temple.

Ceremonial occasions marking major milestones of life such as the passage to adulthood are referred to in Japanese as *kankon sosai* (literally "coming of age, weddings, funerals, and ancestor worship"). Generally, the rites of passage celebrated at these and others of life's important junctures are of three kinds: private occasions, national holidays, and community festivals. Private celebrations such as birthday parties involve only immediate family members. Family-oriented national holidays celebrating various stages in the life cycle are scattered throughout the year, including Coming of Age Day, Respect for the Aged Day, and the like. Such occasions not only honor the individual but, even more importantly, allow the larger social group—the family or the nation as a whole—to reestablish bonds and reaffirm common values. Shrine festivals (*matsuri*) belong to the third kind of celebration, operating on a level midway between the other two—that of the local community.

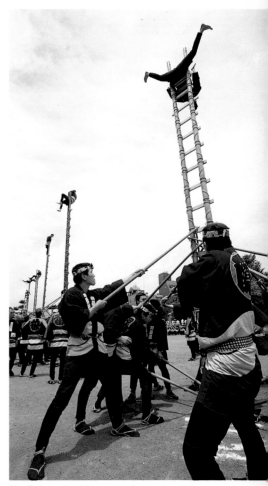

Firefighters in Edo-era garb put on a New
Year's show

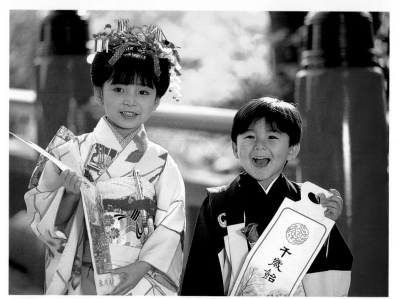

All dressed up for "Seven-five-three" festival day

Matsuri serve not only as a means of communion with the divine but also as a way to establish rapport and create a sense of unity among members of local communities. (This, incidentally, reflects the root meaning of the word "religion": to bind together.) Together, customs and celebrations relating to the life cycle of the individual reveal how Japanese people see themselves in relation to their family, their community, their native history and culture, and their gods.

Omiyamairi ("visiting the shrine") is the custom of taking a newborn infant to the local Shinto shrine, dressed in an elaborate kimono. Depending on the locality, this is done when the child is from twenty to one hundred days old. The infant is usually brought by its mother and father, accompanied by the paternal grandmother. This private ceremony has much the same social function as infant baptism in the West, serving to introduce the child to the guardian spirits of the community and to the community itself.

Every November, the *Shichi-go-san* ("Seven-five-three") festival is held to mark children's attainment of those ages, which are considered significant developmental milestones. Since age was calculated differently before the modern era, children honored on this day during the Edo period, when it first became popular, were actually six, four, and two. It was long customary to reckon age by calendar years, so a child was one year old at birth and another year old each January 1. New Year's functioned as a kind of mass birthday for the nation; a child born December 31 was technically two years old the following day. Since World War II, however, age has been calculated as it is in the West, and many families celebrate children's birthdays with gala parties, complete with a decorated cake and candles.

For the *Shichi-go-san* festival, boys of five and girls of three and seven are dressed up photogenically in traditional or Western-style finery, often at considerable expense, and taken to a nearby shrine to receive a blessing. A special service may be held to give thanks and pray for continued health and growth. The visit is made on November 15, or on any auspicious day around that time when the weather is good. The children usually take away with them pink-and-white *chitose-ame*, "thousand-year candy," and lucky arrows.

There are gender-specific festive occasions for boys and girls as well. The Doll Festival (*Hina Matsuri*), an age-old festival for little girls, is celebrated on March 3. Because it takes place around the time when the peach blossoms

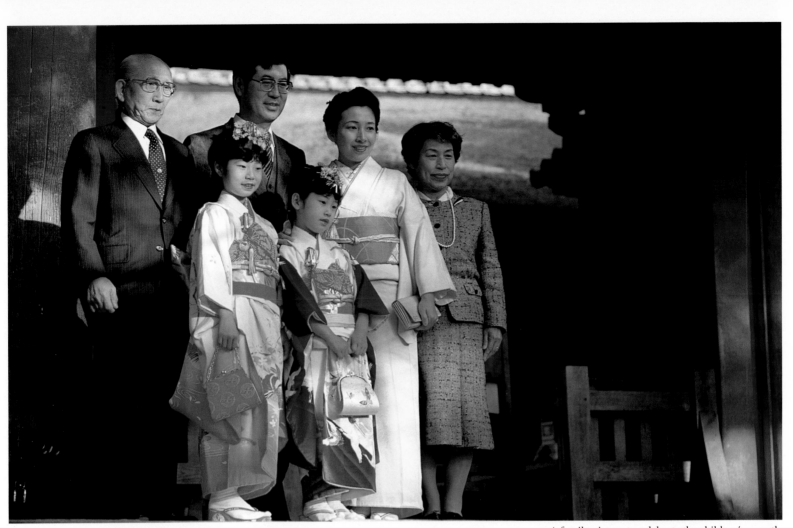

A family picture to celebrate the children's growth

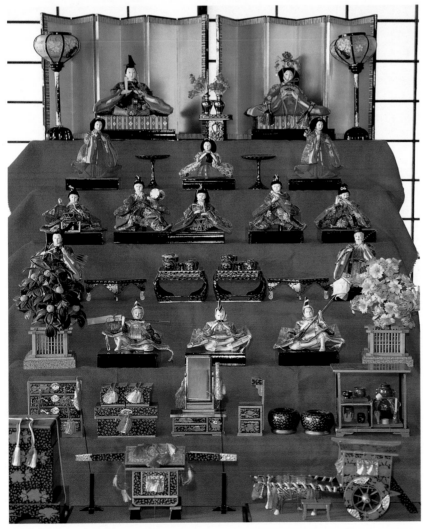

Elegant court dolls for the March Doll Festival

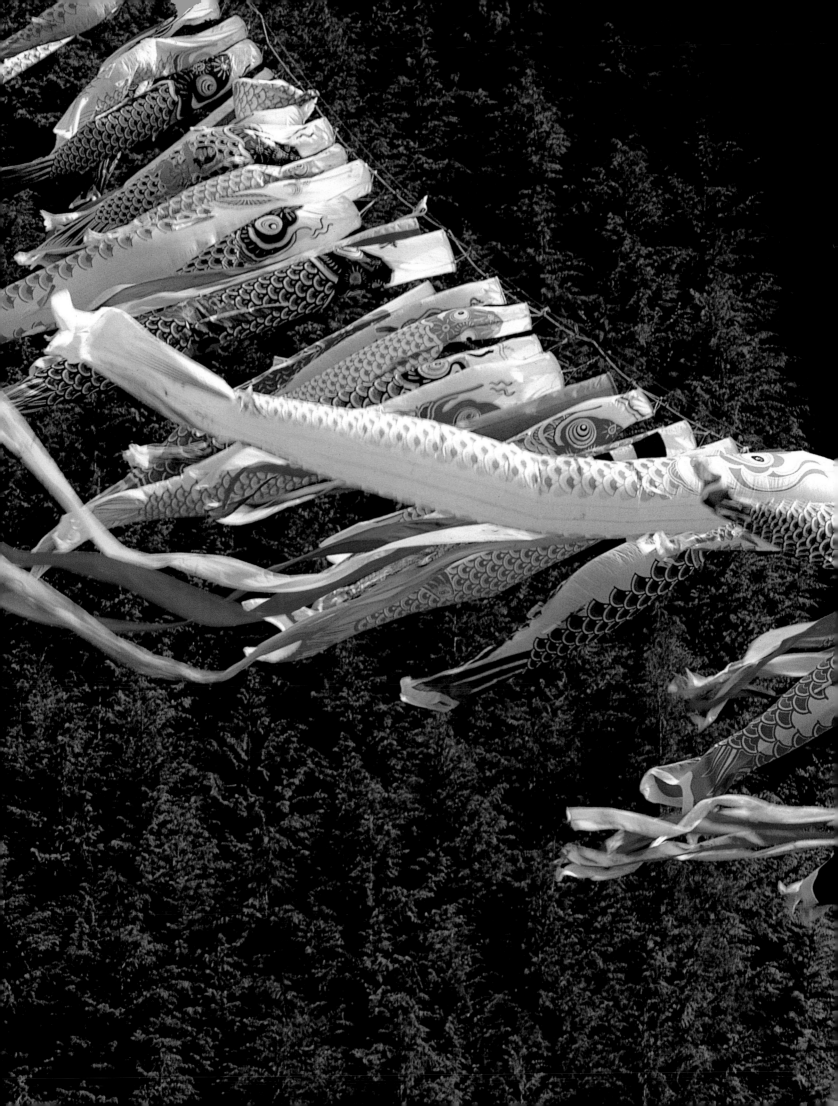

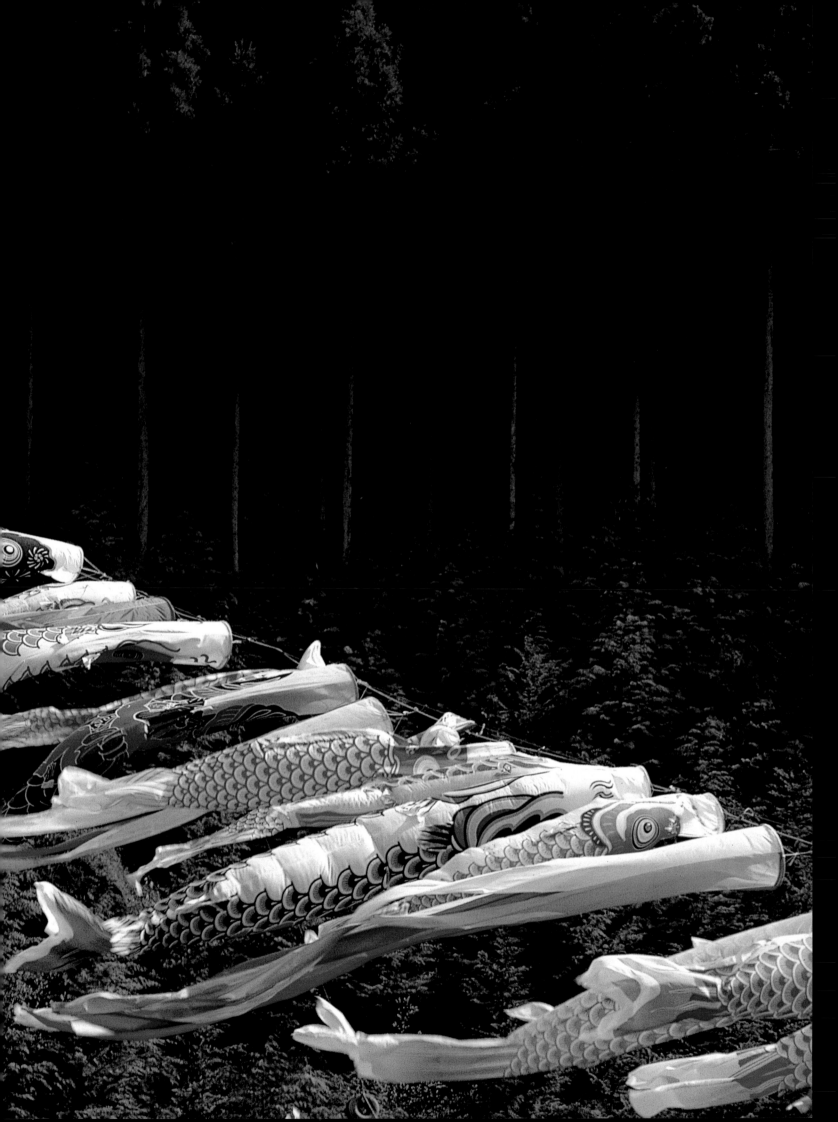

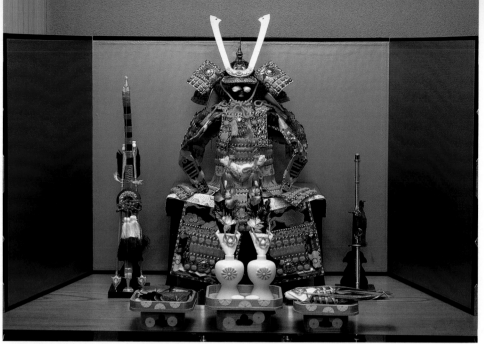

Miniature arms and armor displayed for Children's Day

come out, it is also known as the Peach Festival (*Momo no Sekku*). In its present form, the festival dates from the nineteenth century, replacing earlier rites of fertility or purification. Tiered platforms covered in red felt are set up in the home to display a group of dolls featuring emperor, empress, court ladies, and musicians, all in the elaborate court dress of ancient times. The dolls are often a gift from the mother's family on the little girl's first Doll Festival. Tea parties are held in front of the dolls at which the little girl plays hostess, eating diamond-shaped rice cakes (*hishimochi*) with her friends, sipping sweet, nonalcoholic saké, and singing a traditional song. The dolls are exhibited for about one week, but no longer; tradition has it that they must be packed up and put away expeditiously, or else the girls of the house will marry late.

The corresponding festival for boys is held on May 5. During Japan's postwar occupation, the name of the festival was changed from *Tango no Sekku* (Boys' Day) to *Kodomo no Hi*, or Children's Day—but it goes right on being celebrated in the usual way, for boys only. All over the country, families with sons fly bright carp streamers (*koinobori*) outside the house, the banners—brilliant against a blue sky—appearing to "swim" in the May breezes. The carp is a symbol of strength, persistence, bravery, and success; in Chinese fable, it alone had the stamina to swim up over rapids and waterfalls and at last become a dragon. Inside the house, miniature warrior dolls with armor, weapons, and helmets are displayed. Special foods associated with this holiday are *chimaki* (rice cakes wrapped in bamboo leaves) and *kashiwa mochi* (rice cakes filled with sweet bean paste and wrapped in oak leaves). There is also an ancient association with irises, because the Japanese word for that flower, *shobu*, is a homonym for words meaning "victory" and "reverence for martial arts." Some families sprinkle iris leaves or roots in the bath water on this day.

Momo no Sekku and *Tango no Sekku* are two of the five secular *sekku* still celebrated in Japan, traditional seasonal festivals of ancient Chinese origin. During the Edo period, the following *sekku* were established to mark seasonal turning points, each symbolized by a flower or plant: January 7, the Seven Herb Festival; March 3, the Doll or Peach Festival; May 5, Boys' Day or the

◄ Carp banners galore for Children's Day

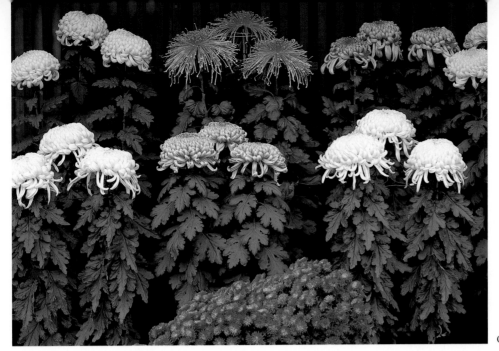
Chrysanthemums at a latticed door

Iris Festival (now Children's Day); July 7, the Star Festival; and September 9, the Chrysanthemum Festival. After the two children's *sekku* in spring, the most popular of these celebrations is the romantic Star Festival, or *Tanabata*.

As its name indicates, the Star Festival derives from a Chinese folk tale about two stars—Vega, the Weaver Girl, and Altair, the Cowherd—who fell in love and then neglected their duties, spending all their time together. As punishment, the lovers were condemned to live on opposite sides of the River of Heaven (the Milky Way), able to cross over and meet only once a year, on the seventh night of the seventh month. If the sky is overcast that night, they must sadly forego their one rendezvous of the year. The Star Festival was introduced to Japan around the beginning of the eighth century and has enjoyed enduring popularity. Today, it has been incorporated into the school calendar and is celebrated in nursery and primary schools across the country. Small tots, older children, and young people write poems or wishes on long strips of colored paper and attach them to sweeping sprays of bamboo, along with colorful paper cutouts of eggplants, cucumbers, watermelons, and the like. The bamboo is displayed somewhere outside the school or house. Traditionally, anyone who wrote out a poem dedicated to the truly "star-crossed" lovers Vega and Altair—using ink supposedly made from morning dew—would come to excel in calligraphy. Decorations are disposed of in the evening, often by being thrown into a stream or pond.

Some cities, such as Sendai and Hiratsuka (in northern and central Honshu, respectively) attract millions of tourists with lavish celebrations of the Star Festival, which they hold on August 7, following the old lunar calendar. Floats in those parades may cost as much as $15,000 apiece; most are traditional, while others feature the latest Disney or television characters. In Akita, *Tanabata* is celebrated with a nighttime Lantern Festival, at which young men balance heavy, twelve-meter bamboo poles, hung with tiers of twenty-four to forty-eight lanterns, on some part of their body—the palms, shoulders, forehead, or elsewhere—to the accompaniment of drums and shouts. This festival dates from the seventeenth century.

At the Chrysanthemum Festival, now among the least celebrated of the five *sekku*, people used to follow Chinese tradition by drinking chrysanthe-

mum wine and rubbing themselves with cotton that had been placed on a chrysanthemum overnight to absorb the flower's dew and scent. The practice was thought to promote long life. The ninth day of the ninth month was set aside for official observance of the festival in the Japanese court as long ago as the early ninth century. The chrysanthemum has long been associated with the nobility, and the imperial crest is a stylized chrysanthemum. Since the Edo period, when the festival underwent a revival at court and many new varieties of the flower were introduced, many department stores, amusement parks, and other public venues feature annual displays of "chrysanthemum dolls" in the fall—life-size mannequins gorgeously attired in clothes made of chrysanthemums of every size and color.

Once children have grown to be adults, perhaps the most important rite of passage is their wedding. In the old days, wedding ceremonies were held not in a religious institution but in the groom's house: the bride was considered to be marrying "into" the groom's house or family. Today, four out of five weddings include a Shinto ceremony. The pattern for such weddings has remained largely unchanged since 1900, when it was first popularized by the elaborate wedding of the future Emperor Taisho. (Legally, it should be noted, no wedding ceremony is required at all in Japan; it suffices if the name of the wife is entered in the husband's family register.)

First, the pledge to marry is formalized with the ceremonial presentation of betrothal gifts (*yuino*) from the man to the woman, which may include cash wrapped in paper, dried bonito and cuttlefish, kelp, linen thread, a folding fan, and saké. The Shinto marriage ceremony itself consists of several rites, the most important being *san-san-ku-do* ("three-three-nine times"), in which the bride and groom take turns sipping saké three times from each of three progressively bigger red lacquered cups. Only the immediate family is present for the marriage ceremony, which may also be Buddhist or Christian; the choice is often more a matter of aesthetic preference than of religious conviction. In any case, the couple chooses an auspicious day for the wedding, and little expense is spared in any detail. The marriage ceremony is often followed by a lavish reception costing several million yen and an overseas honeymoon trip.

A Shinto wedding ▶ Certain years of life are considered lucky in Japanese folk tradition, others

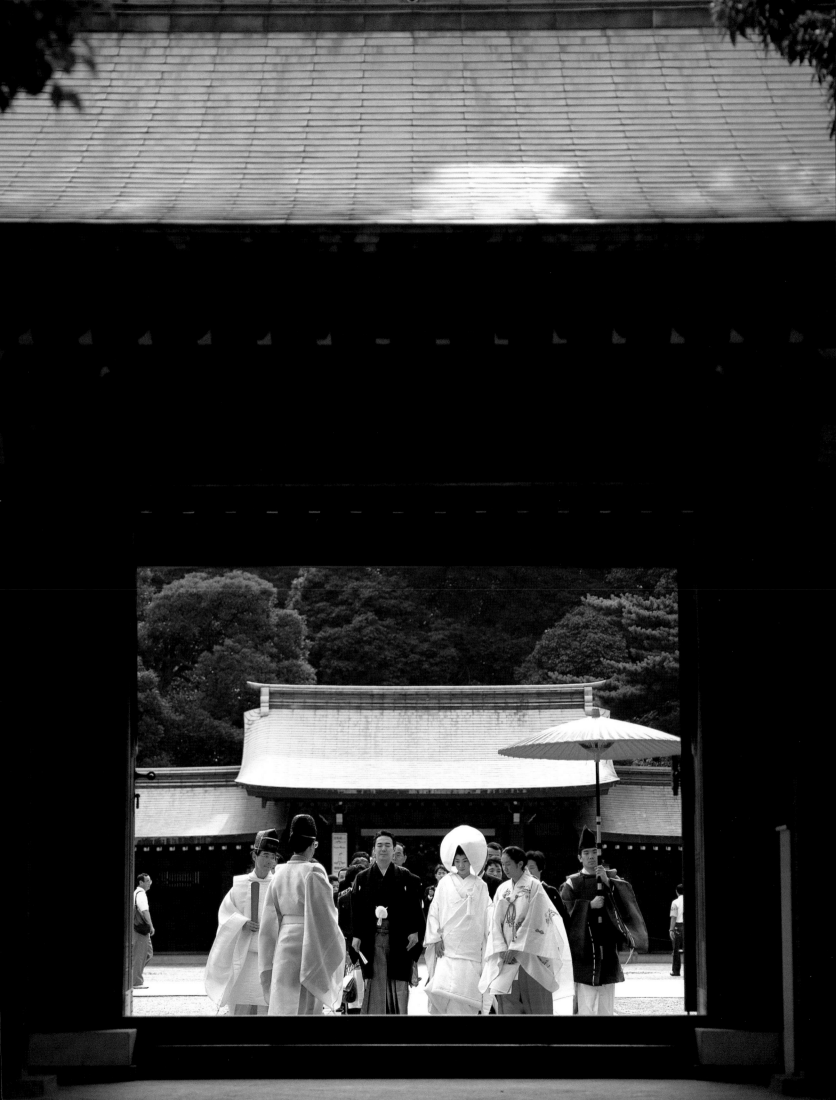

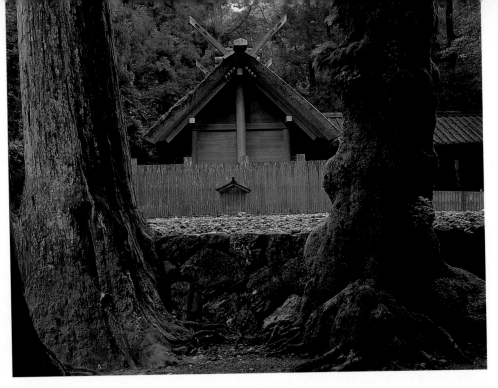

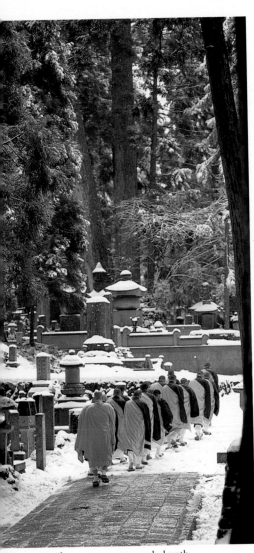

Monks on a snowy wooded path

Bodhisattva in meditation: a seventh-century Buddhist sculpture in the Nara temple of Chuguji ▶

mysteriously dangerous. The fortunate years seem to honor longevity: 60, 70, 77, 80, 88, 90, and 99. The dangerous years (*yakudoshi*) come earlier: for a woman they are generally 19 and 33, for a man 25 and 42. Special caution is to be exercised by people of those ages to ward off sickness or trouble.

Under the influence of Confucian tradition, the elderly have long been highly honored in Japanese society. In today's rapidly graying population, they also pose a significant social problem, as Japan must prepare to care for increasing numbers of infirm and needy old people in the years to come. Respect for the Aged Day (*Keiro no Hi*; September 15) was formally adopted as a national holiday in 1963. It fits in naturally with other days celebrating family members at different stages of life, including the popular American import of Mother's Day and, to a far lesser extent, Father's Day, though neither of these is a national holiday. (Even so, Mother's Day is so firmly established in Japan, carnations and all, that many Japanese are convinced it is an indigenous holiday.) Along with various entertainments provided for senior citizens, Respect for the Aged Day has also come to feature grim statistics in the newspapers about the number of elderly living—and dying—alone.

Funerals are the final, inevitable part of an individual's life cycle. Although weddings are usually Shinto, funerals in Japan are almost invariably conducted according to Buddhist custom. The reasons for the difference have to do with the separate geniuses of the two religions, and the ways in which they have been integrated into Japanese life.

Over the centuries, there has been considerable mingling of Shinto and Buddhist traditions in Japan, and certain Shinto festivals incorporate rites of Buddhist origin as well. Buddhist beliefs have evolved their own niche in Japan, however, one that is easily distinguished from Shinto since it involves funerals and commemorative rites and services for the dead. Whereas Shinto cheerfully celebrates life, Japanese Buddhism has a long and intimate association with death, and it continues to play a major social function in giving meaningful structure to death and providing comfort and support for the bereaved. At the same time, it has accommodated itself to deep-rooted tradi-

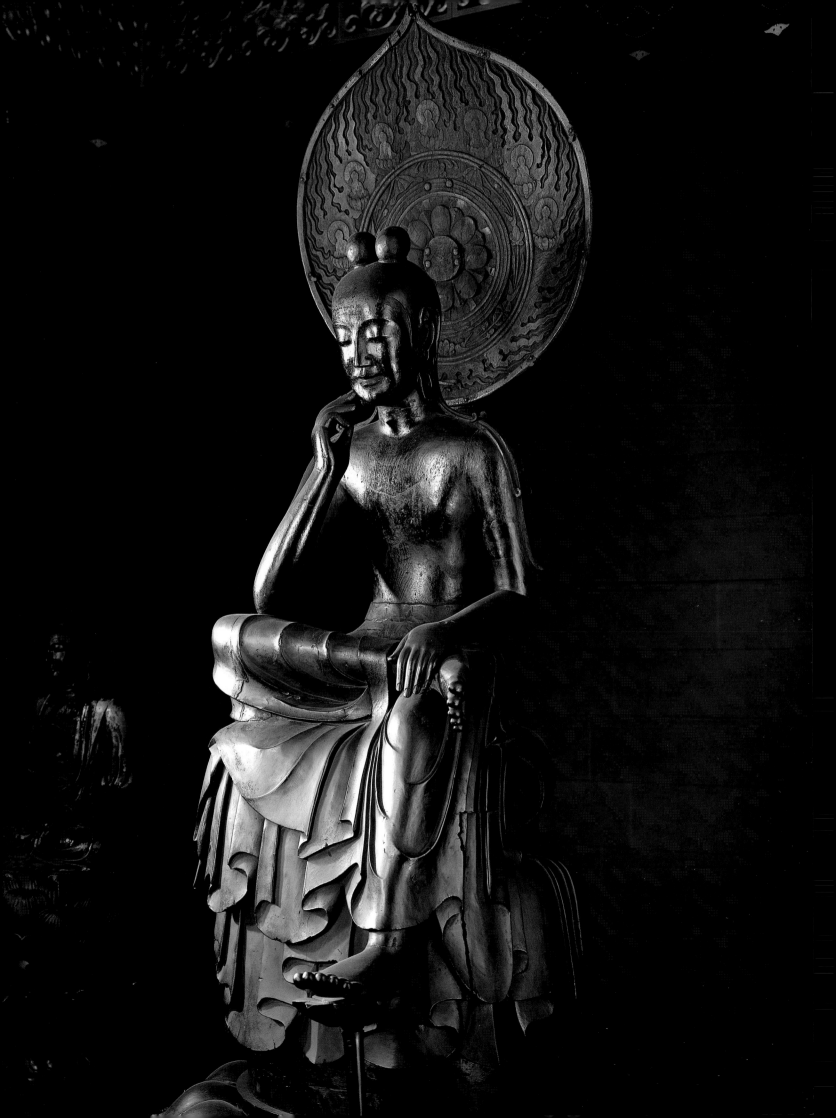

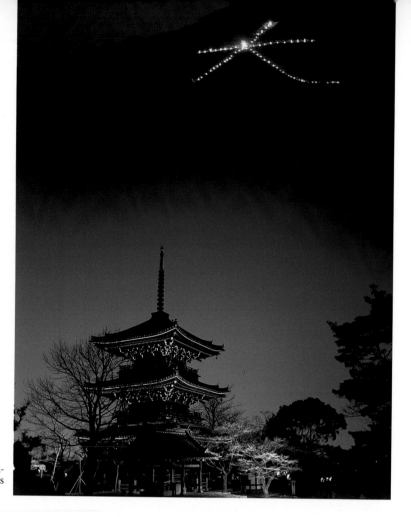

Mountainside bon-
fire marks summer's
end in Kyoto

tional beliefs that a world of the dead exists parallel to that of the living, and that the happiness and well-being of those in this life are contingent on the sincerity of their efforts to ensure the happiness and well-being of the dead.

When death looms, family members gather at the bedside, and, as the inevitable moment draws near, take turns brushing water on the lips of the dying person. After death, the body is laid with the head toward the north and covered with a white sheet. A burning candle, flowers, and offerings of food and water are placed nearby, and a knife is placed on or near the body to ward off evil spirits. Dead bodies are often referred to as *hotoke*, or Buddhas, signifying the rebirth in paradise and the consequent buddhahood of the deceased— an idea fully compatible with the Shinto idea that the dead are elevated immediately to the status of ancestral *kami* and become protectors of the living.

In older, traditional communities, the day after a death occurs, community members rally around the bereaved family, preparing special foods to serve at the evening wake, when gifts of money are presented and a large photograph of the deceased is prominently displayed. The funeral takes place the following day, at home, in a temple, or, increasingly, at a funeral hall. Sutras are chanted, a funeral address is read, and the participants line up to offer a pinch of incense to the spirit of the deceased, whose flower-filled casket is then taken to the crematorium.

After the funeral, the deceased family member is honored as an ancestor and commemorated at specified intervals up to the thirty-third anniversary of the death, with family visits to the grave each spring and fall equinox. *Higan* (literally "far shore," a reference to Buddhist enlightenment) is a week of memorial services to the dead, centering on the vernal and autumnal equinoxes.

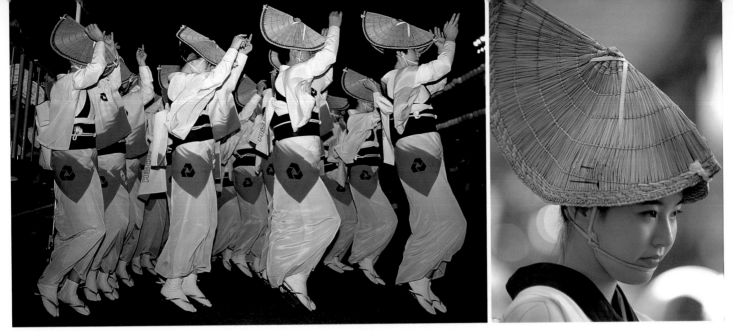

Awa Dance

The dead person's posthumous name (*kaimyo*) is entered on the ancestral tablet and placed in the Buddhist household altar (*butsudan*), the focus of Buddhist ceremonies in the home. It is usually located in the house of the oldest male descendant, who is also expected to take responsibility for maintaining the family grave.

The widely accepted belief that the dead continue to exist in some form, and that they continue to interact with the living, providing unseen guidance—or, it must be said, wreaking havoc if thwarted—allows people to go on treating their ancestors as if they were living and present. It is not uncommon for people to talk to the *butsudan* familiarly, as if the dead person were there in the room beside them, and visitors to grave sites take along not only flowers but gifts of food, even cigarettes and whiskey, or whatever the dead person may have enjoyed in life. This sense of connection with the dead is undoubtedly a source of immense comfort and strength for the bereaved.

The connection between the worlds of the living and the dead is reinforced during the family-oriented midsummer Festival of the Dead, *Obon*, when the souls of the dead are thought to return to visit the living for a three-day period. A gala time second only in popularity to New Year's, *Obon* has been celebrated in Japan for nearly a millennium and a half. It is sometimes rendered in English as the "Festival of Lanterns," because of the bonfires and numerous lanterns lit to welcome the ancestral spirits as they arrive and see them off as they depart again. In some parts of the country, it is traditional to set the lanterns afloat after dark on a river or stream at the end of the festival, creating a scene of unforgettable beauty. Once again, people everywhere take the opportunity afforded by this festival to return to their hometowns to be with their families, honoring the past and, above all, celebrating the present.

In parks and other outdoor gathering places across the country, circles of young and old dressed in bright summer cotton *yukata* perform the rhythmic bends and turns of the folk dances called *bon-odori*, accompanied by lusty singing and clapping, with energetic performances on drums, gongs, and flutes. There are many local variations of the dance, among the most famous being the boisterous four-hundred-year-old Awa Dance of Tokushima City. It is also known as the Fools' Dance (*Aho Odori*), because of a memorable refrain that urges tourists and bystanders to join in the fun with these words: "You're a

A kite festival in Hamamatsu ▶

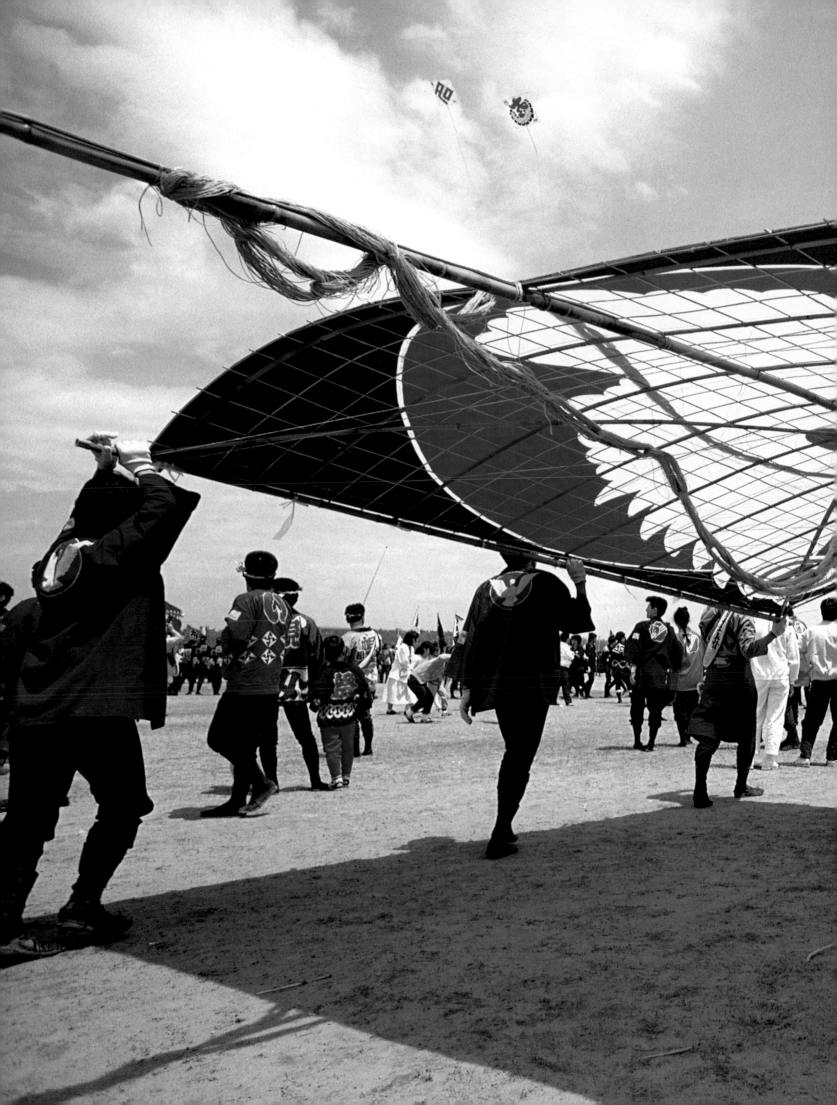

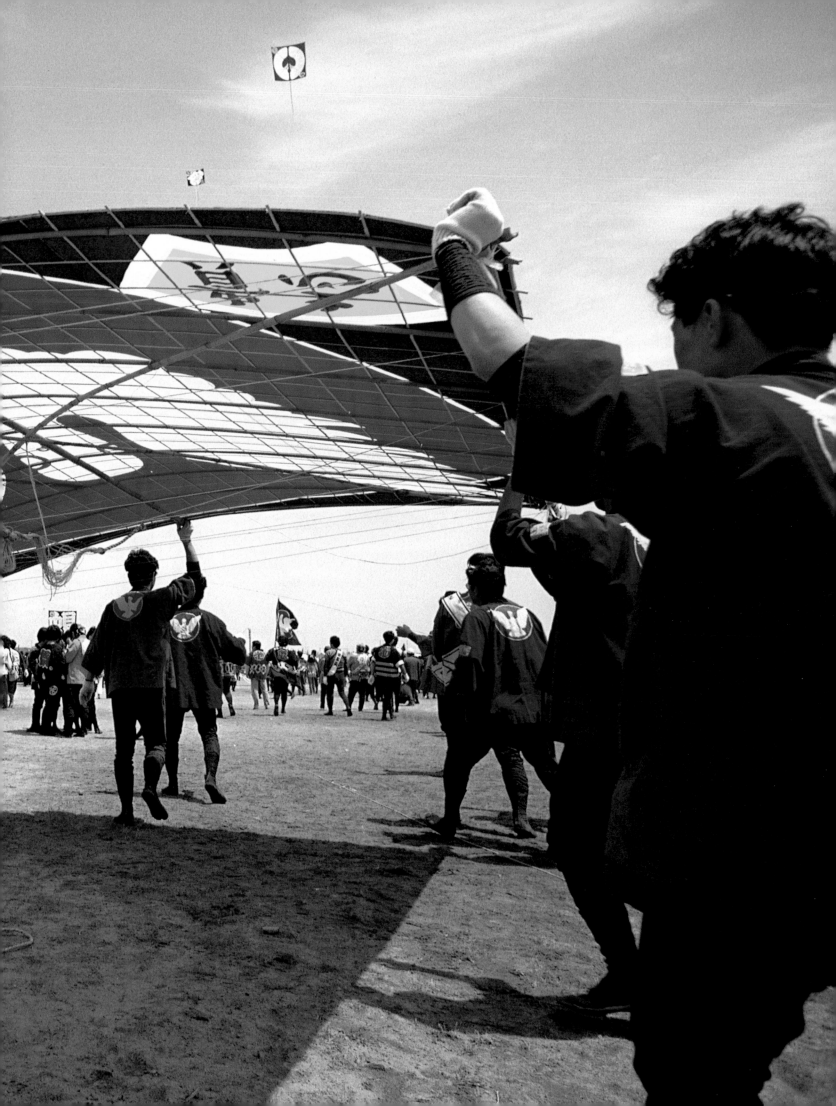

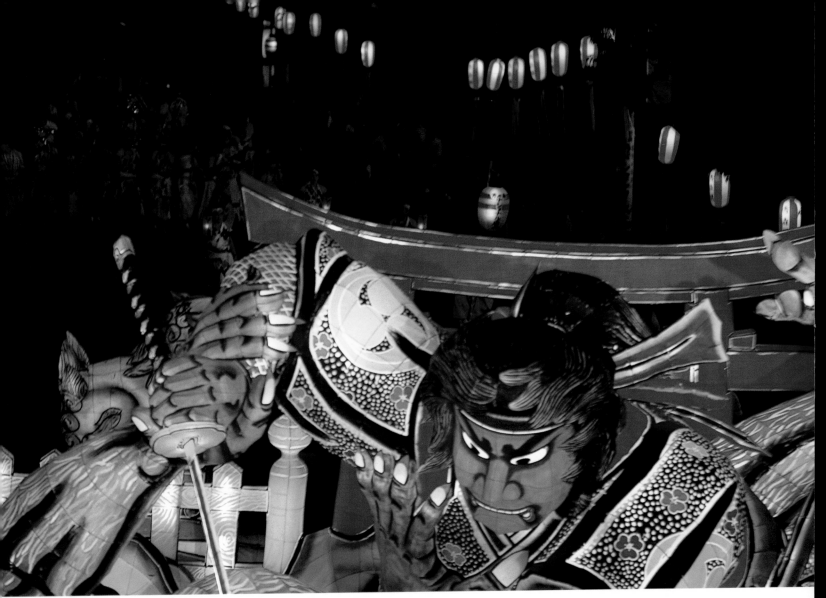

Fierce warrior float at Nebuta
Festival in Aomori

fool (*aho*) if you dance and a fool if you watch; since you're a fool either way,
come on and dance!"

Shinto is associated not only with cleanliness and simplicity, as mentioned
earlier in connection with New Year's, but with a joyful embracing of life in
this world. The origins of Shinto, Japan's only indigenous faith, hark all the
way back to Amaterasu, goddess of the sun and progenitrix of the Japanese
imperial line. Lesser *kami* are everywhere, in uncountable numbers, and they
manifest themselves in all things, both animate and inanimate, and in all
aspects of life. Given the agrarian nature of traditional Japanese society, it is
hardly surprising that, in addition to weddings and infant dedications, most
of the vast number of *matsuri,* or native festivals, are also Shinto at heart.
Many revolve around the growth cycle of rice and other crops: prayers for
abundant crops in spring, harvest thanksgiving in fall, and summer festivals
to pray for rain or drive away the threat of sickness and natural disasters.
Winter festivals may include fertility rites, like the ancient *Enburi Matsuri* of
Hachinohe in northern Aomori with its snow-stomping dances to the deity
Inari in an appeal for the renewal of the land. (An *enburi* is a tool for smooth-
ing the mud in rice paddies.) With their joyous unleashing of pent-up ener-
gies and celebration of the cycle of seasons, the *matsuri* offer participants a

Gion Festival float bearing
musicians and dancers ▶

chance to worship and commune with the gods, to strengthen camaraderie

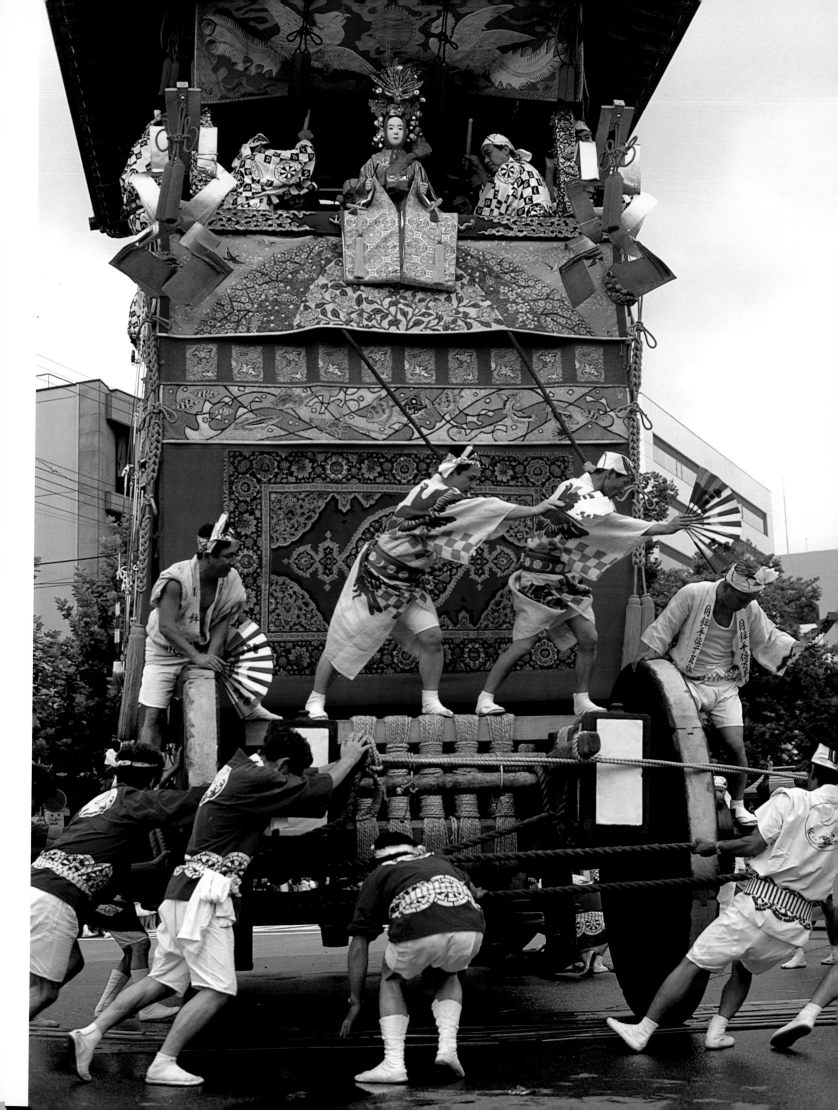

Father and son participate in the Sanja Festival

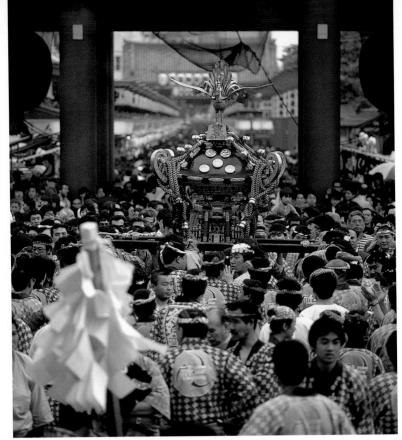

A portable shrine is shouldered by men in festival garb

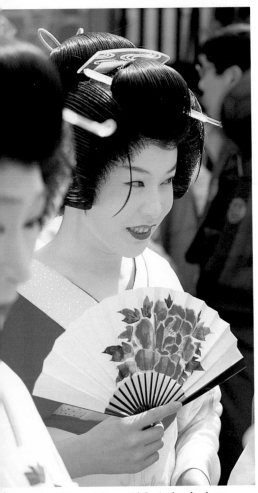

A smiling geisha amid festival onlookers

with neighbors and reinforce communal bonds, to reexamine their own historical and cultural roots, and not least, to let loose, forget the daily grind, and enjoy the sheer fun of a good time.

Many summer festivals have developed not out of farm life in the country but in urban areas, to drive away evil spirits. Often, children wearing colorful headbands and bright jackets pull a high cart with a large drum inside or shoulder a portable shrine (*mikoshi*) through the streets of the neighborhood. Everyone turns out in the local shrine that evening to buy candy, masks, and toys at special stalls, try their hand at catching goldfish with a paper net, and eat grilled corn on the cob, hot dogs on a stick, and other typical foods.

The granddaddy of all summer festivals is Kyoto's spectacular Gion Festival, which has no rival in size or splendor. It dates back to 869, when sixty-six tall spears (*hoko*), one for each province, were erected in the Imperial Park and prayers were said to fight a raging epidemic. Today, sponsored by Yasaka Shrine, the festival lasts the entire month of July, and during this time people pray for good health and enjoy the splendor of their tradition. The spears have been replaced by enormous floats on wheels, also called *hoko*, which feature tall spearlike poles on top. Smaller, shoulder-borne floats called *yama* carry life-size representations of famous figures from history or legend. On July 17, the floats parade through the city streets bearing groups of musicians, accompanied by the haunting music called *gionbayashi*. The floats are decorated with priceless European tapestries from the Middle Ages and other exquisite art. A variety of costumed figures also participate in the parade, such as the dancers in the *Sagi-mai* (Heron Dance), each with striking headgear depicting a graceful heron head and neck. The streets of Kyoto are crowded with millions of sightseers caught up in the excitement of the grand festival.

The oldest of the three great Kyoto festivals is the Aoi Festival, celebrated in

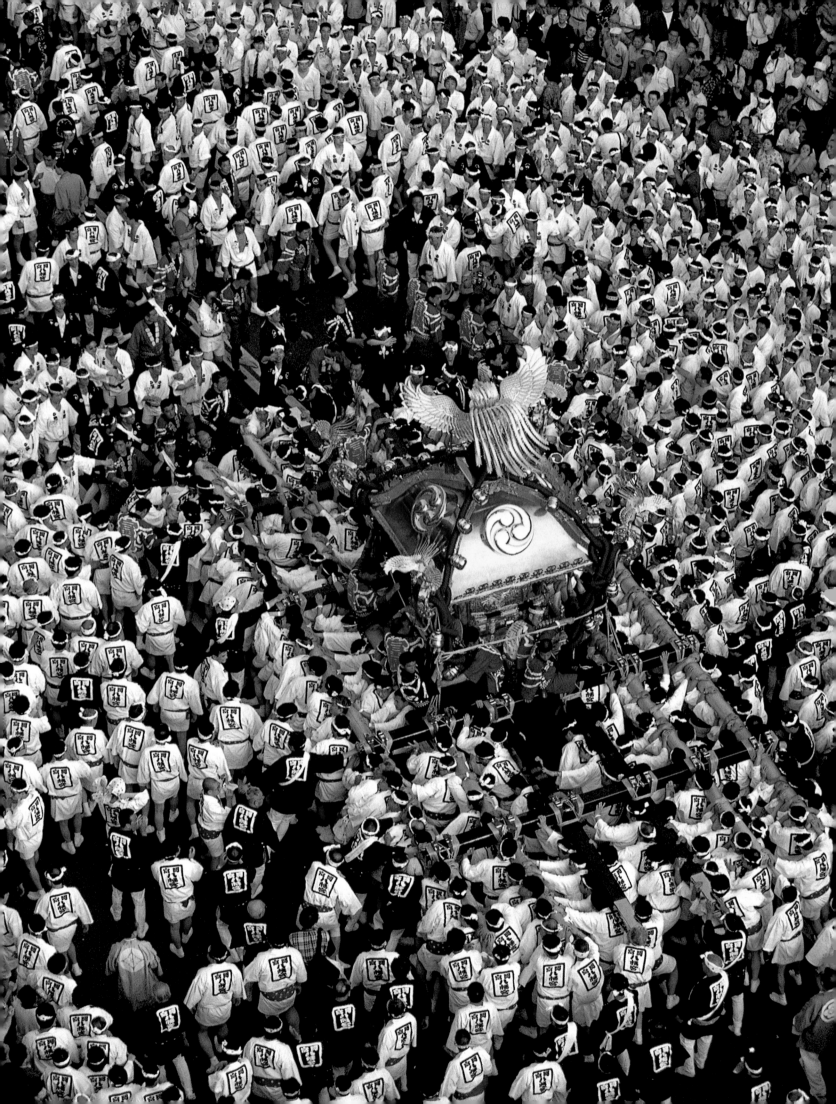

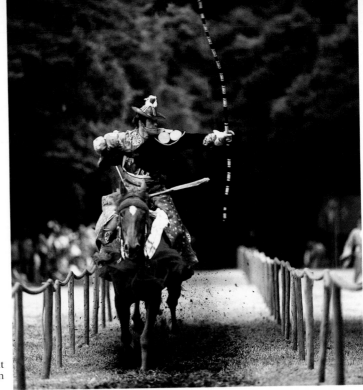

Archery on horseback at
Tsurugaoka Hachiman
Shrine, Kamakura

Sapporo's Snow Festival

May by the two Kamo Shrines. Said to have originated in a sixth-century im-
perial procession to plead with the gods for an end to destructive winds and
rains, the festival celebrates the glorious culture of Heian days. On the morn-
ing of May 15, over one hundred participants dressed in ancient costume
gather at the Imperial Palace, proceeding from there across Aoi Bridge first to
one of the Kamo Shrines, then to the other, and returning to the palace in the
evening. They represent imperial envoys, princess-priestesses in elaborate
twelve-layered silk kimonos, law enforcement officials, female court atten-
dants, and members of the court bureaucracy. The name of the festival
derives from the plant *aoi*, or hollyhock (*Asarum caulescens*), over four thou-
sand stocks of which were used to decorate the costumes, ox-drawn carriages,
buildings, and shrines connected with the festival. In recent years a look-alike
plant has been substituted as *aoi* has become somewhat rare.

The last of the three great festivals of Kyoto is the *Jidai Matsuri*, or Festival
of the Ages, held on October 22 by the Heian Shrine. The newest of the three,
it dates from 1895, when the shrine was built to commemorate the city's
1,100th anniversary. The main event is a procession of actors in costumes,
makeup, and hairstyles representing each period from Heian days to the Meiji
Restoration of 1868. Included are famous personages such as Murasaki Shi-
kibu, author of the *Tale of Genji*; Okuni, the sixteenth-century female shrine
attendant who created Kabuki drama; warlord Toyotomi Hideyoshi and his
entourage; and so on. Interspersed among them are courtesans and their
child attendants, warriors, footmen, shoguns and their servants, troupes of
traditional musicians, itinerant *shakuhachi*-playing monks, a fife and drum
corps from the days of the Meiji Restoration, and more.

Winter festivals offer a fascinating array of different styles around the
country. A few are completely secular and relatively new, like the Sapporo
Snow Festival held early in February in Sapporo, Hokkaido, in which artists
from around the world compete to sculpt enormous works out of snow and
ice, transforming the city into a sparkling fantasy land. A more intimate and

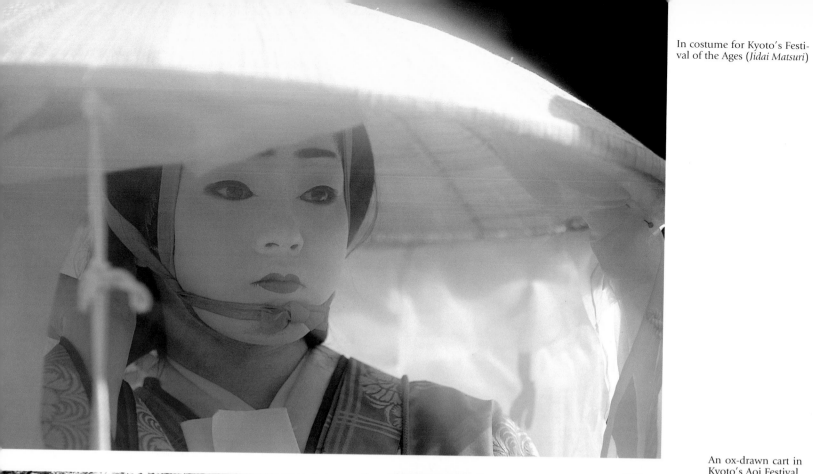

In costume for Kyoto's Festival of the Ages (*Jidai Matsuri*)

An ox-drawn cart in Kyoto's Aoi Festival

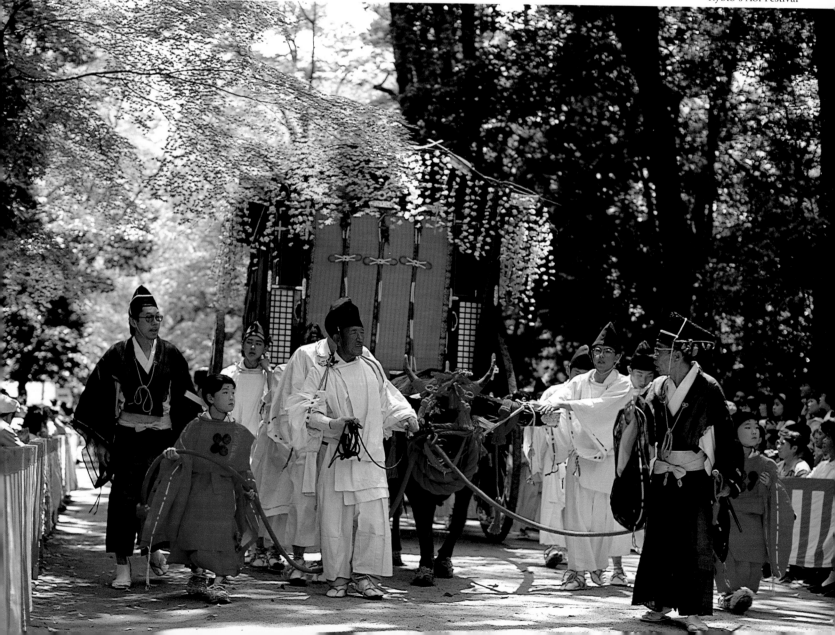

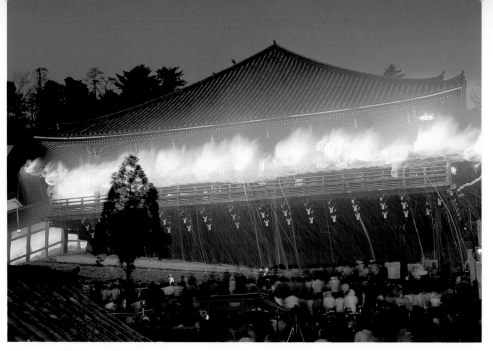

Omizutori: fiery rite of spring at Nara's Todaiji temple

traditional kind of snow festival is the *Kamakura Matsuri*, or Snow Hut Festival, held the same month in Akita and Yamagata prefectures. There, children build round huts or igloos of snow with small ceremonial altars inside to honor the god of water. The custom is said to be a relic of days when winter meant severe hardship, with insufficient food and water, and children were forced to live in the fields and hunt birds to survive. Today they enjoy toasting rice-cakes, playing card games, and breaking the monotonous routine of snowbound winter days.

In Western Japan, at the exuberant Naked Festival, loincloth-clad men shoulder heavy *omikoshi* floats (sometimes weighing as much as four tons) and jostle together as they compete to grab a lucky piece of wood. The festival is one hundred and fifty years old. In Tokyo, a newer winter observance has Buddhist monks from the Myokendo temple warding off evil by chanting sutras on the day of the Water Ritual in February, finally splashing water all over themselves. Elsewhere, the parishioners themselves are the ones sprayed with water. In some villages, young men in loincloths participate in a boisterous Mud Festival which serves as a fertility rite and plea for good crops.

Water also plays a crucial role in *Omizutori* ("Water-drawing"), another spectacular festival that is said to herald the end of winter in Nara. Ever since 752, eleven priests have been specially chosen to perform the sacred ritual of *shunie* at the Nigatsudo hall of Todaiji temple. Starting March 1, every day from noon to midnight for almost two weeks they circumambulate the altar in the hall without consuming a drop of water, constantly intoning the name of Kannon, the goddess of mercy. The climax of the ritual occurs on the evening of March 12, when ten flaming torches are shaken on the high platform of the Nigatsudo, showering down sparks on the spectators, symbolically burning away their sins—and, at the same time, burning away winter so that spring can arrive. Around 2:00 A.M. on the thirteenth, the priests draw the first water of spring from a nearby well and offer it to Kannon and to worshipers. Only then do the people of Nara feel that spring is on its way.

Fire is central to many festivals, including the Nachi Fire Festival of July 14 in Wakayama Prefecture. Twelve gigantic torches made of bamboo and grasses are borne swiftly by twelve white-robed priests through an ancient

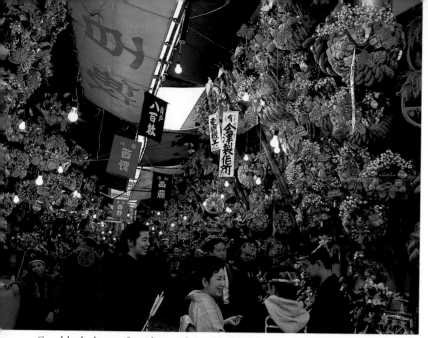

Good-luck charms for sale at a shrine in Shinjuku

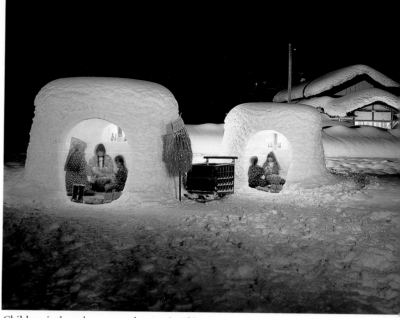

Children in *kamakura,* snow houses in Akita

forest toward the waterfall that is itself the shrine's main deity. They are met on the way by twelve tall, slender portable shrines—their shape is said to represent the shape of the Nachi Waterfall—topped with folding fans, coming in the opposite direction. The spectacle of the confrontation is dramatic, the purpose purification. At the Kurama Fire Festival in Kyoto, blazing torches are held at night by spectators while two portable shrines parade among them, followed by large torches that are carried about the shrine grounds until dawn. The festival is said to date back to a tenth-century initiation rite.

Other festivals celebrate historical events, like the Black Ships Festival held every spring in Shimoda, Shizuoka Prefecture, to commemorate the arrival there in 1853 of an American squadron commanded by Matthew Perry, ending the nearly three hundred years of Japan's self-imposed isolation from the international community. The Yokohama Port Festival celebrates the signing of the Harris Treaty in 1858—the first commercial treaty between the United States and Japan—and the opening of Yokohama as an international port. Going further back in history, the life of the heroic military leader Takeda Shingen (1521–73) is honored by the Festival of Lord Shingen at Kofu in Yamanashi Prefecture. In Nagasaki, the Suwa Shrine Festival (also known as *Nagasaki Kunchi*) features a Shinto procession with a Chinese flavor: the Dragon Dance, an intangible cultural property, is performed by ten young men dressed in Chinese garb to the accompaniment of Chinese gongs and other instruments, while umbrella-topped floats are shouldered through the streets. Said to date from 1638, when Nagasaki was Japan's only door to the world, the festival was apparently created to distract people from the forbidden religion of Christianity. Another significant historical festival is the Hakone Daimyo Parade, which recreates the spectacle of a daimyo proceeding along the old road to Edo with his entourage of two hundred and fifty foot soldiers, as the Edo shogun required all daimyo to reside in the capital in alternating years.

Finally, there is a set of festivals originating in the desire to express thanks for services rendered through the year by animals or even inanimate objects. The *Chaguchagu Umakko* is a horse festival held in Iwate Prefecture to give weary horses, and their owners, a rest from arduous labor in the fields.

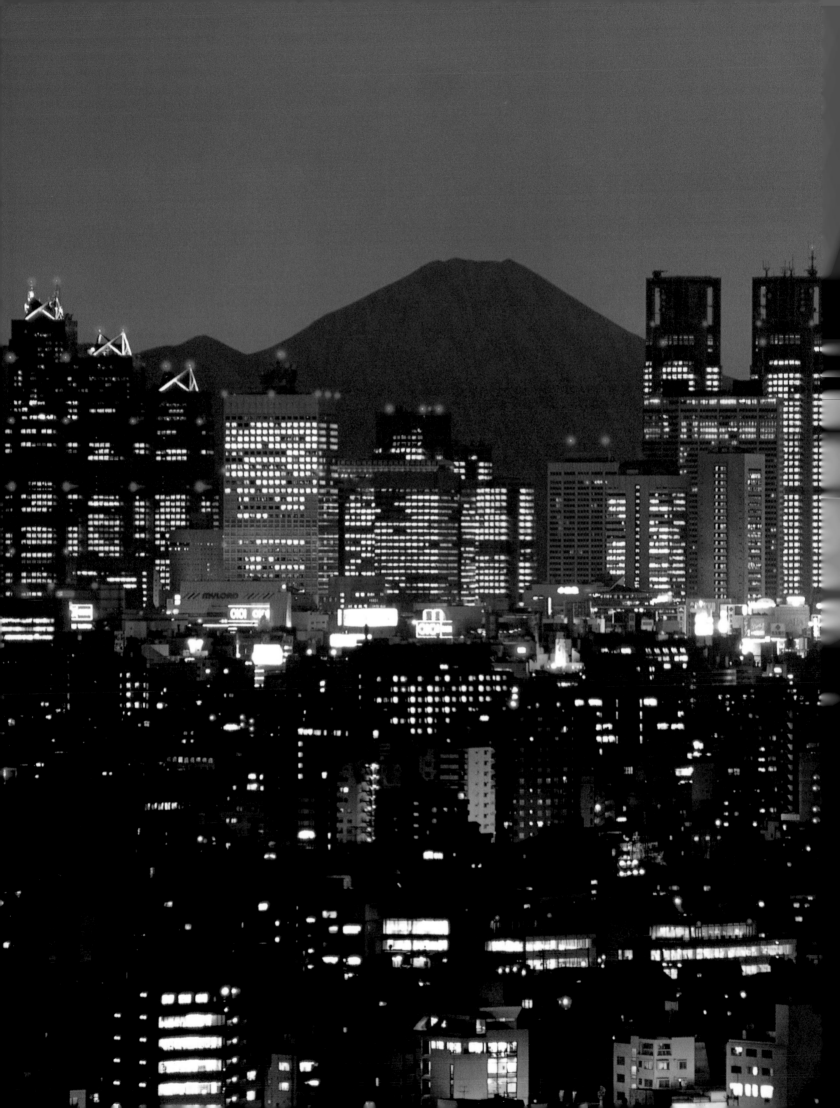

The all-female Takarazuka Revue

A gathering in Kyoto

Mt. Fuji behind a glittering Tokyo cityscape

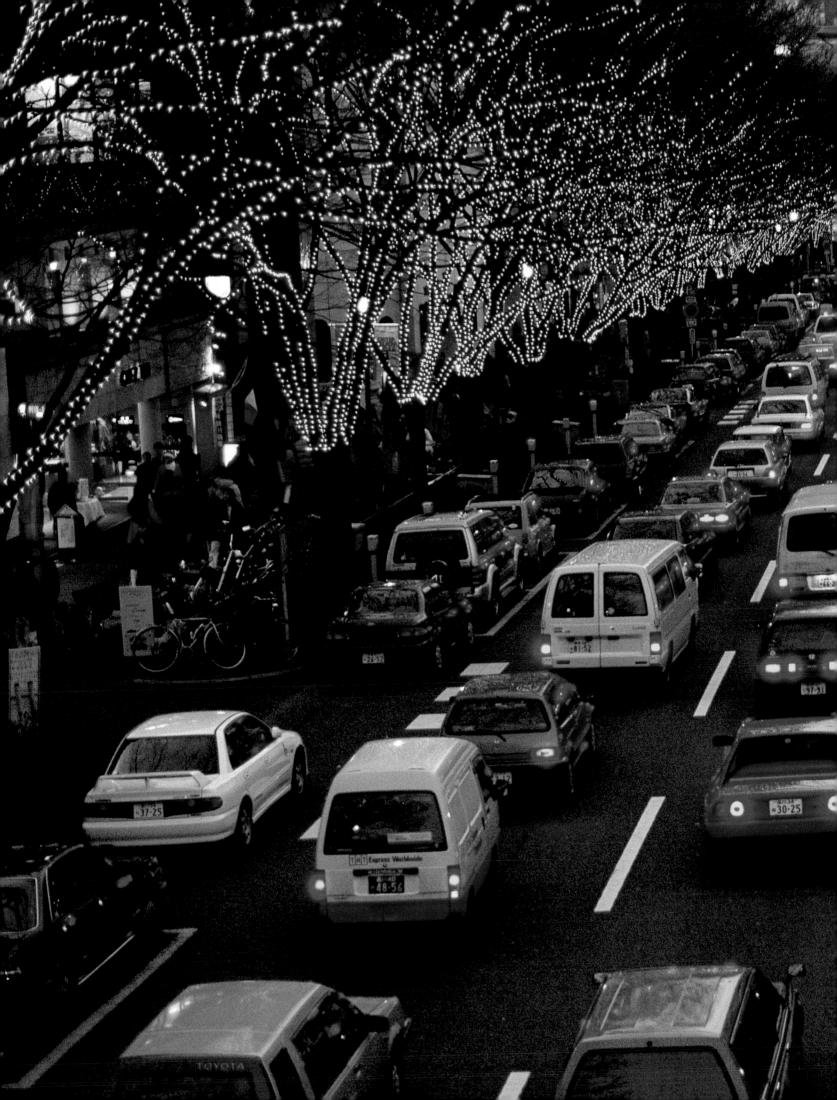

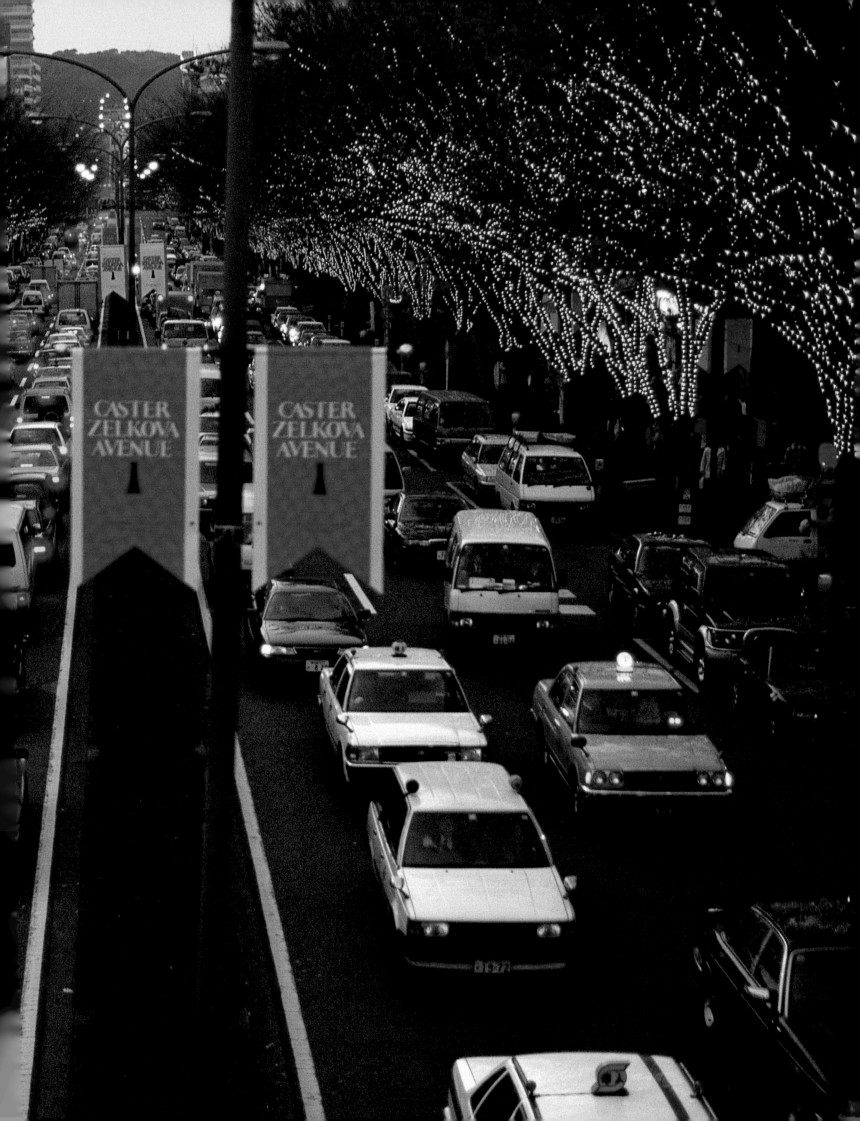

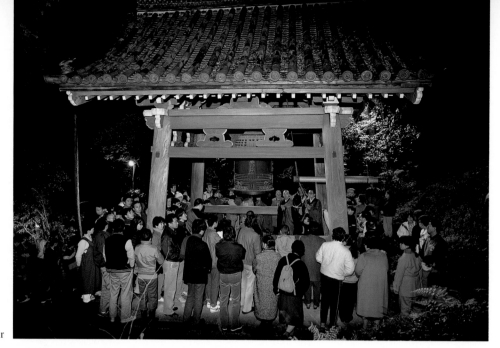

Ringing in the New Year

A fifteen-kilometer procession of horses decked out in fine array is led to a shrine to pray to the tutelary god of horses for health and protection. *"Chaguchagu"* is meant to echo the sound of the horses' bells. At a Needle Memorial Service (*Hari Kuyo*), old or broken needles are rewarded for their years of faithful service by being stuck into blocks of soft tofu or floated away on a river. Similar services are held on behalf of the spirits residing in a range of worn-out objects, from wooden clogs to dolls.

In December, after another year of ritual and remembrance, as well as constant new challenges and struggles to keep up with the pace of progress, it is time once again to prepare for the new year and its joyous promise of renewal and regeneration. *Bonenkai*, "forget-the-year" parties, are held, and the round of busy preparations is undertaken with a will. By December 31, the cleaning, shopping, cooking, and general tidying up of loose ends is done; all is ready. Families settle down to watch television and eat *toshikoshi soba* ("year-crossing noodles") in hopes of lengthening life and good fortune, symbolized in the long soba noodles.

The year goes out not in a haze of drunken revelry, as so often in the West, but in a mood of quiet contemplation. Television shows switch to live scenes of silent, snowy Zen temples. As midnight strikes, the haunting sound of temple bells (*joya no kane*) fills the air, as Buddhist temples everywhere strike their sonorous bells 108 times to expiate the 108 sins that mankind is heir to. People can go to the temple and take a turn at striking the bells themselves if they wish, sharing in the gladness and solemnity of the moment.

In some parts of the country, young men dressed in straw capes and fierce demon masks go from house to house on New Year's Eve, performing symbolic dances or masquerading as devils (*namahage*), warning children not to fail to do their duty in the new year. In Kyoto, people go to the Yasaka Shrine between midnight and dawn to receive a length of rope bearing sacred fire at one end; using that fire to cook the first meal of the new year will, it is believed, prevent illness.

And so the cycle has been completed, the year has come full circle once again. With the deep sound of the bells still reverberating, the Japanese are ready to begin another round in the never-ending cycle of life.

◄ Omotesando, a crowded Tokyo thoroughfare at Christmastime

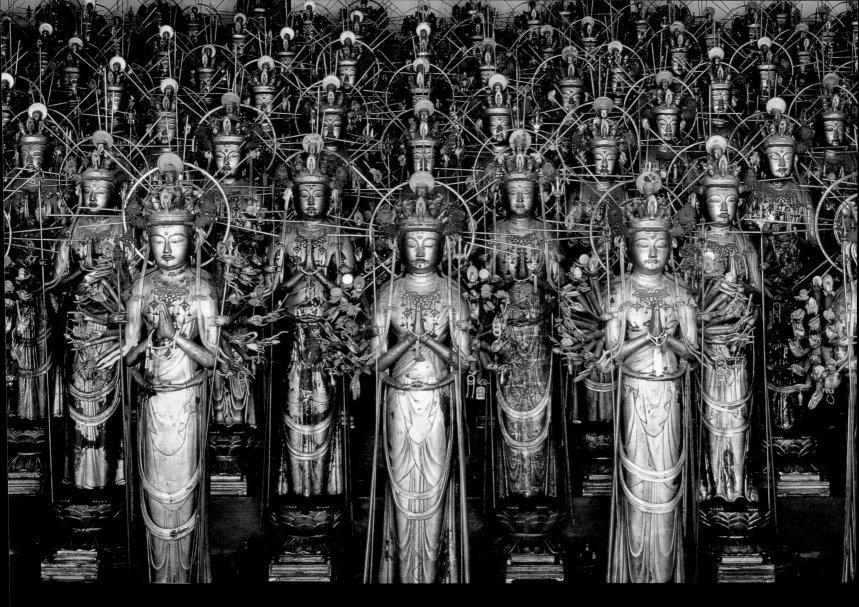

CULTURE AND TRADITION

PART

◀ Images of the bodhisattva Kannon in Sanjusangendo

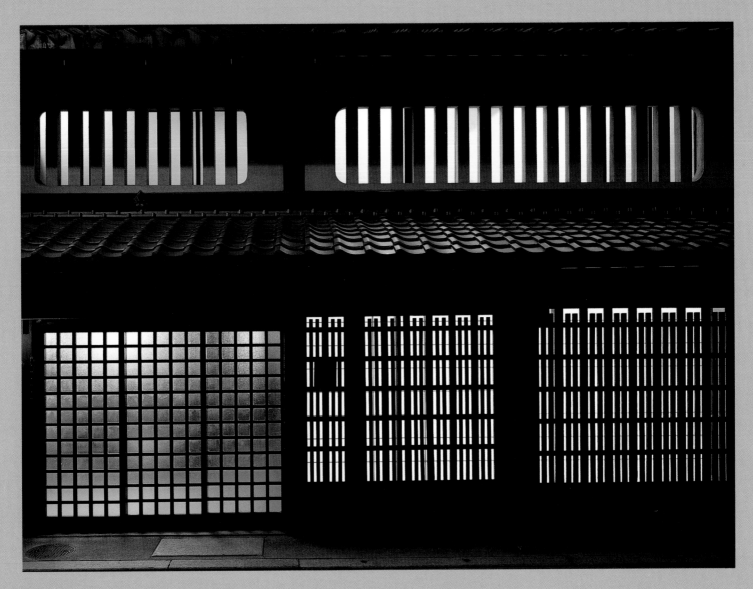

HOUSE AND GARDEN

The Noguchi House. The facade of this elegant Kyoto townhouse glows
in the night like a lantern through gridded *koshi* doors and windows

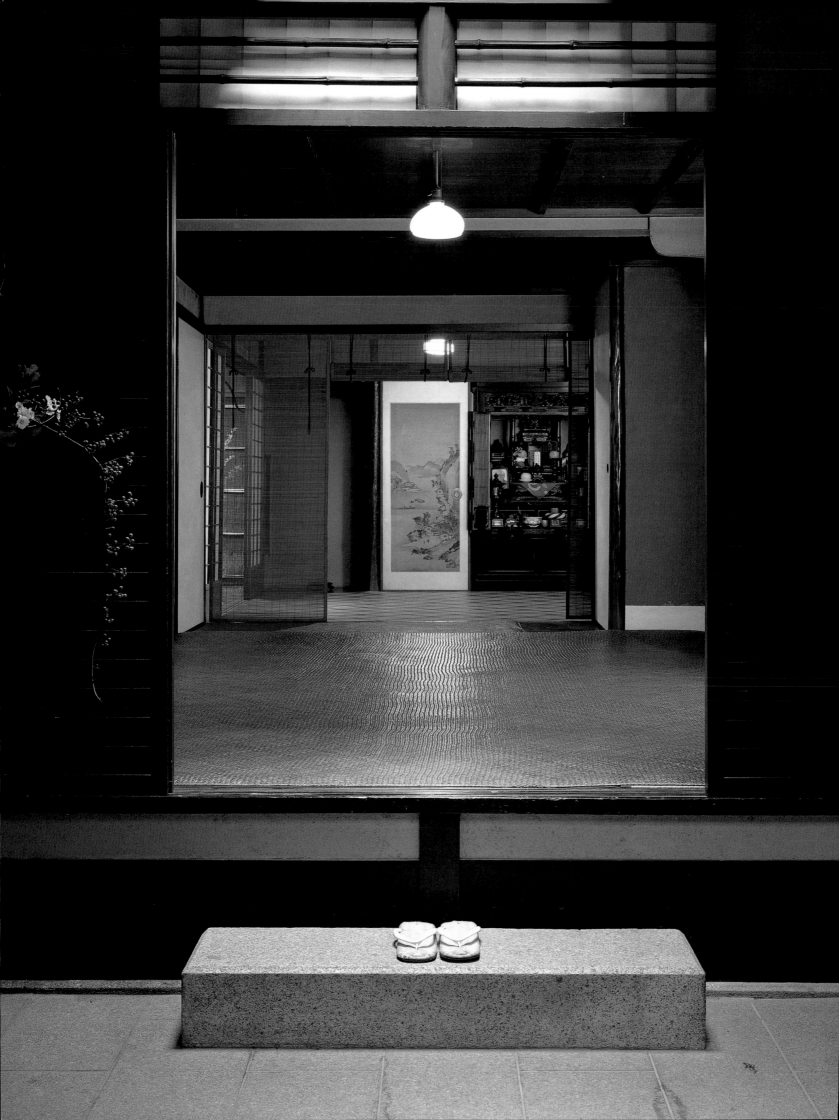

FOOLING SUMMER
Elegance and Simplicity in the Japanese Home and Garden

Diane Durston

"We have ways of fooling summer," says the lady of the house, with a nod at the tiny *furin* bell, tinkling gently with no more than the promise of a breeze. On a humid August night, a real breeze is rare in Japan, but "the sound itself makes us feel cool." And there are other ways of coping with Japan's most intractable season—the ubiquitous cup of cold barley tea, the slice of watermelon served in a clear glass bowl, the texture of melting ice, and a seat on the veranda watching the fireflies make magic in the moonlight above the courtyard garden.

Learning to live with simple elegance in spite of, and perhaps to some degree because of, a long history of hardship is what the Japanese have done so very well. Even in affluent and increasingly garish times, traces of this graciousness and refinement remain in the unrivalled beauty of the traditional Japanese home and garden.

In the middle of a crowded city, the Japanese townhouse, or *machiya*, is still a place of quiet refuge. A vanishing treasure, the small traditional abode was constructed entirely of natural materials—unpainted wood and bare clay walls, paper windows and bamboo fence. Built originally to house the merchant class, the design of the *machiya* reflects the lives of their inhabitants, who in feudal times were forbidden the trappings of the aristocracy. Forced to develop other means of expressing their dignity, they refined and perfected every detail of their simple dwellings without the use of elaborate ornamentation. Restricted by shogunal edict in size, shape, and ornamentation, these dwellings would be considered cramped and plain by Western standards. Open to the elements, without adequate heating, with scant furniture, and washrooms outside, they nonetheless embody a graceful and disappearing way of life.

No experience equals an ordinary summer night in a traditional *machiya*. From the street, the paper-covered *shoji* windows glow like paper lanterns in a facade of dark wood. Within, moonlight slants through a stand of bamboo in the courtyard garden, casting a delicate pattern across tatami mats. Clay walls and wooden doors are appreciated for themselves, for the color and texture of their grain and their natural lustre—without paint, wallpaper, or varnish. The tatami mat floors are most beloved in summer. The cool comfort of this tightly woven grass matting is still considered the ideal place to stretch out and listen hopefully for the cooling sound of the *furin*.

◀ The Noguchi House. Viewed from the entryway, the Buddhist altar in memory of the family's ancestors is the heart of the traditional home

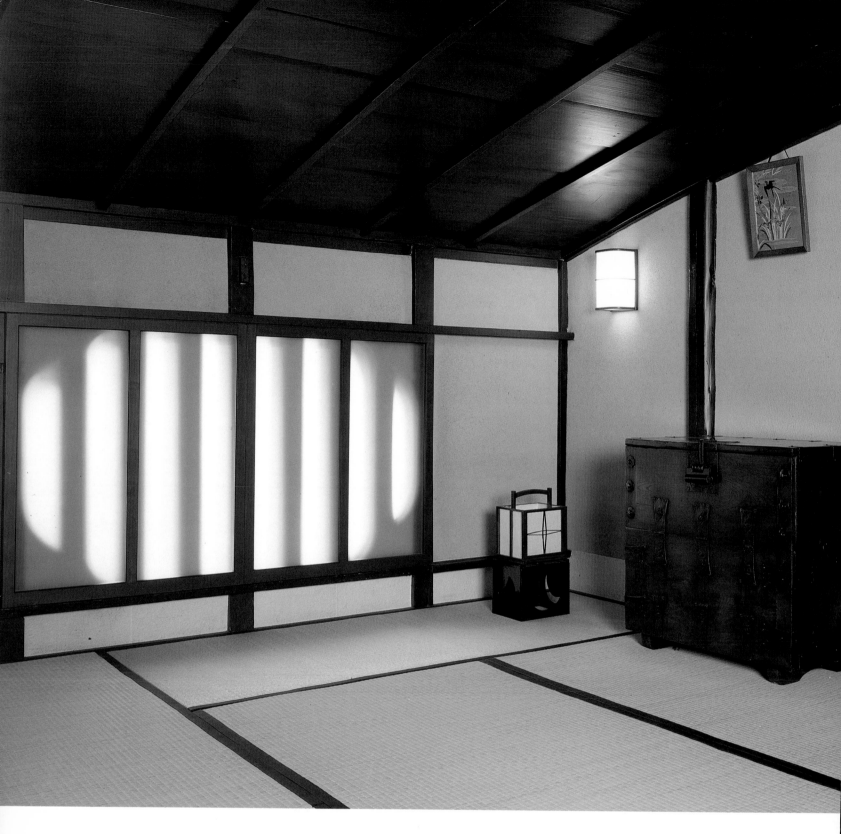

Particularly in the old capital city of Kyoto, meticulous attention was paid to the subtlest details of construction: the natural line of a post in the main alcove, the simple carved gourd shape in a wooden transom, the beauty of hand-forged metalwork—perhaps in the shape of a peach—concealing every visible nail. Every weed that threatens the delicate moss in the garden outside is plucked with tiny tongs by hand by the gardener who created the space, thereby taking responsibility for its maintenance for the rest of his life.

The *machiya* was built for a slower, more deliberate way of life. The garden and entryways are sprinkled daily to convey the feeling of perpetual freshness

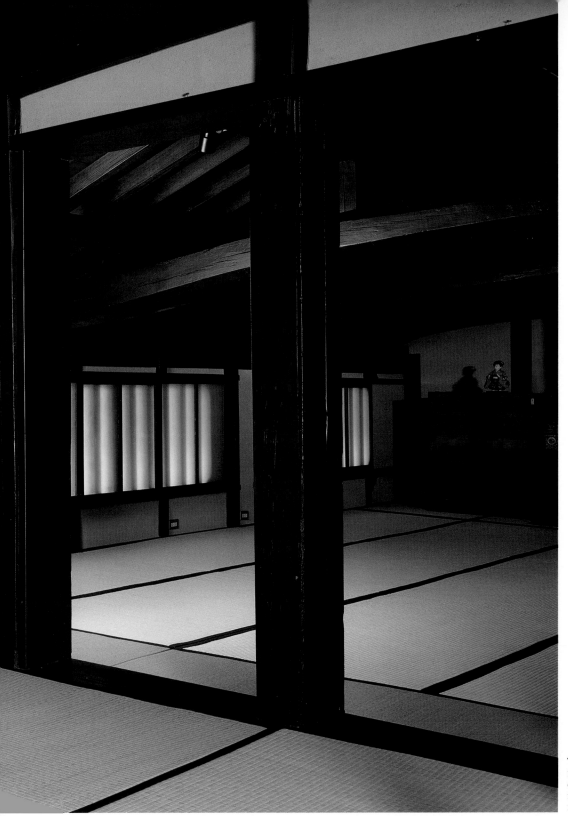

The Noguchi House (rooms on the second floor at the front). The sparse furnishings of the versatile *machiya* allow the rooms to function as living space by day and bedrooms at night

and welcome. Bedrooms become drawing rooms by day; it was the wife's responsibility to lay out the *futon* bedding and put it away each morning. The bath was a family event each evening, with father entering first and every member taking their turn for a soak in its soothing waters. The bath itself was made of wood and kept immaculate to prevent mildew. The care of a *machiya* was a full-time job.

Shoes are never worn inside the home, underlining a distinction between the polluted world outside and the sacred dwelling space within. Compared with Western living, the traditional Japanese home is spartan. Wooden chests,

The Noguchi House. With sliding doors removed, the main rooms of the house open completely to the garden in midsummer ▶

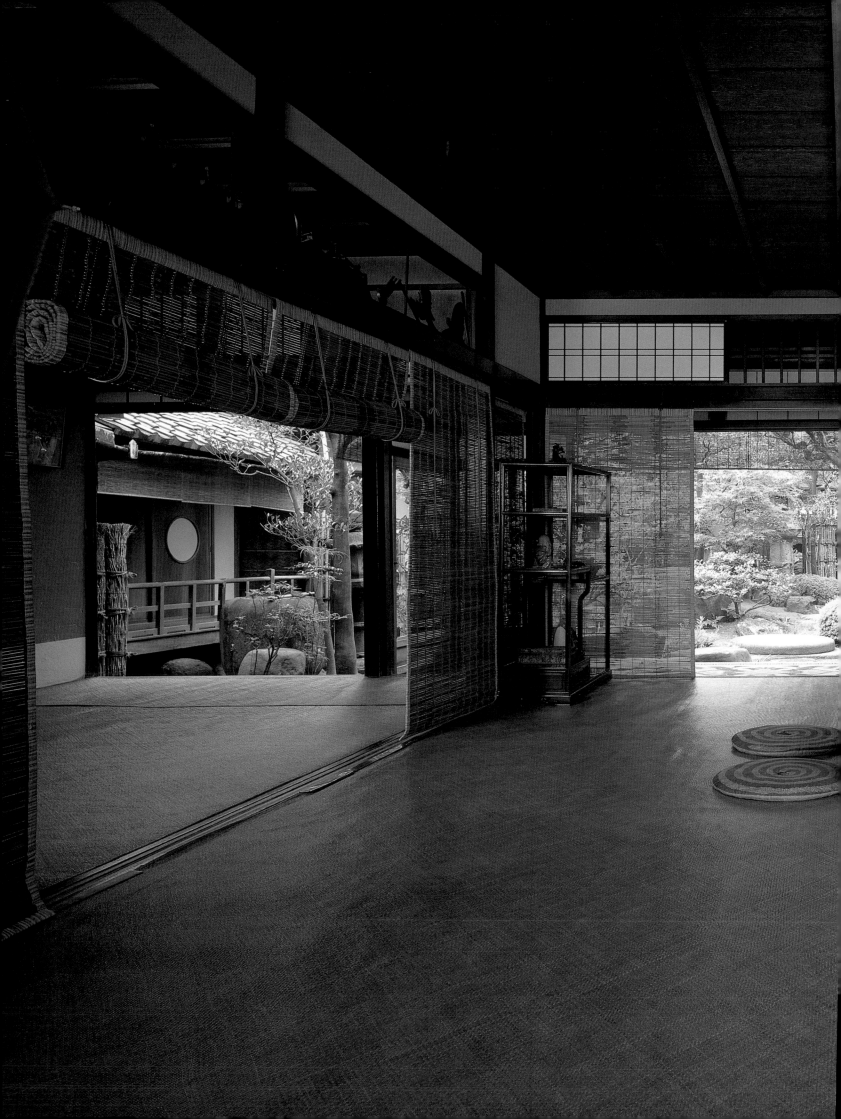

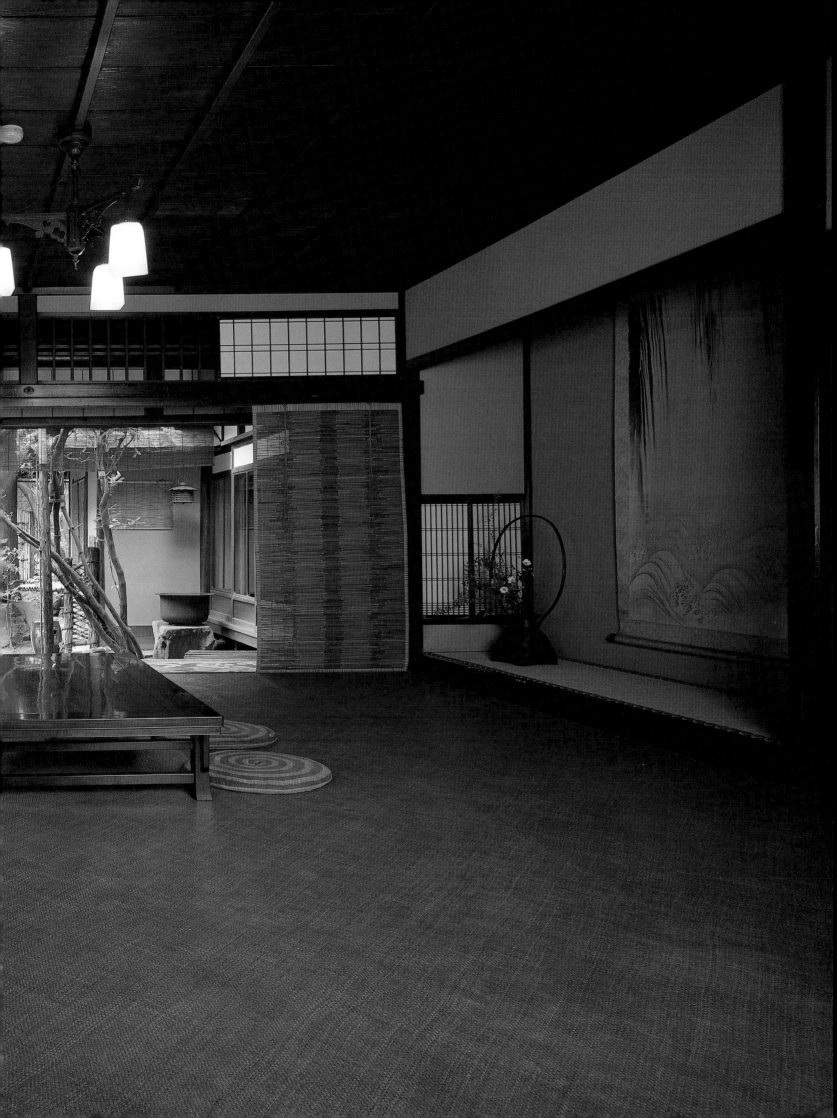

lanterns, screens, and low tables are the only furnishings. One sits on the floor on *zabuton* cushions. The gardens are designed to be seen from a seated position on the floor, as are the scroll paintings hung in the alcove. The beautiful proportions of the rooms in a traditional *machiya* can only truly be appreciated from this position.

The eighteenth-century proscription against displays of extravagance in the dwellings of the merchant class is now manifest in the general disgust for anything garish in traditional homes. Paintings and art objects are discreetly displayed with constant awareness of the precise time of year. A single scroll is hung in the *tokonoma*, the alcove in the formal room designed for this purpose. The scroll is changed every month, its words and images alluding to the subtleties of the particular season:

> In my ten foot bamboo hut this spring,
> there is nothing;
> there is everything.
>
> —Sodo

Beneath the hanging scroll in the alcove a basket of flowers echoes the seasonal message, calling nature indoors. *Ikebana* arrangements are designed to be seen from one direction only—when one is seated in front of the alcove—rather than in the round. *Ikebana* aims to reflect the patterns of plant growth and the natural balance of color and plant materials. The word itself contains the nuance of "bringing flowers to life." The aim of the designer is to capture their living beauty by positioning the flowers and branches in a manner that is quintessentially "natural."

Even the most Westernized apartment in Japan will not be without its touch of flowers in season. Every neighborhood flower shop carries the season's first and most beloved blossoms. This goes far beyond imported tulips and common chrysanthemums to carefully trained clematis in June, rustic pampas grasses of September, branches laden with golden persimmons in November, and sprigs of bare willow and pine in January.

One frozen afternoon in mid-winter, perhaps the master of the house will bring out a small, hand-made, paulownia wood box and prepare ceremoniously to unveil its contents to his guests: a tiny tea container that bears the

The Sakaguchi House. The homes of most Kyoto merchant families possessed at least one courtyard garden such as this one, where the master of the house could retreat from the cares of the world ▶

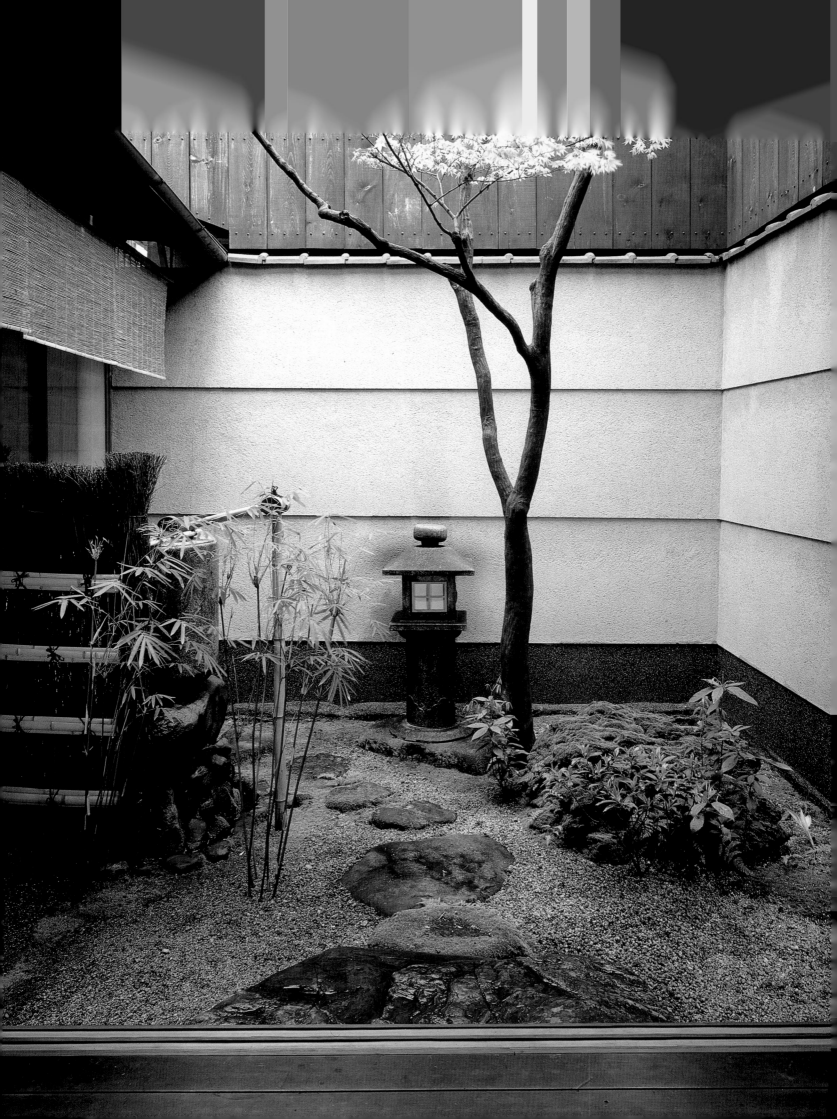

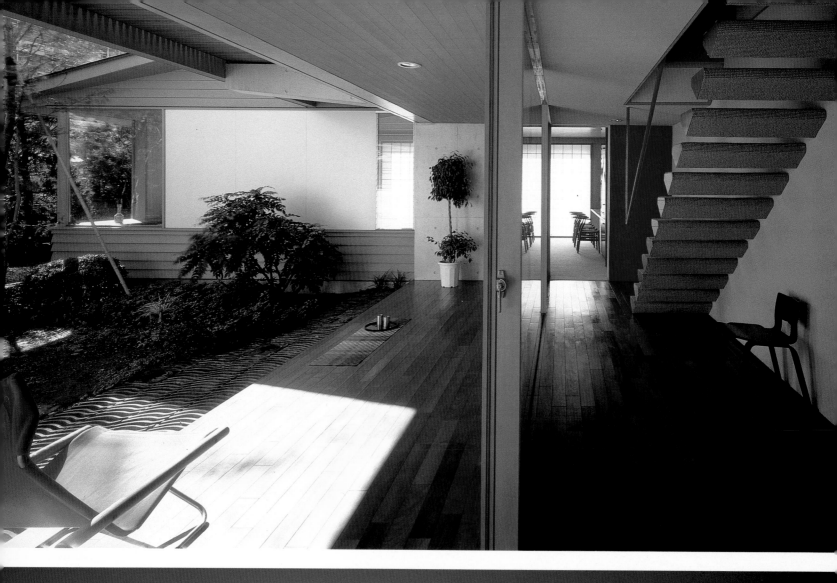

image of a snow scene in gold relief on lustrous black lacquer. The wooden box itself draws sighs of admiration, signed by a famous tea master and bearing his coveted seal of approval. Duly admired by one and all, the box and its treasured contents will then be returned to the family storehouse to await another special occasion.

No matter what the season, however, it is the love affair between house and garden that gives a traditional Japanese dwelling its special beauty. This relationship was viewed as an essential part of the whole, and no permanent barriers are erected. Doors and windows are designed to be removed, allowing the outside in and changing the size, shape and function of the rooms. The design of both house and garden is based on a human scale: a unit of measure approximately six by three feet—the size of a single tatami mat.

The floor space of the rooms is discussed in number of mats, a six- or eight-mat room being the average size. Sliding doors of paper or wood are made to the same scale, and are modular and often interchangeable from house to house. A two-mat space is referred to as one *tsubo*, a unit still used in measuring the size of any property. The tiny courtyard gardens of the *machiya* are called *tsubo-niwa* because they take up little more space than two tatami mats.

With no insulation, the house communicates the heat of summer and the chill of winter to its inhabitants, putting them in touch with the realities of nature, its changes and caprice. A constant awareness prevails—that man does not dominate the natural world, but must live in harmony with it.

The house and garden form a single unit, linked by stepping stones that lead to lanterns, or by bamboo fence "sleeves" that visually and spatially connect the veranda to the garden beyond. More than stylistic motifs, these devices symbolize the physical and spiritual relationship between man and nature. The failure to incorporate this notion of unity between house and garden is one of the reasons why some Japanese-style gardens in the West seem lifeless replicas.

Historically, these town dwellings and their diminutive gardens echo the great traditions of the austere sand and stone gardens of Zen, linked inextricably with the halls of great Buddhist temples such as Ryoanji. Some reflect, on a smaller scale, the stepping stones of the graceful stroll gardens that surrounded the estates of the wealthy aristocracy in centuries past. Paths appear

◀ The Konosu House. The *roka* corridor links inside with outside and, in this contemporary residence, the modern quarters with a traditional Japanese room in the background. More than a passageway, the *roka* has long been a favorite spot to enjoy the garden view with guests

◀ The Sasaki House. Interior and exterior spaces meet in a modern interpretation of the design concepts intrinsic to a traditional house

Tofukuji temple. The bold checkerboard design of this 1938 garden contrasts hard-edged stone with the soft lushness of moss in this modern design for Tofukuji's abbot's quarters

Katsura Rikyu Imperial Villa. The asymmetrical patterns of this seventeenth-century stone pathway through the moss are timeless and elegant ▶

to wander through the woods and disappear, as they do in the magnificent moss gardens of Saihoji temple. Recreated in the tiny *tsubo-niwa*, it is nothing more—or less—than a masterful illusion created in a space said to be no bigger than a "cat's forehead."

Walk down the cobbled path at Katsura Rikyu in Kyoto. Stand for a moment on the peerless balcony of the moon-viewing arbor and imagine it is the night of the harvest moon and this exquisite palace belongs to you. The pond stretches before you and disappears into the distance, and for a moment you are convinced that its streams—*and* your garden—flow all the way to the sea. The reflection of the full moon on the water alone is occasion for celebration, and friends have joined in your moment of reverie. Poetry is written and recited. Saké is sipped and other moons remembered. For a moment, you are fooled by this manicured existence into believing that life is civilized and refined. And just for a moment, it is.

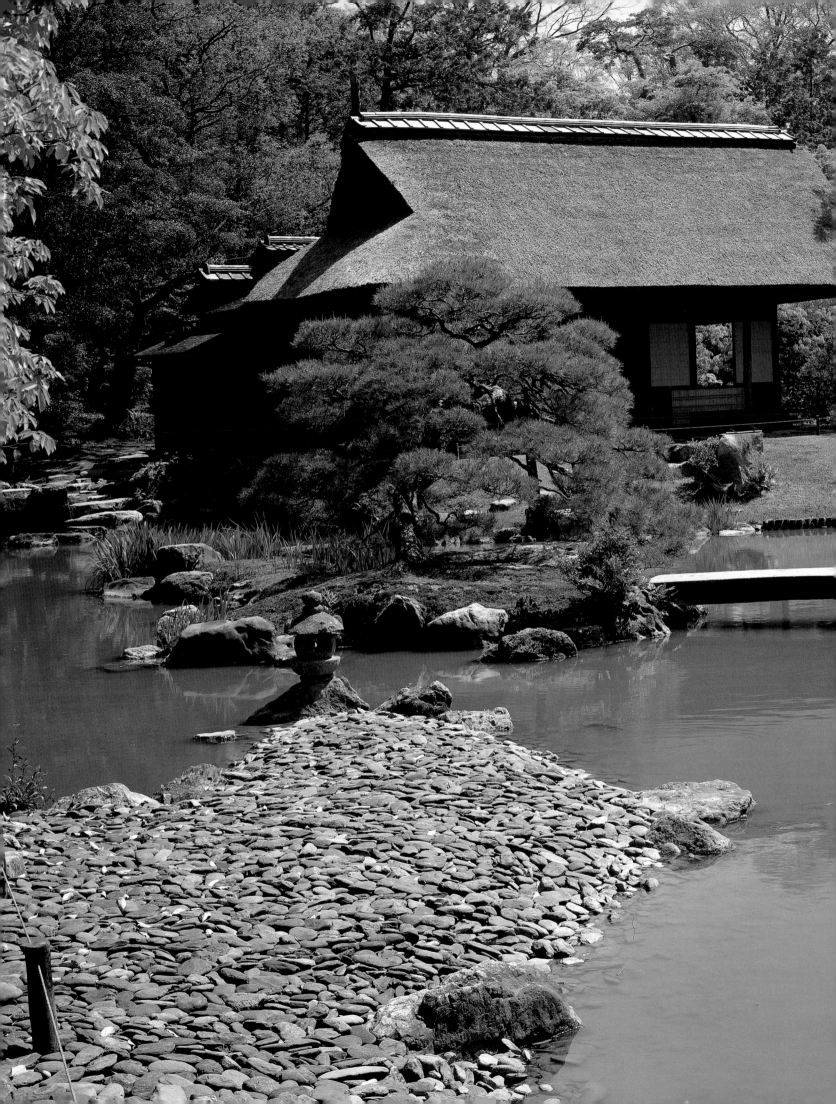

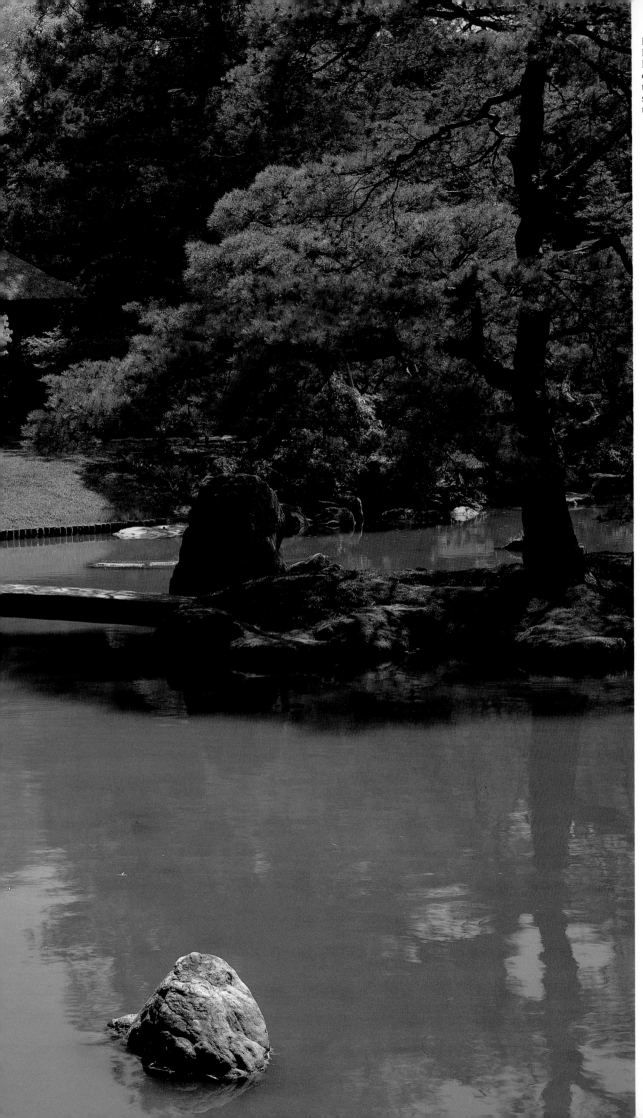

Katsura Rikyu Imperial Villa. Built in 1620 as a villa for Prince Hachijo, this pavilion on the pond at Katsura illustrates the harmony between structure and garden sought by traditional garden designers

Ryoanji temple. Designed by a Buddhist monk in the fifteenth century, the stark abstraction of the famed Zen rock garden defy interpretation today ▶

183

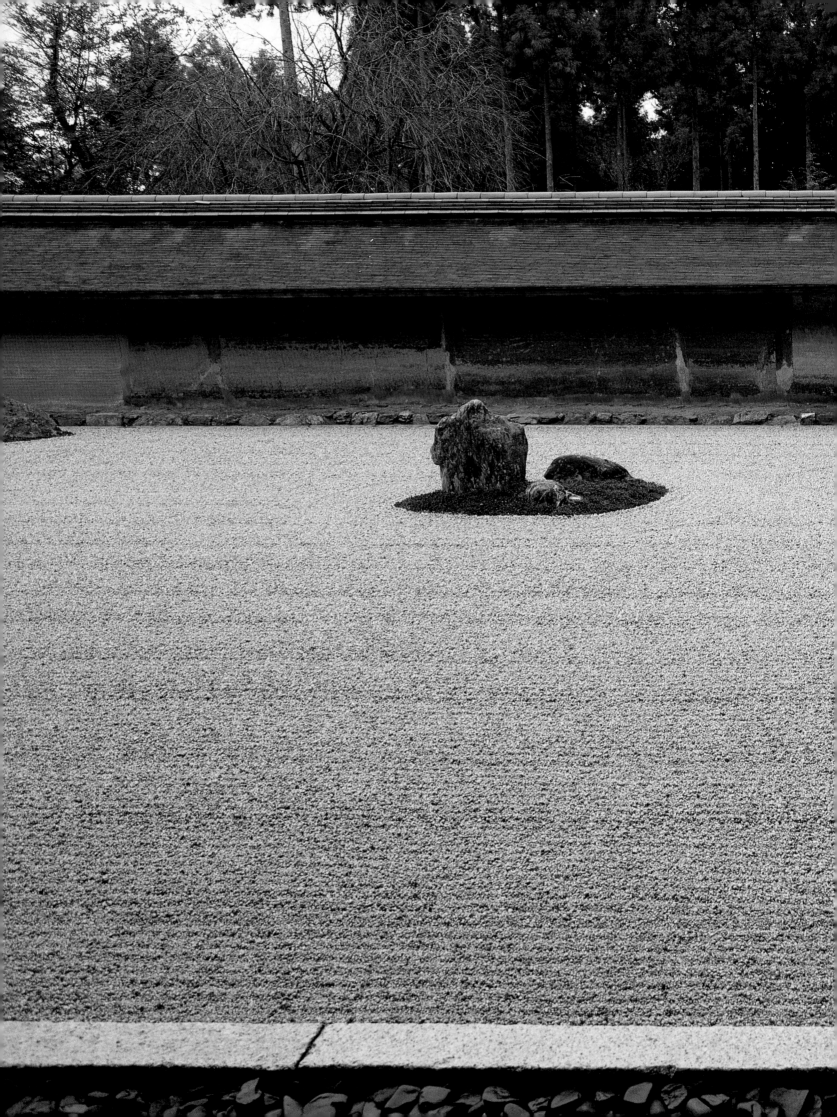

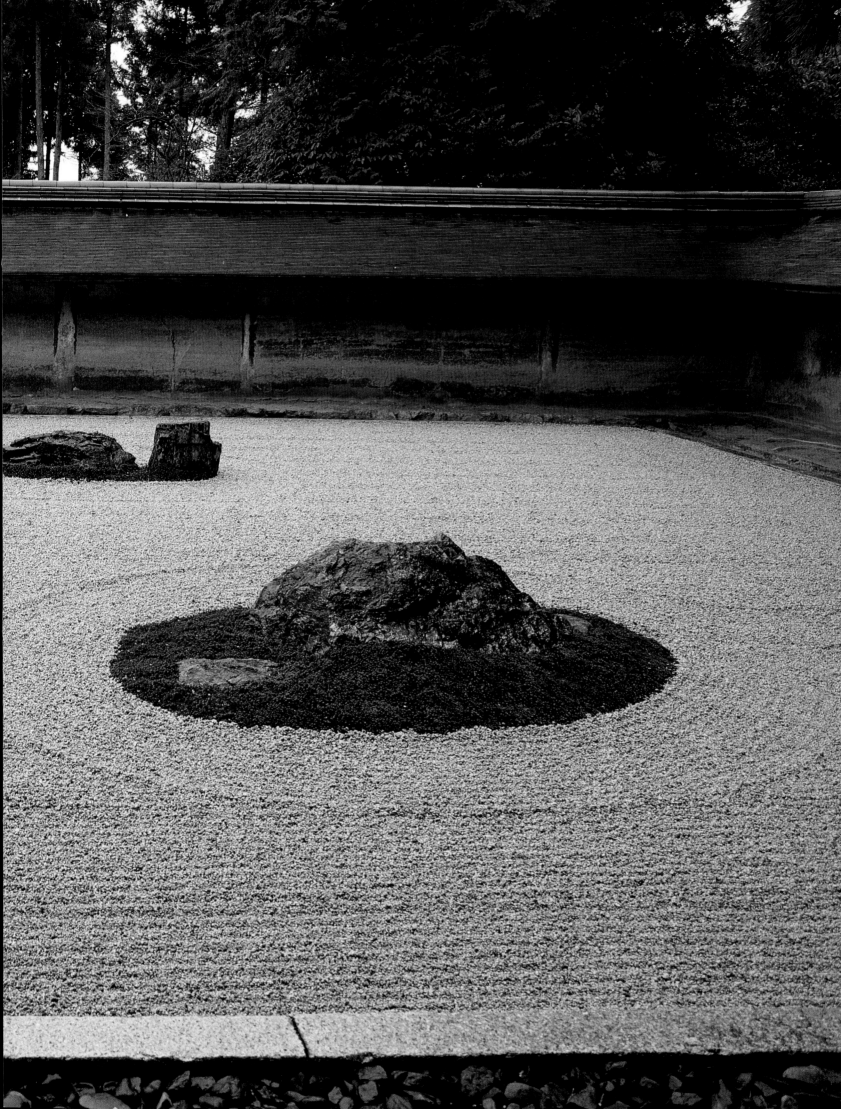

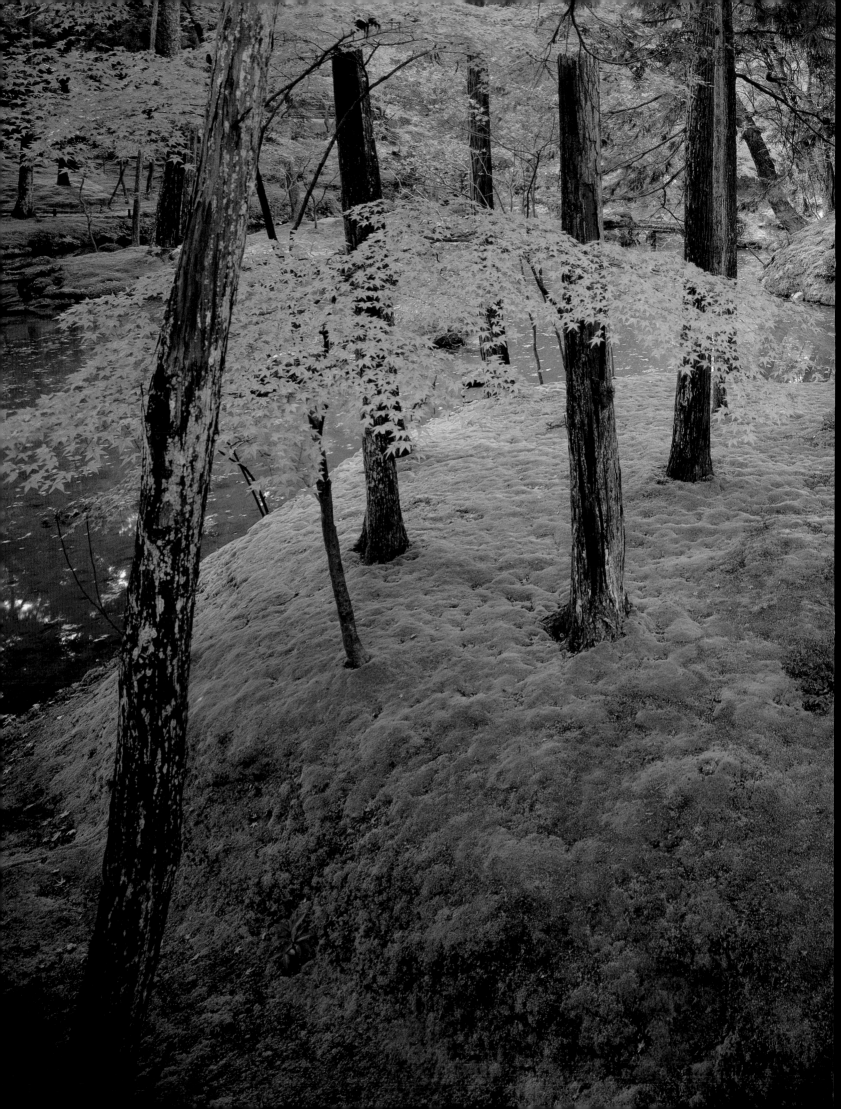

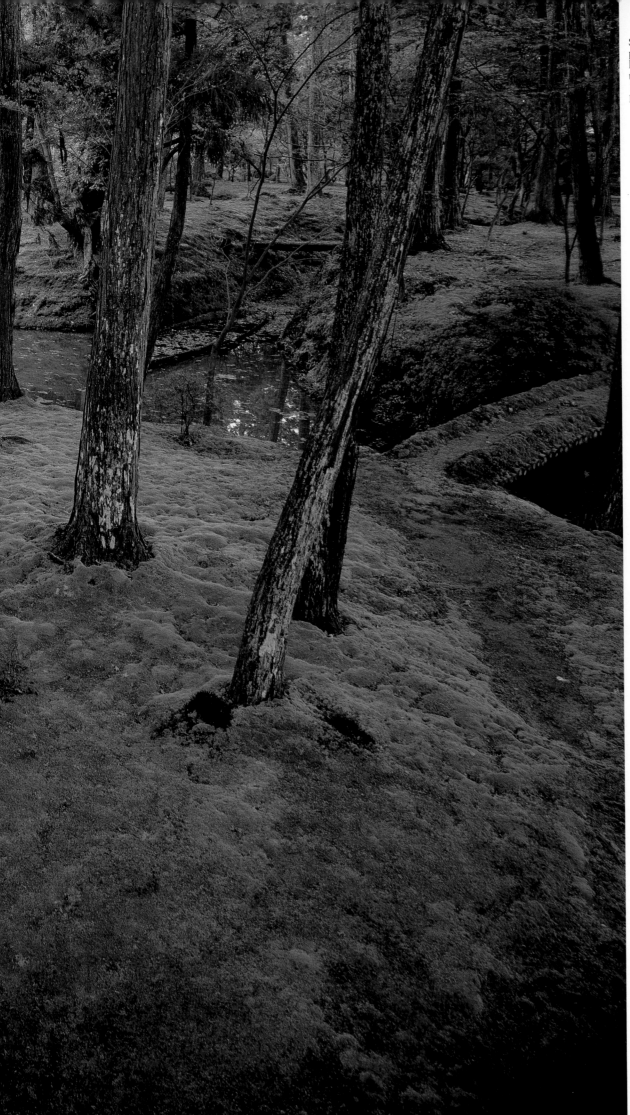

Saihoji temple. The "Moss Temple" is the apt nickname of this heavenly landscape, designed by the Zen monk Muso Kokushi in 1339 to represent the Western Paradise

Daigoji temple. This ornate garden, designed to be viewed from the veranda, is said to reflect the sixteenth-century warlord Toyotomi Hideyoshi's preference for more elaborate effects ▶

187

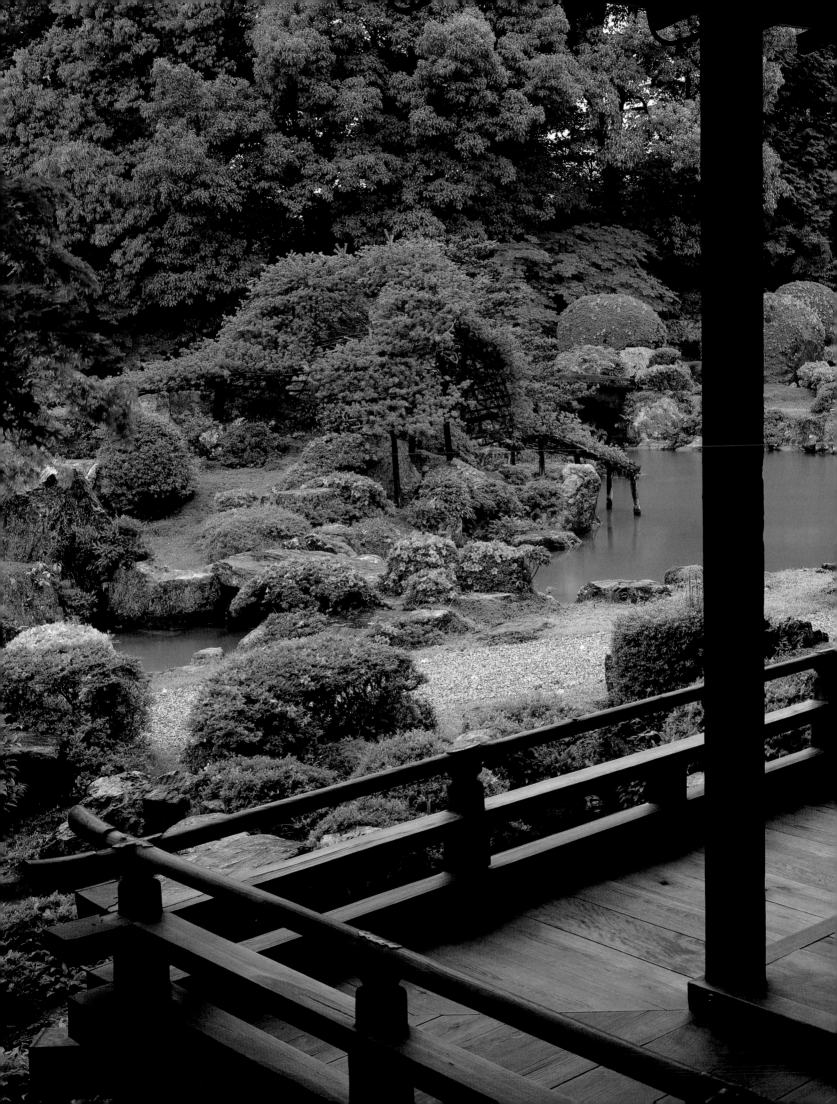

Nanakusa-gayu: a rice gruel with seven savory herbs eaten on the seventh day of the New Year

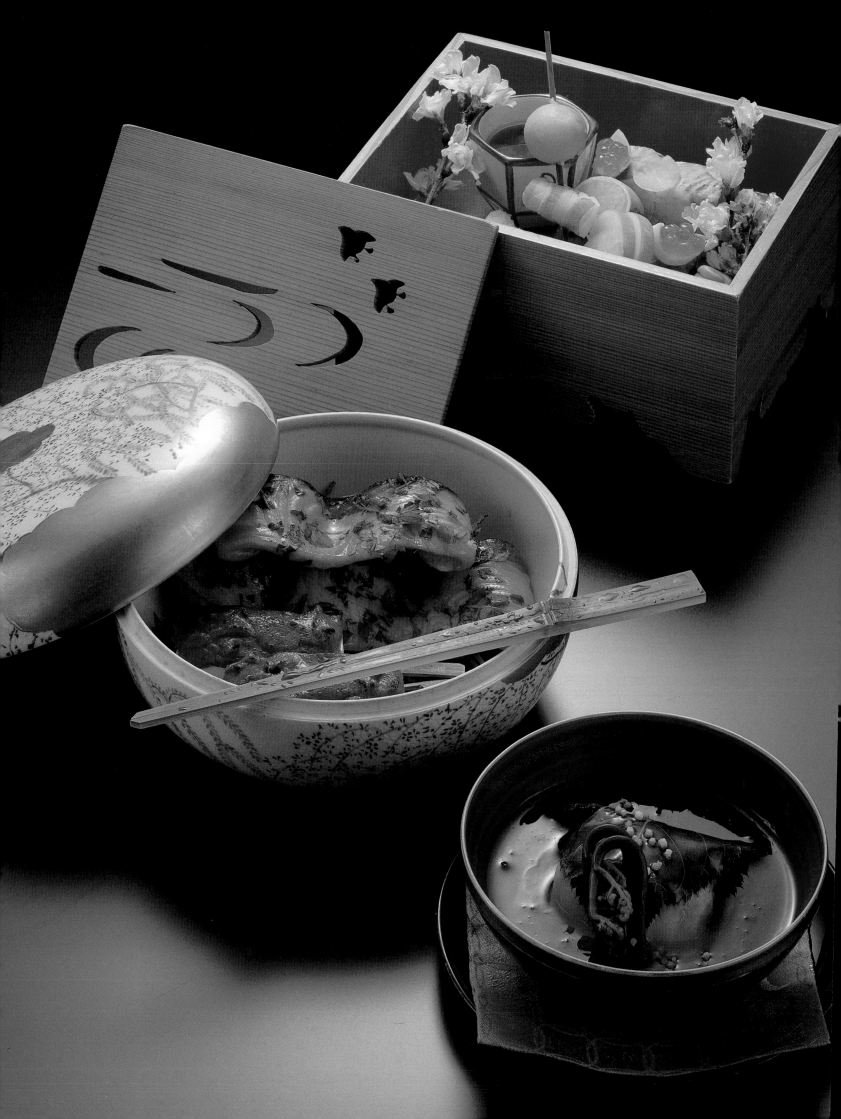

THE BLESSINGS OF LAND AND SEA

Patricia Massy

Kimi ga tame	For you
Haru no no ni idete	Have I gone to the awakening meadows
Wakana tsumu	To gather herbs of spring.
Waga koromode ni	Yet upon my sleeves
Yuki wa furitsutsu	Still falls the snow.

The author of this famous poem, part of the *Hyakunin isshu* anthology, is none other than Emperor Koko, and the product of his excursion into the fields a millennium ago was the young shoots of seven herbs, or *nanakusa*, that would be added to a rice gruel called *nanakusa-gayu*. Although the outing may have been imaginary, gathering wild herbs was certainly a worthy occupation, not at all beneath his dignity. *Nanakusa-gayu* was eaten on the seventh day of the New Year, as it still is. There is one notable difference today, however.

According to the lunar calendar, upon which Japanese life was based until 1873, the New Year coincided with the advent of spring. That would make it February 4 on today's solar calendar, just when the plum blossoms are opening and the first hint of green is appearing in the fields. The joy of seeing winter come to an end and of tasting fresh green things must have been quite beyond anything we can experience in the comfort of our present-day existence. Yet even today, with all the amenities of modern life, the thought of young plants pushing through the snow and reaching for the warming rays of the spring sun thrills the Japanese heart. Whether they live in a town or in the country, many Japanese will venture out to search the southern slope of a hillside or river bank for a telltale bulging of earth—the sign of a just-emerging cluster of butterburr flowers. The search for wild plants is infused with the joy of discovery, and as we consume those plants we partake of spring.

There is a mouth-watering phrase cherished by the Japanese: *shun no mono*—things in season. It denotes more than just what happens to be on the market at present, however. It refers more specifically to something that cannot be had at any other time, like wild vegetables. Bamboo shoots are greeted with inordinate pleasure, because after a year's incubation they pop out of the earth literally overnight, and must be harvested immediately before they mature further. In a matter of weeks the bamboo season is finished. *Shun no*

◀ A selection of spring colors and flavors as presented by one of Kyoto's famous restaurants, Kikunoi

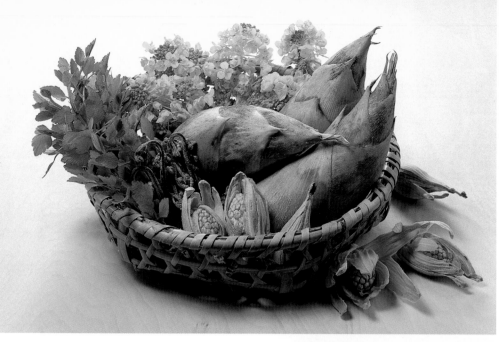

A basketful of spring's bounties

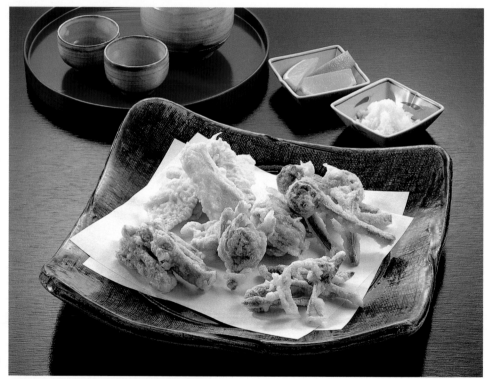

Deep-fried wild vegetables
in a tempura batter

Bamboo shoots garnished
with piquant *sansho* leaves

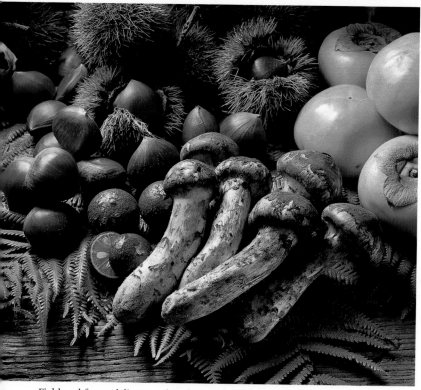

Field and forest deliver an abundance of autumn flavors

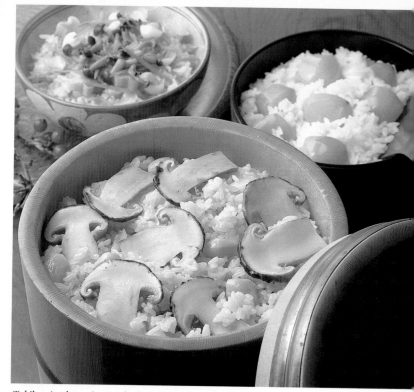

Takikomi gohan: rice cooked with mushrooms, chestnuts, or vegetables indicates autumn has arrived

mono are also sought because they are sweeter, tenderer, or crisper than at any other time.

The bonito that appear off the Japanese coast in May are an example. The early arrivals are rich in oil, and the flesh is firm. Men were known to pawn their kimono just to buy one fish. At the end of the eighteenth century, when the craze for early bonito had reached irrational proportions and the fish was eaten with nose-burning horseradish, we find numerous comic poems about bonito. One of them goes, "First bonito of the season; twice I cried: first over the money, then over the horseradish." In July, the *ayu* season begins. Throughout Japan people take to the rivers to catch *ayu*, or sweetfish, a small delicacy that has hardly any fishy taste at all. Fishermen like to skewer *ayu* on bamboo splits, sprinkle them liberally with salt, and grill them over a fire on the rocky riverbank.

Late summer is eggplant time—shiny, purplish-black eggplants with a soft, sweet flesh and none of the bitterness of the European variety. The finest eggplants are the round *kamo nasu* of Kyoto. They are cut in half, deep-fried in oil, and served with a topping of miso paste. After the eggplants, cucumbers, green soy beans, fragrant *shiso* leaves (perilla) and tomatoes of summer have disappeared from the open-air vegetable markets, autumn brings mushrooms, especially the delicate *matsutake*. The connoisseur delights in a broth of *matsutake*, duck, and white fish, flavored with fragrant *mitsuba* (trefoil) leaves and the peel of an aromatic citron called *yuzu*.

Autumn is also when the *sato-imo* are at their best. Although this taro-like tuber may not look particularly appetizing, it has a wonderfully earthy flavor and soft texture. The late inimitable gourmet Kitaoji Rosanjin believed that hardly anything could surpass *sato-imo* simmered in a broth of bonito flakes, kelp, and soy sauce. So adored are the little *sato-imo* and its *imo* relatives that the full moon of October is known as the *imo*, or potato, moon.

The tastes of summer refreshingly presented by the gourmet Kyoto restaurant Kikusui ▶

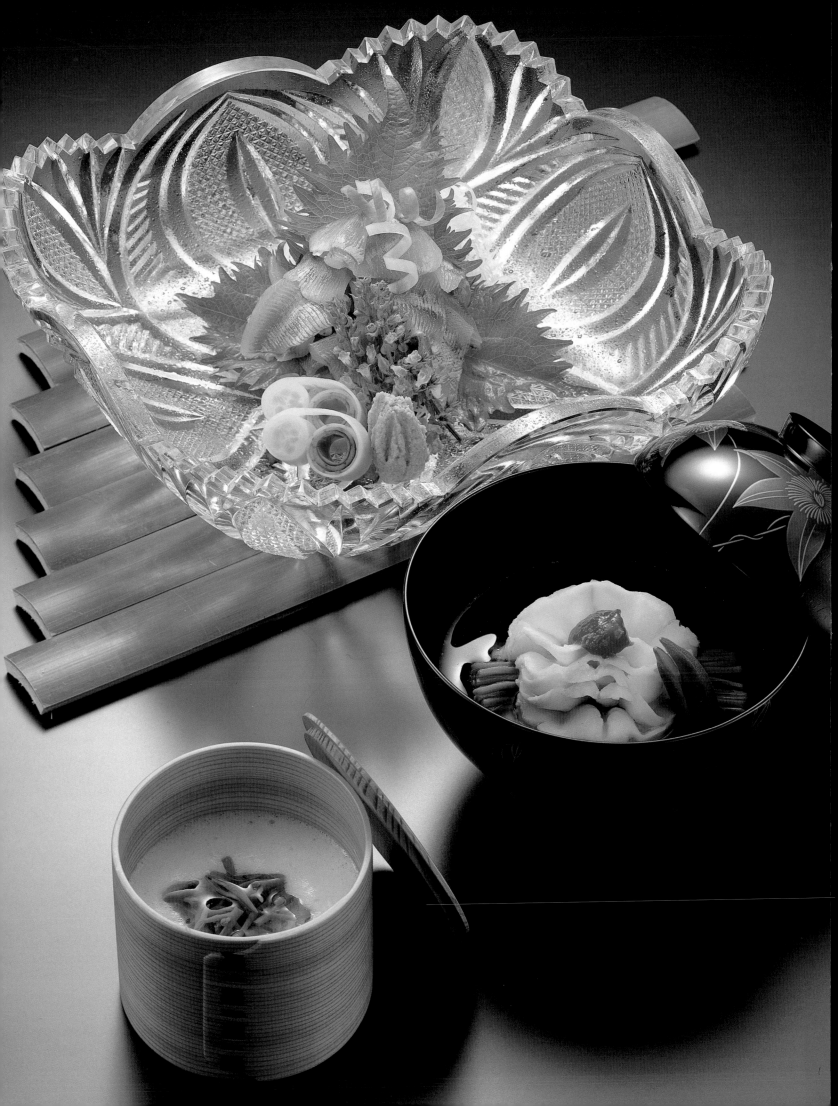

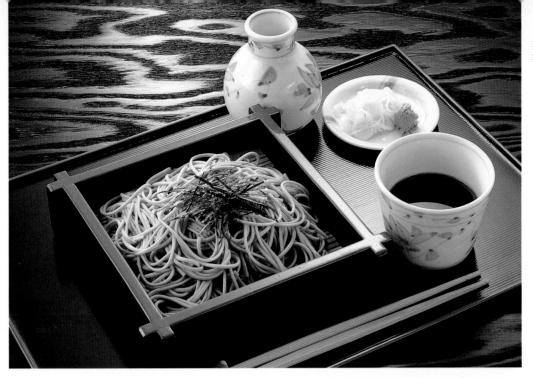

Buckwheat noodles to be dipped in a soy sauce broth mixed with chopped green onions and horseradish

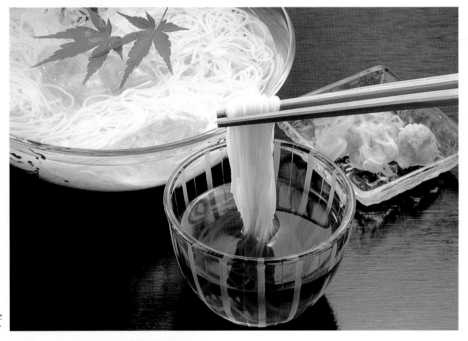

The thin white noodles called *somen* are a favorite repast at the height of summer

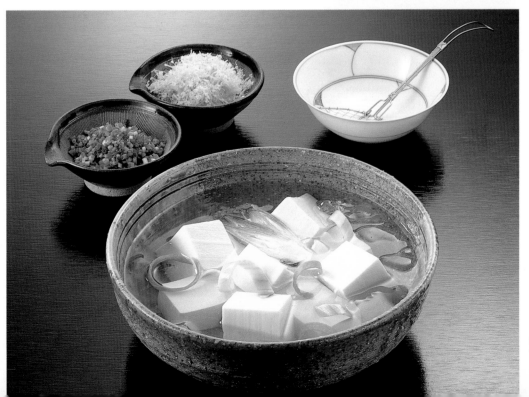

Cubes of fresh tofu in chilled water: a refreshing summer dish

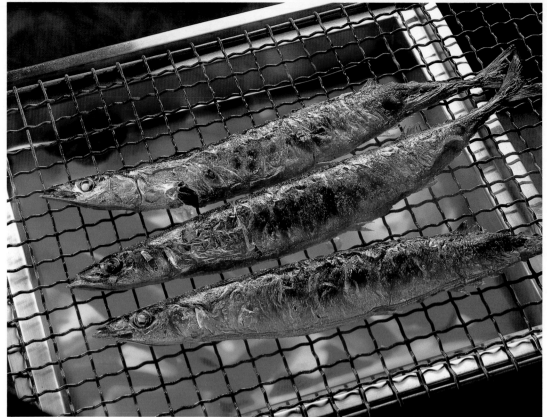

Charcoal-grilled *sanma*, or saury

Whatever happens to be at its prime thus invites us to enjoy the season to its fullest. Not only will the taste be at its finest, there is also the pleasurable experience of taking part in the moment, like the sensation offered by a haiku poem. A sophisticated restaurant will have a deck built out over a river or stream where the guests can eat grilled *ayu* served with an aromatic vinegary sauce. The juicy white meat of the *ayu*, the clear rippling water, and the deep green of the leafy canopy overhead together create a refreshing respite from the summer heat. Even in an ordinary home, creating an image of coolness is one of the joys of summer. The white noodles called *somen* are served at this time of year, because, being thin and translucent, they look cool, and they will be presented in a large glass bowl filled with ice water. A sprig of miniature maple leaves perhaps will be floating in this sea of *somen*, and the chopsticks might be of freshly cut green bamboo.

A fat and therefore warmer-looking noodle called *udon* is the choice in winter, served piping hot in a thick, handmade earthenware casserole. In early winter, a chef might slice carrots in the shape of maple leaves and cut yellow pumpkin to look like ginkgo leaves. These would be combined with lotus root, *shiitake* mushrooms, green flat beans, and ginkgo nuts threaded on pine needles so that the whole colorful arrangement resembles leaves blown together by the wind. Vegetables deep-fried in a tempura batter might be placed in a miniature winnowing basket to create the impression of harvest time. Boiled yellow chrysanthemum petals in a vinegar dressing would be a perfect complement.

The poetic aspect of Japanese food is particularly evident in Japanese sweets. During the *ayu* season, one might receive a basket of *ayu*-shaped cakes. At the peak of the summer, white jelly-like wedges with a sprinkling of dark beans on the surface appear in the sweet shops. These are meant to resemble the ice that in former days only the imperial household could enjoy. When

Fukiyose, leaves blown together by the wind, describes the autumn presentation by the Kyoto restaurant Tankuma ▶

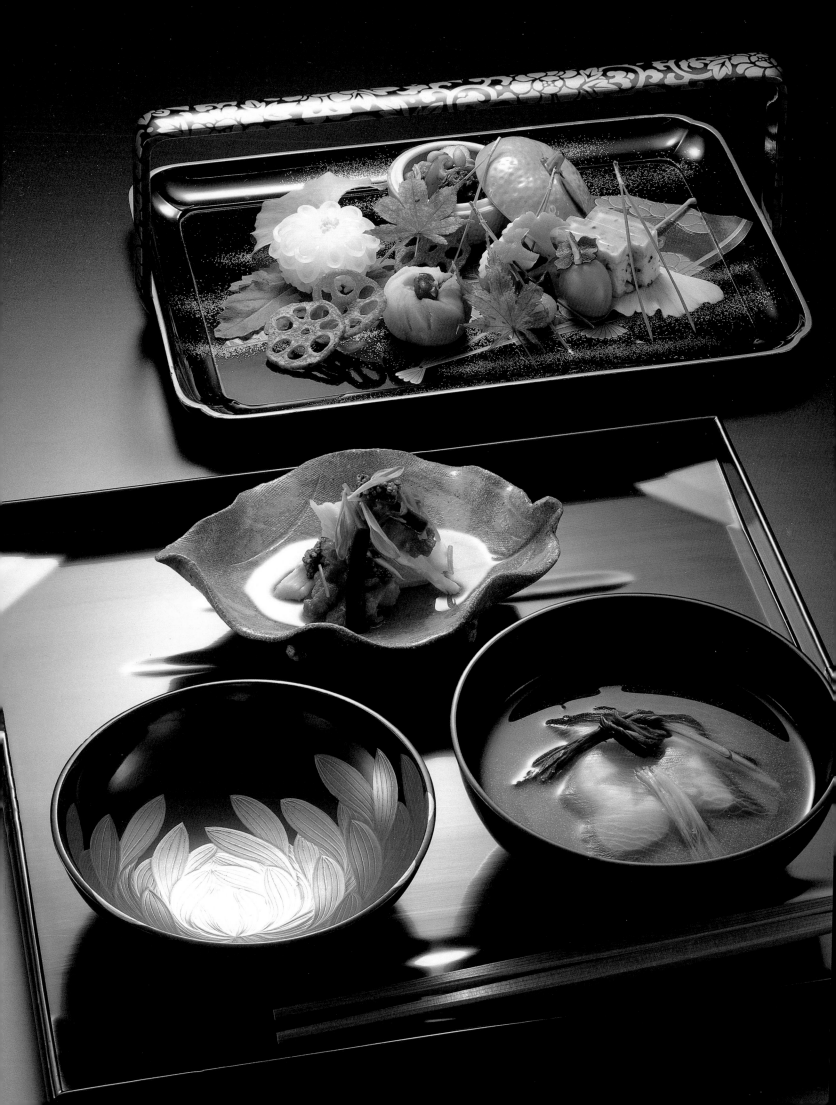

Steaming hot *oden*: a nourishing and invigorating
winter meal for the family or a party of friends

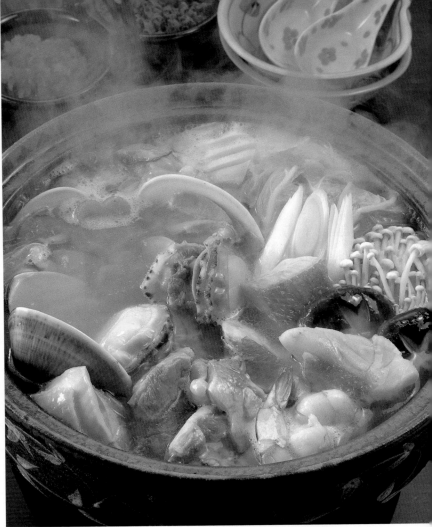

Yosenabe: a casserole of vegetables
and fish cooked at the table

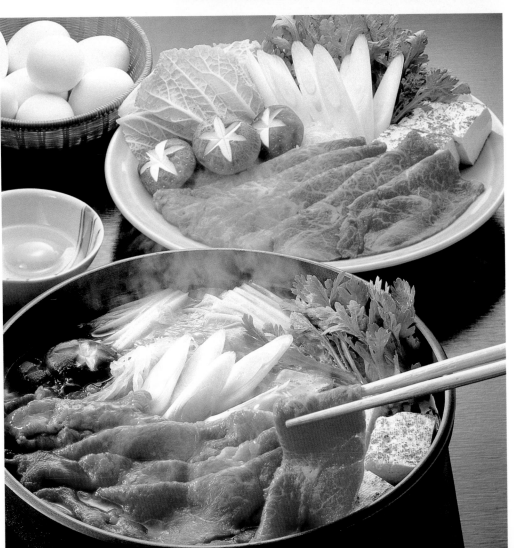

Sukiyaki: a perfect combination of meat
and winter vegetables cooked at the table

Wrapped in an oak leaf, the sweet called *kashiwa mochi* is eaten on May 5

the cherry blossoms are in their glory, the specialty is a sweet crepe delicately tinted pink and wrapped in a salted cherry leaf. No matter how delicious this *sakura mochi* may be, it would be entirely incongruous to eat something reminiscent of cherry blossoms when the maple leaves were beckoning us to admire their autumn colors.

In the same way, the oak leaf–wrapped sweet called *kashiwa mochi* is available for only a month or so on either side of May 5, and no one would feel like eating it at any other time. Here, however, the seasonal association refers to human events rather than the natural world. May 5 is what is called *sekku*, a day that was originally set aside for special rites to mark the passage of the seasons and assure protection from illness. The oak leaf was adopted for the May 5 event because it has a strong scent that would, it was hoped, repel evil spirits. When in later years May 5 became primarily a celebration for boys, the oak leaf was seen as a symbol of spiritual strength. January 7 is also a *sekku*. Appropriately, the seven herbs eaten on this day are extremely healthful and were thus an ancient form of health insurance. In fact, most of the wild spring plants are rich in vitamins A and C. One plant in particular, the *yomogi*, or mugwort, was the primary medicine in premodern times. Boiled and mixed with rice flour, it is what makes the rice cakes called *kusa* (grass) *mochi* green. They, too, are eaten on May 5 and other *sekku*. Today we know that *yomogi*, like green tea, is an anti-carcinogen.

It begins to seem as if the practice of eating certain foods at specific times was a deliberate means of ensuring that the body was getting necessary nutrients and vitamins. *Azuki* beans, because they are a felicitous red, appeared at any celebration, but they were also often eaten on the first and fifteenth days of the month, especially January 15. In this way people were assured of getting the protein they needed. Eel, packed with vitamin A, is eaten on the day in summer called *Doyo* to combat the fatigue that accompanies Japan's debilitatingly humid heat. Pumpkin, another source of vitamin A, is served in Kyoto with red beans at the winter solstice to prevent colds. That the founder of macrobiotics was a Japanese thus comes as no great surprise.

Although health may have been, and still is, a prime factor in the Japanese way of eating seasonally, there seems to be another fundamental reason why, for instance, cookbooks are often arranged seasonally, why poetry extols the

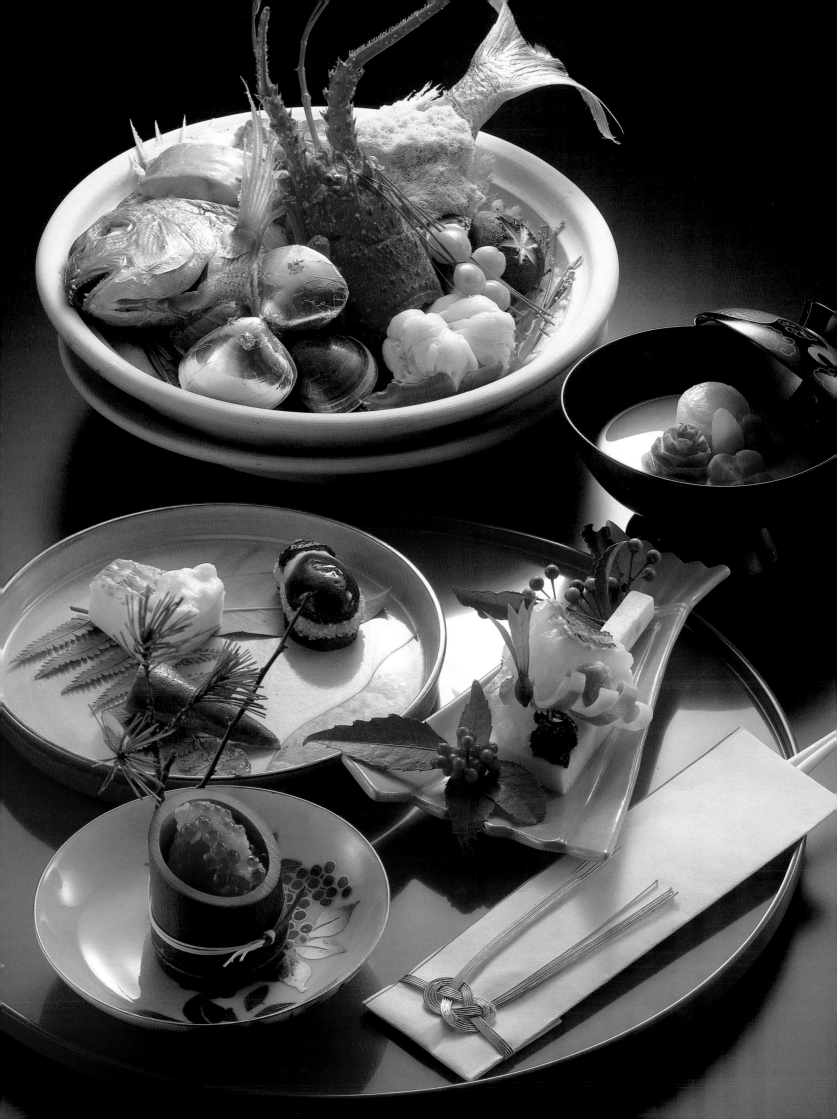

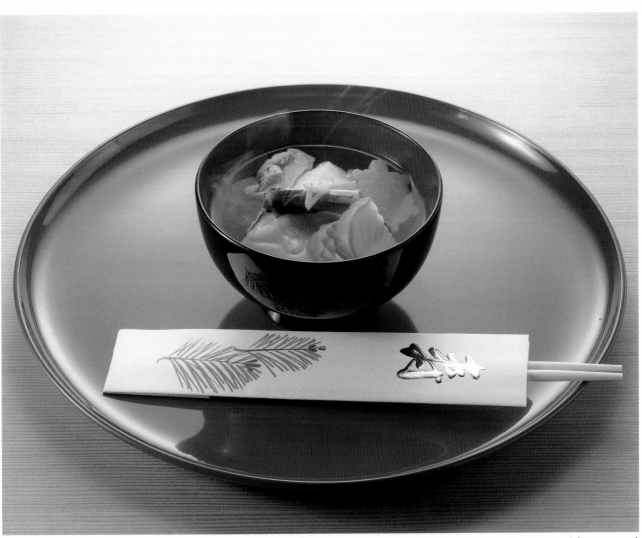

O-zoni, a special soup served on New Year's Day

pleasures of eating rape blossoms in March or deep-fried tassels of new rice in November, and why a spring without bamboo shoots or autumn without mushrooms would be like a year without cherry blossoms or maple leaves. The reason is the love and wonder for nature that has through the ages characterized the Japanese outlook. They admired the zelkova tree for its dark, burly grain, the cryptomeria for its light-colored wood that is straight and smooth, and from these trees they produced magnificent works of art and architecture. Does not the contrasting beauty of these woods mirror the crumpled skin of acorn squash and the crisp whiteness of daikon? In the squash is the power of the sun; in the daikon the power of the earth, and both of these command awe. At Ise stands the grand shrine to Amaterasu, the goddess of the sun. A few miles away is the shrine of Toyohime-no-mikoto, the goddess who provides Amaterasu, and by extension the people of Japan, with sustenance, for if the sun were to die, so would the people. Every day without fail, offerings of the bounty of land and sea are prepared for both goddesses. The harvest of rice in November is occasion for special celebration at Ise, as it is in farming communities throughout the land, where smaller offerings are made at appropriate times in the year. New Year's is one of these. Whether fish or plant or animal, all things are believed to spring from a spiritual power, the same that created human beings. To the Japanese the beauty of nature and the joy of eating are one and the same: they are the blessings of the gods, the blessings of the seasons, and part of the celebration of life.

◄ Winter is the time to enjoy the bounties of the sea as prepared here by the Kyoto restaurant Isecho

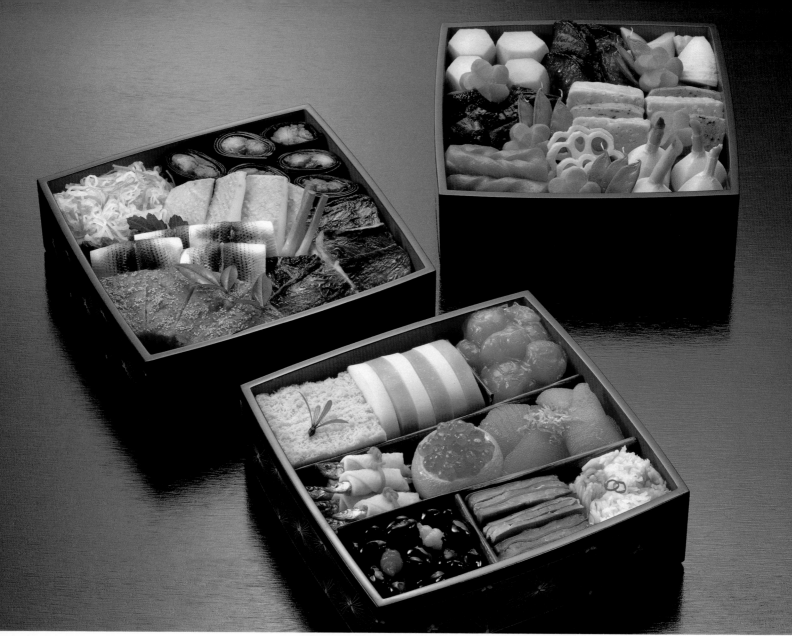

The New Year is celebrated with
special delicacies neatly packed
in lacquered boxes

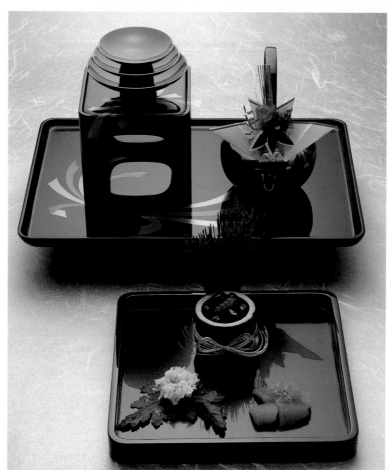

O-toso, saké with medicinal herbs,
served in a lacquered vessel made
solely for festive occasions

Path to the tea garden's inner gate

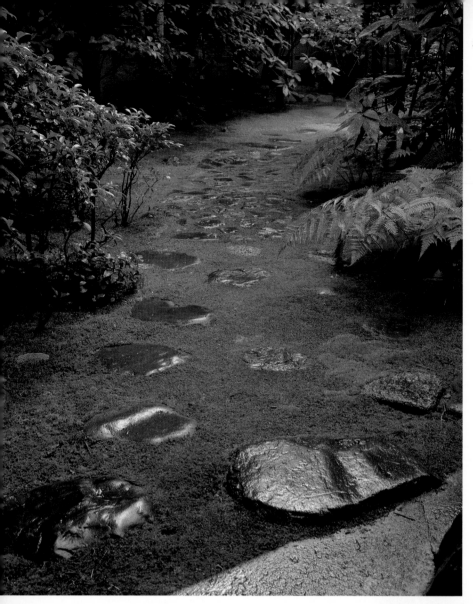

Stepping stones to the tea house

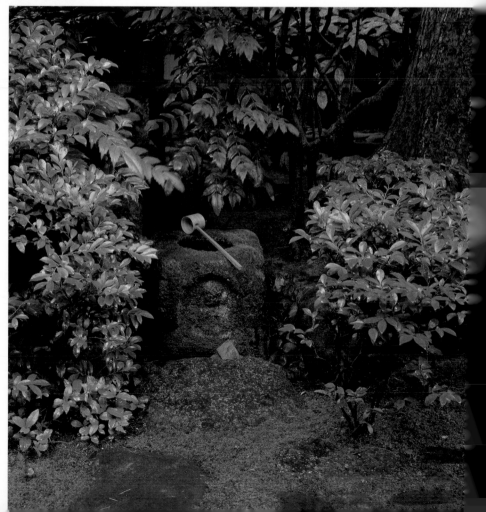

Guests cleanse themselves ritually here
before entering the tea house

A PRESENCE OF MIND

Margaret Price

I t is dawn on a midsummer day in Tokyo. The cooler hours just before and after sunrise are the only time that one will be invited to a tea ceremony in the month of August. Our party takes a seat in the waiting arbor. There are no flowers in a tea garden. The garden is formally known as the "dewy path," and that's what it must be like—a track in the woods fresh with dew. This one has been sprinkled with water before our arrival, and the smell of damp earth rises from it.

We exchange a silent bow of greeting with the host, then rinse our hands and mouths at a stone basin brimming with cool water. The entrance to the tea house is low enough to make us stoop and bow our heads. The scroll in the alcove reads "Mountain Breeze," and the translucent paper window screens have been replaced with bamboo slats, which let in a breeze and the cry of wakening cicadas.

The host adds charcoal to the brazier and serves a meal—the thick green tea we are about to drink can be hard on an empty stomach. Soup, fish, pickles, and rice. Every grain is consumed, and we wipe our bowls clean with a sheet of soft paper before returning the tray.

Sweets are served, and the preparation of the tea begins. Kneeling in silence, we watch a familiar routine: the folding of the silk cloth for the ritual purification of the tea container and tea scoop, the rinsing and wiping of the tea bowl, the cascade of brilliant green as the powdered tea is poured from the tea container into the bowl, and the measured rhythm of the blending of the tea with hot water.

The bowl is passed from hand to hand: three sips each in fellowship for the occasion. The "thick tea" (*koicha*) is followed by more sweets and a bowl of thinner whisked tea (*usucha*), one for each person. The atmosphere lightens, and we comment on the taste of the tea, the antiquity of the tea container, the pedigree of the tea bowls, the cool freshness of the water jar with its lotus leaf lid, even variances in the weather. We express our thanks and the host sees us off in silence. A hot day lies ahead.

So what does all this mean? People often ask if a tea ceremony like this is something the Japanese practice at home for relaxation. No—few people have the luxury of owning a tea house today, and, more importantly, few have the motivation to entertain friends or family in one. The tea ceremony has always been, with the exception of the Buddhist priesthood, the privilege of the elite.

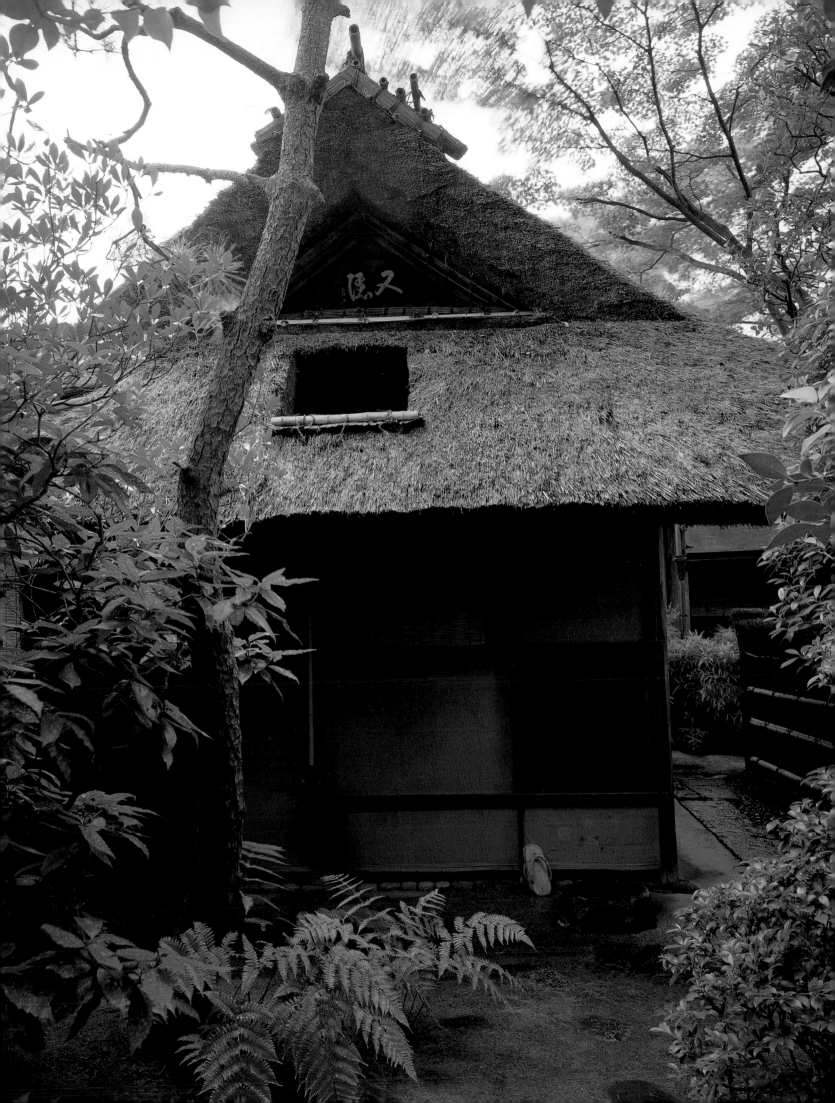

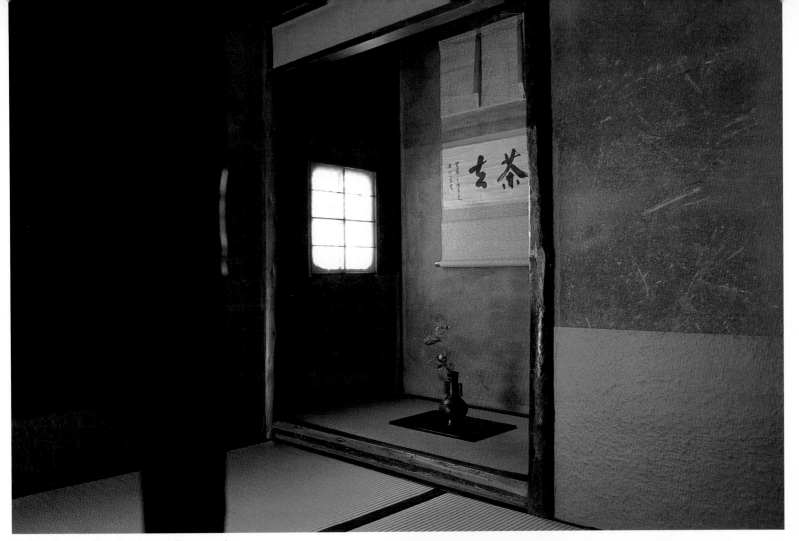

The hanging scroll in the alcove tells guests the spiritual meaning behind the day's gathering

In winter, a sunken hearth is used to heat the water

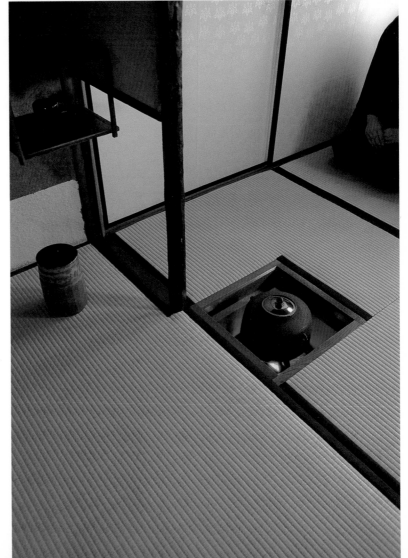

The tea house is as a humble hermit's cottage. The small door is only big enough to crawl through

However, rephrase the question and ask if there are many people in Japan who study tea, and the answer would be yes, there are millions—men and women, rich and poor, belonging to a hundred or more different tea schools, in every corner of Japan. Every week, all year round they go to their teacher for two hours, sharing a class with three or four others. Each takes a turn preparing tea and practicing being a guest. They return home and come again the next week, many for the whole of their lives.

In the process the tea student not only learns how to make tea but also how to make the perfect charcoal fire, how to look after utensils and prepare the powdered tea, how to appreciate calligraphy, poetry, pottery, lacquerware, woodcraft, gardens, and flower arrangement. They learn how to deport themselves in a tatami room and always to think of others first.

The teacher discourages studying from a book and makes sure all movements are learned with the body and not with the brain. The important thing, she says, is to practice until you can carry on in spite of yourself. "One day you'll be making tea in front of real guests. You'll get nervous and your mind will go blank. At that time you must rely on your body to get you through. That is why you must practice until the movements are second nature." And that is why the traditional arts of calligraphy, flower arranging, and the martial arts were originally taught without texts or manuals—because the goal is never the intellectual grasp of the subject but a gradually acquired presence of mind.

So each week there are slight variations in the practice routine as dictated by the utensils and the season. Each week, something new to knock the complacent off balance again. Each week the student is reminded that this is not a course of study to be completed but life itself. And it does not matter if the student never goes to the kind of formal tea gathering described above, the culmination of the art. For the student, it is the process of learning that counts: the tiny accumulations of knowledge and gradual fine-tuning of the senses; the small but satisfying improvements in the ability to cope gracefully with the small dramas of the everyday.

The mysterious power of the tea ceremony lies here, in this very unfurling of self-realization. It is not something that is revealed to the casual observer but only to those who have embarked on the long path. We owe this beautiful system of spiritual training to the sixteenth-century tea master Sen no Rikyu and his Zen teachers.

Tea utensils: containers for thin and thick tea, bamboo scoop and whisk, and cold-water jar ▶

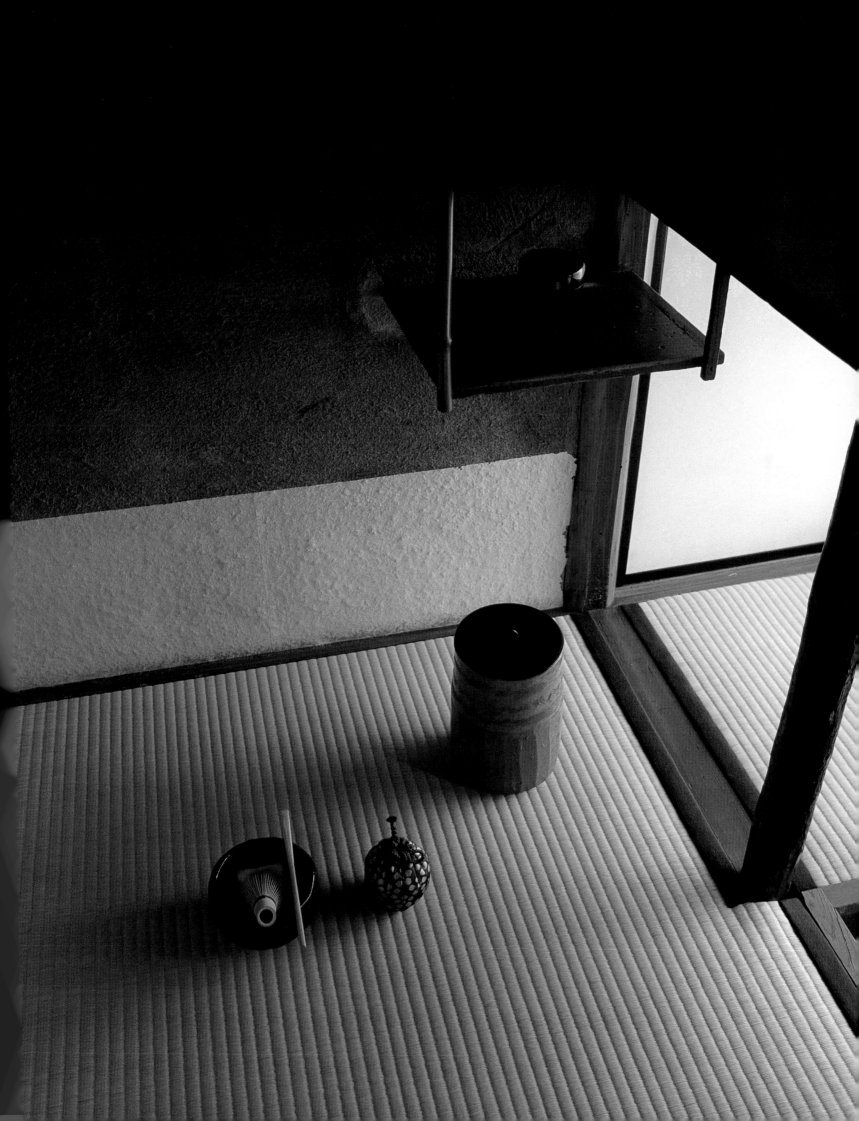

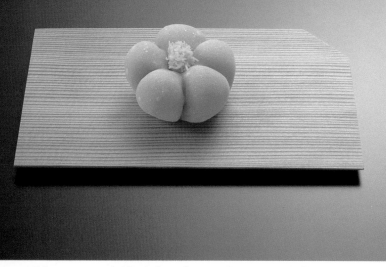

A February sweet, the "Red Plum Blossom of Deep Winter" ("*Kankobai*")

A May sweet, the "Chinese Silk Robe" ("*Karagoromo*")

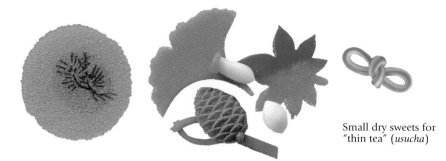

Small dry sweets for "thin tea" (*usucha*)

Sweets for "thick tea" (*koicha*) are usually served in individual boxes

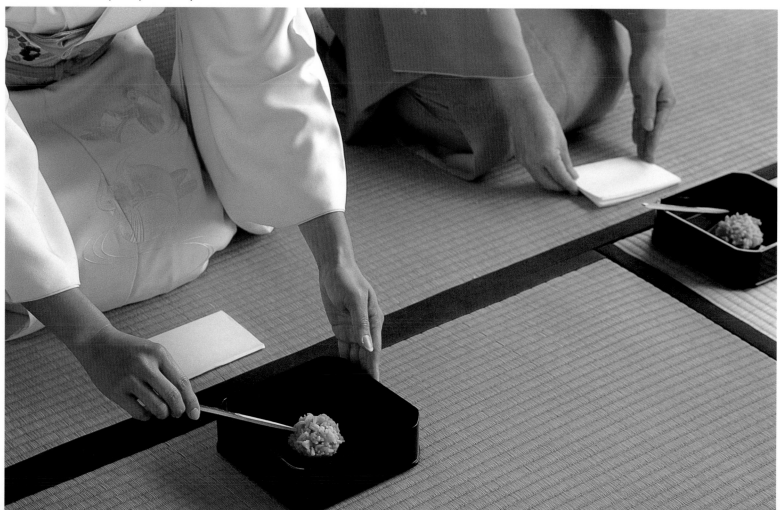

Tea is scooped and then poured
into the bowl for thick tea

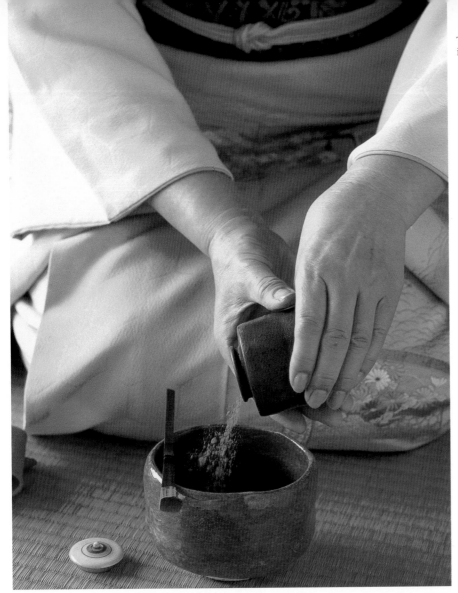

Thick tea is served

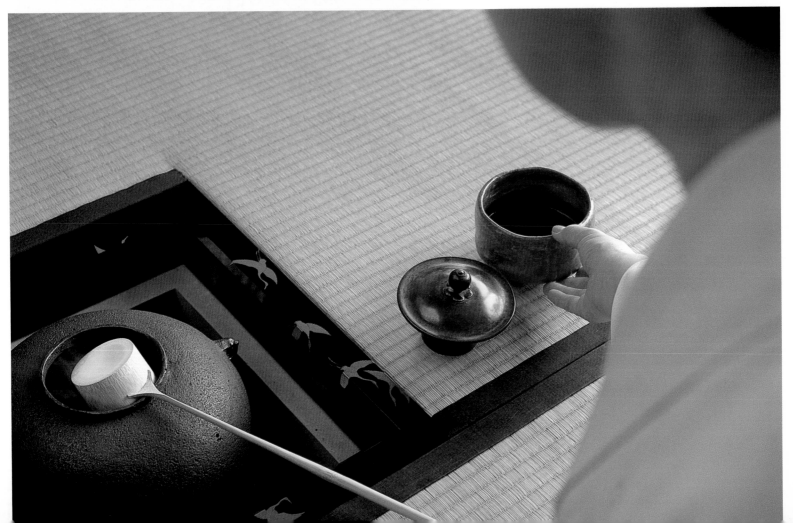

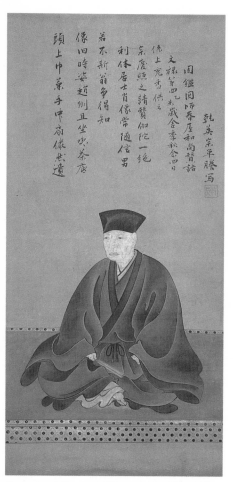

Portrait of Sen no Rikyu, who refined the concept of *wabi*-style tea

The meal served at a formal tea gathering should be just enough to take away the pangs of hunger ▶

Sen no Rikyu (1522–91) was the son of a rich merchant of Sakai, near Osaka. During the sixteenth century, Sakai was the most prosperous trading port in Japan. Rikyu's lineage is significant. Only the rich and powerful came into contact with the world of tea, and when Rikyu began to study, the tea ceremony was usually an occasion for the ostentatious display of rare and expensive tea utensils. But Rikyu became more interested in the way Zen priests approached the tea ceremony, seeing in it an embodiment of Zen principles and their appreciation of the sacred in the mundane.

One fifteenth-century Zen master in particular, Murata Juko, broke with all convention. He performed the tea ritual for an aristocratic audience in a humble four-and-a-half mat space. Taking his cue from such example, Rikyu started to simplify tea and eventually stripped everything non-essential from the tea room and the style of preparation. He developed a tea ceremony in which there was no wasted movement and no superfluous object.

Central to Rikyu's tea ceremony was the concept of *wabi*. *Wabi* literally means "desolation." Zen philosophy sees this positively and says that the greatest wealth is to be found in desolation and poverty. When we have no attachments to material things, we look inside ourselves and find true spiritual wealth there. *Wabi* is therefore sometimes referred to as "the beauty of poverty."

Rikyu's tea ritual was designed to direct the consciousness to this wealth within. Instead of using expensive imported vessels in lavish reception halls, Rikyu prepared tea in a thatched hut using nothing but a simple iron kettle, a plain lacquered container for tea, a tea scoop and tea whisk whittled from bamboo, and a common rice bowl to drink from.

The only decoration in a *wabi* tea room, apart from the inherent beauty of the architecture, is a hanging scroll or a vase of flowers placed in the alcove. Because of the very lack of decoration, we become more aware of details, and we see, hear, and smell things we don't normally notice—the hiss of simmering water, the beauty of glowing charcoal, the heady aroma of the tea. We suddenly remember that these simple gifts are the most important things in life. The tea ceremony opens the senses. It is not a time for relaxation but a time to be awakened to our surroundings and to ourselves.

It is because of Sen no Rikyu and the simplicity of his *wabi* style of tea that the tea ceremony endures today. Within the simplicity of the world he created, there lies a beauty of which one never tires.

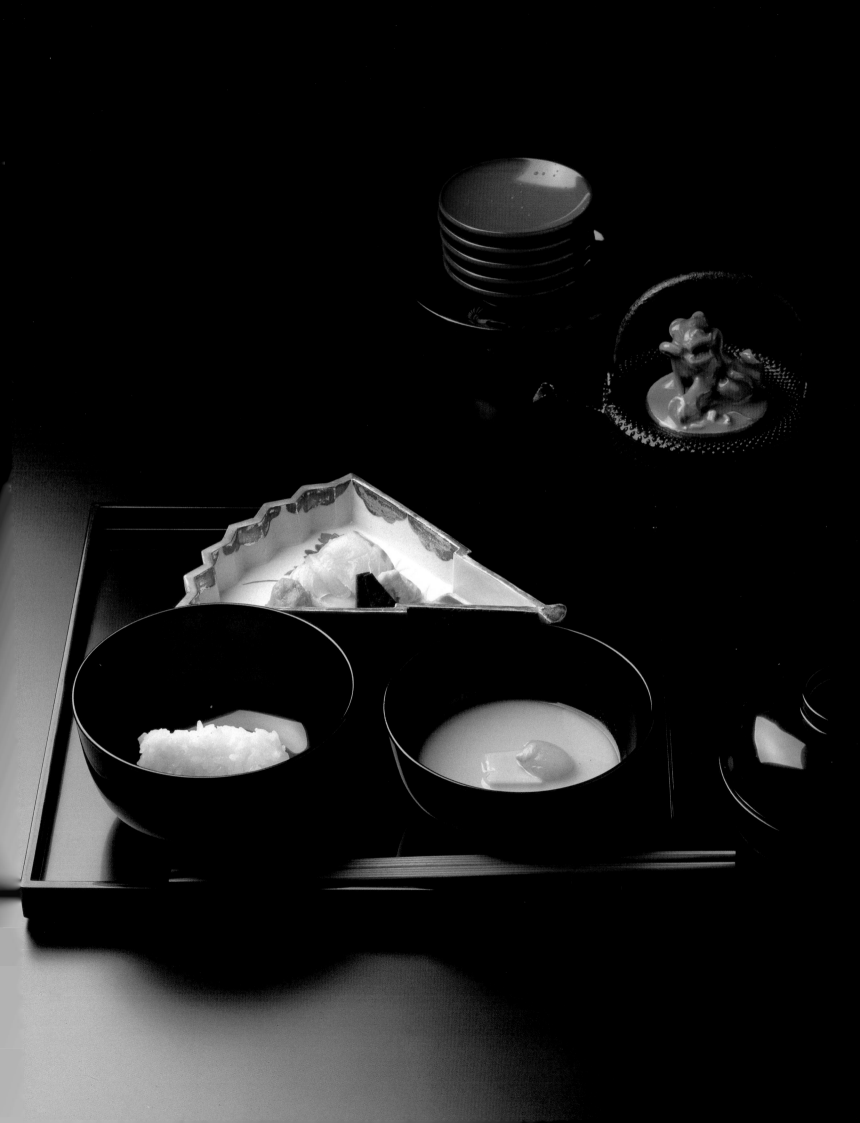

Spring arrangement: Bleeding heart in a lacquered bamboo hanging vase

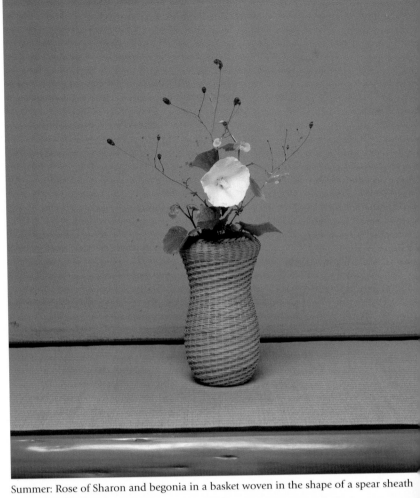

Summer: Rose of Sharon and begonia in a basket woven in the shape of a spear sheath

Autumn: Japanese anemone in an antique crane-necked bronze vase

Winter: Camellia bud and *Tosa mizuki* dogwood in a bamboo vase

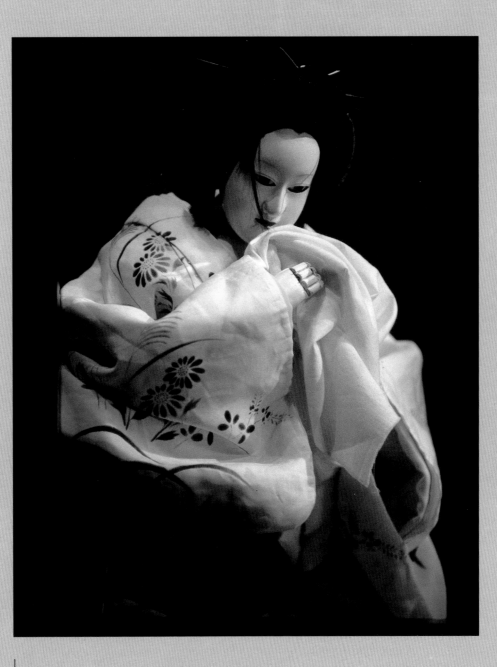

Bunraku: A wife who has committed adultery with the handsome spear carrier Gonza prepares to be executed by her husband. *Yari no Gonza Kasane Katabira*

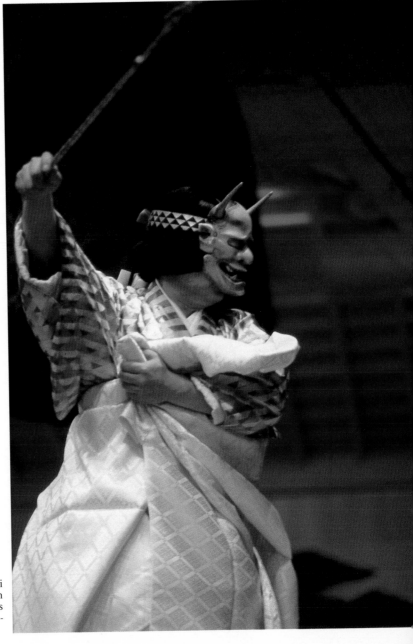

Noh: The ghost of the young warrior Atsumori appears to the man who killed him in battle. *Atsumori*

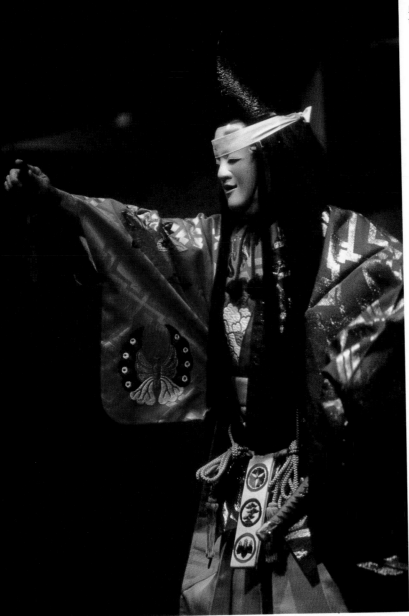

Noh: The spirit of a scorned woman arrives at Dojoji temple to destroy the bell that once prevented her from meeting the object of her affections. The mask expresses the woman's demonlike anger. Above the actor is a brocade-covered prop that represents the bell. *Dojoji*

BLOSSOMS AND THE MOON
Seasons of the Heart on Stage

Mark Oshima

Japan has a rich variety of performing arts, from the classical simplicity of the Noh theater and the spectacular melodramas of Kabuki to a wide range of modern theatrical forms. Running through all of these is a sensitivity to nature and the changing of the seasons. Human drama is transposed onto natural imagery, not as mere symbols, but almost as though people's hearts were actively worked upon by flowers and the moon and the shifting of the seasons. Fragile cherry blossoms evoke images of love and human mortality, snow might suggest aging, or purity, or human coldness. Nature inspired the song and the texts of the drama, and in turn, as if by a kind of magic, words almost physically invoke the sights of nature, which form an essential element in the world of traditional theater.

In Japanese myth, performances have the capacity to move the gods and nature. Ancient chronicles describe the sun goddess Amaterasu hiding in a cave when she was angry at the misbehavior of her brother. This brought darkness to the land, so the goddess Uzume jumped onto an upturned wooden tub and did a lewd comic dance. The laughter of the gods tempted Amaterasu out, bringing sunlight to the land once again. This tale could be regarded as the founding myth of the performing arts in Japan, and it is reenacted in many traditional performances, especially those associated with Shinto ritual.

One ancient religious ritual has found a home in the Noh theater. *Okina*, the oldest play in the Noh canon, opens any full program of Noh in which it appears and consists of prayers and dances unconnected by a story line. The word "okina" means "old man," the figure symbolic of longevity and eternal youth. In the play, an old man dances slowly and solemnly for prosperity. After this dance, performed by a Noh actor, there is a lively parodic version of his dance called a *sanbaso* operformed by a comic Kyogen actor. The climax of this dance features stamping and the vigorous shaking of bells at the stage floor. Sometimes, as part of a festival, this is performed outdoors on an earthen stage. Then, the performer shakes the bells at the earth, underscoring the fact that this has evolved from an agricultural fertility dance. Special austerities must be observed by the Noh actor in preparation for taking on the role of the old man, and the play itself is now only presented at New Year's and other special occasions, but the *sanbaso* has taken on a life of its own in

the Kabuki and Bunraku theaters, being performed in a bewildering variety of forms, including a version in which a Kabuki actor dances as an enormous marionette.

Noh, in the poetic drama form that we are familiar with today, was largely the accomplishment of Kan'ami and his son, Zeami, in the latter half of the fourteenth century, an age when the rough world of the warrior blended with the cultured elegance of the imperial court. In presentation it seems very slow and spare, being performed on a bare wooden stage decorated solely with a painting of a gnarled pine on the back wall. It features very few performers: the main actor, or *shite*, who is masked, the secondary actor, or *waki*, and a Kyogen actor, supported by a chorus and a flute-and-percussion ensemble. However, this economy of setting is offset by the richness of the accoutrements, from the lavish brocade of the costumes of the *shite* to the exquisite carving of the masks he wears—many of them artistic treasures—and the poetic richness of the chants and songs.

Most often, the *waki* is a priest wandering through Japan who comes to a famous place, encounters the ghost of some great historical figure, and prays for the spirit's salvation as he beholds the drama of the character's past life narrated and danced. In *Atsumori*, the priest played by the *waki* was once a warrior. He travels to the scene of an important battle he participated in. Although the performer barely moves, the chorus describes the scenes as he travels, evoking them for the audience. While lost in memories at the battle-field, he encounters a grass-cutter, played by the masked *shite* actor. The grass-cutter is actually the ghost of Atsumori, a young general of the Heike clan that the priest had been forced to kill in his samurai days; his remorse for this death first set the priest on the path of religion. The grass-cutter disappears, asking the priest to pray for him, and, in the second half, the *shite* reappears as an armored warrior, in a different costume and mask. In a passage full of natural imagery, he tells the story of the rise and fall of his clan. Although the ghost of Atsumori tries to attack the priest, the latter's prayers bring forgiveness and reconciliation between the two and with the dawn the ghost vanishes.

Noh is so stylized as to seem artificial, but it is firmly rooted in nature. To many it feels unbearably slow, but to theater director and designer Robert

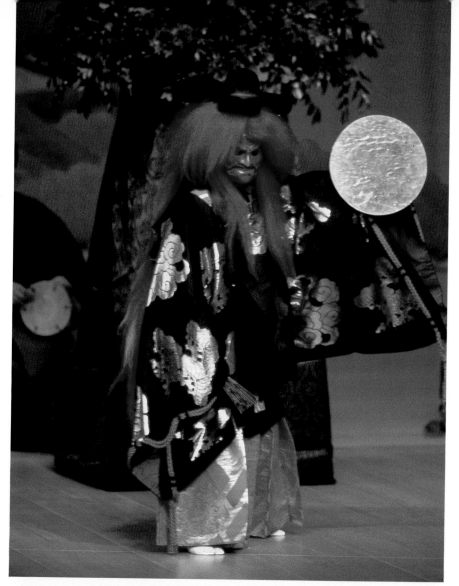

Noh: A protective demon emerges from an earthen mound holding a sacred mirror. In the daytime, this mirror is embodied as a pond. *Nomori*

Noh: The ghost of the courtesan of Eguchi appears with her attendants in a magnificent pleasure boat, suggested by the simple wooden framework. *Eguchi*

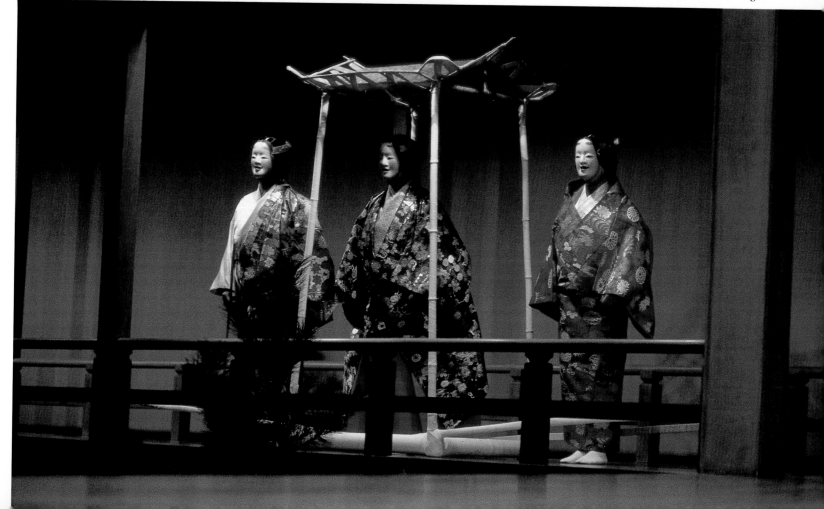

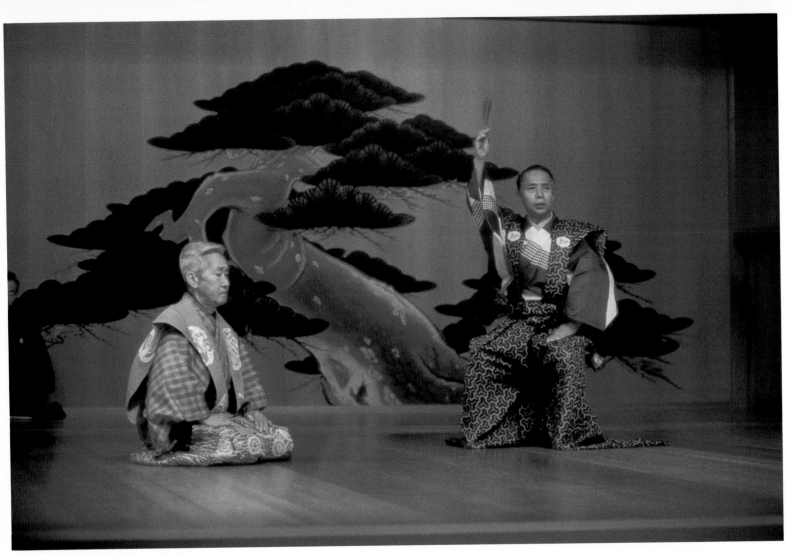

Kyogen: This type of traditional theater combines humor and drama at the most universal level. Solemnly, a master recites in song and word the story of his family to his servant Tarokaja. *Jisenseki*

Wilson, Noh is superbly natural: "It is the speed that it takes for the sun to set or for a tree to grow." Noh is full of seemingly innocuous natural imagery that, in fact, represents the full range of human psychology.

Stylization has another impact as well. In one of his essays, Zeami, the great performer and Noh playwright, distinguishes between the freshness of a young character played by a youthful actor and the same character played by a seasoned actor. Both are to be valued, but the youthfulness created after years of artistic training can have a depth and power a young actor could not attain. Noh actors come back again and again to the same roles, and each time—whether the character is young or old, male or female—the older actor approaches it with an accumulation of experience and maturity that brings to the role layered nuances. Noh is an all-male theater and when one of the actors takes a female role no particular effort is made to imitate a female voice. Nonetheless, the Noh actor effortlessly conveys the impression of a delicate woman.

Alongside the solemn Noh plays, there are exuberant farces called Kyogen. Most Noh dramas feature a single notable character played by the *shite*. There are stories about gods, warriors, beautiful women, and people driven to madness by grief, demons, and other supernatural creatures. If the characters of Noh are larger than life, the characters of Kyogen are rooted very much in the everyday world and have a universality that has made Kyogen popular far beyond Japan's shores. A program of Noh might feature several plays, which

are usually alternated with Kyogen performances. Most Kyogen performances feature a rather stupid master and slightly cleverer servant named Tarokaja. In the play *Bo Shibari* ("Tied to a Stick"), the master wants to stop his servants from drinking his wine while he is out. He tricks his two servants, leaving one tied to a pole and the other with his hands bound behind him. Nevertheless, the two servants manage, while constrained, to get into the saké storehouse and drink their fill, to the extent that they start singing and dancing. The play ends as virtually all Kyogen do, with an explosion of laughter as the master chases after his servants.

If Noh belongs to the aristocracy, Kabuki and Bunraku are for the commoners, part of the rich flowering of merchant culture that developed among the social strata beneath the dominant samurai class in the Edo period. Samurai not only patronized but practiced Noh as the art form of their class. Kabuki became the popular theater of the time. Kabuki originated with the dances of a woman named Okuni in a dry riverbed of Kyoto. Soon her style of dancing was copied by prostitutes. Eventually, the shogunate banned women from the stage, considering them a threat to public morals and safety. After many more bouts with the repressive tendencies of the shogunate, Kabuki emerged at the turn of the eighteenth century as a performing art combining dramatic and comic sketches and dances. Since women could not perform, female roles came to be played by actors called *onnagata*, who specialized in these roles and polished the art of femininity to a high level, even becoming models for the real women of the time. As Kabuki acting moved from daily life to the artificial creation of *onnagata*, actors also were freed from the realistic constraints of age and so even the most delicately feminine young girl might be performed by a master artist in his sixties.

The world of the Kabuki theater might be compared to the form of linked verse called *haikai*, in which several poets collaborate, each adding a link. (The detached opening verses of these series are now known as "haiku.") *Haikai* always starts in the here and now with an evocation of the season at the time of composition. Then, with the addition of each new verse, the composition progresses and changes direction. If the poetic language of the tradition that came before is relentlessly elevated and serious, *haikai* jumps from high to low, one moment evoking mythical heroes of the past, the next pickle

Kabuki (spring): The ultimate dance for an *onnagata*, an actor specializing in female roles, features a spectacular series of dances in the midst of cherry blossoms. *Musume Dojoji* ▶

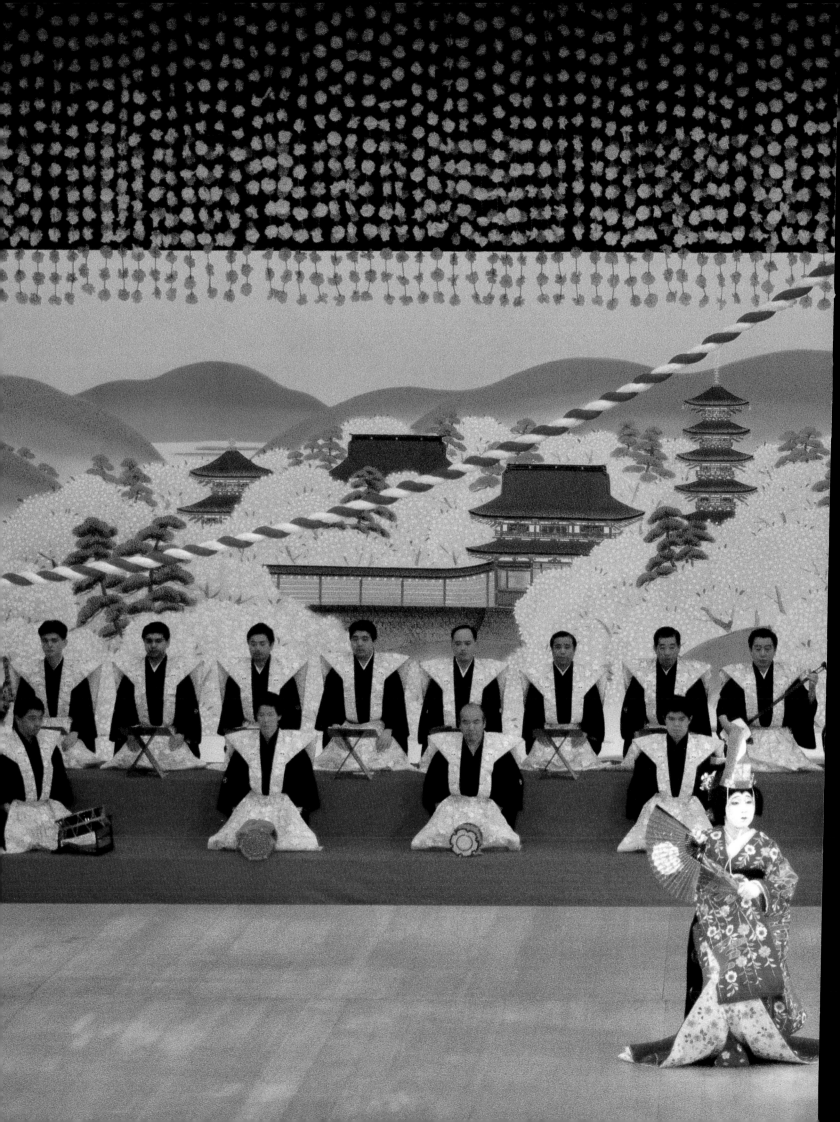

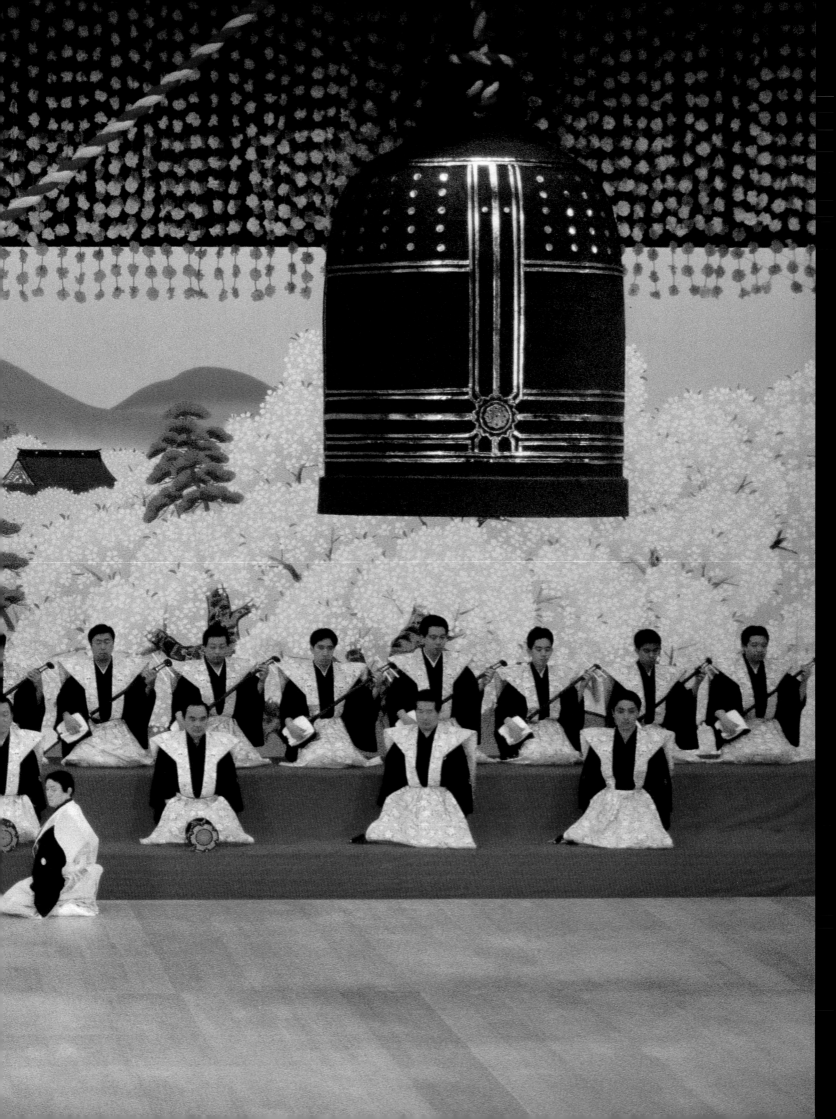

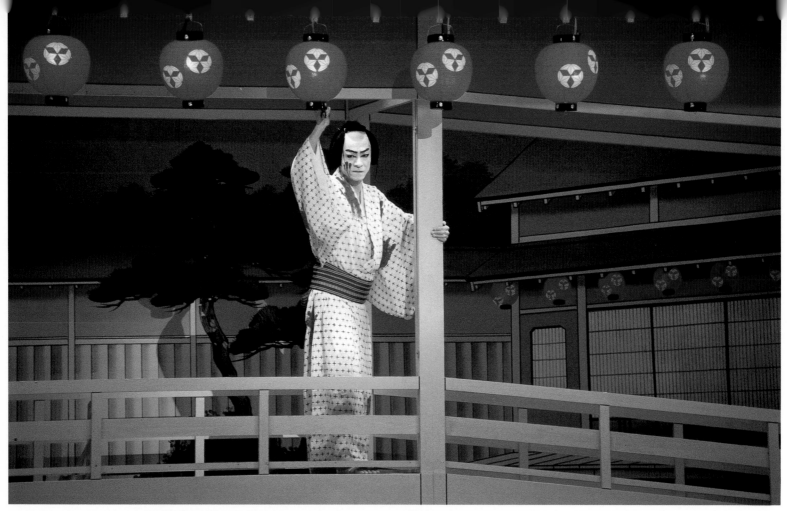

Kabuki (summer): A relatively realistic portrait of the pleasure quarters of Ise is the background to a chilling murder designed to make audiences forget the heat of summer. *Ise Ondo Koi no Netaba*

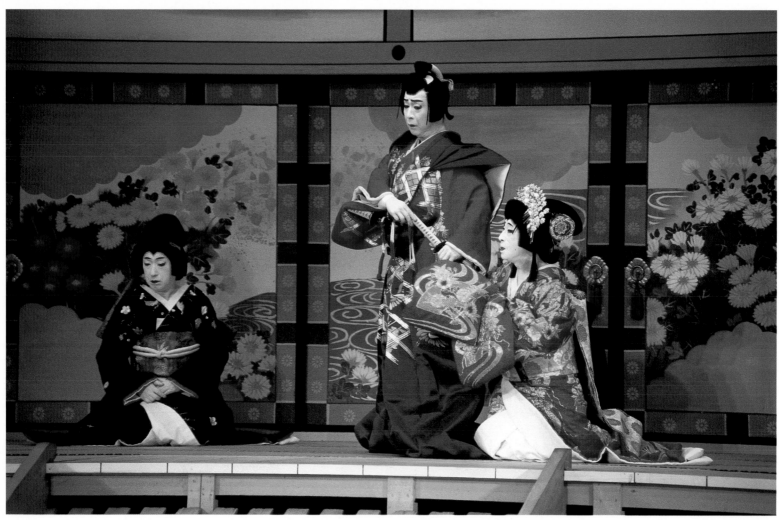

Kabuki (autumn): The opulent world of a period play. A princess, in red kimono, is overjoyed to finally be united with her fiancée, but he has come to her family's mansion as a spy along with the woman in black. *Honcho Nijushi Ko*

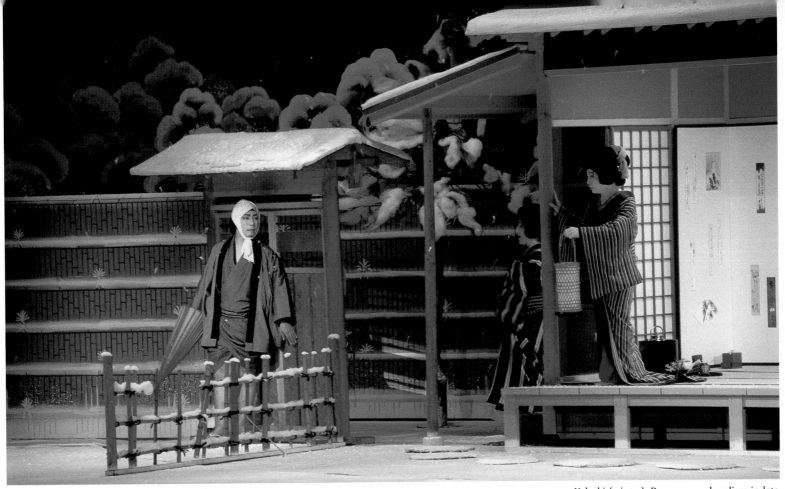

Kabuki (winter): Romance and realism in late nineteenth-century Kabuki. A gritty story of thieves and courtesans is transformed by the passionate singing of Kiyomoto narrative music. *Yuki no Yugure Iriya no Azemichi*

buckets in a humble kitchen, now solemn, now comic. In the same way, Kabuki begins by reflecting the current season, but then shifts through a dizzying range of historical events, dances, comedies, and portrayals of contemporary pleasure quarters.

Performances of Kabuki were originally closely linked to the seasons, with sets on stage mirroring the weather out of doors. Plays in the spring, for example, would usually have a scene filled with cherry blossoms, and since this was also the season when the ladies-in-waiting serving in samurai households were allowed some time for recreation, Kabuki theaters often featured plays showing the trials and tribulations of life in the women's quarters of samurai mansions. In contrast, summer plays often concerned violence. Plays like *Natsu Matsuri Naniwa Kagami* ("Summer Festival in Osaka") and *Ise Ondo Koi no Netaba* ("Massacre in the Ise Pleasure Quarters") depict good characters forced to kill someone, the chilling action supposedly causing the audience to forget the summer heat. For similar reasons, ghost plays were also traditionally performed at the hottest time of the year. In autumn the stage was filled with the red leaves typical of that season, and in the *kao-mise*, or "face showing," plays that showed off the actors for the new theater year beginning in November, there was always a snow scene.

The Bunraku puppet theater developed alongside Kabuki, and in the eighteenth century evolved into a dramatic art form of great sophistication. The wide repertoire of Bunraku ranges from larger-than-life period plays to portrayals of commoner life, but perhaps the most famous plays are those on love suicides by Chikamatsu Monzaemon (1653–1724). Dramatizing real incidents, the plays focused on the social tensions of the time that prevented lovers from being united, forcing them to achieve in death what they could

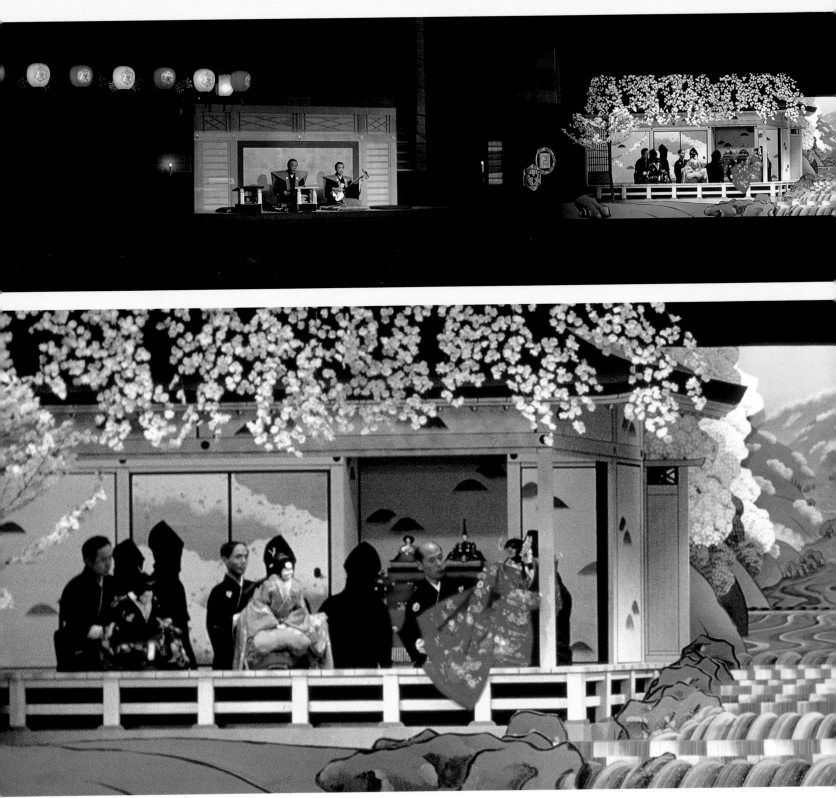

Bunraku: Two rival clans live on either side of a great river, but the son of the house on the right and the daughter of the house on the left have secretly fallen in love. *Imoseyama Onna Teikin*

not in life. The performances were sung and narrated by chanters accompanied by a shamisen, and in Chikamatsu's plays great realism in the first part of the drama gives way to singing and poetry of exquisite beauty as the lovers proceed to their death. This is epitomized by the travel scene of Chikamatsu's first love-suicide play, *Sonezaki Shinju* ("Love Suicide at Sonezaki"): "Farewell to this world, and to the night farewell. We who walk the road to death, to what should we be likened? To the frost by the road that leads to the graveyard, vanishing with each step we take ahead" (translated by Donald Keene). In powerful poetic language, the characters merge with the image that represents them: the

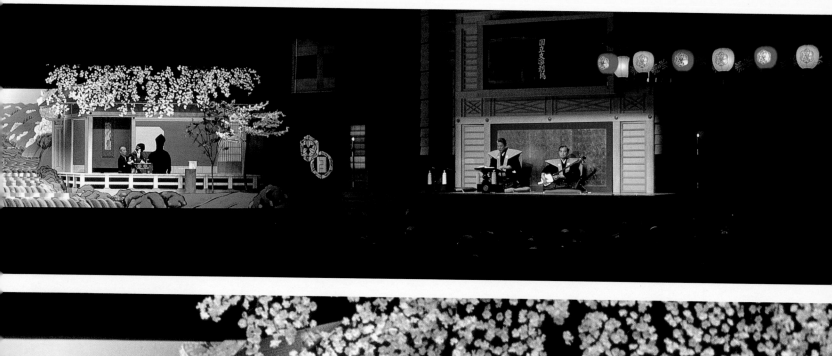

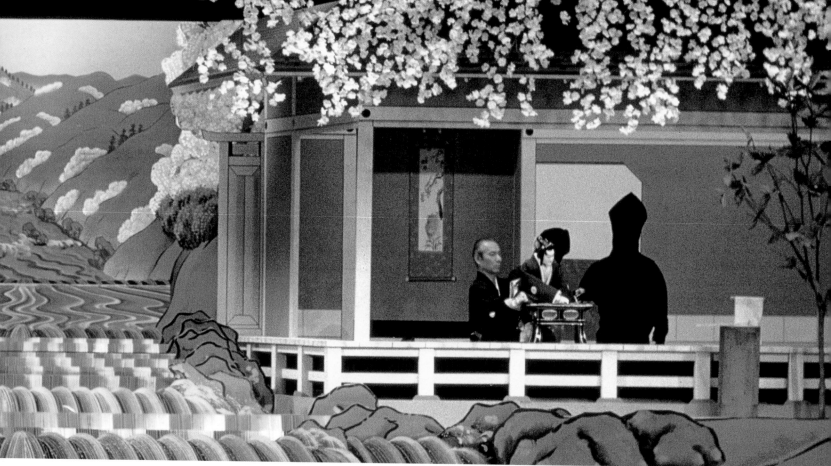

stark image of frost on the road, about to melt away and vanish at any moment.

By the mid-eighteenth century, the artistry of the puppeteers had become highly sophisticated, and major roles required three puppeteers—one for the head and right arm, one for the left arm, and one for the legs. Obviously working together requires long years of training, and a puppeteer must spend as long as ten years operating the legs, then another ten years working the left hand before becoming a master puppeteer and principal operator. The principal operator manipulates the head and right hand and controls the entire expression of the character with silent instructions to the two other puppeteers.

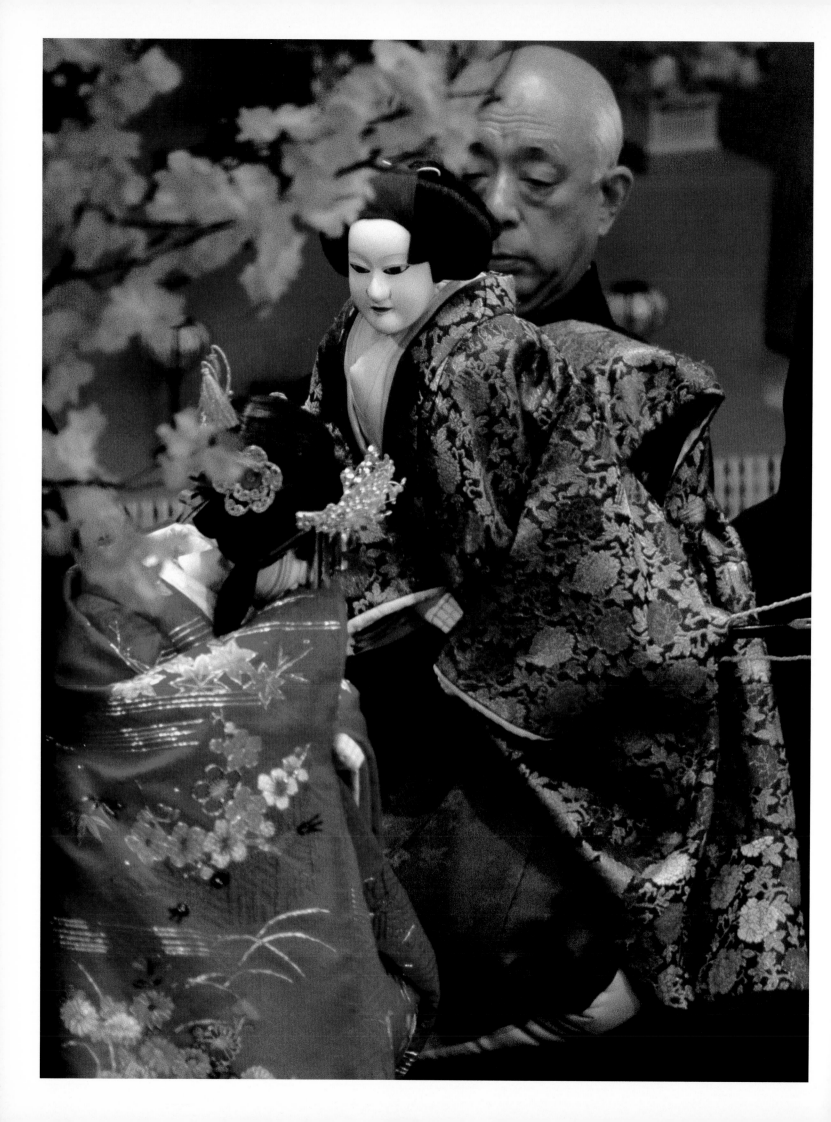

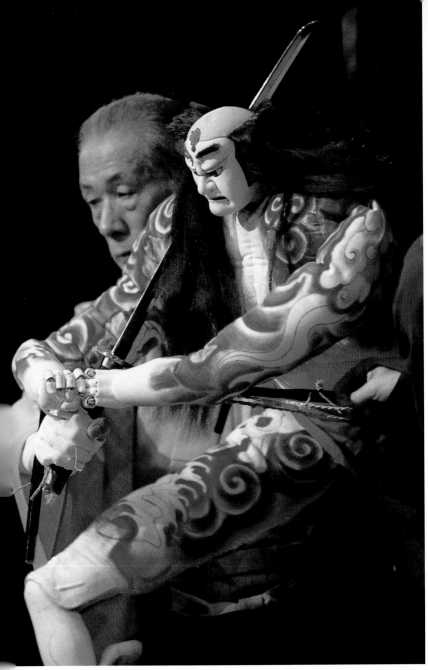

Bunraku: A gallant commoner whose body is covered with tattoos rests after being forced to kill a man. Puppeteer Yoshida Tamao seems to watch the character's torment impassively. *Natsu Matsuri Naniwa Kagami*

Bunraku: Blind Sodehagi sits in the snow outside her home and tells her story as she accompanies herself on the shamisen. She has been disowned and duty prevents her grieving parents inside from ever allowing her back again. *Oshu Adachi ga Hara*

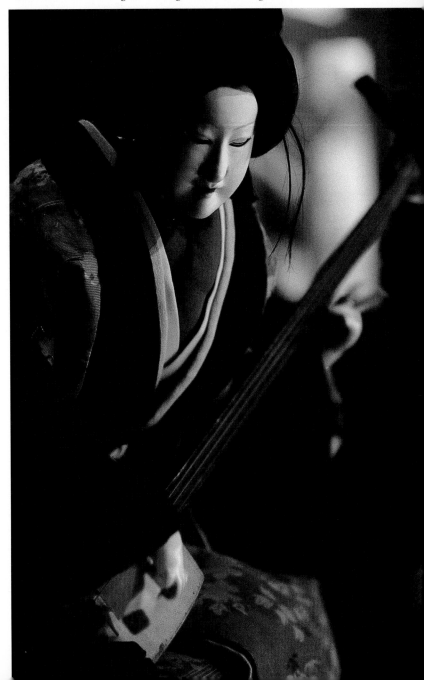

◀ Bunraku: Although they are bound by the severe morality of the warrior class, mother and daughter reach a moment of mutual understanding. The main puppeteer for the mother seems cool, but his passionate involvement in the scene creates the drama. *Imoseyama Onna Teikin*

The worlds of Noh, Kyogen, Kabuki, and Bunraku, while distinct art forms, have much in common. They share plays and characters—the young Atsumori, for example, has found incarnations in all four genres. They share techniques—the puppeteers of Bunraku incorporated the choreography of Kabuki into the movements of their dolls and Kabuki actors borrowed stylized stances from Bunraku. But most of all, they share the imagery of nature, which is woven into the very fabric of the drama. Character, story, and seasonal setting are often merged in a snapshot-like image that seems to capture the essence of the drama: the image of a beautiful young woman dancing in a temple filled with cherry blossoms embodies all the beauty and fragility of human passion; a princess in red emerges from the brilliant crimson foliage of autumn and invites a traveling courtier to an outdoor banquet, only to reveal that she is a demon in disguise; a thief on the run visits his lover, a courtesan, for the last time in an elegant villa surrounded by the snow-covered rice fields near the pleasure quarters, the pure white beauty of a snowy landscape evocative of the desolation of parting from loved ones. Each scene is simple yet poignant, a rich distillation of drama, language, and nature—an effect that is, perhaps, the distinct and unifying thread of Japan's traditional theater.

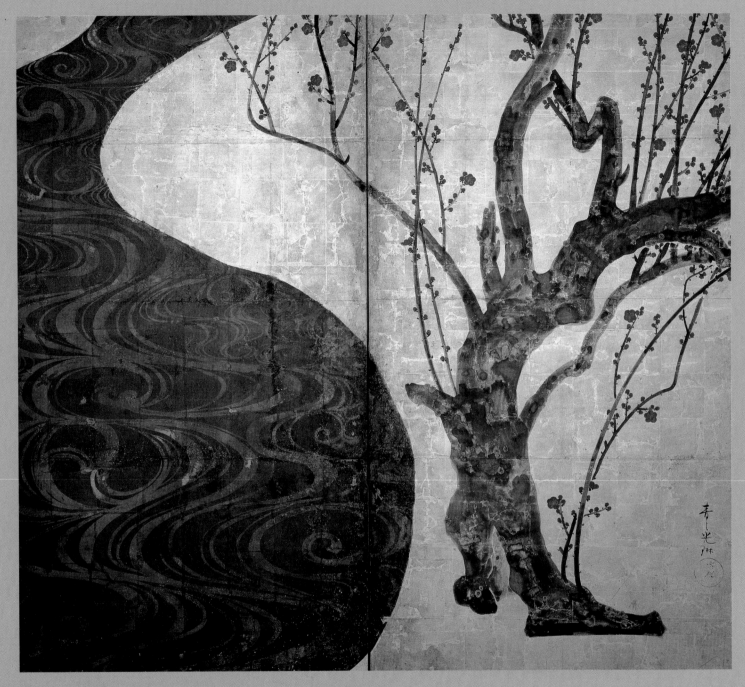

ART

Ogata Korin (1658–1716), *Red and White Plum Blossoms*.
Right half of a pair of two-panel screens, color and gold and
silver leaf on paper, each 156.5 x 172.5 cm. National Treasure

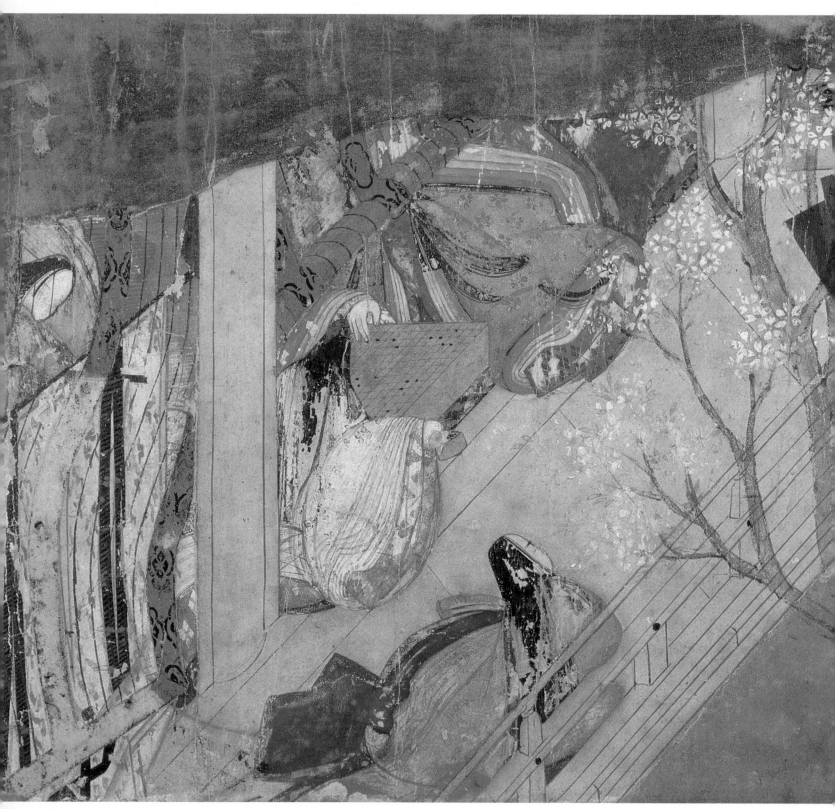

Illustration from the Takekawa chapter of *Genji monogatari emaki*, 12th century.
Ink and color on paper, 22 x 48.1 cm. National Treasure

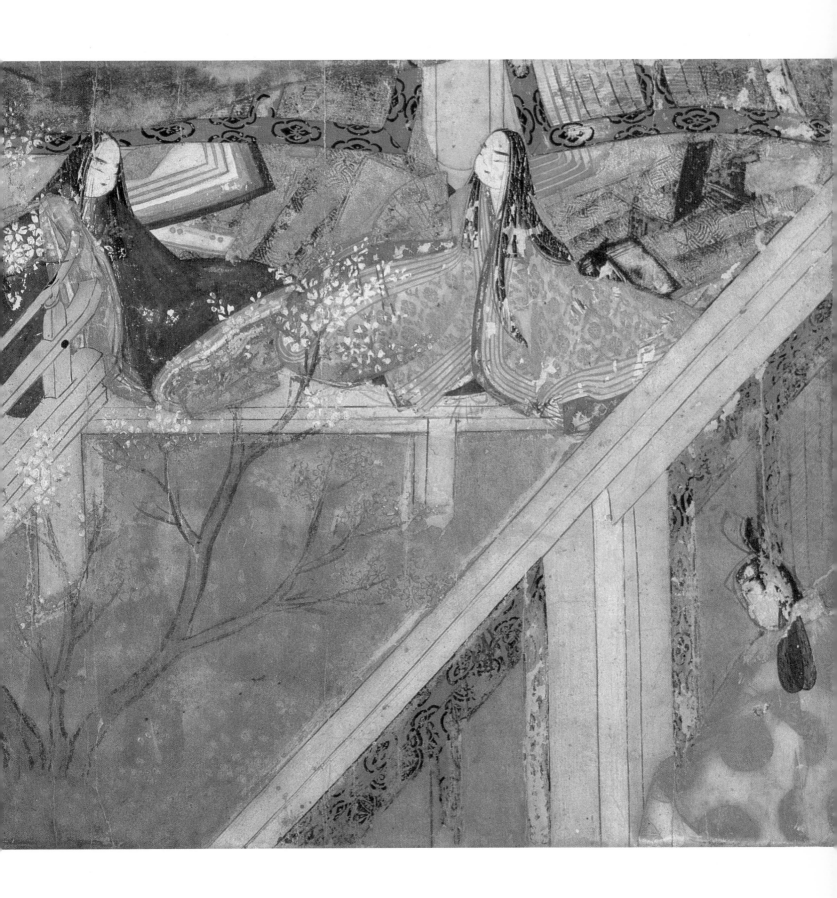

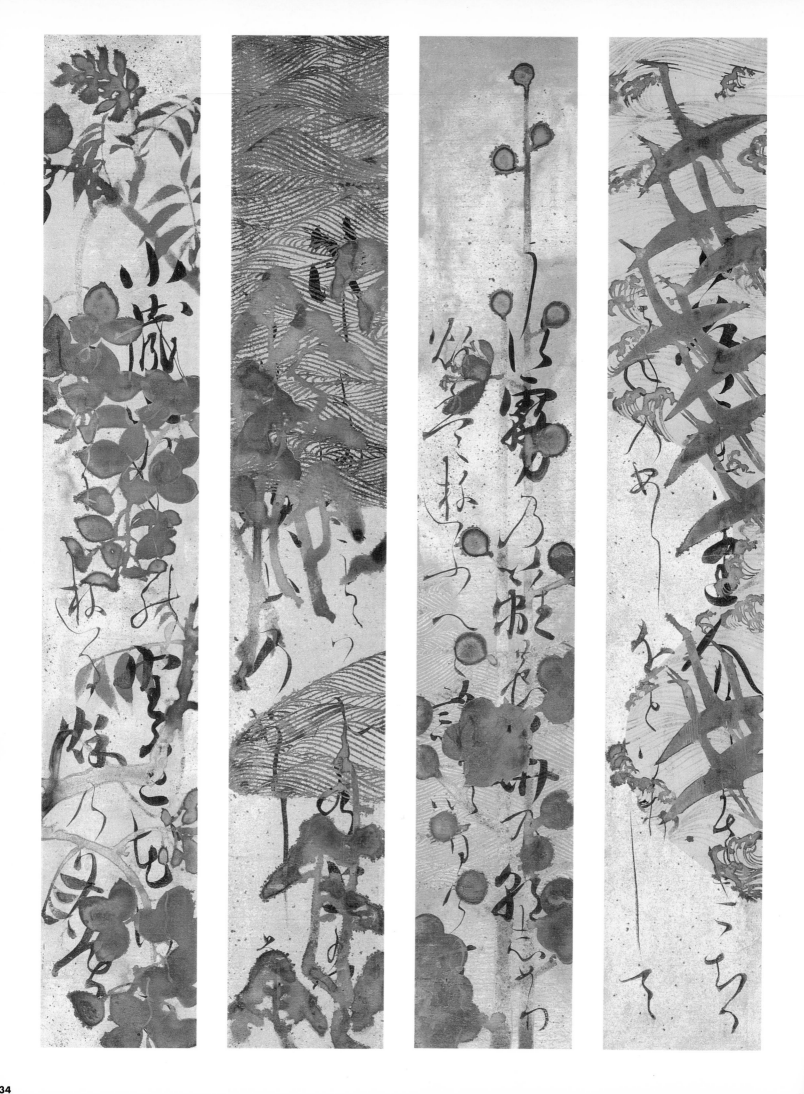

THE FOUR SEASONS AND JAPANESE ART

Patricia Fister

A respect for nature and a keen awareness of the seasons has dominated Japanese life and aesthetics for centuries. Attitudes toward nature have been nurtured throughout Japan's long history as an agrarian society. The Japanese archipelago, blessed with fertile soil and a hospitable climate, is endowed with some of the most beautiful scenery on earth. People instinctively adjusted their lives to nature's rhythms and observed a profusion of seasonal rituals. In short, the Japanese have long been preoccupied with the changes of the seasons—changes that metaphorically allude to the human condition. Scholars have interpreted this close identification with nature as a way of coming to grips with the transience of human life, since everything on earth is subject to the ever-changing cycle of birth, growth, decline, and death.[1] Perhaps the realization that nature's beauty was fleeting made the Japanese want all the more to savor it in their art.

The four seasons are clearly defined in Japan and have been celebrated in its art for centuries. Paintings of the four seasons (*shiki-e*) and of famous scenic spots (*meisho-e*) associated with a particular season were popular from the Heian period. Pairs of screens depicting the seasons and sets of four hanging scrolls were common. The seasons were also sometimes represented sequentially as a continuous panorama in a single painting. The inspiration for this type of composition came from China. The abundance of seasonal works suggests that the cycle of life—the ebb and flow of seasonal changes—was important in itself over and above an appreciation for natural beauty.

The Japanese concern with the seasons is also reflected in many ukiyo-e prints of landscapes. Utagawa Hiroshige, for example, took care to represent all four seasons, as well as various times of day, in his series *Fifty-three Stations of the Tokaido Road*. He did this in spite of the fact that he traveled the famous highway only once, during the late summer and early autumn. In addition to recording his observations of people and places, Hiroshige set out to capture the changing character of the terrain. To the Japanese of the day, the series might have seemed incomplete without the full cycle of seasons. Hiroshige used changes in foliage and weather to great effect, as in his view of Shono, depicting travelers scurrying for shelter from the onslaught of rain.

Whereas Hiroshige based his print designs on sketches made during his travels, guidebooks, and other artists' work, Umehara Ryuzaburo, influenced

◀ Hon'ami Koetsu (1558–1637), Album of *Tanzaku*. Ink on decorated paper, each 37.5 x 6.0 cm.

by European impressionists such as Renoir, did many paintings directly on location. One of his favorite subjects was Mt. Asama in Gunma and Nagano prefectures. Through bold, primary colors and dynamic brushwork, Umehara sought to convey the vitality of the smoking volcano, which he painted in different seasons. Many painters use nature as a vehicle to express their own emotions, and there is no question that Umehara's series of paintings of Mt. Asama chronicles his changing state of mind as well as the shift in seasons.

Annual festivals and rituals have also been featured frequently in Japanese art. Some seasonal celebrations involve the direct appreciation of nature, such as viewing cherry blossoms in spring, as depicted in a scene from the *Tale of Genji*, or the colorful maple foliage in fall. Even today, the Japanese fondness for these pastimes goes beyond mere admiration of the scenery; the poetic sentiments and emotions evoked are equally important. Cherry blossoms mark the arrival of spring and the renewal of life, yet the brevity of their ethereal beauty is a reminder of the ephemeral nature of our world. In contrast, the maple trees in autumn offer their splendor more slowly, culminating in a final burst of scarlet before the leaves wither and fall. Both the beauty and melancholy of each cycle is embraced.

Seasonal activities and celebrations were especially common themes in ukiyo-e prints, and many series were organized according to the seasons or months. In one series of prints Suzuki Harunobu features poets writing on the four seasons; beneath the verse for the sixth lunar month (July), two lovers cool off by the riverside—a typical summer evening diversion. The fact that the seasons were so frequently used as a kind of organizing principle indicates that the lunar calendar figured importantly in the Japanese world view.

Nature imagery abounds in Japanese art and poetry, with plants, animals, and birds often serving as metaphors for particular seasons or places. Artists selectively employed motifs instead of faithfully depicting or describing the actual scenery in order to create bolder designs and to elicit certain responses from viewers. Conditioned by imagery in poetry, sentiments toward particular plants became deeply rooted. The autumnal motif of swaying pampas grasses, for example, traditionally induces a feeling of sadness at the passage of time. Fall is generally regarded as the season with the most depth and richness, accompanied as it is by a sense of *sabishisa* (desolation, sorrow), which most Japanese

Sesshu Toyo (1420–1506), *Winter Landscape*. Hanging scroll, ink on paper, 46.4 x 29.4 cm. National Treasure ▶

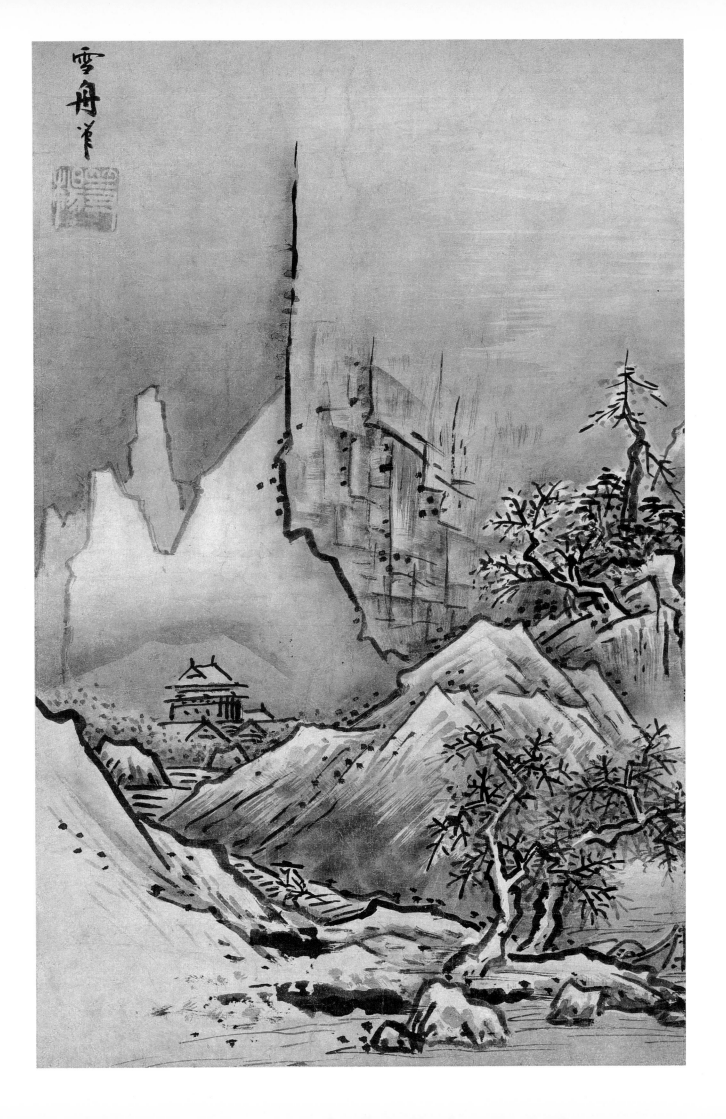

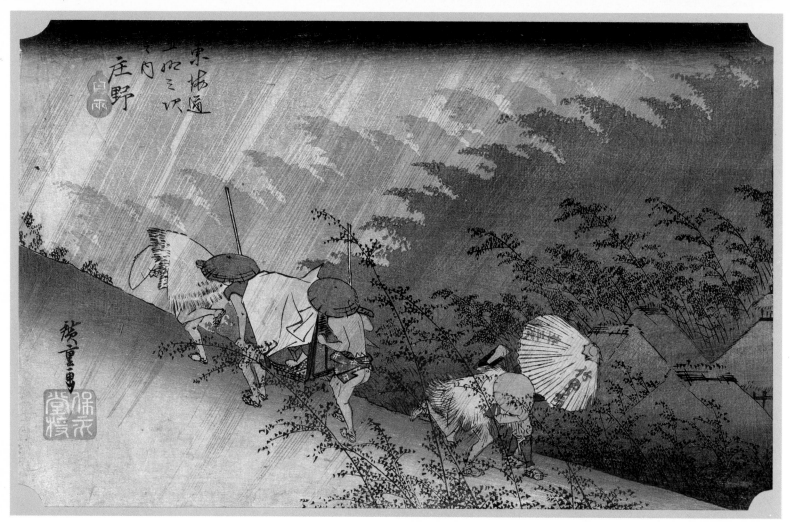

Utagawa Hiroshige (1797–1858), *Shono*, from the series *Fifty-three Stations of the Tokaido*, 1832–34. Polychrome woodblock print on paper, 38 x 26 cm.

Suzuki Harunobu (1725–70), *The Sixth Month*. Polychrome woodblock print on paper, 28.3 x 21.5 cm.

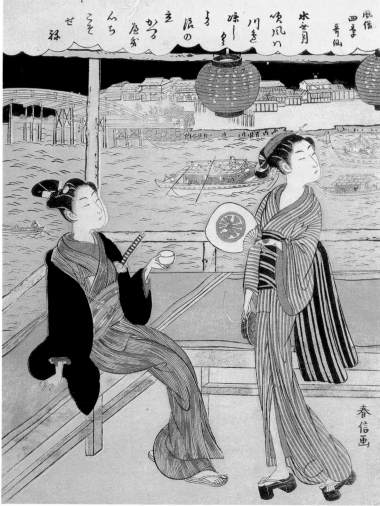

Yokoyama Taikan (1868–1958), *In the Shade of Willows*, 1913. Detail from the right half of a pair of six-panel screens, color and gold on silk, each 191.8 x 546.8 cm. ▶

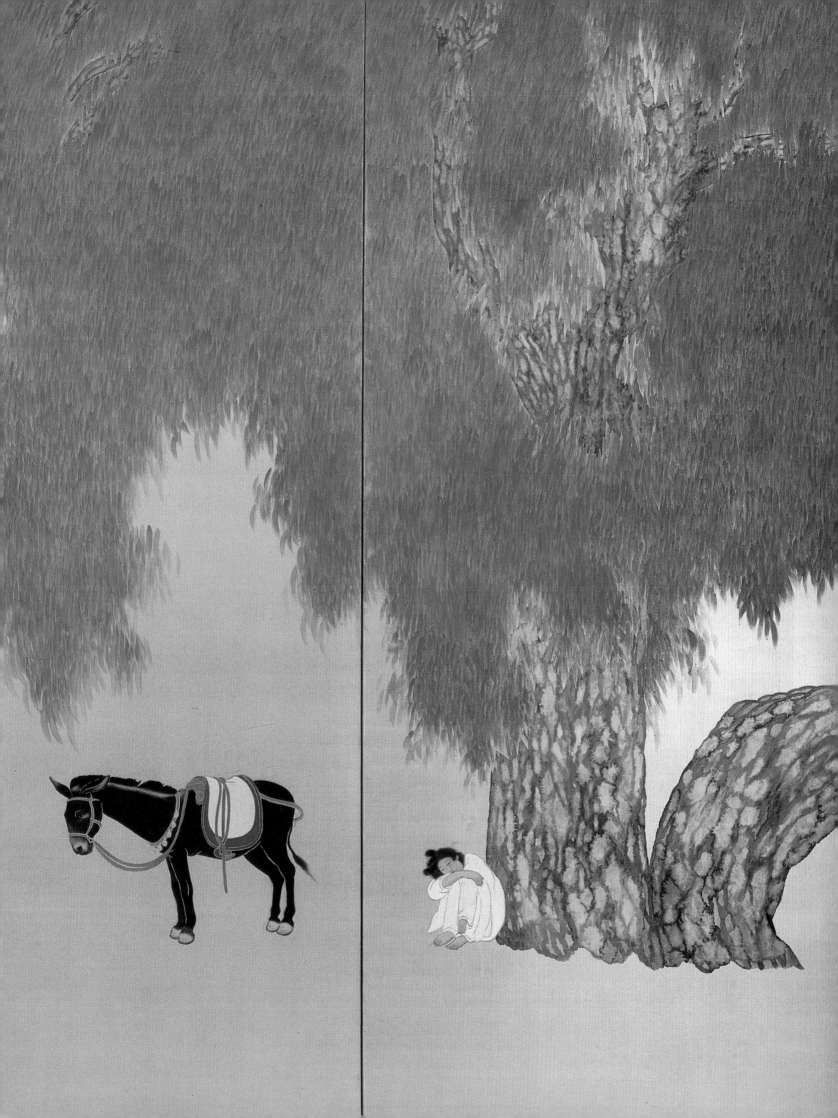

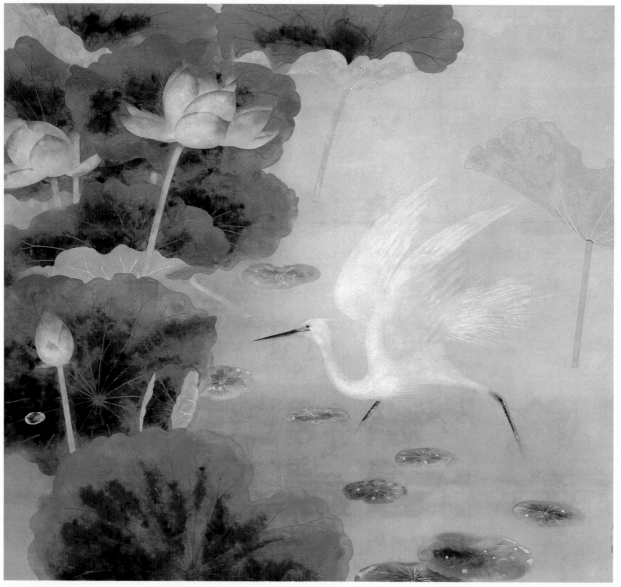

Okumura Togyu (1889–1990), *Lotus Pond*, 1929. Color on silk, 134.8 x 142.8 cm.

Kumagai Morikazu (1880–1977), *Dragonflies*, 1962. Framed panel, oil pigments on wood, 24.1 x 33.3 cm.

Umehara Ryuzaburo (1888–1986), *Smoke from Mt. Asama*. Tempera on paper, 118.8 x 92 cm.

choose to embrace rather than to elude. The proliferation of fall imagery in Japanese art indicates that this season was favored over spring. Autumn is unquestionably the season in which the feeling of transition is the most pronounced, a poignant reminder that another year of our lives is drawing to a close. Seasonal images also figure prominently in the designs of decorated paper, as can be seen in the set of *tanzaku* with poems calligraphed by Koetsu.

Some nature motifs have symbolism and literary associations that extend beyond the merely seasonal. The lotus, for example, is an important symbol in Buddhism. Because its long stems grow from the mud at the bottom of ponds and rice paddies and rises above the water surface to produce magnificent, large-petaled flowers, Buddhist teachings employed this flower as a symbol of enlightenment. The inherent symbolism makes it impossible for a Japanese to look upon Okumura Togyu's painting of a white heron and lotuses simply as a pleasant summer scene.

Pine, bamboo, and plum are also imbued with symbolism. Known collectively as the "three friends of winter," they share qualities of strength and endurance; pine and bamboo remain green throughout the winter, and the plum puts forth its blossoms in February, often when there is still snow on the ground. Since they are associated with longevity and vitality, the three are regarded as propitious symbols regardless of the season. Bamboo and plum are also included among the "four gentlemen," along with chrysanthemum and orchid. All four plants possess qualities admired in humans, such as fortitude and modesty. Their auspicious connotations made them popular motifs as we see in the decoration on the octagonal Kakiemon ware jar, where three of the four appear.

A number of seasonal themes have specific literary associations. Ogata Korin's lacquer box featuring irises and an eight-planked bridge stands as a superb piece of decorative art, yet the subject matter takes on greater meaning if the viewer knows it refers to an episode in the tenth-century classic *Tale of Ise*, in which a group of traveling Kyoto courtiers stop to admire the irises blooming in the marshes at Yatsuhashi ("Eight Bridges") in Mikawa province. Korin's design is highly stylized and abstracted, but the allusion would have been immediately recognized by many.

While occasionally the complete cycle is represented in one artwork, pairs

of screens or sets of four or twelve paintings (scrolls, fans, *tanzaku* poem cards, and other formats) featuring flora and fauna of the seasons are more common. This custom may derive from the practice of creating "gardens of the four seasons" (*shiki no niwa*), which were fashionable from the Heian period. Professor Tsuji Nobuo has pointed out that representations of the seasonal cycle of foliage in art may also be suggestive of paradise and thus reflect the influence of Buddhist teachings.[2] The practice of creating sets of flower and bird paintings—one to hang during each of the twelve months—is characteristic of Japanese art. The desire to harmonize interior decoration with the seasons demonstrates how life in Japan revolves around the natural cycle.

The Japanese people's sensitivity toward the seasons extends to their choice of tableware, which has been elevated to an art. It is no exaggeration to say the seasons are savored as much as the cuisine in traditional Japanese meals. Not only does the menu change in accordance with the seasons, but so do the vessels. Seasonal factors in ceramics are color, texture, thickness, shape, and motif. The basic idea is to evoke coolness in summer and warmth in winter with considerable attention paid to which ceramics will enhance the visual appeal of particular foods and drinks. Chojiro's dark brown Raku ware teabowl, for example, is the perfect complement to the bright green color of *matcha*.

The seasons themselves may be discerned in the colors and textures of the clays and glazes of some wares. Louise Cort, curator of ceramics at the Smithsonian's Freer Gallery of Art, noted in her discussion of Shigaraki wares that "some jars are as bright and vivacious as a spring morning, with green glaze cascading over a warm orange surface. Others are moody and withdrawn, barely touched with color—streaks of lavender and blue—against dry gray clay."[3] A Japanese would consider which of the four seasons is suggested by the natural ash "landscape" covering Tsujimura Shiro's Iga ware jar before taking it out to display.

Yet another way in which people express their sense of the seasons is in their choice of kimono. This custom is still observed today, although western-style clothing has almost completely replaced kimono as everyday wear. To begin with, single-layer kimono are worn in the summer and lined kimono during the rest of the year. The choice of fabric, color scheme, and design

motifs is coordinated with the season. Lighter colors are generally worn in the spring and summer, and darker colors in the autumn and winter. An example celebrating the rich hues and foliage of autumn is the splendid Noh robe shown here. As in flower arrangement, the seasons are anticipated: "By the time a flower has actually come into bloom, it is too late to wear it on kimono."[4] Seasonal motifs also appear on the *obi* sashes worn with kimono, and other accessories such as combs.

The growth of modern cities, and life in modular townhouses and apartment complexes, has to some extent insulated people from nature. Yet the desire for close contact with nature lingers on as part of the Japanese tradition. Local festivals celebrate the harvest or other seasonal events. Sightseeing trips to places noted for their beauty at certain times of the year remain popular with young and old alike. Even the more commercial aspects of modern life are seasonally coordinated: posters promoting travel within Japan almost always link the destination with a season; plastic flowers adorn shopping streets; and producers of foods, sweets, and drinks weave seasonal elements into advertisements and packaging. Thus, in spite of the "internationalization" of Japan and the physical distancing from nature common in the modern age, the people remain attuned to the seasons, and nature, in her seasonal guises, remains inextricably interwoven into the country's art.

Jar with autumn grasses design. Tokoname ware (Atsumi area), ca. 12th century. Stoneware, with natural ash glaze, height 40 cm. National Treasure ▶

1 Saito Yuriko, "The Japanese Appreciation of Nature," *British Journal of Aesthetics*, Vol. 25, No. 3 (Summer 1985), 248.

2 Tsuji Nobuo, "Shiki no naka ni ikiru," *Shukufuku sareta shiki: Kinsei Nihon kaiga no shoso* (Chiba-shi Bijutsukan, 1996), 10–11.

3 Louise Cort, *Shigaraki: Potters' Valley* (Tokyo: Kodansha International, 1980), 5.

4 Liza Crihfield Dalby, *Kimono: Fashioning Culture* (New Haven and London: Yale University Press, 1993), 212.

Large dish with peonies and butterfly design. Old Kutani ware, ca. 17th century. Porcelain, with overglaze enamels; diameter 35 cm.

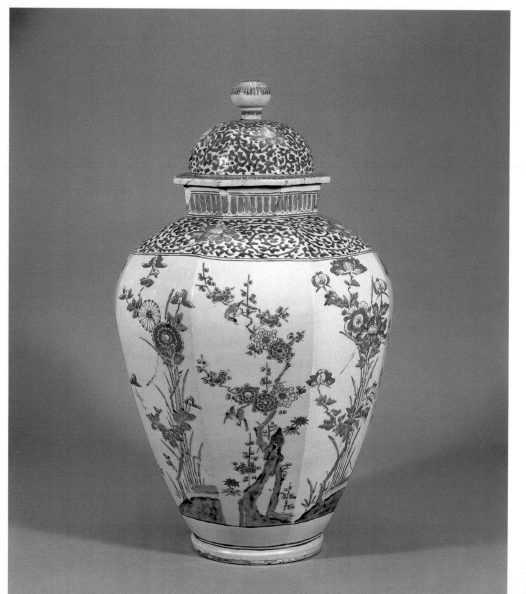

Octagonal covered jar with design of flowers and birds. Kakiemon ware, early Edo period. Porcelain, with overglaze enamels; height 61.8 cm.

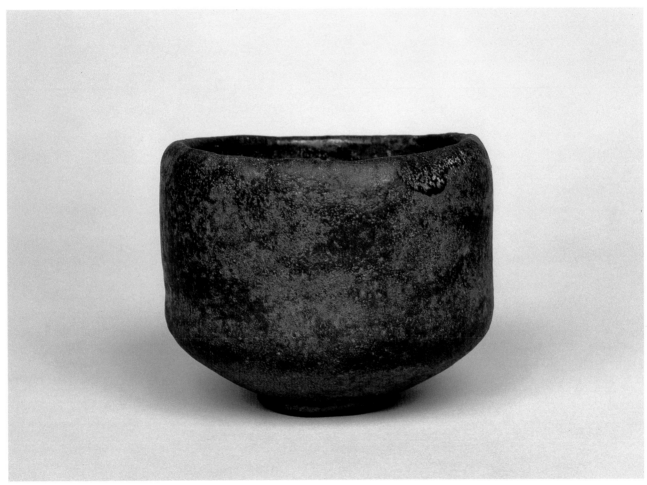

Tea bowl, called "Ayame," by Sasaki Chojiro (1516–92). Raku ware. Earthenware, diameter 11.3 cm.

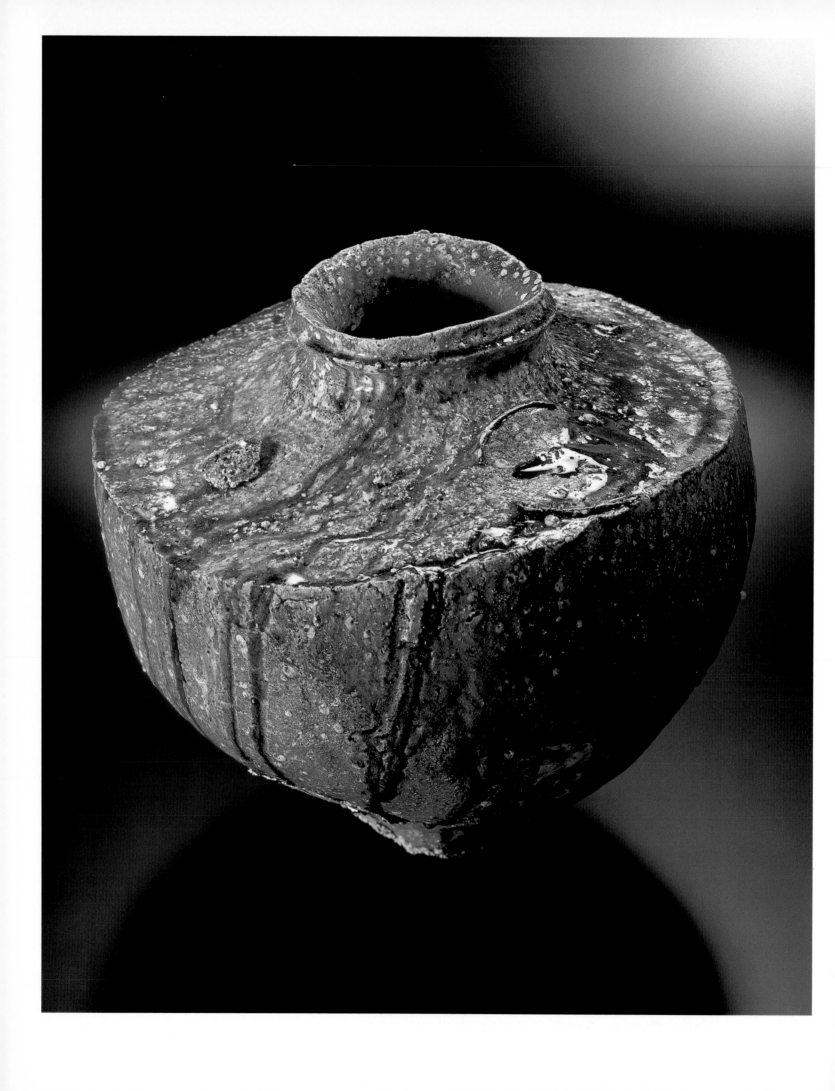

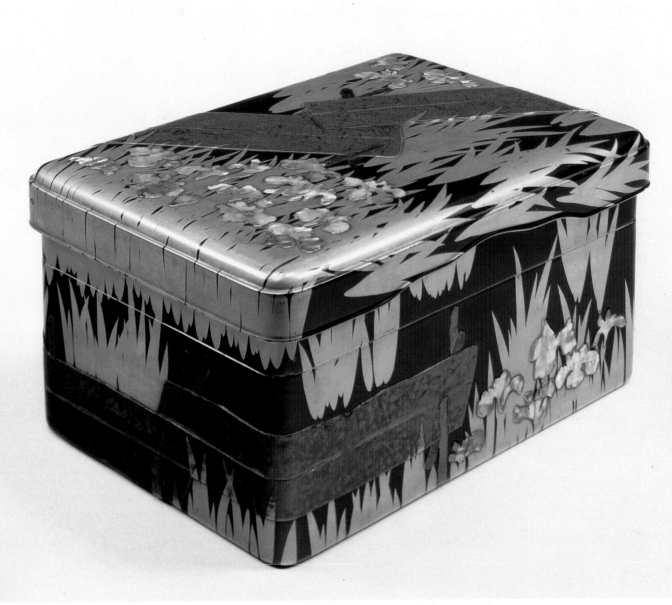

Writing box, with design of Yatsuhashi ("eight-planked bridge"), by Ogata Korin (1658–1716). *Maki-e* lacquer and mother-of-pearl; height 19.8, width 19.8, length 27.5 cm. National Treasure.

◄ Large wide-shouldered vase, by Tsujimura Shiro (1947–). Iga ware, 1986. Stoneware, with natural ash glaze and fragments, height 37 cm.

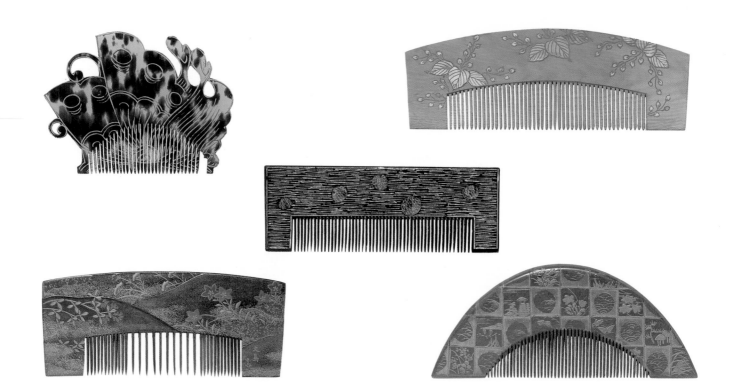

Ornamental combs. Edo period, length 6.4 to 10.9 cm. TOP LEFT: Comb in the shape of a swallowtail butterfly; tortoise shell; TOP RIGHT: Comb with carved lacquer design of paulownia leaves; lacquered wood; CENTER: Comb with design of pine needles; wood with mother-of-pearl inlay; BOTTOM LEFT: Comb with design of autumn plants and distant mountains, lacquered wood with *maki-e*; BOTTOM RIGHT: Comb with design of alternating squares, lacquered wood with *maki-e*.

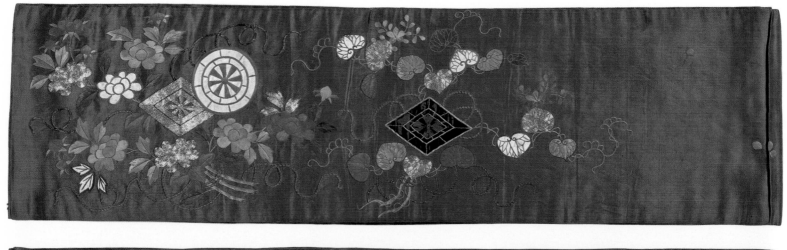

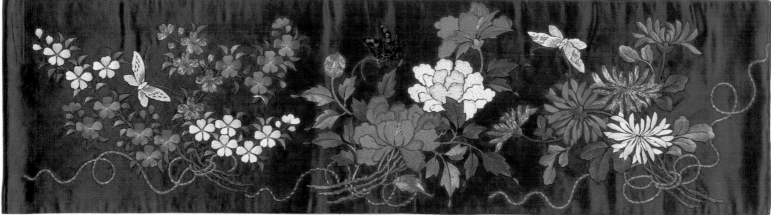

Obi. 18th century. TOP: *Obi* with design of peonies, hollyhocks, and Genji carriage on dark green silk; 417 x 29 cm. BOTTOM: *Obi* with design of peonies, chrysanthemums, cherry blossoms, and butterflies on purple silk; 380 x 28 cm.

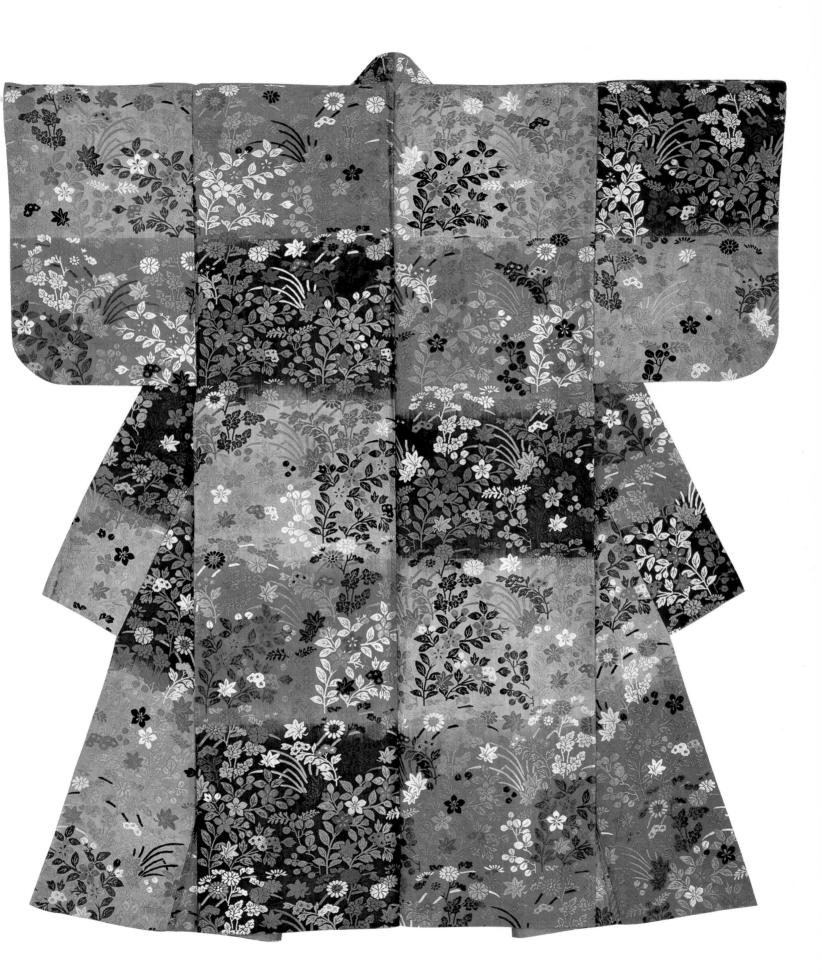

Karaori Outer Robe for Noh play, with design of autumn grasses over a ground of brown, water blue, and dark blue alternating blocks. 17th century. Silk, length 153 cm.

APPENDICES

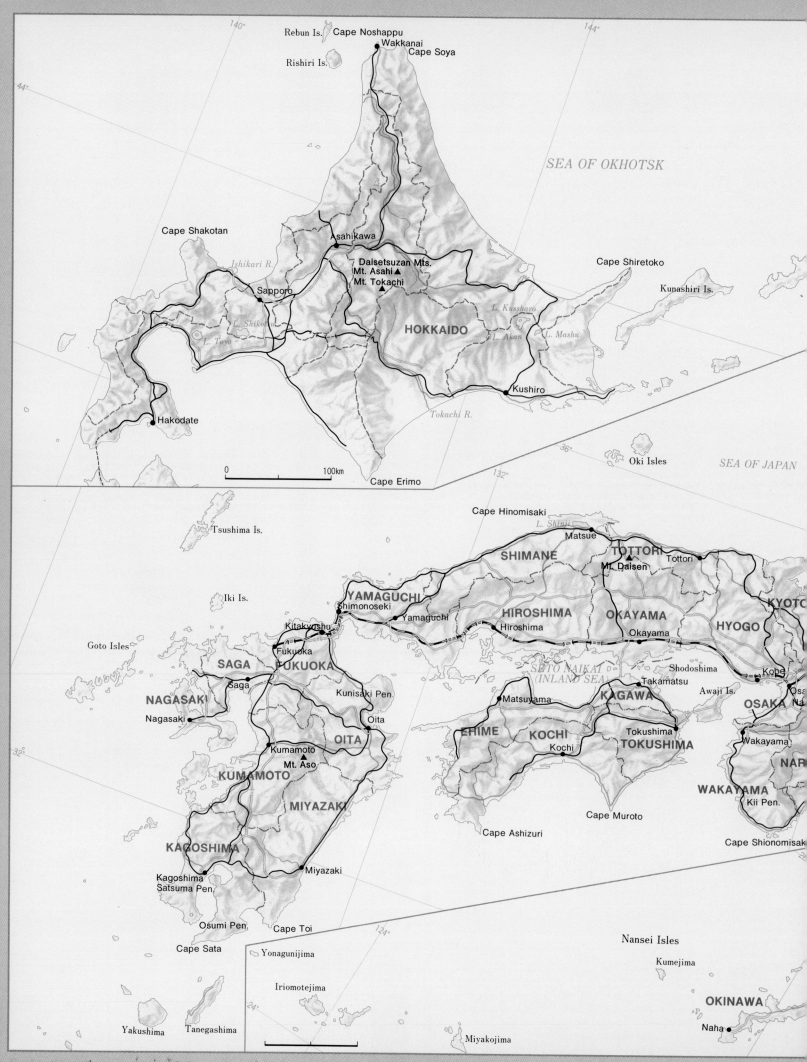

Rebun Is. Cape Noshappu
Wakkanai
Cape Soya
Rishiri Is.

SEA OF OKHOTSK

Cape Shakotan

Asahikawa

Daisetsuzan Mts.
Mt. Asahi ▲
Mt. Tokachi ▲

Cape Shiretoko

Kunashiri Is.

Sapporo

Ishikari R.

L. Kussharo

L. Shikotsu

L. Akan *L. Mashu*

HOKKAIDO

L. Toya

Kushiro

Hakodate

Tokachi R.

0 100km

Oki Isles

SEA OF JAPAN

Cape Erimo

Cape Hinomisaki
L. Shinji

Tsushima Is.

Matsue TOTTORI
SHIMANE Mt. Daisen Tottori

Iki Is. YAMAGUCHI
Shimonoseki Yamaguchi HIROSHIMA OKAYAMA
Kitakyushu Hiroshima Okayama HYOGO KYOTO

Goto Isles

Fukuoka
SAGA FUKUOKA SETO NAIKAI Shodoshima
NAGASAKI (INLAND SEA) Takamatsu Kobe
Saga Kunisaki Pen. KAGAWA Awaji Is.
Nagasaki Matsuyama OSAKA Osa
Kumamoto OITA Oita Tokushima Na
 EHIME KOCHI TOKUSHIMA Wakayama
Mt. Aso Kochi
KUMAMOTO NAR

MIYAZAKI Cape Muroto WAKAYAMA
 Kii Pen.
KAGOSHIMA
Kagoshima Cape Ashizuri Cape Shionomisak
Satsuma Pen.

Osumi Pen. Cape Toi

Cape Sata

Nansei Isles

Yonagunijima Kumejima

Iriomotejima

OKINAWA

Yakushima Tanegashima Miyakojima Naha

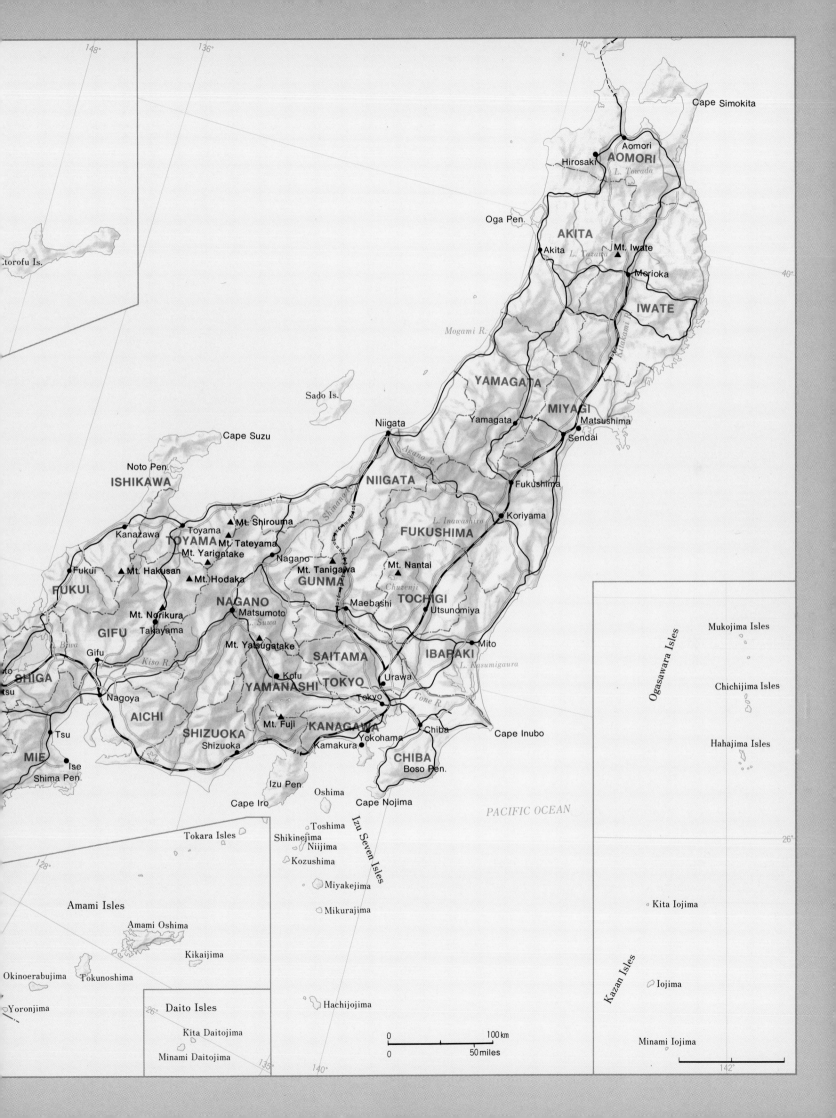

JAPANESE HISTORICAL PERIODS

PREHISTORIC

Jomon ca. 10,000 B.C.–ca. B.C. 200

Yayoi ca. 200 B.C.–ca. A.D. 300

Kofun ca. 300–710

✣

ANCIENT

Nara 710–94

Heian 794–1185

✣

MIDDLE AGES (MEDIEVAL)

Kamakura 1185–1333

Northern and Southern Courts 1333–92

Muromachi 1392–1573

(Warring States 1482–1573)

✣

PREMODERN

Momoyama 1573–1600

Edo 1600–1868

✣

EARLY MODERN / MODERN

Meiji 1868–1912

Taisho 1912–26

Showa 1926–89

Heisei 1989 to present

NOTES TO THE PLATES

Wind surfing near Mt. Fuji. The five lakes dotted around the base of Mt. Fuji, besides increasing the number of striking views of that loveliest of mountains, offer a variety of tourist attractions in their own right. These vary from season to season, but outstanding among them in summer is the sport of wind surfing, which has been drawing growing numbers of young people to the area in recent years.

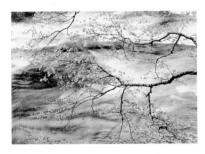

Plum and peach blossoms. In April, near the town of Enzan, in Yamanashi Prefecture, the hills are splashed with festive spring colors. The fruit of both the peach and the plum trees (the pink and white blossoms, respectively) is picked for the market in autumn.

SPRING

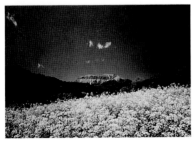

Spring foliage by a mountain stream. A scene in Yagen Valley, on the Shimokita Peninsula in Aomori Prefecture. In early spring the thawing of winter's snows brings a sudden rush of clear, pure water to the Ohata River, and new buds on the maples and other deciduous trees make an attractive showing.

Mt. Daisen and rape blossoms. Daisen, a volcano of which the highest peak, Kengamine, rises 1,731 meters above the broad sweep of the plain below, is known for the beauty of its form, which has earned it the nickname "the Hoki Fuji." For many centuries, rape was cultivated for the oil yielded by its seeds, but today the buds are eaten or the flowers sold as cut flowers. The brilliant yellow of the blossom, splashing vivid color over the countryside in early spring, was a favorite of Sen no Rikyu, the celebrated tea master of the sixteenth century, and the flower is invariably seen at ceremonies marking the anniversary of his death.

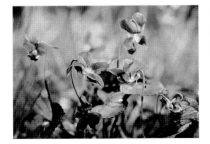

Manchurian violets (*sumire*). A typical harbinger of spring, the violet boasts some fifty different species distributed throughout Japan. The flower shown, *Viola mandshurica*, one of the most common types, grows wherever there is plenty of sunshine, both near human habitation and in the nearby hills. Flowers of the color known—in Japanese as in English—as "violet" are easiest to find, but white ones are seen as well.

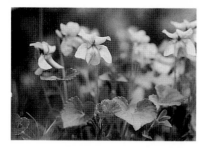

Purple-leaf violets (*tachitsubo-sumire*). Another species of violet (*Viola grypoceras*), found growing in thickets and by the roadsides near human habitation as well as in nearby hills, is one of the most familiar in Japan. Popular for its dainty flowers of a pale, slightly bluish mauve, it is frequently mentioned in poetry.

Dog's-tooth lilies. This flower (*Erythronium japonicum*), one of the first to bloom in the snowy regions of northern Japan in the early spring, has particularly poetic associations for the inhabitants of those areas. It grows in damp, well-shaded ground, for example, the hillsides near country villages. It has always been a favorite, being celebrated in the *Manyoshu*, the great verse anthology of the Nara period.

Dandelions. The dandelions shown here, known as "Western dandelions" (*Taraxacum officinal*) in Japan, came from Europe during the Meiji period, and by now are the most common species found in and around cities. The bright yellow blooms open in response to sunlight and close again when dusk falls or the sky clouds over.

Gathering the Chinese milk vetch (*renge*). *Renge* (*Astragalus sinicus*), native to China, was formerly cultivated in paddy fields as a fertilizer, and in time spread to grow wild in Japan as well. With the widespread use of chemical fertilizers, it has become comparatively rare, and the poetic sight of paddy fields pink with *renge* in spring is now a thing of the past. This photograph was taken at Hachioji, on the outskirts of Tokyo.

A traditional house (*minka*) and spring blossoms. Shimoichi, the town in southern Nara Prefecture to which this thatched home belongs, was originally a market town that grew up along the road taken by pilgrims on their way to climb Mt. Omine. Today, its primary industries are agriculture and forestry, but in olden times, six markets were held there every month. Shimoichi was once extremely prosperous; Japan's first promissory notes circulated there, and the town is mentioned in Saikaku Ihara's novel *Nihon Eitaigura*. The area is now chiefly known for the production of chopsticks made of Japanese cedar and the cultivation of Japanese damsons, persimmons, and vegetables.

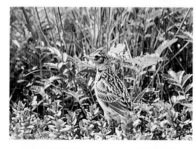

Skylark. The skylark (*Alauda arvensis*) lives in open spaces—uncultivated meadows, agricultural land, dry riverbeds and so on—in all parts of Japan from Kyushu northward. It makes its nest on the ground and is known for its cheerful twittering—actually a declaration of its territorial rights—that is heard high in the sky from March onward.

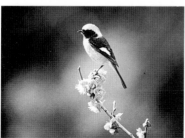

Daurian redstart (*jobitaki*) and red plum blossoms. The Daurian redstart (*Phoenicurus auroreus*), seen here perched on a branch of red Japanese damson, is a migratory bird that spends the winter all over Japan, chiefly in sunny woodlands where it feeds on insects and berries. Its movements are marked by a characteristic bowing of the head and quivering of the tail. When April comes, it flies north again.

Bush warbler. The bush warbler (*Cettia diphone*), seen here perched on a branch of dogwood, is popular for its mellifluous warbling, heard on warm spring days as if in response to the pleasant weather. It takes some time for the bird to master its characteristic cry, which sounds to Japanese ears like *ho-ho-kekyo*, the Japanese name for the Lotus Sutra.

Deer at Tobihino, Nara. This area of Nara Park, known as Tobihino, forms part of the sacred precincts of Kasuga Shrine. The name, which means "flying fire field," seems to derive from the fact that brushwood fires were kindled here in the Nara period as signals to the nearby capital of Heijo in times of emergency. The deer wandering over the new grass are one of the best-loved symbols of peaceful spring in the ancient capital.

Cherry blossoms at Mt. Yoshino in Nara Prefecture. The cherry trees that cover the hillsides of Mt. Yoshino are accorded special protection as sacred trees. The area has been celebrated for its cherry blossoms ever since the Heian period; from around mid-April, when the slopes are totally covered with blossoms, it is said that one can take in "a thousand cherry trees at a glance."

Mt. Hakuba in cherry blossom time. Omachi, in Nagano Prefecture—a town of which only five percent consists of level land—is well-known as a base for mountain climbers, and in winter as a ski resort. Mt. Hakuba, in the extreme north of the Northern Alps, consists in fact of three peaks known together as the "Three Mountains of Hakuba": Mt. Hakuba (2,933 meters), Mt. Shakushi (2,812 meters) and Yarigatake (2,903 meters).

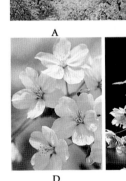
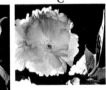

A: Cherry blossom: *somei-yoshino.* The most common variety of cherry found in Japan, *somei-yoshino* accounts for almost all the trees growing at well-known cherry blossom–viewing spots throughout the country. It has single flowers that bloom before the leaves appear. The pink of the buds gradually fades to near-white as the flowers open, and the cloudlike masses of blossom, especially when viewed against a clear blue sky in early April, have a beauty that attracts enormous crowds.

B–E: Cherry blossom: *ukon-zakura, kiku-zakura, ichiyo-zakura, kanzan-zakura.* *Sakura* in Japanese is the general term for a wide variety trees of the *Rosaceae* family that grow wild or are cultivated throughout Japan. It is generally classified into six main types, but in all some three hundred different varieties have been developed for ornamental purposes. They include strains with single or double flowers of widely varying size, ranging in color from deep pink to near-white, with some pale cream varieties also. Many have names with literary or other stylish associations. An avenue of cherry trees with many different varieties in the grounds of the old mint building in Osaka entices large numbers of visitors when it is opened to the public each spring.

F: Cherry blossom: *beni-shidare-zakura.* A popular ornamental variety, this "weeping" cherry is often found in the precincts of Shinto shrines and Buddhist temples, as well as in gardens and parks. Noted for its long life, it grows to a height of twenty-five meters, with a trunk sometimes more than one meter in diameter. The trees in the Gion district of Kyoto, which are particularly famous, are lit up at night during the season and draw many sightseers.

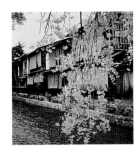

Weeping cherry at Gion Shinbashi in Kyoto. Beside a stream in Gion, the geisha district in eastern Kyoto where, as the popular ballad has it, "the water flows beneath one's pillow," the branches of ancient weeping cherry trees are heavy with blossoms. Even today, the bamboo blinds hanging over the tea house verandas in this most famous of traditional entertainment quarters preserve the atmosphere of the old days. The Agency for Cultural Affairs has designated the area as an "important district for the preservation of groups of traditional buildings."

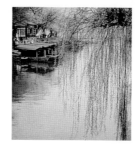

Quayside at Kyoto's Arashiyama. The neighborhood of Togetsukyo, a bridge over the Oigawa, is one of the most popular scenic spots in the Arashiyama district of Kyoto. The area first became famous when the Hata family, who came to Japan from China, began developing the riverbank, building a dam to divert water for irrigation. The aristocrats of the Heian court were fond of boating in the area.

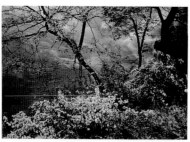

Kerria (*yamabuki*) blooming by the river. A scene in the Sugoroku Valley, part of Chubu Sangaku National Park on the upper Takahara River in northeastern Gifu Prefecture. The *yamabuki* (*Kerria japonica* DC), which blooms by mountain streams and in low-lying areas, has been popular ever since the time of the *Manyoshu* anthology, and the brilliant color of its flowers has lent its name to this particular shade of yellow.

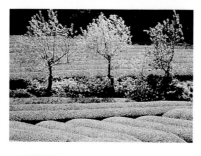

Tea fields in Shizuoka. Neat rows of tea bushes like well-trimmed hedges, seen here at the village of Kawane, are one of the most familiar sights of Shizuoka Prefecture. In 1995 the prefecture produced 46,000 tons of tea, nearly half of Japan's total output of 86,300 tons. By contrast, the figure for the celebrated tea of Kyoto, 2,790 tons, was a mere three percent of production.

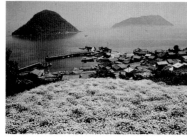

Port town on Sanagi Island in the Inland Sea. Sanagishima is a small, verdant island in the Inland Sea between Fukuyama in Hiroshima Prefecture and Marugame in Kagawa Prefecture. The white flowers are a species of small chrysanthemum cultivated for use in making *katori-senko*, the insect-repellent incense that was once a standard feature of Japanese domestic life in the summer. As lifestyles have changed, however, production is decreasing steadily. The yellow chrysanthemums are grown for sale as cut flowers.

Late spring along the coastal waters of the Japan Sea. A late spring scene at Yuya Bay on the Japan Sea coast, in northwest Yamaguchi Prefecture.

Yacht race in Sagami Bay, near Tokyo. In May, members of yachting clubs from universities in the Kanto area gather in Sagami Bay for an intercollegiate race, the largest annual event for smaller sailboats in Japan.

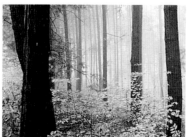

Cedar forest in Yoshino, Nara Prefecture. Yoshino, in the southern part of Nara Prefecture, is known primarily for its cherry blossoms, but the groves of cryptomeria mingling with the cherry trees create a variety that is especially beautiful in the spring, when the dark green of the foliage makes a striking contrast with the pink and white of the blossoms.

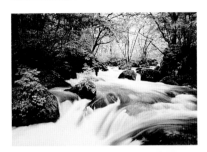

Murooji temple in Nara, with flowering dogwood and rhododendron. The Murooji temple, founded during the Nara period, has a superb setting, its various buildings—including three, the Main Hall, the Golden Hall, and the pagoda, designated as National Treasures—nestled on a hillside amidst luxuriant foliage. The temple was formerly known as an alternative place of worship for women of the Shingon sect, who were not permitted to worship at the main Koya monastery. It is particularly popular nowadays for its rhododendrons and autumn leaves.

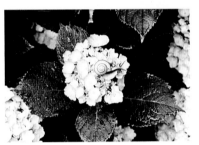

Oirase Gorge swollen with spring runoff. The Oirase River, flowing from the northeastern shore of Lake Towada, is swelled by waterfalls as it rushes down its rocky course toward the Pacific. The Oirase Gorge is noted for its many waterfalls and bizarrely shaped rocks, which are particularly beautiful against new spring foliage or the red leaves of autumn, and is a central feature of Towada-Hachimantai National Park.

Hydrangea and snail. The hydrangea is seen at its best in the rain, which never deters the crowds of visitors who flock to view it at such celebrated spots as Hakone or the temples of Kamakura. Its alternative Japanese name, *nana-henge* ("seven changes," a reference to the seven rapid changes of costume that Kabuki actors make in some plays) derives from its wide range of hues, from white through blue and purple to red.

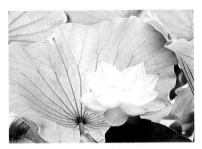

Water lily. The water lilies seen here in the pond at the Hokongoin, an ancient temple founded in Kyoto in 1130, have flowers very similar to the lotus, and are popularly known as "sleeping lotuses" because they close up at dusk. The most common colors are red, white, and pink.

The moss garden of Saihoji temple. True to its popular name of "Moss Temple," the old Buddhist temple of Saihoji features a garden in which everything, including the small bridge over the pond, is thickly carpeted with moss. The temple itself is said to have been founded by Gyoki in the Nara period under the name of Sai-hokyoin, but later fell into disuse until it was restored during the Muromachi period by Muso Kokushi. The garden is a famous example of the type intended to be viewed while walking around a path encircling the central feature, a pond.

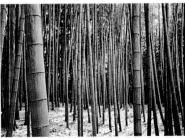

Bamboo grove, Sagano. Bamboo groves are perhaps one of the most typically Japanese sights. The bamboo has a hollow stem, without growth rings, and is said to flower once every sixty to one hundred and twenty years, producing no fruit even then. The attractive green of its foliage, its clean, straight lines and the characteristic rustling of its leaves in the breeze have always made it a favorite among the Japanese people. In the more practical sphere it is widely used as a material in architecture and furniture-making.

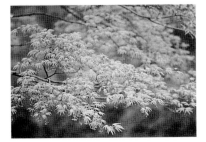

New maple foliage. The period from late April on into May in Japan is particularly beautiful because of the new foliage of the trees, clothed in a variety of greens that change their precise hue from day to day. The maple tree, of course, is celebrated for its red autumn foliage, but the transparent greens it presents in early summer have an unsurpassed freshness that seems to communicate itself to the surrounding air.

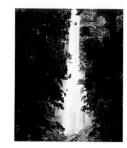

Nachi waterfall. Strictly speaking, the name Nachi is given to the whole complex of forty-eight falls around Mt. Nachi (909 meters) in Wakayama Prefecture, but generally the name Nachi Waterfall refers only to the largest of them, Ichinotaki. At 133 meters, Ichinotaki is one of the longest falls in Japan and is traditionally numbered among the nation's "Three Great Falls." The area is part of Yoshino-Kumano National Park (59,798 hectares), which extends over Mie, Nara and Wakayama Prefectures.

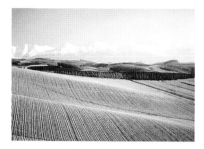

Hokkaido farmlands and the Tokachi Mountains. Compared to the rest of Japan, which is mostly covered with volcanic ash, the plain on either side of the middle and lower reaches of the Tokachi River in Hokkaido is more fertile, a vast farming district given to the cultivation of wheat, soy beans, and potatoes. The main peak of the Tokachi range (in Daisetsu-zan National Park), seen here still covered with snow, is volcanic Mt. Tokachi (2,077 meters).

Ichinokura Gorge in summer. Although Tanigawa-dake, on the boundary between Gunma and Niigata Prefectures, is a relatively small mountain of less than two thousand meters, it is a celebrated spot for rock-climbing. The peak itself forms part of a ridge from which many small valleys—among them Ichinokura-sawa—descend. Despite the beauty that draws so many visitors, it is also dreaded on account of its treacherous weather, which brings, a number of mountaineers to grief every year.

Lilies in the valley. In the "Garden of Lilies" in Fukuroi City, not far from Hamamatsu in Shizuoka Prefecture, a full one hundred and fifty different species of lily have been planted in the woods between the hills. Every year in June, the slopes below the trees are a riot of color, and the air is filled with the almost suffocatingly sweet scent of the flowers, which adds to the magical atmosphere.

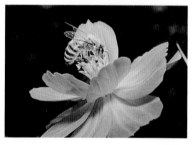

Bumblebee. In summer, the most active season for insects, the bumblebee is to be seen busily doing the rounds of the flowers, collecting its honey. Trusting its head deep into each bloom, it is amusingly unaware, in its eagerness, of the bright yellow pollen dusting its body, which it will later carry elsewhere, thus unwittingly repaying its debt to the blossom. If one stands in the open countryside on a summer's day and listens carefully, one can easily imagine that one hears the murmur of the bumblebees at their task.

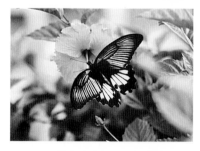

Hibiscus and swallowtail butterfly. This butterfly (*Papilio [Menelaides] memnon thunbergii* von Siebold), which feeds on the nectar of a wide variety of flowers, is an inhabitant of southern Japan—southern Honshu, Shikoku, Kyushu, and the Nansei Islands. This photograph was taken on one of the latter, Yoronjima.

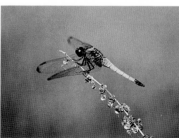

Skimmer dragonfly (*o-shiokara-tonbo*). This dragonfly, the "greater *shiokara*" (*Orthetrum triangulare*), which breeds in ponds, swamps, wetlands and any other shallow stretch of water, is generally larger than the preceding species, with a thicker body and a length of 5 to 5.7 centimeters. Yellow with clearly marked black stripes, it is found in parts of Hokkaido and all the way down the archipelago through Honshu, Shikoku, Kyushu, and Okinawa.

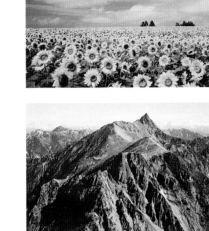

Sunflower field in Hokkaido. Hokuryu, an agricultural town in central Hokkaido, is famous for sunflowers, which are cultivated mainly for the oil extracted from their seeds. The sunflower is an annual of the chrysanthemum family and grows to a height of two to three meters, with large flowers as much as thirty centimeters in diameter. At the height of summer, it is a familiar sight not only in Hokkaido but in other parts of Japan as well.

The Northern Alps in summer. Mt. Yarigatake, part of the Hida Range and the principal peak (3,180 meters) of the Northern Alps, consists in fact of three sharply pointed peaks known, respectively, as Oyari (Big Spear), Koyari (Little Spear) and Magoyari (Grandchild Spear). It was scaled in 1878 by W. Garland and in 1892 by W. West, then in 1902 by a Japanese party led by Kojima Chosui, marking the beginning of mountaineering as a sport in Japan. The course crossing Yarigatake from Mt. Tsubakuro to Kamikochi is a favorite among mountain climbers.

Low tide on Ishigakijima, Okinawa. Ishigakijima, a verdant island of the Yaeyama group, lies close to Taiwan, some four hundred kilometers to the southeast of the main Okinawa island. Its coral reefs, among the most beautiful in the world, are a major attraction for divers. The white sand of the beaches is pulverized coral, and the waters are spectacularly clear.

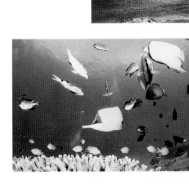

Yellow coral, Okinawa. Among the numerous reef fishes are the needle-nosed Forcepfish, with its tri-colored body dominated by a striking patch of lemon yellow, and the Butterflyfish, the large fish in the upper-right hand corner.

Coral reef, Okinawa. The red leaflike hydroid coral's fragile grace is a popular draw among divers.

Coral reef. The bright pink fish seen here—*kingyo-hanadai* (*Franzia squamipinnis*)—is about ten centimeters in length and common in the west Pacific, the Indian Ocean, the Red Sea and elsewhere. It swims in shoals that suggest large, colorful balls.

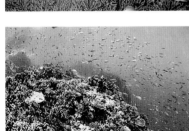

The primeval forest on Yakushima. The natural scenery on Yakushima, part of which is registered as a World Heritage site, ranges from coral reefs to a lofty mountain (Miyanoura-dake, at 1,935 meters the highest peak in Kyushu) on which snow sometimes settles in winter. The seventh largest island (502.6 square kilometers) in Japan, its yearly rainfall, at 4,500 millimeters, is three times that of Tokyo. With almost no level land, it is covered at a height of 1,000 to 1,500 meters by a primeval forest of Yaku cryptomerias, some of them 1,000 to 1,500 years old, including one enormous specimen, some 1,500 years old, with a girth at its root of forty-one meters.

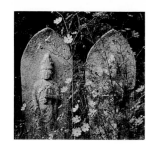

Cosmos and stone Buddhist figures. The cosmos, a native of Mexico, was not brought to Japan until the latter part of the nineteenth century, but by now it has become one of the typically colorful sights of the Japanese autumn, with patches of white, pink and magenta flowers waving gaily in the breeze in highland areas, by rivers, and on vacant plots of land.

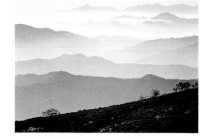

Mountains and the Norikura Highlands. Norikura ("saddle") Highlands is the name given to the eastern slopes of Mt. Norikura, a lofty volcano (3,026 meters) at the southern extremity of Chubu Sangaku National Park. Beside Mt. Norikura itself, Norikura Highlands includes several other volcanoes, including Kengamine and Mt. Fujimi; the name derives from the fact that the gentle curve of the mountains resemble a horse's saddle. With its beautiful silver birch and pine woods, the area is popular as a summer resort and also attracts many visitors in the autumn and during the ski season.

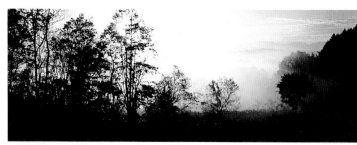

Autumn in Akino, Nara Prefecture. The Akino district, a farming area occupying the south-eastern slopes of the Ryumon Hills and the western Uda Hills in east central Nara Prefecture, has been known since ancient times for a type of arrowroot called *yoshino-kuzu.* Akino also has literary associations, being celebrated with a poem in the *Manyoshu* anthology.

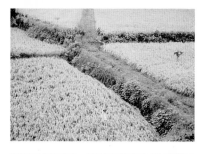

Paddies ready for the harvest and red spider lilies. Ears of rice are heavy for harvesting at the village of Hirokawa in Wakayama Prefecture. The splashes of red are spider lilies (*higanbana*, "equinox flower"), which bloom every year around the autumn equinox; an unusual plant, the spider lily no leaves at the time when its single flower opens. The fiery red of the flowers, which often grow on the paths between paddy fields, creates a striking contrast with the gold of the ripe rice.

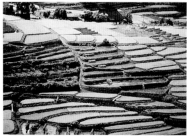

Terraced paddies in autumn. Standing only 310 meters above sea level, the Iiyama Basin (54 square kilometers) is the lowest part of Nagano Prefecture. Since the area lies under heavy snows in winter, the paddies are almost all restricted to a single yearly crop.

Autumn foliage on Mt. Shirane. Mt. Shirane (2,150 meters) is an active volcano extending over parts of Gunma and Nagano Prefectures, the name sometimes being used to include Hon-Shirane, which extends from Shirane to the south. Shibu Pass, between Mt. Shirane and Mt. Yokote, lies at a height of 2,172 meters on the boundary of the two prefectures, and has been a popular sightseeing route ever since the completion of the Shiga Kusatsu tollroad. The area is also popular with hikers and skiers.

Dahurian patrinia (*ominaeshi*). The Dahurian patrinia bears bright yellow flowers, each only three to four millimeters in diameter. The Chinese characters with which the name is written mean "harlot flower," a reference to the legend (also retold in a Noh play) of an abandoned prostitute who threw herself into a river in despair. Pitying her, the local inhabitants erected a memorial mound on the spot to pray for the repose of her soul, and that autumn, a single *ominaeshi* bloomed forlornly there.

Pink (*nadeshiko*). The *nadeshiko*, a kind of pink that grows on open land in the plains and hills of Honshu, Shikoku, and Kyushu, bears five-petaled pink flowers from summer to autumn. It is known as *yamato-nadeshiko*, or fringed pink, to distinguish it from the *kara-nadeshiko* originally brought from China; the word has become a poetic term signifying the traditional Japanese ideal of womanhood.

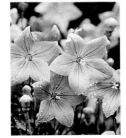

Balloon flower (*kikyo*). Also known as the Japanese (or Chinese) bellflower, the balloon flower (*kikyo*), which grows on sunny, open stretches of land throughout the Japanese countryside, has attractive, bell-shaped, purplish-blue flowers. It is associated with Kikyo, the favorite concubine of the popular twelfth-century hero Taira no Masakado, and often appears as a motif on clothing and in painting and *maki-e* lacquerware designs.

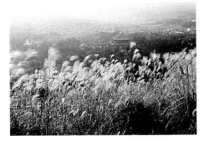

Silver grass (*susuki*) on the hillside of Wakakusayama. *Susuki* (*Miscanthus saccariflorus*), a member of the rice family, grows one to two meters tall all over the Japanese countryside. Rather than the silvery flowers, it is the dried fronds that, with their feeling of autumnal regret, have appealed to the Japanese through the ages. A vase holding a stem or two of *susuki* is essential to the autumn moon-viewing ritual. In the past, the plant also had economic significance, being used for thatching roofs and making the woven bags in which charcoal was kept. The celebrated Wakakusayama in Nara, though only two kilometers from the station, is elegantly covered with a green carpet of grass and affords splendid views of the Yamato Basin from its summit.

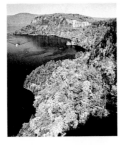

Autumn foliage at Lake Towada. The shape of Lake Towada, a double caldera lake on the border of Aomori and Akita Prefectures, has been likened to a split walnut. The new spring foliage and the autumn colors ringing the lake are equally attractive, and make it an essential part of any sightseeing visit to the remoter parts of northern Tohoku. The various lookout points around the lake give unrivalled views of the surrounding countryside.

Autumn colors in Nakatsugawa Gorge. The Nakatsugawa river, a tributary of the Abukumagawa east of Koriyama City, Fukushima Prefecture, is a celebrated spot for viewing autumn foliage. It forms part of Bandai Asahi National Park, which covers an area of 187,041 hectares in Yamagata, Fukushima, and Niigata Prefectures.

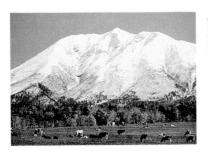

Autumn on a Hokkaido dairy farm. Hokkaido is Japan's major dairy farming area, taking advantage of the wide open spaces and cool climate. Mt. Oputashike, seen here covered with the season's first snow, is a 2,013-meter volcano in central Hokkaido.

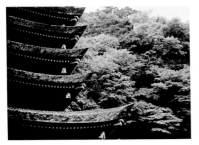

Pagoda with autumn foliage. The Tanzan Shrine on Tonomine Hill, standing at the mouth of the Hatsuse River Valley in the southeastern Nara Basin, has a thirteen-tiered (strictly speaking, five-storied) pagoda.

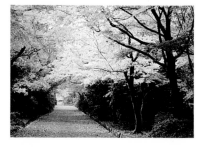

Shrine precincts in fall. The Oharano Shrine in Kyoto's Ukyo Ward was founded by the Fujiwara family as a sub-shrine of the celebrated Kasuga Shrine in Nara, and was widely popular as a place of worship among the court nobles of the Heian period. Its fortunes declined in medieval times, but it was restored in the early Edo period. It is celebrated among the inhabitants of Kyoto as a spot for viewing the autumn foliage.

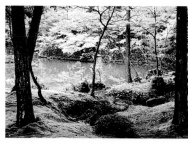

Autumn leaves at Saihoji temple. A temple of the Rinzai sect of Zen Buddhism in Sakyo Ward, Kyoto, Saihoji's garden was reorganized when Muso Kokushi restored the temple's fortunes in 1339. Tea houses and small Buddhist shrines are arranged around the central pond, and the garden as a whole is covered with the many varieties of moss that give the temple its nickname "Moss Temple." The garden is especially beautiful in autumn, when the red maple leaves form a vivid contrast with the velvety blanket of green.

Persimmons in fall. Jochiji, a temple of the Rinzai sect of Japanese Zen Buddhism in Kamakura, was established by Hojo Munemasa at the end of the thirteenth century, and was counted fourth among the five great Zen monasteries of Kamakura.

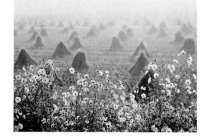

Cosmos and mounded rice straw. In this scene at Gosho-gawara in western Aomori Prefecture, the rice threshing is over, and the straw stands drying in the fields; it is early October, and time for the cosmos to bloom. A member of the chrysanthemum family, the cosmos bears delicate flowers on stalks that grow 1.5 to 2 meters in height, yet always right themselves if beaten down by strong winds.

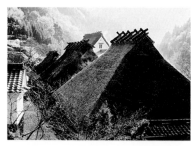

Traditional houses in autumn. Koran Valley, where these houses are situated, is a well-known scenic spot on the upper reaches of the Yahagi River in northern Aichi Prefecture.

White birch in late autumn. The Daisetsu Mountains, known as "the roof of Hokkaido," are a chain of nearly twenty peaks in the 2,000 meter class, among them the 2,260-meter Asahidake, the highest peak on the island. Daisetsu is famed for the brilliance of its autumn foliage, but when the last of the leaves have fallen in late autumn, the mountains take on a bleakness that foretells the approaching rigors of winter.

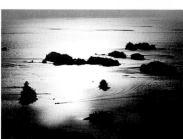

Islands of the Kujukushima group, Kyushu. Kujukushima—the "ninety-nine islands," some of which are seen here from the Ishidake lookout point in Nagasaki—consists in reality of more than two hundred islets scattered from Hirado all the way to Sasebo. The view over the island-studded sea presents a constantly changing aspect depending on the season and the time of day.

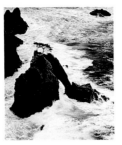

The Uradome coast with pine-tree islet. With its sheer cliffs, caves, oddly shaped rocks, rocky shallows, and countless small islands, this stretch of Japan Sea coast in Tottori Prefecture, close to the border with Hyogo Prefecture, forms part of Sanin Kaigan National Park, and is often compared with the more celebrated Matsushima on the opposite, Pacific side of Honshu.

White frost (*muhyo*). Sugadaira is an upland some 1,300 to 1,500 meters above sea level and 77 square kilometers in area in northeastern Nagano Prefecture. In the center is swampy land created by lava that blocked the flow of water from the mountains, but in the surrounding foothills there are dairy farms and fields of vegetables suited to the upland environment. The area is popular both as a summer resort and for skiing in winter. A white frost (*muhyo*) is formed when the moisture in clouds or mist settles on the frozen surfaces of trees or undergrowth.

Nandina (*nanten*; *Nandina domestica* Thunb). The name of this tree could also be written with two homonymous Chinese characters meaning "averting misfortune," and it is often planted in gardens in the hope that it will do just that. The leaves and berries garnish the red-tinted rice served on auspicious occasions, and the wood is used for making what are known as "long-life" chopsticks. The berries are also a favorite with the birds.

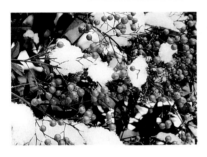

Amur adonis. *Fukujuso* (*Adonis amurenis* Reget et Radd), a perennial that grows beneath trees in the hills and mountains, has long been considered an auspicious flower for the way in which, braving the cold, it opens its bright yellow blooms around the middle of January every year. As a potted plant, it is often seen in flower shops around the New Year. The flowers open in the morning and close in the evening on fine days; in cloudy or rainy weather they refuse to open at all.

Camellia. Particularly after a fall of snow, the *kan-tsubaki* ("cold-weather camellia"), with its smallish flowers that bloom from November to January, provides one of the favorite poetic images of winter in Japan. Camellias, which are found throughout Japan from northern Honshu down through Shikoku and Kyushu to Okinawa, have been popular for five thousand years; in recent centuries, a single camellia bloom in a vase has become a favorite adjunct of the tea ceremony.

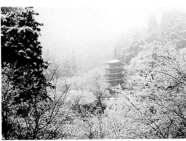

Hasedera temple in the snow. There are various theories as to when this temple in Sakurai, Nara Prefecture, was first built, but stories concerning it date back as far as the year 733. The figure of the Eleven-Faced Kannon that it houses was a favorite object of worship among women in the Heian period, and in the middle ages it was thought to represent the original, Buddhist form of the Japanese sun-goddess Amaterasu Omikami. In the period of civil strife that preceded the reunification of the country in the late sixteenth century, the temple fell into disrepair, but it was restored by Toyotomi Hideyoshi; at present it numbers eighth among the thirty-three Kannon temples of western Japan that still form a circuit for pilgrimage.

Traditional homes in the snow. The village of Kawanami, in Shiga Prefecture on the Japan Sea side of Honshu, is buried in deep snow every winter.

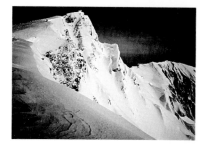

Midwinter on Mt. Hakuba. Mt. Hakuba, at 2,933 meters, is one of the principal peaks of the Northern Alps, a string of mountains in the 3,000-meter class forming the central mountain system—the backbone, as it were—of Japan's main island of Honshu. It is a favorite of mountain climbers, hikers, and skiers alike, and is noted for the way the prospect opens up as the climber emerges onto the summit to present a magnificent, 360-degree panorama of the surrounding landscape.

Winter waterfall. Nanatsu Falls in Tamugimata, a small mountain village standing beside the river of the same name at the foot of Mt. Yudono (1,504 meters) in Bandai Asahi National Park. Long ago, the village was the site of inns used by religious ascetics on their way to the Yudono Mountains. With an annual precipitation of 3,000 millimeters, the accumulated snow reaches up to six meters, the heaviest in Yamagata Prefecture.

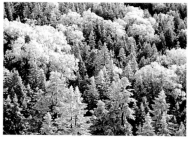

Iced trees (*juhyo*). These ice-covered trees stand in Towada-Hachimantai National Park, an area of 85,409 hectares extending over Aomori, Akita, and Iwate Prefectures. The park itself is a volcanic upland topped by a gently sloping area of marshes with a rich variety of alpine plants.

Iced trees under snow. Mt. Zao (1,841 meters), which extends over parts of Yamagata and Miyagi Prefectures, is famous for its ski slopes and for its *juhyo*. *Juhyo*, a kind of *muhyo*, are formed when the temperature close to the earth falls below freezing point and particles of frozen mist are blown against the branches of trees and other objects on the ground. They have an extraordinary brittle texture, in appearance suggesting a bird's down or fish's fins.

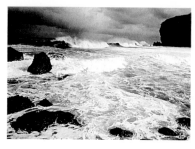

Stormy seas, Otaru, Hokkaido. At one time, Otaru was Hokkaido's most important harbor, from which much of the island's coal was shipped. It was also, for a while, a center for herring fishing. Although few herring are caught nowadays, the waters of the Okhotsk Sea are still rich in fish, the type of midwinter seas seen here affording particularly rich yields.

The cedar forest of Kitayama. The slopes of the hills lining the river at Kitayama, on the northern outskirts of Kyoto, are covered with orderly, man-made ranks of cryptomeria. The lower branches of the trees are all lopped off, leaving only a small portion of the upper foliage, so that the trees come to resemble half-open umbrellas and have a very special beauty of their own. The aim is to produce perfectly straight trunks. The unpainted cryptomeria pillars so highly prized for use in the *tokonoma* of traditional Japanese houses are produced here.

Winter mountainsides, Kirigamine. The gently undulating upland lying between Kurumayama and Washigamine to the northeast of Lake Suwa in Nagano Prefecture is covered with *susuki* and alpine vegetation, and is well-known for its skiing and camping areas.

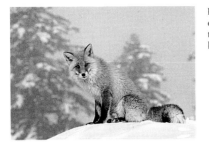

Red fox. The number of red foxes (*Vulpes vulpes schrencki*) observed in various parts of Hokkaido has increased markedly in recent years. With a long tail in proportion to its body, the red fox has bright brownish-orange fur on its back that is particularly attractive.

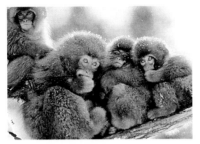

Japanese macaque. Also known as the snow monkey, the macaque ranges farther north than any other species of monkey. With long, dense fur, red face and buttocks, and a short tail, it is found in Honshu, Shikoku and Kyushu, its most northerly habitat being the Shimokita Peninsula in Aomori Prefecture.

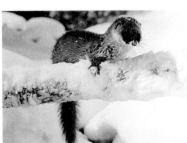

Japanese weasel. Although the Japanese name of this weasel, *hondo-itachi* ("main island weasel"; *Mustela sibirica itatsi*) suggests that it is only found in Honshu, it also lives in Hokkaido, presumably having swum across the intervening straits. It is an odd animal equally adept at swimming and climbing trees.

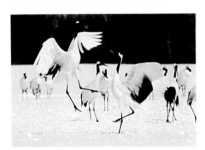

Japanese crane. The largest bird native to Japan, the Japanese crane (*tancho*) is also one of the most popular, both as a kind of "national bird" and as an auspicious symbol. At one time it was feared that it might become extinct, but careful protection policies have increased its numbers again, and now some five hundred birds inhabit the Kushiro Wetlands. In spring, they make nests in the wetland grass to hatch their eggs and rear their chicks, while in winter they perform their famous stately courting dance in the snow.

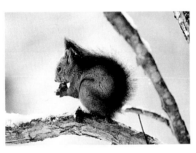

Red squirrel. The red squirrel, a Hokkaido subspecies (*Sciurus vulgaris*), is seen in winter happily bounding about when other squirrels are already fast asleep, hibernating. It feeds on walnuts and acorns and spends almost all its time up in the branches, but is occasionally seen scuttling at enormous speed over the ground between the trees.

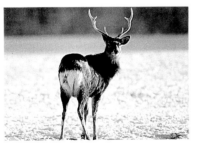

Sika deer. The *Ezo-shika*, a Hokkaido subspecies (*Cervus nipon yesoensis*), once seemed in danger of disappearing, but restrictions on hunting have increased its number again, and it is once more sighted frequently in and around the Kushiro Wetlands, where it lives on the buds, bark and leaves of trees such as the *hannoki*. The splendid horns of the male are shed and grow again in spring each year, the number of branches increasing annually.

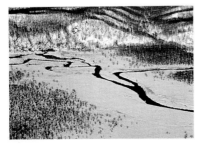

Winter in the Kushiro Wetlands. With an area of 21,400 hectares, the Kushiro Wetlands in the west of the Konsen Plain in Hokkaido are the largest swampy area in Japan. Extremely rich in all kinds of flora and fauna, they were designated as a National Park in 1987. They are the habitat of the Japanese crane, and large numbers of migratory birds come here to breed and spend the winter every year.

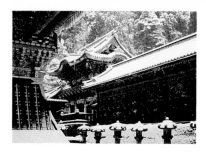

Nikko shrine in the snow. The Toshogu is a shrine dedicated to Tokugawa Ieyasu, the shogun who finally brought the whole of Japan under his rule in the early seventeenth century. The shrine was founded by Tokugawa Hidetada in 1617, when he had Ieyasu's remains transferred to Nikko from Suruga. It acquired its present scale when, from 1634 to 1636, Tokugawa Iemitsu had lavishly decorated buildings built here in the *gongen-zukuri* style (a blend of Buddhist and Shinto architecture). The shrine (now designated as a National Treasure) is of a magnificence calculated to vaunt the shogun's authority—and cost a correspondingly astronomical sum to complete.

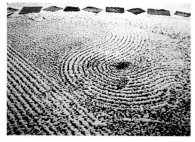

Raked sand garden in Nanzenji temple, Kyoto. The Konchiin, a subsidiary temple within the great Nanzenji complex, dates from the early seventeenth century, when the temple was restored by Ishin Suden, and has a *kare-sansui* ("dry landscape") garden designed by the celebrated Kobori Enshu. Nanzenji itself was founded in the Kamakura period when the Emperor Kameyama had one of his villas converted into a Zen temple; it subsequently developed into one of the "Five Great Monasteries" of the Rinzai sect of Japanese Zen Buddhism.

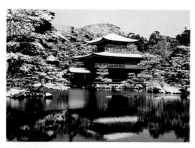

Kinkakuji temple in the snow. Kinkaku (Golden Pavilion) is the popular name of Rokuonji temple of the Rinzai sect of Zen Buddhism in the north of Kyoto. Originally a villa built by the Ashikaga shogun Yoshimitsu in 1397, it became a temple following Yoshimitsu's death; in recent times, Mishima Yukio's novel *Kinkakuji* has made it even better known.

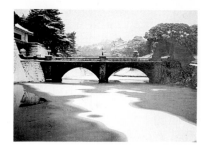

Entrance to the Imperial Palace, Tokyo. The bridges visible in the photo, as well as the general area, are known as Nijubashi ("Double Bridge"). Although the bridges have been made of iron since the Meiji era, the originals were constructed of wood in the Edo period, when the lie of the land and technical difficulties presented by the material dictated this unusual structure.

Drifting ice floes off the coast of Hokkaido in the Okhotsk Sea. Taken at Monbetsu, a town on the Okhotsk Sea coast of Hokkaido, this photograph shows the ice floes that drift down to Hokkaido from distant northern waters every year. The precise date of their arrival varies from year to year, and the locals take an almost poetic pleasure in speculating on the subject.

PART II DAILY LIFE AND RITUAL

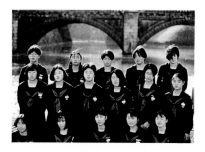

Schoolgirls pose by the Imperial Palace Bridge. The Double Bridge, entrance to Tokyo's Imperial Palace, is a popular place to take souvenir photographs on school trips from around the country. These schoolgirls are wearing typical middy-style uniforms; the solemnity of their expressions is also typical for such a formal setting.

Cherry blossoms at Ueno Park. This aerial photograph captures the greens and pinks of spring at Ueno Park in downtown Tokyo, with cherry blossoms in full bloom.

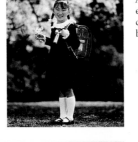

A new student on the day of the school entrance ceremony. School entrance ceremonies are held across Japan in early April, often coinciding exactly with the cherry blossoms at their peak. This pigtailed first-grader is all ready for classes; red backpacks are for girls, black for boys.

Crowds of revelers at cherry-blossom time in Ueno Park. Ueno Park has a carnival-like atmosphere during cherry-blossom season, as crowds flock there day and night to take in the famous sight. In large and small groups they come ready to feast and drink, making the most of the blossoms' brief glory.

A Japanese white-eye among plum blossoms. The plum blossom comes out a little before the cherry. These blossoms are from Dazaifu Tenmangu shrine in Kyushu, where the Heian courtier Sugawara Michizane was exiled long ago. Tradition has it that his favorite plum tree flew through the air to join him there.

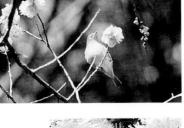

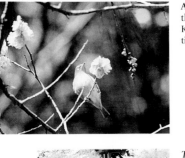

Torii **gate in Ueno Park straddles flower-viewing crowds.** The temple grounds of Benzaiten in Ueno Park are crowded with blossom-viewers on a sunny spring day. The vermilion of the *torii*, or shrine gate, is a striking contrast with the spring pastels.

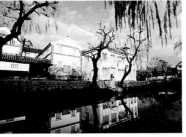

Old warehouses reflected in a canal in Kurashiki. Located in Okayama Prefecture, the city of Kurashiki is famous for its many Edo-period stone warehouses (*kura*) lining the canal along the main street. The city is also known for its fine museums.

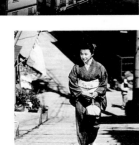

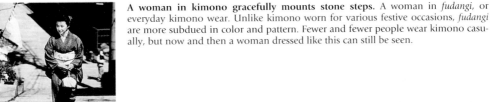

A woman in kimono gracefully mounts stone steps. A woman in *fudangi*, or everyday kimono wear. Unlike kimono worn for various festive occasions, *fudangi* are more subdued in color and pattern. Fewer and fewer people wear kimono casually, but now and then a woman dressed like this can still be seen.

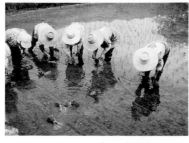

Planting rice. Rice-planting season is late April through early May. After the dry paddies are flooded with water, seedlings are carefully set out. Nowadays the planting is usually done by machine.

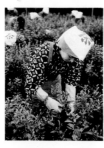

Tea-picker in traditional costume. The eighty-eighth night of the year, by the traditional calendar early in May, is the traditional time to begin picking new tea leaves. Once a drink of the ruling class, tea did not become the national beverage until the twentieth century.

Strolling among bright azaleas. After the cherry blossoms have fallen, next to bloom is the azalea. Their vivid colors make this one of the loveliest times of the year.

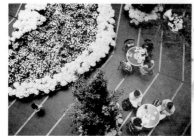

Teatime by hydrangeas in Shibuya, Tokyo. Hydrangeas come into bloom just before the rainy season in Japan. The weather then is generally sunny and mild, perfect for an afternoon tea outdoors on the terrace.

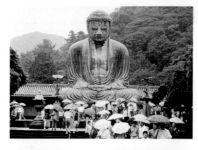

Kamakura's Great Buddha in early summer rain. The Great Buddha in Kamakura is 11.5 meters high, and dates from 1252. The *tanka* poet Yosano Akiko (1878–1942) wrote scandalously of her amorous attraction to the beautiful, sacred statue.

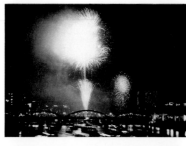

Summer fireworks along the Sumida River. The fireworks along the Sumida River in Tokyo are a famous summer attraction. In late July, the river is crowded with boatloads of sightseers.

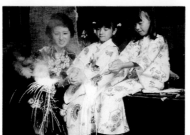

Children in summer kimono play with sparklers. On a muggy summer night, stepping outside to play with fireworks provides a welcome diversion. Night after night, the crack and sizzle of fireworks can be heard.

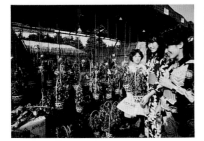

The *Hozuki Ichi* fair at Tokyo's Asakusa Kannon temple in July, where Chinese lantern plants are featured. The ground-cherry fair, held every July 9 to 10, is a staple of summer at Tokyo's Asakusa Kannon Temple. A visit to the temple on this day is considered especially lucky. The potted plants (*Physalis alkekengi*, also known as Chinese lantern plants) are sold with wind bells attached to them. The ground cherries are used to make medicine and toy whistles as well as to decorate Buddhist altars.

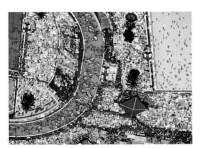

Midsummer mosaic of pools and bathers. Swimming pools are ever-popular in Tokyo as a way to escape the crushing heat of the city.

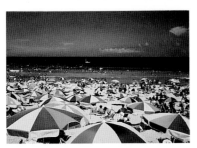

A panoply of umbrellas at Shirahama Beach. Shirahama Beach on Izu Peninsula, Shizuoka Prefecture. The crowded seaside is festive with colorful beach umbrellas under a cobalt sky.

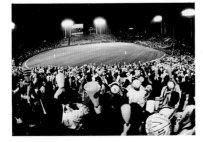

Cheering fans fill a baseball stadium for a night game. Night games (*naita*, "nighters") attract large numbers of fans. There are two professional baseball leagues with six corporate-owned teams each, featuring names like the Chunichi Dragons, the Yakult Swallows, and the Nippon Ham Fighters. Plastic megaphones, standard equipment for fans, can be waved, drummed, or shouted through.

Unwinding after work over grilled chicken and beer. After a long day in the office, nothing revives the spirits like some good food and a tankard or two of beer, in the company of convivial coworkers.

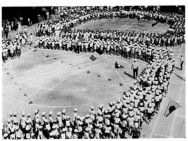

Schoolchildren at a fall field day. Summer heat a memory, people look forward to the fall sports festival, a much-anticipated event of the school year that features a day-long series of races, stunts, and games, with a midday break for a picnic lunch under blue autumn skies. Weather permitting, the festival is held on a Sunday so the whole family can turn out to cheer. Here the children are divided into two teams, Red and White.

"On your mark, get set..." This girl, a member of the Blue relay team, waits breathlessly for her teammate to pass the baton to her. She is poised to take off; a second or two more and she will be flying toward the goal.

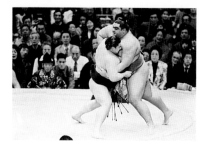

Sumo wrestlers. Sumo, the national sport of Japan, is a form of wrestling with a two-thousand-year-old history. Mammoth men wearing only loincloths face off inside a ring and try to force each other out or down. Tournaments are held in alternating months, as follows: January, Tokyo; March, Osaka; May, Tokyo; July, Nagoya; September, Tokyo; and November, Fukuoka. Here, Takanohana (left) grapples with Musashimaru.

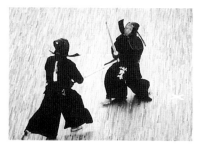

Kendo: the way of the sword. Kendo is a martial art dating from the late twelfth century, when a military-style government was set up in Kamakura. Gradually kendo evolved from a means of self-defense to a form of mental and physical discipline. Today it is a popular sport akin to fencing; participants wear heavy protective clothing, and fight with wooden or bamboo swords.

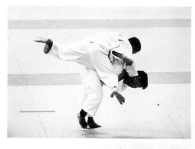

A judo match. Judo (literally "the way of softness") is another sport that developed out of a martial art of self-defense. Techniques consist of throwing, grappling, and attacking vital points. Judo has been an Olympic sport since the 1964 Tokyo Olympics.

Young women practice Japanese archery. Kyudo (literally "the way of the bow"), or Japanese archery, is another ancient martial art. There are several schools, some of them heavily influenced by Zen Buddhism.

Himeji Castle. Himeji Castle is a fourteenth-century castle located in Himeji City, Hyogo Prefecture. Also known as Shirasagi (Egret) because of its elegance and beauty, the castle has been designated a National Treasure.

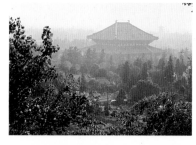

Todaiji's Great Buddha Hall amid fall colors. The Todaiji temple in Nara, set in beautiful Nara Park, houses the colossal Great Buddha. First constructed in 752, this building has been destroyed in war and reconstructed again and again; the present building dates from 1692.

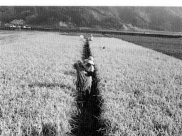

Rice at harvest time. Fall is the season of harvest. It is important to get the rice crop in expeditiously, before it is flattened by the typhoons that buffet Japan at this time of year.

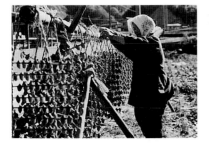

Jewel-like persimmons hanging out to dry. Astringent persimmons can be made sweet and delicious by peeling them and hanging them to dry in the sun; this is also a natural way of preserving the fruit for the winter.

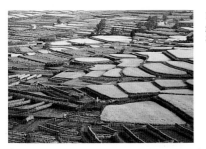

Rice harvest underway in terraced paddies. This aerial photograph provides a good view of terraced paddies in northeastern Nagano Prefecture, near Nozawa Hot Springs. Harvested rice is hung on racks to dry before threshing.

Saké and snacks at an open hearth. In traditional farmhouses, the hearth in the center of the room was set into the floor; in addition to functioning as a cooking place, its charcoal fire could be used to heat water for tea, grill rice-cakes, or simply take the chill from the room.

New Year's Eve tradition: receiving sacred fire. *Okera-mairi* refers to the Kyoto custom of going to Yasaka Shrine sometime during the night of December 31 and receiving holy fire to guarantee freedom from disease in the coming year. Local residents light rice-straw torches at a bonfire of *okera*, a medicinal plant in the chrysanthemum family. The burning torches are carried home, and were traditionally used to kindle the hearth and cook the celebratory foods of the New Year.

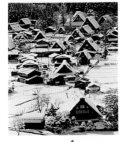

Snow country: a cluster of traditional farmhouses. Shirakawa-go in Gifu Prefecture is famous for its large number of surviving farmhouses in the *gassho-zukuri* ("praying hands") style, with deeply slanting roofs like inverted Vs.

A doorway framed by *kadomatsu*, New Year's decorations. At New Year's, it is customary in many parts of the country to decorate the outside of one's home with *kadomatsu*, festive arrangements of bamboo and pine. Sometimes red earth is sprinkled on the ground as well.

Visitors at a shrine in sumptuous New Year attire. These young women are wearing *furisode*, elaborate silk kimono with long, waving sleeves that can be worn only by young unmarried women. The lucky arrows they are purchasing are said to purify their owners from all distractions, making it easier for them to pray.

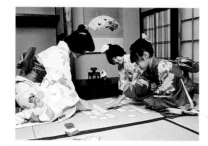

Playing New Year's card games. It wouldn't be New Year's without card games (*karuta*). One player reads the first half of a classical poem—most often from the thirteenth-century collection *Hyakunin Isshu* (Single Poems by One Hundred Poets)—while others scan cards spread out in front of them to find the other half. *Iroha karuta*, popular among children, uses sets of forty-eight cards containing poems or proverbs beginning with the Japanese equivalent of the ABCs.

Kites soar in a blue sky. Kite-flying is a traditional New Year's activity. Japanese kites like those pictured here consist of a light bamboo or wood frame covered with paper painted in brilliant colors and bold designs: renditions of Chinese characters for "dragon," "god," or the like; geometric patterns; or faces of legendary heroes.

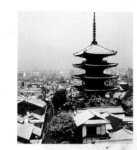

Pagoda of Yasaka Shrine on a snowy night in Kyoto. A dusting of snow covers the pagoda and rooftops of Yasaka Shrine, an oasis of quiet in the busy downtown Gion district of Kyoto. The month-long Gion Festival is held here in July.

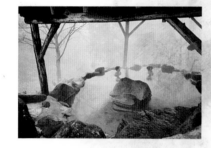

A hot spring in the backwoods. This scenic outdoor bath is part of Azuma Takayu *onsen* (hot spring) in Yamagata Prefecture.

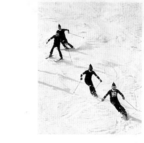

Skiers chase one another downhill. Skiing was introduced to Japan by an Austrian military officer in the 1910s, and soon became extremely popular. Its appeal among Japanese youth is unabated; all winter long, the ski slopes are crowded.

Coming of Age Day: a young woman in formal kimono visits a temple. A woman newly turned twenty makes a votive offering (*ema*)

Firefighters in Edo-era garb put on a New Year's show. Every year around January 6, Tokyo firefighters stage an outdoor display of their skills. For the annual fire-brigade review, known as *dezomeshiki*, the men dress up as Edo firefighters and perform breathtaking stunts on high ladders, singing traditional chants.

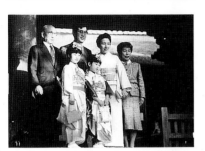

All dressed up for "Seven-five-three" festival day. A boy of five and a girl of seven in traditional finery smile happily as they clutch *chitose-ame*, literally "thousand-year candy," a sticky confection that celebrates their health and growth.

A family picture to celebrate the children's growth. On or around November 15, boys of three and five, and girls of three and seven, are dressed up and taken to the local shrine for a blessing in celebration of their growth.

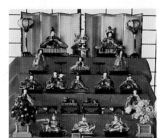

Elegant court dolls for the March Doll Festival. The tiered stand for the display of *hina* dolls has the imperial couple arranged on the top level; below them are three ladies-in-waiting, musicians and dancers, ministers, an orange tree and a blossoming cherry, and miniature furnishings including a mirror, chests, a needle case, a palanquin, and a carriage.

Carp banners galore for Children's Day. Carp banners from all over the country are strung on eight wires across the Kanna River in Gunma Prefecture each year in early May. Koi Jinja, a shrine dedicated to the spirit of carp, is located in nearby Manba-machi.

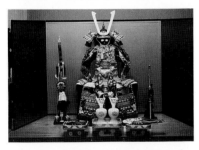

Miniature arms and armor displayed for Children's Day. In conjunction with the display of carp banners of Children's Day, a doll-sized suit of armor with helmet and weaponry is set up in homes with male children. The tradition dates from the days of the samurai when such displays symbolized a wish for a strong male child.

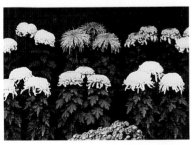

Chrysanthemums at a latticed door. September 9 is *Choyo no Sekku* or the Chrysanthemum Festival, when people drink chrysanthemum wine to celebrate long life. The chrysanthemum ranks with the cherry blossom as a symbol of Japan, and it is also the official crest of the imperial family. Gardeners show off their skills with colorful exhibits of carefully tended chrysanthemums such as these.

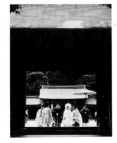

A Shinto wedding. For a Shinto wedding ceremony, the bride dresses all in white with a white headdress, while the groom wears *haori* and *hakama*, formal attire emblazoned with the family crest.

Ise Shrine: most sacred of Shinto sites. Located in the city of Ise, Mie Prefecture, Ise Shrine comprises the Inner Shrine (Kotai Jingu or Naiku) and the Outer Shrine (Toyoke Daijingu or Geku). Pictured here is the Outer Shrine, said to enshrine the god of food, clothing, and housing. It is built of unpainted Japanese cypress. Both the Inner and outer Shrines are razed and rebuilt every twenty-one years, as dictated by Shinto custom.

Monks on a snowy wooded path. Monks of the Enryakuji temple, head temple of the Tendai sect of Buddhism, located on Mount Hiei just outside Kyoto. The mountain setting contributes to the secluded, holy atmosphere of a strict Buddhist monastery.

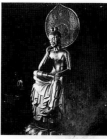

Bodhisattva in meditation: a seventh-century Buddhist sculpture in the Nara temple of Chuguji. Chuguji is a convent-temple said to originally have been built as a palace at the end of the sixth century by Prince Shotoku for his mother. Among the pieces on the grounds is this figure, designated a National Treasure. Its lightness of form and line contrasts with the bulkier Tori style that predominated at the time, and the distinctive fluidity of this work places it in the highest ranks of Japanese Buddhist sculpture.

Mountainside bonfire marks summer's end in Kyoto. On August 16, *Bon* festivities conclude with *Daimonji-yaki*, an enormous bonfire laid out in the shape of the Chinese character *dai* ("great") on a mountain at the city's eastern edge. This and other, smaller fires lit immediately afterward on other mountains encircling the city are *okuribi*, bonfires to send off the spirits of departing ancestors at the festival's end.

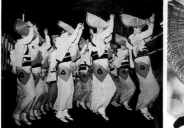

Awa Dance. The *Awa Odori* is a type of *Bon* dance held August 12 to 15 in the city of Tokushima in Shikoku. Groups of men and women parade gaily through the streets, dancing to the infectious rhythm of the accompanying flutes, *shamisen*, and drums.

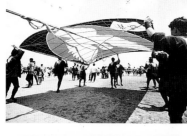

A kite festival in Hamamatsu. In the city of Hamamatsu, Shizuoka Prefecture, a grand kite festival is held every May 3 to 5. Local groups compete in making enormous square kites 3.3 meters on a side, weighing as much as ten kilograms. The object is to keep your creation aloft while attacking and bringing down those of your foes.

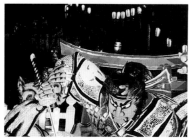

Fierce warrior float at Nebuta Festival in Aomori. The Nebuta Festival takes place early in August in the northern cities of Aomori and Hirosaki. Enormous lantern-lit floats with paper images of legendary or historical figures, including fierce warriors such as this one, are paraded through the streets. One of the three great festivals of the Tohoku Region (the others are Sendai's Tanabata Festival and Akita's Lantern Festival).

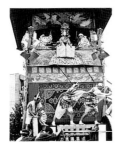

Gion Festival float bearing musicians and dancers. The Gion Festival (July 17 to 24) is held at Yasaka Shrine in Kyoto. Musicians begin practicing around the beginning of July. The high point of the festivities is the procession of *yamaboko* (floats bearing tableaux and costumed musicians) on the seventeenth. Many of the floats are beautifully decorated with works of art including valuable medieval European tapestries. This is one of the three great festivals of Kyoto; the others are the Aoi Festival in May and the Festival of the Ages in October.

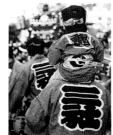

Father and son participate in the Sanja Festival. This young man and his father are dressed in traditional festival garb, printed with the name of the festival: "Sanja." The costume includes *hachimaki*, a thin towel or strip of cloth worn around the crown of the head.

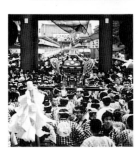

A portable shrine is shouldered by men in festival garb. The *mikoshi* is a portable Shinto shrine carried through parish streets on festival days. The morning of the festival, the priest transfers the *shintai* ("god-body") or object of worship to the *mikoshi*, where it will remain for the duration of the festival. The roof of this *mikoshi* is decorated with a phoenix, and the entire shrine is a superbly crafted work of art.

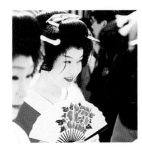

A smiling geisha amid festival onlookers. Festivals offer a good chance to catch sight of geisha, who are not usually out and about. Though declining in numbers, geisha still enjoy a respected position in Japanese society as embodiments of traditional arts and culture.

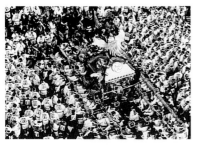

Sanja Matsuri **is Tokyo's biggest festival.** For four days in mid-May the Sanja Festival, a major festival of old Edo, takes place at Asakusa Shrine. Even today, it draws the biggest crowds of any festival in Tokyo. At dawn the three *mikoshi* or portable shrines of Asakusa Shrine are taken out and paraded through the streets, along with some eighty other local *mikoshi*.

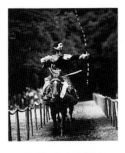

Archery on horseback at Tsurugaoka Hachiman Shrine, Kamakura. Equestrian archery is a martial art dating from the Kamakura period in which the archer shoots at three stationary targets in a row while riding past at full gallop. It can be seen at the festival of Kamakura's Tsurugaoka Hachiman Shrine in mid-September.

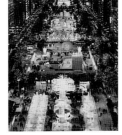

Sapporo's Snow Festival. The popular Snow Festival in Sapporo, Hokkaido, takes place February 5 to 11, with an array of snow and ice sculptures on display in the city's parks. Some entries tower as high as fifteen meters.

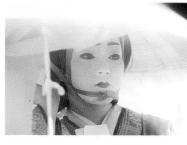

In costume for Kyoto's Festival of the Ages (*Jidai Matsuri*). The Festival of the Ages is held October 22 at Kyoto's Heian Shrine. A thousand years of Japanese history, from the Meiji Restoration of 1868 all the way back to Heian days, are represented by a pageant of costumed figures. Historical figures like medieval warlords Toyotomi Hideyoshi and Oda Nobunaga are included along with palanquin-borne women, ladies-in-waiting from the era of the *Tale of Genji*, and so on.

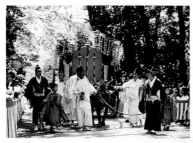

An ox-drawn cart in Kyoto's Aoi Festival. Held on May 15, the Aoi Festival is held at the Kamo Shrines in Kyoto. Participants gather at the Imperial Palace dressed in the garb of Heian court nobles, and proceed to Shimogamo Shrine, crossing the Kamo River, then on to Kamigamo Shrine. The exquisitely decorated ox-carts and traditional costumes make this a living picture of the life of ancient times.

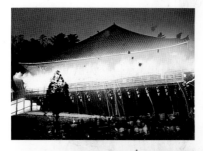

***Omizutori*: fiery rite of spring at Nara's Todaiji temple.** *Omizutori* (literally "water-drawing") is a rite of spring performed March 1 to 14 at Todaiji temple in Nara. On the night of the twelfth, specially chosen monks dash around the veranda of Nigatsudo Hall carrying enormous torches one meter in diameter and eight meters long; over the next two days, they draw water from a nearby well and offer it to the image of the Eleven-Faced Kannon.

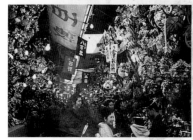

Good-luck charms for sale at a shrine in Shinjuku. Tori no Ichi ("Rooster Fair") is a festival held on the day of the rooster in November, of which there are always at least two and sometimes as many as three. In years when there are three fairs, it is said there will be many fires. Generally the fairs are associated with good luck, and various charms are sold at the shrines, including rakes to "rake in" happiness and wealth.

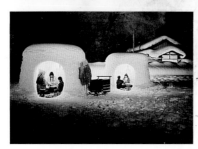

Children in *kamakura*, snow houses in Akita. On February 15 and 16, children in the northern city of Yokote, Akita Prefecture, make snow huts called *kamakura*, building shrines inside them to honor the water god. Dressed in traditional clothes, they light lanterns and sit around *hibachi* to warm themselves at night, while passers-by stop in to offer gifts of rice-cakes and money to the water god, and to receive a bit of sweet saké.

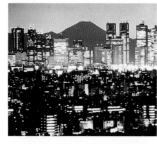

Mt. Fuji behind a glittering Tokyo cityscape. Mount Fuji, durable symbol of Japan, is a beautiful backdrop for Tokyo at night. Once unheard-of in earthquake-prone Japan, high-rise buildings like the skyscrapers of Shinjuku are now a common sight here.

The all-female Takarazuka Revue. The wildly popular Takarazuka Revue consists of four all-female troupes who stage musical extravaganzas covering an impressive range of styles. Their official motto is "pure, proper, beautiful"; teenaged girls and young women are among their most ardent fans.

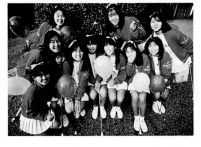

A gathering in Kyoto. A clutch of young women at a year-end festival for a local business group.

Omotesando, a crowded Tokyo thoroughfare at Christmastime. Christmas is widely enjoyed in Japan even though few people are Christian. In homes, hotels, and restaurants across the country, millions of people celebrate Christmas Eve. Trees along Omotesando in Harajuku are decorated with lights for the season.

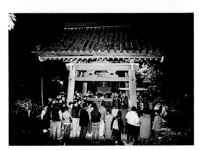

Ringing in the New Year. On New Year's Eve, as the hour of midnight strikes, temple bells toll solemnly all over Japan. For this ceremony, *joya no kane*, the bells are rung 108 times to dispel the 108 earthly desires that are held to be the root cause of human suffering.

PART III CULTURE AND TRADITION

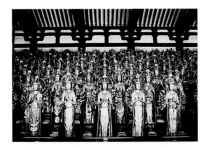

Images of the bodhisattva Kannon in Sanjusangendo. The inner sanctum of the well-known Kyoto temple Rengeoin is composed of 33 (*sanjusan*) bays (*ken*), a notable characteristic that not only lent the temple one of its most memorable features but the name by which it is popularly known. The hall runs an impressive 118 meters and contains 1,001 images of Kannon: a large seated Kannon at its center (unseen) flanked on each side by 500 standing images. These smaller statues, carved in the Kamakura period, were colored, or japanned, then covered in gold-leaf, and as a group have been designated an Important Cultural Property.

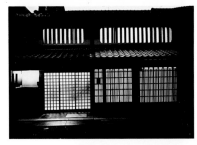

The Noguchi House. The facade of this elegant Kyoto *machiya*, or townhouse, glows like a lantern in the night through slatted *koshi* doors and windows. The *koshi* afforded privacy to the urban townhouse dwellers, whose homes were built right up to the edge of the street. Behind them, sliding paper *shoji* screens further conceal the interior of the house, while allowing a filtered white light to enter the rooms.

HOUSE AND GARDEN

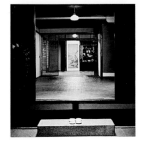

The Noguchi House. Viewed from the entryway, the Buddhist altar in memory of the family's ancestors is the heart of the traditional home. At the *genkan*, or entrance to the living quarters of the house, shoes are removed before stepping up into the main rooms. The removal of shoes is a symbol of respect for the cleanliness and purity of the residence, and the *butsudan*, or Buddhist altar, attests to the spiritual presence of the ancestors revered by members of the household.

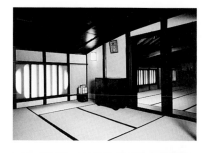

The Noguchi House (rooms on the second floor at the front). The sparse furnishings of the versatile *machiya* allow the rooms to function as living space by day and bedrooms at night. Tatami mats cover the floor in every room of the traditional house, although many contemporary dwellings often have only one or two such rooms. The number of the mats determines the size of the room itself, and hence of the entire house.

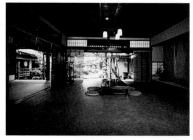

The Noguchi House. With sliding doors removed, the *zashiki* or main room of the house opens completely to the garden in summer. The *zashiki*, where guests are received, always has the finest view of the garden, and is usually furnished with a *tokonoma* or alcove on one wall for the display of art. In the Noguchi House this room is constructed in the *shoin* style, a term which refers to a low built-in desk beside a window overlooking the garden on one end of the alcove (not pictured). The *shoin* comes from Buddhist temple architecture, where it functioned as the abbot's writing desk.

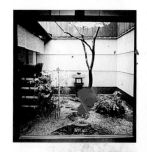

The Sakaguchi House. The homes of most Kyoto merchant families possessed at least one courtyard garden such as this one in a contemporary residence, where the master of the house could retreat from the cares of the business world. These gardens were called *tsubo-niwa*, or gardens the size of one *tsubo* (about six feet square, the size of two tatami mats). Though the actual size varied, almost every Kyoto *machiya* had a tiny courtyard garden, a revered space that was carefully tended and treasured as a private natural haven in the densely populated urban environment.

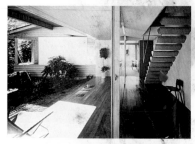

The Konosu House. This contemporary residence combines traditional architectural features with modern lifestyles. The long *roka* corridor links a Western living room in the foreground with the Japanese-style room extending into the garden space beyond. Apart from its function as a hallway, the *roka* provides an inviting space in which to relax with guests and enjoy the garden view.

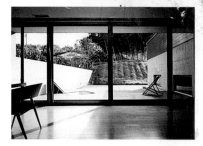

The Sasaki House. Interior and exterior spaces meet in a modern interpretation of the design concepts intrinsic to a traditional house. Although concrete has become a popular material among modern builders in Japan—perhaps for the ease and economy with which clean, simple lines can be achieved—the traditional idea of connecting living space with nature survives in modern homes such as this, where the bamboo in the distance is linked visually to the interior by the patio space in between.

Tofukuji temple. The bold checkerboard design of this twentieth-century garden contrasts hard-edged stone blocks with the soft lushness of moss. It was designed for Tofukuji's Abbot's Quarters in 1938 by landscape architect Shigemori Mirei. His concept was to create a garden that was at once modern and in keeping with the preference for simplicity that was characteristic of the Muromachi period when the temple was first built. Among the most famous of Kyoto's great Zen temples, Tofukuji was founded in 1236 and possesses three fine gardens from different periods, though its main buildings have been destroyed by fire and reconstructed.

Katsura Rikyu Imperial Villa. The asymmetrical patterns of this seventeenth-century stone pathway through the moss at Katsura Rikyu are timelessly elegant. Said to be designed by Japan's greatest landscape architect, Kobori Enshu, for Prince Toshihito in the seventeenth century, the garden is famous not only for its splendid views, but for the exceptional attention to detail shown in every exquisite path that links them—each one different from the next.

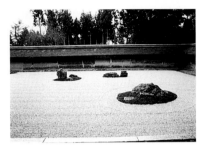

Katsura Rikyu Imperial Villa. The quiet little tea house beside the pond at Katsura Rikyu is called the Shokintei, or Pine Lute Pavilion. Built in the seventeenth century, this pavilion illustrates the harmony between structure and nature sought by traditional garden designers. The view of the moon above the pond from the veranda is as lovely as the view of the tea house itself from the garden path across the pond. Rather than a garden to be viewed from a single perspective, Katsura Rikyu is a stroll garden that leads from one breathtaking scene to the next and integrates buildings with their natural surroundings as if they existed naturally in a mountain village rather than within a meticulously orchestrated series of garden vistas.

Ryoanji temple. The stark asymmetry of the famed Zen rock garden at Ryoanji temple defies interpretation today, nearly five hundred years after it was created. Attributed to Soami, it is the quintessential *karesansui*, or dry landscape garden, with its raked white gravel and clay-walled enclosure. Residential courtyard gardens designed centuries later drew upon some of the same concepts: raked immaculately clean, enclosed and intimate—little more than a symbolic touch of nature visible in the sparse placement of stone, shrubbery, and moss.

Saihoji temple. The "Moss Temple" is the apt nickname of this heavenly landscape, designed by the Zen monk Muso Kokushi in 1339 to represent the Western Paradise. As one strolls silently through the garden in the rains of May, the air itself seems emerald green, part of a realm truly not of this earth.

Daigoji temple. The Sanboin imperial sub-temple of Daigoji was founded in 1185, though it was rebuilt by Toyotomi Hideyoshi in the late sixteenth century. The garden design is said to have been directed by the great warlord himself and includes an abundance of costly rocks and elaborate plantings. Intended to be seen from the veranda of the temple, its paths and bridges foreshadow the stroll gardens that were to become popular later during the Edo period. The view is busier and perhaps less restful than others, expressing the general's preference for the ornate.

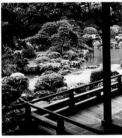

Nanakusa-gayu: **a rice gruel with seven savory herbs eaten on the seventh day of the New Year.** Rice gruel, *o-kayu,* is made by cooking rice in five times its volume of water, rather than an equal amount. Like porridge in Europe, it is often eaten for breakfast, and being easily digestible it is served to the ill. In former days the New Year's feasting continued for a whole week, so by January 7 the stomach was in need of the simple mixture of medicinal herbs that comprises *nanakusa-gayu,* or "seven herb gruel": *seri* (dropwort), *nazuna* (shepherd's purse), *gogyo* (cottonweed), *hakobera* (chickweed), *hotokenoza* (henbit), *suzuna* (turnip), and *suzushiro* (daikon).

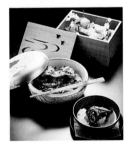

A selection of spring colors and flavors as presented by one of Kyoto's famous restaurants, Kikunoi. *Under the cherry trees/On soup, and raw fish, and all,/Flower petals.* The joy of searching for wild herbs seems to have given rise to what is known as *no-asobi,* "frolicking in the meadow," in other words savoring the seasons by picnicking as illustrated in this haiku by Buson. To heighten the beauty of the occasion, special boxes were created for cherry blossom–viewing, and in the boxes were lovingly packed seasonal delicacies such as those presented here. The soup bowl contains steamed fish covered with a cherry leaf and garnished with a fern, and the round bowl holds grilled spring salmon with pungent *sansho* leaves.

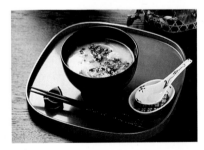

A basketful of spring's bounties. Bamboo shoots, bracken ferns, cresslike *seri* (dropwort), mustardlike rape blossoms, and the unopened buds of butterburr flowers bear the slightly bitter yet delightful taste that characterizes spring.

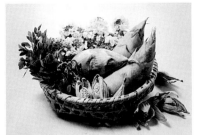

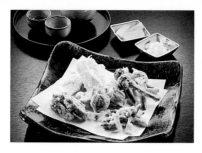

Deep-fried wild vegetables in a tempura batter. Deep-frying brings out the sweetness of wild vegetables while preserving their natural aroma. Below the fiddlehead ferns are *tsukushi* (horsetails); in the middle are *fukinoto* (butterburr buds); and in the left-hand corner *taranome* (terminal buds of the thorny *tara* tree), to name the better-known foods.

Bamboo shoots garnished with piquant *sansho* leaves. Bamboo shoots are relished not only because their availability is of such short duration. Freshly dug from the earth and immediately cooked they are exquisitely aromatic and tender. The *sansho* (Japanese pepper) leaves sprout at exactly the same time, as if nature had expressly arranged for this delectable combination.

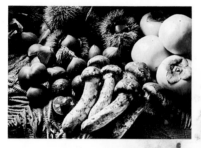

Field and forest deliver an abundance of autumn flavors. *Matsutake,* mushrooms that grow only in stands of pine, can fetch a princely price for their delicate and incomparable aroma; those who know where to find these mushrooms in the wild keep their location secret. The juice of the green *sudachi* lime adds a tantalizing zest to grilled *matsutake*. Chestnuts and persimmons complete the picture.

***Takikomi gohan*: rice cooked with *matsutake* mushrooms, chestnuts, or vegetables indicates autumn has arrived.** In September and October the year's new crop of rice appears on the market simultaneously with chestnuts and mushrooms. September 9 is still celebrated in parts of Japan as the "chestnut *sekku*," when it is the custom to eat chestnuts cooked with rice seasoned with a little saké and salt. Since prehistoric times, chestnuts have been an important part of the Japanese diet and chestnut gathering a joyful time. In mountainous areas where rice was scarce and eaten only on festive occasions, the delight in receiving a steaming bowl of chestnut rice on a chilly day must have far exceeded that of the epicurean of today.

The tastes of summer refreshingly presented by the gourmet Kyoto restaurant Kikusui. The *ayu*, or sweetfish, inhabits swift rivers. By swimming against the current it develops a firm flesh which, when eaten raw, as served in this chilled glass bowl, evokes an image of pellucid water. A contrasting texture is found in the ingredients of the bentwood cup: *tororo*, a slippery yam whipped up to a milkshake-like consistency; and *junsai*, the young leaves of a water plant with a gelatinous coating. In the lacquered bowl is greenling steamed with buckwheat noodles and topped with a bright dab of piquant pickled plum.

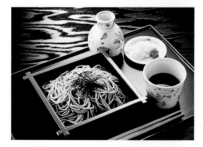

Buckwheat noodles to be dipped in a soy sauce broth mixed with chopped green onions and horseradish. Until the twentieth century, grains other than rice supplied the greater part of the starches of the daily diet for many families. Buckwheat, or *soba*, was especially favored in the eastern part of Japan, and so it was that *soba* noodles became standard noon or evening fare in Tokyo, and wheat noodles in Kyoto. *Soba* may be eaten cold with a dipping sauce and garnished with *nori* (seaweed) as shown here, or served in a hot broth, which is preferred in winter. Throughout Japan it is the custom to have buckwheat noodles to ensure long life when the New Year's bells toll.

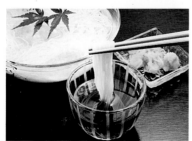

The thin white noodles called *somen* are a favorite repast at the height of summer. When appetites languish in the heat of summer, most people will choose cool *somen* noodles. They are dipped in a chilled sauce of soy sauce, sweet rice syrup, and bonito stock flavored with grated ginger and finely chopped green onions. *Somen* is made from a dough of wheat flour and salted water that is stretched repeatedly between poles into a multitude of thin strands. *Somen* are traditionally produced only in winter, and thus the thought of the delicate threads of white drying in the icy wind acts as a mental air conditioner.

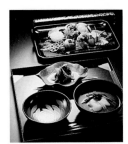

Cubes of fresh tofu in chilled water: a refreshing summer dish. Tofu makers rise in the early hours of the morning to boil and press the soy beans, then add brine to the soy milk to gel it. By seven o'clock pure white blocks of tofu lie in a tank of water awaiting the first customers. The clean appearance and taste of freshly-made tofu are most exquisitely experienced when eaten in the *hiya-yakko* style: chilled (sometimes served in ice water) and accompanied by bonito flakes, chopped green onion, grated ginger, and soy sauce. In winter, tofu is served in a hot kelp broth as a dish called *yudofu*.

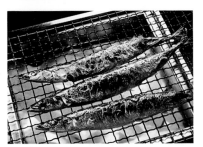

Charcoal-grilled *sanma*, or saury. Juicy *sanma*, rich in fish oil, arrive off the Pacific coast at the end of summer. Although inexpensive, *sanma* have a full-bodied flavor relished by gourmets which is best experienced by charcoal grilling. The oil dripping onto the fire produces volumes of smoke, and for this reason some people still prefer to grill the fish on a brazier outdoors. *Sanma* smoke is synonymous with September.

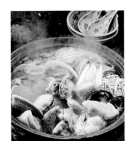

Fukiyose, leaves blown together by the wind, describes the autumn presentation by the Kyoto restaurant Tankuma. On a lacquered tray flecked with gold like morning frost, a "windblown" assortment of autumn's bounties: squid sushi in the shape of a chrysanthemum, chestnut purée molded like a round squash, a quail egg colored to resemble a persimmon, and in the fragrant *yuzu* citron cup *matsutake* with chrysanthemum flowers and pine nuts. The leaf-shaped plate holds crab with seaweed, trefoil leaves and a few purple chrysanthemum petals. The lacquered soup bowl contains a turtle-flavored egg custard topped with grated daikon, the maple leaf motif having been created with carrot. Each dish has been chosen to complement the food and to play upon the theme of autumn.

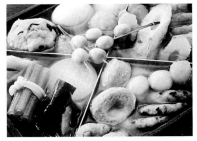

Steaming hot *oden*: a nourishing and invigorating winter meal for the family or a party of friends. Daikon, kelp, ground fish prepared in various ways, hard-boiled eggs, *konnyaku* gelatin, and tofu are the basic ingredients of *oden*. The secret is in the broth made of bonito stock, kelp, and soy sauce and the slow cooking which allows the combination of flavors to mature.

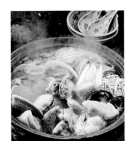

Yosenabe: a casserole of vegetables and fish cooked at the table. When it's time to wear a muffler, it's time to take out an earthenware casserole (*nabe*), fill it with hot water (and maybe a piece of kelp for flavor), place it on a tabletop burner, prepare a large platter of Chinese cabbage, leeks, mushrooms, chicken, white fish, clams, and tofu and then call everyone to the table. As the food cooks, each person takes out a favorite morsel and dips it in soy sauce and citron juice or grated daikon with chili pepper as shown here.

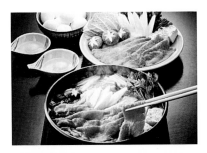

Sukiyaki: a perfect combination of meat and winter vegetables cooked at the table. Although beef was still an exotic western food at the beginning of the twentieth century, today *sukiyaki* is eaten whenever the family wants something a little special. The vegetables are winter produce: Chinese cabbage, leeks, edible chrysanthemum leaves, and burdock root. Cooking is simple: a little fat from the beef, soy sauce, and sugar.

Wrapped in an oak leaf, the sweet called *kashiwa mochi* is eaten on May 5. Japanese sweets are healthful—they have no fat. The dough of *kashiwa mochi* is made of rice flour and water. Inside is dark bean paste or sweet white *miso*. The oak leaf lends a special flavor. In this picture, the dough has been flavored with *yomogi* (mugwort), which makes it green. Other varieties are white or pink.

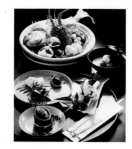

Winter is the time to enjoy the bounties of the sea as prepared here by the Kyoto restaurant Isecho. A *kaiseki* meal is a gourmet's delight. The food is presented so as to reflect the season not only in the choice of ingredients but also in the pictures they form. Here the theme is the New Year. We find felicitous symbols in the bamboo container (vitality), the red of the salmon roe (fertility), and the lobster (long life). The plate depicts the three lucky things to dream about on New Year's Eve: Mt. Fuji, an eggplant, and a hawk. The yellow plate is in the shape of a battledore, a game played during the holidays.

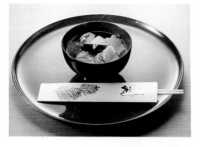

O-zoni, a special soup served on New Year's Day. Each region has its unique New Year's soup. This *o-zoni* eaten in the Tokyo area contains chicken, carrot cut in the shape of a felicitous plum blossom, red-tinted fish paste, *shiitake* mushroom, and trefoil leaves with a bit of citron peel for flavor. All *o-zoni* include the pounded rice cakes called *o-mochi*.

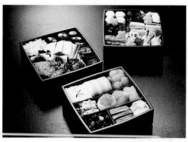

The New Year is celebrated with special delicacies neatly packed in lacquered boxes. The feast enjoyed during the New Year's holidays takes several days to prepare. Chosen for their symbolic meaning, color, and ability to stay fresh for the duration of the celebration, the ingredients include fish paste, sweet beans, and sweet mashed potato (top box); grilled fish, sweet omelette, and vinegared fish (middle box); and taro, lotus root, carrots, *shiitake* mushrooms, water chestnuts, burdock, and *konnyaku* gelatin (bottom box).

O-toso, saké with medicinal herbs, served in a lacquered vessel made solely for festive occasions. The New Year's meal begins with a toast to health with *o-toso*. A bundle of medicinal spices including licorice and cinnamon is soaked in saké or *mirin* (a syrupy sweet saké) for several days to produce this aromatic concoction. It is drunk ceremoniously in three sips, or from three saké cups.

THE TEA CEREMONY

Path to the tea garden's inner gate. This path is a cool, leafy way, its paving stones sprinkled with water just before the arrival of the guests. A tea garden is called *roji*, which means the "dewy path," and is meant to be reminiscent of a mountain path. Once you enter the inner gate, you have passed from the mundane world into a higher spiritual dimension.

Stepping stones to the tea house. Inside the inner gate, the *roji* begins to look more like a mountain path. Rikyu prescribed that the stepping stones leading to a tea house be small, neat, and not too high, easy to use and pleasing to the eye. These stepping stones, leading to the Yuin tea house of the Urasenke tea school in Kyoto, were placed by Rikyu's grandson Sotan (1578–1658), and are known as "the scattered bean stones."

Guests cleanse themselves ritually here before entering the tea house. The rinsing of hands and mouth at a stone basin before entering the tea house is a symbol of removing the "dust of the world." Rikyu designed the water basin with four main stones: a hollowed one for the basin itself, a large flat stone for the guest to stand on, and two more at either side for a lantern and a water bucket. The basin is always set low, requiring the guest to kneel in a position of servitude.

The tea house is as a humble hermit's cottage. The small door is only big enough to crawl through. All people great and small must bow their heads and crouch to enter the tea room, through the small entrance known as the *nijiri-guchi*, literally "crawling-through entrance." Here, the host's straw sandals rest outside the *nijiri-guchi* of Yuin. A thatch-roofed tea house in the style of a hermit's cottage, Yuin is the epitome of Rikyu's ideal of *wabi*.

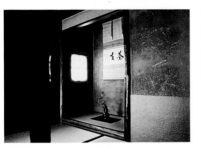

The hanging scroll in the alcove tells guests the spiritual meaning behind the day's gathering. The alcove is the spiritual focus of the tea room. On entering the room, guests first approach the alcove to view the hanging scroll, which is most commonly a Zen saying brushed by a priest. Flowers are placed in a vase without artifice, to appear just as they would in the field. This is the alcove at the Kanin tea room of the Jukoin temple, Kyoto.

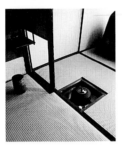

In winter, a sunken hearth is used to heat the water. One of the joys anticipated by tea guests in the cold months is the beauty of the fire in the sunken hearth. Guests gather around to watch the host add coals and then enjoy the deepening of the embers' glow as the tea ritual proceeds. In the warm months the sunken hearth is replaced with a standing brazier.

Tea utensils: containers for thin and thick tea, bamboo scoop and whisk, and cold-water jar. The large lidded container is the cold-water jar (*mizusashi*) for replenishing the kettle. The tea bowl, ready with bamboo scoop and whisk, sits next to the container for thick tea in its silk pouch. On the small shelf above is the plain black lacquer container for thin tea, designed by Rikyu. This is at the Kanin tea room of the Jukoin temple, Kyoto.

A February sweet, the "Red Plum Blossom of Deep Winter" (*Kankobai*). Great artistry is used to sculpt the sweets into shapes and colors that have seasonal significance. This one, for thick tea, is served in the coldest part of the year and represents a type of plum blossom that flowers even in the bitter cold. This and the following confection come from the Kyoto sweet maker Suetomi.

A May sweet, the "Chinese Silk Robe" (*Karagoromo*). This sweet, in the shape of a beautiful mauve-and-white folded garment, gives the impression of something rare and lovely, just as precious silk robes from China must have seemed to early Japanese. Its color and transparent quality lend it a fresh, cool appearance appropriate for the warmer days of May.

Small dry sweets for "thin tea" (*usucha*). The delicate sugariness of these sweets by Kameya Iori in Kyoto is the perfect complement to the astringency of the thin tea. The two exterior confections (shown in the color plate only) are meant for January tea, while the central grouping, called *fukiyose* ("leaves blown together by the wind"), evokes an autumn image and is meant for ceremonies given in November.

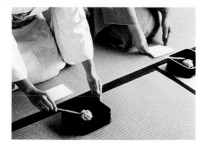

Sweets for "thick tea" (*koicha*) are usually served in individual boxes. In this case the boxes are of black lacquer. Each guest takes a sweet, places it on paper, and eats it with a wooden pick that has been provided. This wooden pick is traditionally whittled from the spicebush (*kuromoji*), which has antiseptic qualities.

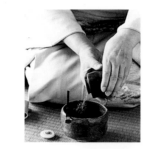

Tea is scooped and then poured into the bowl for thick tea. There is exactly enough tea in the container for three scoops per guest.

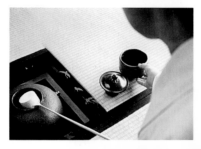

Thick tea is served. The host has just removed the tea whisk from the bowl after spending some time blending the thick tea to just the right consistency, and has placed the bowl ready for the guest to take. The amount of tea, the temperature of the water, the rhythm and length of blending, even the weather, all affect the flavor of the tea.

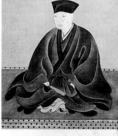

Portrait of Sen no Rikyu, who refined the concept of *wabi*-style tea. Sen no Rikyu elevated ritual tea preparation to a form that has lasted for four hundred years. Tea practitioners hold special tea ceremonies all over Japan every year on the anniversary of his death. He was ordered to commit ritual suicide by the hegemon Toyotomi Hideyoshi, whom he served. It is because of Sen no Rikyu and his *wabi* style of tea that the tea ceremony is still practiced today.

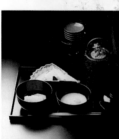

The meal served at a formal tea gathering should be just enough to take away the pangs of hunger. At the most formal of tea gatherings, tea is preceded by a meal, known as *kaiseki*. The word *kaiseki* means "warmed stone," after the stone that Zen priests would place on their stomachs to help them forget their hunger. The meal begins with rice, miso soup, and raw fish. Saké is also served; the small red dishes are for drinking it. The meal shown here was prepared by Tsujitome.

Spring arrangement: Bleeding heart in a lacquered bamboo hanging vase. This vase, inscribed by the early Urasenke grand master Ennosai (1872–1924), is named "One Thousand Years."

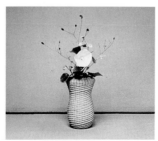

Summer arrangement: Rose of Sharon and begonia in a basket woven in the shape of a spear sheath. This style is favored by Hounsai (1923–), the present grand master of the Urasenke tea school.

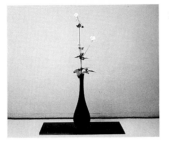

Autumn arrangement: Japanese anemone in an antique crane-necked bronze vase. The vase is of unknown antiquity.

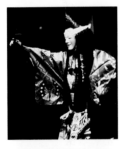

Winter arrangement: Camellia bud and Tosa *mizuki* dogwood in a bamboo vase. This dogwood is from the area in Shikoku formerly known as Tosa. The vase is a style favored by Senso (1622–97), an early Urasenke grand master.

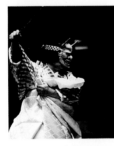

Bunraku, *Yari no Gonza Kasane Katabira* (Gonza the Lancer). A play by the great Chikamatsu Monzaemon on the theme of adultery. Plotting and misunderstanding force a wife to appear as an adultress, which was punishable by death in the Edo period. But the suspicion of wrongdoing was as bad as an actual crime at this time, and once she is thought to be an adultress, the wife decides to live up to her role. The main puppeteer is Yoshida Bunjaku.

Noh, *Atsumori*. A priest returns to the site of a battle where, as a warrior, he was forced to kill the young general Atsumori. One of the grass-cutters he encounters on the old battlefield is actually the ghost of Atsumori. During the battle, the priest had hoped to spare the boy, especially since he was the same age as his own son at the time, but the arrival of others forced him to take Atsumori's life. Remorse caused him to renounce the world for a priesthood. The ghost returns in his true form and tells the story of the rise and fall of his clan and tries to attack the priest. In the end, however, the two are reconciled through prayer. The *shite* playing Atsumori is Shiozu Tetsuo of the Kita school.

Noh, *Dojoji*. The Noh version of this play is long and solemn, with most of the first half taken up with the ceremonial dance of the ghost, who appears as a beautiful *shirabyoshi* court dancer. In the scene here, from the second half of the play, she takes her true form as a jealous spirit. The triangular pattern suggests the scales of a serpent, while the shiny gold thread of the costume conventionally means that this ghost is actually invisible. The *shite* is Asami Masakuni of the Kanze school.

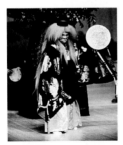

Noh, *Nomori* (The Guardian Demon of the Field). While other Noh plays show gods and demons, this play dramatizes a legend about a particular place. A traveling priest encounters an old man who explains the origin of the name for a sacred old pond. In the second half of the play, the old man reappears as the benevolent demon that protects this pond, holding the mirror that is the pond's true form. The *shite* is Teshima Michiharu of the Kongo school.

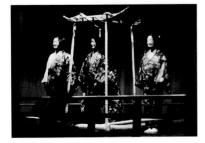

Noh, *Eguchi* (The River Crossing at Eguchi). There is a legend that the poet-priest Saigyo encountered a courtesan at Eguchi, near present-day Osaka. At first he thought she was merely a woman of pleasure, but then he was impressed by her sensitivity and culture. Finally, he learned that she was an incarnation of a Buddhist deity. Based on this legend, the play shows another priest visiting the site of the ancient story centuries later and asking a local woman about the courtesan. In the second half, the woman in question appears as the ghost of the courtesan in a pleasure boat accompanied by her attendants. The *shite* is Asami Masakuni.

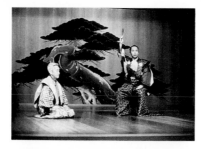

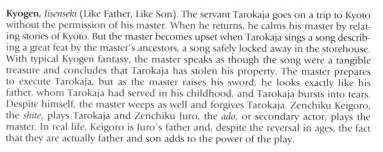

Kyogen, *Jisenseki* (Like Father, Like Son). The servant Tarokaja goes on a trip to Kyoto without the permission of his master. When he returns, he calms his master by relating stories of Kyoto. But the master becomes upset when Tarokaja sings a song describing a great feat by the master's ancestors, a song safely locked away in the storehouse. With typical Kyogen fantasy, the master speaks as though the song were a tangible treasure and concludes that Tarokaja has stolen his property. The master prepares to execute Tarokaja, but as the master raises his sword, he looks exactly like his father, whom Tarokaja had served in his childhood, and Tarokaja bursts into tears. Despite himself, the master weeps as well and forgives Tarokaja. Zenchiku Keigoro, the *shite*, plays Tarokaja and Zenchiku Juro, the *ado*, or secondary actor, plays the master. In real life, Keigoro is Juro's father and, despite the reversal in ages, the fact that they are actually father and son adds to the power of the play.

Kabuki, *Musume Dojoji* (The Maiden at Dojoji Temple). The greatest of pure Kabuki dances. A *shirabyoshi* dancer dedicates the new temple bell. In reality, she is the spirit of the jealous woman who destroyed the old bell. The dancer is played by Nakamura Kankuro and the dance is accompanied by *nagauta* singers and *shamisen* players, who sit on the platform at the back of the stage, with the flute and percussion ensemble taken from the Noh theater sitting below them.

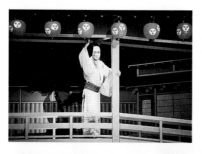

Kabuki, *Ise Ondo Koi no Netaba* (Massacre in the Ise Pleasure Quarters). Mitsugi is a loyal retainer who has recovered his master's sword against great odds. But the sword has a curse on it that compels him to kill all in his path including the villains, in a dreamlike fight scene played out against the beautiful languid music of the pleasure quarters of Ise. Mitsugi is played by Nakamura Baigyoku.

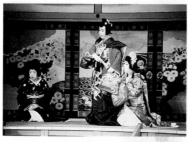

Kabuki, *Honcho Nijushi Ko* (The Japanese Twenty-Four Examples of Filial Piety). *Jidaimono*, or "period pieces," depict the lives of the samurai class, but due to the censorship of the time, their stories are set in the remote past. This particular play is one adapted to Kabuki from the puppet theater, and the actors, copy the conventional movements of the puppets from time to time. From right to left, Nakamura Jakuemon as Princess Yaegaki, Onoe Kikugoro as Katsuyori, and Sawamura Sojuro as Nureginu. Jakuemon is in his seventies, but masterfully performs the role of a young girl.

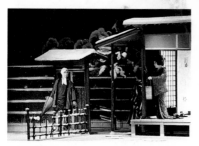

Kabuki, *Yuki no Yugure Iriya no Azemichi* (The Thief Naozamurai and the Courtesan Michitose): A thief is on the run, but goes to see his lover, a courtesan staying in a villa by the snow-covered rice fields behind the Yoshiwara pleasure quarters. The thief is played by Ichikawa Danjuro.

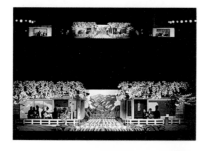

Bunraku, *Imoseyama Onna Teikin* (Mt. Imo and Mt. Se: An Exemplary Tale of Womanly Virtue). This is the most spectacular Bunraku play in existence, with two separate narrative ensembles, one for the action on each side of the stage.

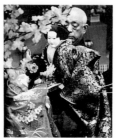

Bunraku, *Imoseyama Onna Teikin*. A daughter bows in thanks to her mother for allowing her to die to save the life of the man she loves, the son of their family's enemy. Outwardly severe, the mother is moved by her daughter's devotion and heartbroken at the fact that soon she must behead her own daughter. The main puppeteer for the mother is Yoshida Bunjaku.

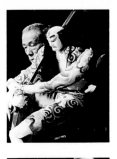

Bunraku, *Natsu Matsuri Naniwa Kagami* (Summer Festival in Osaka). Pushed beyond endurance, the spirited commoner Danshichi is forced to kill his greedy father-in-law in a fight by a muddy pond. In a scene worthy of Hitchcock, Danshichi desperately washes off the mud with buckets of water from a nearby well as a raucous festival procession approaches. The main puppeteer is Yoshida Tamao.

Bunraku, *Oshu Adachi ga Hara* (The Ballad of Sodehagi). The puppet for Sodehagi has a special hand that holds the plectrum for playing a *shamisen* and, as the character is blind, the puppet's eyes are closed. The intense pathos of this photo is a sign of the mastery of the main puppeteer Yoshida Minosuke, even though he cannot be seen in this shot.

Ogata Korin (1658–1716), *Red and White Plum Blossoms*. Right half of a pair of two-panel screens, color and gold and silver leaf on paper, each 156.5 x 172.5 cm. MOA Museum of Art, Atami, Shizuoka Prefecture. National Treasure.

The son of a Kyoto textile merchant, Korin painted primarily themes from classical literature and flowers and birds, selectively choosing motifs and fashioning them into bold designs. While symbolic of spring, the imagery of plum trees and flowing water in these screens may also allude to a particular Noh drama. The mottled texture of the tree trunks and branches was achieved through applying color and ink on top of ink that was still wet. This technique—called *tarashikomi*—was a hallmark of Korin and other members of the Rinpa school.

Illustration from the Takekawa chapter of *Genji monogatari emaki*, 12th century. Ink and color on paper, 22 x 48.1 cm. The Tokugawa Art Museum, Nagoya. National Treasure.

In this scene from the *Tale of Genji*, a group of court ladies are admiring a cherry tree in full bloom in the courtyard. The two playing a game of *go* in the room at the left have made the tree their stakes. Cherry blossoms are beloved in Japan largely because of their evanescence, and when strong winds begin to tear at the blossoms, the women lament this in their impromptu poems. A "Peeping Tom" courtier mesmerized by the beauty of the blossoms and the ladies in their springtime costumes can be seen in the bottom right-hand corner.

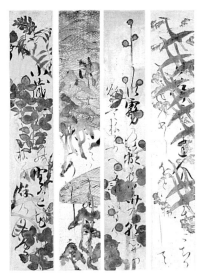

Hon'ami Koetsu (1558–1637), Album of *Tanzaku*. Ink on decorated paper, each 37.5 x 6.0 cm. Yamatane Museum of Art, Tokyo.

Tanzaku poem cards are often decorated with gold and silver designs featuring seasonal motifs such as plum blossoms and bush clover. The painted designs on these *tanzaku* are attributed to Tawaraya Sotatsu, who frequently worked in collaboration with Koetsu. While there is no direct correlation between the painted imagery and the poems, which are selected from the *Shin kokin waka shu* (New Collection of Japanese Poems of Ancient and Modern Times; thirteenth century), visual harmony is achieved through the subtle interaction between Koetsu's flowing calligraphy and the underpainted decoration. Although now preserved in an album, these four *tanzaku* are from a set of twenty that were originally affixed to a pair of screens.

Sesshu Toyo (1420–1506), *Winter Landscape*. Hanging scroll, ink on paper, 46.4 x 29.4 cm. Tokyo National Museum. National Treasure.

This scroll is from a set of four depicting landscapes of the four seasons. The Zen monk Sesshu's works were inspired by the Chinese academic ink painting tradition and by his own journeys through the Chinese and Japanese countryside. His crisp, bold lineament and "axe-cut strokes" forming the crystalline rocks derive from Chinese brush methods, but Sesshu transformed the Chinese tradition in ways that express his own character as well as Japanese design sensibilities. The use of fewer strokes (in comparison with Chinese painting) without layering results in a bolder, more direct presentation that appealed to Japanese tastes.

Utagawa Hiroshige (1797–1858), *Shono,* from the series *Fifty-three Stations of the Tokaido.* Published by Hoeido, 1832–34. Polychrome woodblock print on paper, horizontal *oban* size (38 x 26 cm.). Tokyo National Museum.

Hiroshige designed many series of prints depicting scenes along the Tokaido (Eastern Coastal Highway), which extended from Edo to Kyoto. While he journeyed once down this road (which took about two weeks), his prints depict far more than he could have actually seen, such as views in all four seasons. Hiroshige portrayed the land and people with great affection and his prints were prized for their poetic atmosphere. Here travelers near the rest stop of Shono are caught in a sudden rainstorm. Gusts of wind cause the bamboo and grasses to bend diagonally to the left, the shadowy foliage echoing the forms of figures trudging up the hill.

Suzuki Harunobu (1725–70), The *Sixth Month,* from the series *Fuzoku shiki kasen.* Polychrome woodblock print on paper, *chuban* size (28.3 x 21.5 cm.). Keio University.

Cooling off by the riverside was a favorite summer evening pastime in old Japan. Here a teahouse waitress flirts with a young dandy (at left, with sword) in a room overlooking the Sumida River in Edo, crowded with pleasure boats. While the two figures are juxtaposed against a festive background, our attention is centered on the couple and their existing or pending romantic involvement. This print is one from a series of twenty-four by Harunobu focusing on women's activities throughout the year.

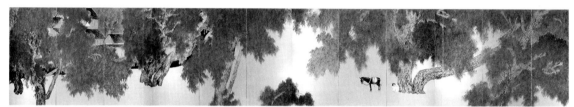

Yokoyama Taikan (1868–1958), *In the Shade of Willows,* 1913. Detail from the right half of a pair of six-panel screens, color and gold on silk, each 191.8 x 546.8 cm. Tokyo National Museum.

The unhurried pace and tranquil mood is the subject of this pair of screens by the Nihonga painter Taikan. Luxuriant willow trees dominate the compositions of both screens, the sea of green color evoking coolness. Taikan was adept in many styles: the use of bright green pigment and *tarashikomi* in the trees recall the Yamato and Rinpa traditions, respectively. Moreover, Western influence is evident in the shading and in Taikan's efforts to convey the tactile quality of bark, and the subject matter is reminiscent of Chinese painting. This kind of synthesis is not uncommon in twentieth-century Japanese painting. These screens were painted for Hara Sankei, who was an enthusiastic art patron in the early part of the century.

Okumura Togyu (1889–1990), *Lotus Pond,* 1929. Color on silk, 134.8 x 142.8 cm. Museum of Contemporary Art Tokyo.

Togyu was one of the most highly regarded Nihonga artists in postwar Japan. This painting, combining a naturalistic depiction of lotuses with a strong sense of design, is a product of what became a lifelong study of traditional Japanese and Chinese painting as well as Western art. Using a palette dominated by pastels, Togyu has eloquently captured the purity and magical beauty of the luminous pink blooms as well as the lyrical mood of this ubiquitous summer scene.

Kumagai Morikazu (1880–1977), *Dragonflies,* 1962. Framed panel, oil pigments on wood, 24.1 x 33.3 cm. Private collection.

Trained in traditional Japanese as well as Western styles of painting, Morikazu developed a unique style featuring simplified, almost abstracted forms, and a limited range of colors. Many of his works are small in format. The color combination here is reminiscent of the Fauves but Morikazu's compositional design featuring flat pattern and asymmetry is distinctly Japanese. Dragonflies are synonymous with summer and similar bold designs are commonly found on the cotton kimono (*yukata*) worn at summertime festivals.

Umehara Ryuzaburo (1888–1986), *Smoke from Mt. Asama.* Tempera on paper, 118.8 x 92 cm. The National Museum of Modern Art, Tokyo.

One of the most successful Western-style painters in Japan, Ryuzaburo initially trained under Asai Chu but was strongly influenced by Renoir during his five-year sojourn in France. He was particularly fond of painting Mt. Asama in Gunma and Nagano prefectures, depicting the smoking volcano in all different seasons. Ryusaburo even set up a painting studio nearby where he had a splendid view from the second-floor window. He also worked outdoors in a pavilion he had constructed in the garden. Ryuzaburo sought to capture the mountain's sense of energy through vivid colors and dynamic brushwork. Here the emphasis on greens and yellows conveys the lushness of the surrounding countryside in summer.

Jar with autumn grasses design. Tokoname ware (Atsumi area), ca. 12th century. Stoneware, with natural ash glaze, height 40 cm. Keio University, Tokyo. National Treasure.

This jar is unusual because of the plethora of freely incised designs on the neck and body. The motifs are all drawn from nature: pampas grass, melons, willow, and dragonflies. The yellowish-green glaze covering the shoulders and running down the body is the result of airborn ashes from the wood fuel settling upon the clay body and fusing during firing. The rivulets of glaze and sweeping linear designs impart a sense of life and movement to this vessel, which is believed to have been used as a funerary urn.

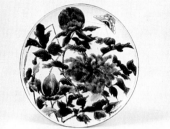

Large dish with peonies and butterfly design. Old Kutani ware, ca. 17th century. Porcelain, with overglaze enamels; diameter 35 cm. Tokyo National Museum.

Old Kutani ware is noted for its boldly painted designs featuring green, blue, purple, yellow and red enamels. As was true for other Japanese porcelain wares, the decoration was often influenced by Chinese art, with birds and flowers among the most favored subjects. Regarded in China as the "king of flowers," peonies symbolize wealth and royalty. The poetic theme of a butterfly hovering over peony blossoms became especially popular in Japan.

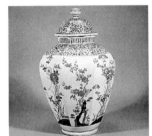

Octagonal covered jar with design of flowers and birds. Kakiemon ware, early Edo period. Porcelain, with overglaze enamels; height 61.8 cm. Idemitsu Museum of Arts, Tokyo.

Kakiemon porcelain was produced in large quantities for the domestic and foreign commercial markets from the seventeenth century. This jar was originally exported to England. The shape and design, while inspired by Chinese ceramics, have been modified by Japanese sensibilities. Birds and flowers of the four seasons rendered with red, green, and yellow overglaze enamels decorate the bottom portion of the vessel. The lid and shoulder feature a more abstract design consisting of peonies and foliate scrolls (*tako karakusa*).

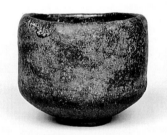

Tea bowl, called "Ayame," by Sasaki Chojiro (1516–92). Raku ware. Earthenware, diameter 11.3 cm. MOA Museum of Art, Atami, Shizuoka Prefecture.

Raku ware, a low-fired, lead-glazed ceramic produced in Kyoto beginning with the potter Chojiro, is one of the most preferred wares for tea bowls. Chojiro was deeply influenced by the tea master Sen no Rikyu and under his tutelage created bowls like "Ayame," which in many ways epitomizes the artlessness cultivated in the tea ceremony. Great care was taken in shaping the bowl so that it could be comfortably cradled in both hands, and the lip was contoured to facilitate drinking. "Ayame" was coated with a black lead-oxide glaze that acts as a natural foil for the grass-green tea.

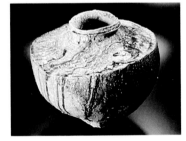

Large wide-shouldered vase, by Tsujimura Shiro (1947–). Iga ware, 1986. Stoneware, with natural ash glaze and fragments; height 37 cm. Private collection.

Iga ware has long been favored for use in the Japanese tea ceremony. The potter and painter Tsujimura was not formally trained in this tradition, but he has followed his own vision and experimented with non-traditional, vigorous shapes. Much of the rustic beauty of this jar is the result of the natural ash glaze, which collected on the broad shoulder and flowed over the sides during firing. The rich contrast between the orange-red clay body and dark green glaze is one of the distinctive features of Iga ware.

Writing box, with design of Yatsuhashi ("eight-planked bridge"), by Ogata Korin (1658–1716). *Maki-e* lacquer and mother-of-pearl; height 19.8, width 19.8, length 27.5 cm. Tokyo National Museum. National Treasure.

The upper layer of this lavish box was intended for writing utensils and the lower for paper. The decoration was appropriately inspired by classical literature, i.e., an episode from the *Tale of Ise*. The stylized design featuring irises (mother-of-pearl and gold *maki-e*) growing along a plank bridge (lead sheet) wraps ingeniously around the box and over the lid. Korin was particularly fond of the Yatsuhashi theme, as were later followers, and it appears in paintings, ceramics, and textiles as well as on lacquerware.

Ornamental combs. Edo period, length 6.4 to 10.9 cm. Tokyo National Museum. TOP LEFT: Comb in the shape of a swallowtail butterfly; tortoise shell; TOP RIGHT: Comb with carved lacquer design of paulownia leaves; lacquered wood; CENTER: Comb with design of pine needles; wood with mother-of-pearl inlay; (overleaf) TOP LEFT: Comb with design of autumn plants and distant mountains, lacquered wood with *maki-e*; TOP RIGHT: Comb with design of alternating squares, lacquered wood with *maki-e*.

Combs made of a variety of materials including lacquered wood, tortoise shell, and ivory were used by women in traditional Japan to comb their long hair and to secure elaborate coiffures. The decoration became increasingly diversified and lavish from the middle Edo period, with many shapes and motifs inspired by nature. The exquisite designs are creatively adapted to the combs' shapes, often continuing over both sides in ingenious ways. The expert craftsmanship and striking decoration makes them a pleasure to hold, look at, and use; Japanese women have long counted combs among their most intimate possessions.

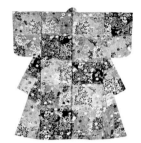

Obi. 18th century. Tokyo National Museum. TOP: *Obi* with design of peonies, hollyhocks, and Genji carriage on dark green silk; 417 x 29 cm. BOTTOM: *Obi* with design of peonies, chrysanthemums, cherry blossoms, and butterflies on purple silk; 380 x 28 cm.

Obi—the sashes used to hold kimono in place—are important elements in kimono design. The widths vary according to the period in which they were made, the age and gender of the wearer, and the occasion on which they are worn. It was during the Kyoho era (1716–36) that the wide *obi* resembling those worn today came into favor. *Obi* are made from a variety of fabrics, and feature a wide range of colors as well as intricate woven and embroidered designs. While splendid works of art in themselves, *obi* colors and motifs are carefully coordinated with the kimono they are worn with and, of course, the season.

Karaori Outer Robe for Noh play, with design of autumn grasses over a ground of brown, water blue, and dark blue alternating blocks. 17th century. Silk, length 153 cm. The Tokugawa Art Museum, Nagoya.

This is the outer robe for a Noh actor playing a middle-aged woman's role, in a drama that takes place in autumn. The sumptuous woven design appropriately features chrysanthemums, bush clover, and other autumn grasses and flowers.

ACKNOWLEDGMENTS

The publisher wishes to express its gratitude to all of the following people and institutions for graciously granting permission to use the photographic images in the present volume: in *Part One* and *Part Two*, Asukaen, Chuguji, Fuji Film (pages 10, 46, 58, 59, 100, 102), Kinkakuji, Imperial Household Agency, Nihon Sumo Kyokai, and Takarazuka Revue Company; in *Part Three, House and Garden*, Hayashi Masako (architect of the house on page 178, top), Imperial Household Agency, Kobari Shuichi (architect of the house on page 178, bottom), and Noguchi Mari (owner of the house shown on pages 169, 170, 172, 174–75); in *Food*, Daiko in Kyoto (for assistance with the photographs on pages 190, 194, 197, 200), Isecho (page 200), Kidosaki Ai (for preparing the food on page 189), Kikunoi (page 190), Kikusui (page 194), Tankuma (page 197); in *The Tea Ceremony*, Jukoin (pages 207, 209), Kameya Iori (Kyoto confectioner; page 210, center), Suetomi (Kyoto confectioner; page 210, top), Tsujitome (*kaiseki* restaurant; page 213), Urasenke Foundation, and Yamaoka Kimiko and Ogawa Miyoko of Tankosha Publishing Co., Ltd. (for their assistance with permissions and acquisition of the photographs in this section); in *Traditional Theater*, Asami Masakuni, Ichikawa Danjuro, Japan Actors' Association, Japan Bunraku Association, Kawahara Hisao (photographer), Nakamura Baigyoku, Nakamura Jakuemon, Nakamura Kankuro, Ogawa Tomoko (photographer), Onoe Kikugoro, Sawamura Sojuro, Shiozu Tetsuo, Teshima Michiharu, Yoshida Bunjaku, Yoshida Minosuke, Yoshida Tamao, Zenchiku Juro, and Zenchiku Keigoro; in *Art*, Auction Japan Co., Ltd., Idemitsu Museum of Arts (Tokyo), Keio University, Korinsha, Kumagai Morikazu Museum (Tokyo), MOA Museum of Art (Atami, Shizuoka Prefecture), Museum of Contemporary Art Tokyo, The National Museum of Modern Art (Tokyo), Shimada Akara, Shiroshita Ruriko, Tokugawa Art Museum (Nagoya), Tokyo National Museum, KK Tsuchi, Tsujimura Shiro, Yamatane Museum of Art (Tokyo), Yokoyama Takashi, and Yoshikoshi Tatsuo (photographer).

PHOTO CREDITS

Araki Toshisumi (courtesy of Fuji Film): page 58.

Asukaen: page 149 (courtesy of Chuguji temple).

Auction Japan Co., Ltd.: page 240 (bottom; courtesy of Kumagai Morikazu Museum, Tokyo).

Bon Color Photo Agency: front jacket, page 199.

Camera Tokyo Service: pages 78–79, 82, 104, 113 (top), 129, 130 (top), 131.

Chinami Toshihiko (Q Photo International): page 154.

Dandy Photo: pages 27, 30–31, 38, 43, 50–51, 56 (bottom), 64, 66, 68–69, 76, 86–87, 89, 90 (top right), 91 (top), 92–93, 97 (top), 101, 134, 139 (top), 150.

Fujita Takao (Spirit Photos): page 127 (center).

Goto Kenji (Q Photo International): page 96.

Hamaguchi Takashi: pages 8–9.

Hayashida Tsuneo: pages 102 (bottom), 103 (top & bottom).

Hiza Yukio: page 102 (top left).

Hori Chuzo (Dandy Photo): page 83 (top).

Hosoda Koichi (Nature Photo Library): page 103 (top left).

Hymas, Johnny (Q Photo International): pages 52–53 (bottom).

Ichimura Tetsuya: page 39 (center left & right [2], bottom left & right).

Idemitsu Museum of Arts, Tokyo: page 246 (bottom).

Image Life: pages 140, 158 (bottom), 161 (bottom).

Imamori Mitsuhiko (Nature Photo Library): page 60 (bottom).

Inoue Hiromichi: pages 186–87, 188.

Inoue Takao: pages 203, 207 (top & bottom; courtesy of Jukoin), 209.

Irie Taikichi (Nara City Museum of Photography): pages 2–3, 181 (courtesy of Imperial Household Agency).

Ishii Mitsuyoshi (Nature Photo Library): pages 34 (top right), 35 (top).

Iwamiya Takeji (courtesy of Daitokuji; Pacific Press Service): pages 6–7.

Iwasawa Toshio (courtesy of Fuji Film): page 10.

JTB Photo Library: pages 132 (bottom), 138 (top), 148 (top), 158 (top), 161 (top).

Kawahara Hisao: pages 215, 226–27 (top & bottom; courtesy of Japan Bunraku Association), 228, 229 (left & right).

Kawamoto Takeji (Q Photo International): pages 34–35 (bottom), 48–49 (both), 67, 70–71 (top), 75 (top right), 74–75 (bottom), 80 (top), 90–91 (bottom), 160, 180.

Kawasumi Isao (Dandy Photo): pages 72–73.

Keio University: pages 238 (bottom), 245.

Kimoto Osamu (Nature Photo Library): page 75 (top left).

Kobayashi Yasuhiro: page 213.

Korinsha: page 248 (courtesy of Tsujimura Shiro).

Maeda Shinzo (American Photo Library): spine.

Matsuo Yujiro (Nature Photo Library): page 60 (center).

Minowa Studio: pages 192 (center & bottom), 193 (left), 195 (all), 196, 198 (all), 201, 202 (both).

Miyano Masaki: page 210 (top left & right, center).

Mizukoshi Takeshi (Pacific Press Service): page 97 (bottom).

Mizunaka Soichiro (courtesy of Fuji Film): page 100.

Mizuno Katsuhiko: pages 117 (top right), 130 (bottom), 136 (top), 137, 145, 166, 169, 170, 172, 174–75.

MOA Museum of Art (Shizuoka Prefecture): pages 231, 247.

Murai Osamu: page 178 (top).

Murata Tsuguo (Minowa Studio): pages 192 (top), 193 (right).

Muromachi Masahiko (Dandy Photo): pages 77, 106–7.

Museum of Contemporary Art Tokyo: page 240 (top; copyright © KK Tsuchi).

Nakajima Hisato (Minowa Studio): page 192 (bottom).

Nakanishi Masamitsu (Nature Photo Library): page 32 (center left).

Narimatsu Gakuto: (Dandy Photo): pages 57, 61.

The National Museum of Modern Art, Tokyo: page 241 (copyright © Shimada Akara, copyright © Shiroshita Ruriko).

Nimura Haruo: pages 190, 194, 197, 200.

Noro Kiichi (Nature Photo Library): page 32 (top right & center right).

Oda Yojiro (Dandy Photo): pages 94–95.

Ogawa Tomoko: pages 222–23 (courtesy of Japan Actors' Association), 224 (top & bottom; courtesy of Japan Actors' Association), 225 (courtesy of Japan Actors' Association).

Ohashi Haruzo: page 177.

Ooishi Shizuka (courtesy of Fuji Film): page 102 (top right).

Ooki Akira: pages 210 (bottom), 211(top & bottom).

Photo Office Plus One: page 138 (bottom).

Sautter, Hans: pages 163 (top; courtesy of Takarazuka Revue Company), 164–65, 253.

Sekai Bunka Photo: pages 1, 4–5, 144, 151 (top left), 167.

Shimizu Kazuyoshi (Spirit Photos): page 127 (top).

Shinkenchiku-sha: page 178 (bottom).

Simmons, Ben: back jacket, pages 17, 113 (bottom), 115, 117 (bottom), 118–19, 125 (top & bottom), 132 (top), 136 (bottom), 151 (top right), 152–53, 156 (top left & right).

Straiton, Ken: pages 22, 23, 24, 25, 109, 116 (top & bottom), 117 (top left), 120, 124 (top & bottom), 127 (bottom), 128, 133, 135, 139 (bottom), 141 (top), 147, 148 (bottom), 156 (bottom), 157, 162, 163 (bottom), 184–85.

Sugiyama Fumiei (Nature Photo Library): pages 32 (top left), 74 (top left).

Suzuki Kuniaki (courtesy of Fuji Film): page 59.

Takada Takashi (courtesy of Fujingaho-Sha): page 189.

Takama Shinji: pages 54–55.

Takeuchi Toshinobu (Q Photo International): pages 142–43.

Tanaka Masafumi (Photo Library Noanoa): page 65 (top right).

Tanaka, Ryu (Dandy Photo): page 108.

Tankei: pages 28–29, 32 (bottom), 33, 36–37, 40, 41, 42, 44–45, 56 (top), 70 (bottom), 71 (bottom), 80 (bottom), 81, 84–85, 90 (top left), 98–99, 105 (bottom; courtesy of Kinkakuji), 123 (bottom), 182–83 (courtesy of Imperial Household Agency).

Tankosha Publishing: pages 204 (top & bottom, courtesy of Urasenke Foundation), 206, 212, 214 (all).

Tokugawa Art Museum, Nagoya: pages 232–33, 251.

Tokyo National Museum: pages 237, 238 (top), 239 (copyright © Yokoyama Takashi), 246 (top), 249, 250 (all).

Tonoshiro Hiroshi (Dandy Photo): page 88.

Tooyama Takayuki: pages 39 (top), 121 (top), 141 (bottom).

Toyotaka Ryuzo (Q Photo International): pages 47, 112, 123 (top).

Tsumori Yoshitaka (courtesy of Fuji Film): page 46.

Uchiyama Akira: page 103 (center).

Unno Kazuo (Nature Photo Library): page 60 (top).

Yamada Yuzo (Q Photo International): pages 83 (bottom), 121 (bottom), 122.

Yamamoto Ikio (Q Photo International): pages 52 (top), 53 (top), 114, 155, 159 (top & bottom).

Yamamoto Kazuo (Nature Photo Library): pages 62–63.

Yamamoto Nobuo (Photo Library Noanoa): page 65 (top left, bottom).

Yamatane Museum of Art, Tokyo: page 234 (all).

Yomiuri Shinbun: page 126 (courtesy of Nihon Sumo Kyokai).

Yoshikoshi Tatsuo: pages 216 (right & left), 219 (top & bottom), 220.